A Guide to the

Sculpture Parks and Gardens of America

A Guide to the

Sculpture Parks and Gardens of America

Jane McCarthy and Laurily K. Epstein

Michael Kesend Publishing, Ltd., New York

Copyright 1996 © by Jane McCarthy and Laurily K. Epstein
First publication 1996

Published by Michael Kesend Publishing, Ltd.
1025 Fifth Avenue, New York, NY 10028

Library of Congress Cataloging-in-Publication Data
McCarthy, Jane, 1932—
 A guide to the sculpture parks and gardens of America / Jane McCarthy and Laurily K. Epstein.
 p. cm.
 Includes bibliographical references and index.
 ISBN 0-935576-51-7
 1. Sculpture gardens—United States—Guidebooks. 2. Outdoor sculpture—United Sates—Guidebooks. 3. United Sates—Guidebooks. I. Epstein, Laurily Keir. II. Titles.
NB205.M33 1996
730' .973—dc20 96-17393
 CIP

Contents

Preface *xi*

Introduction *1*

Sculpture Parks in the Northeast

Map of Sculpture Park Locations *18*

Connecticut
Kouros Sculpture Center (Ridgefield) 19

Aldrich Museum of Contemporary Art (Ridgefield) 21

Stamford Museum & Nature Center 23

Maryland
Baltimore Museum of Art, Wurtzburger & Levi Sculpture Gardens 25

Massachusetts
De Cordova Museum & Sculpture Park (Lincoln) 28

MIT List Visual Arts Center (Cambridge) 30

Butler Sculpture Park (Sheffield) 33

Chesterwood Museum (Stockbridge) 34

New Hampshire
Saint-Gaudens National Historic Site (Cornish) 36

New Jersey

Grounds for Sculpture (Hamilton) 38

Newark Museum Alice Ransom Dreyfuss
Memorial Garden 42

William Paterson College Outdoor Sculpture
Collection (Wayne) 44

Princeton University, John Putnam, Jr. Memorial
Collection 46

Quietude Sculpture Garden (East Brunswick) 49

New York

New York City

Battery Park City (New York) 50

Fordham University (The Bronx) 53

Museum of Modern Art, Abby Aldrich Rockefeller
Sculpture Garden (New York) 54

Studio Museum in Harlem (New York) 57

The Isamu Noguchi Garden Museum (Queens) 60

P.S. 1 Museum (Queens) 63

Socrates Sculpture Park (Queens) 64

Brooklyn Museum, Frieda Schiff Warburg
Sculpture Garden 67

New York City Region

PepsiCo, Donald M. Kendall Sculpture Gardens (Purchase) 68

The Rockefeller Estate Kykuit Sculpture Gardens,
(North Tarrytown) 71

Hofstra University Sculpture Park (Hempstead) 76

Nassau County Museum of Fine Arts (Roslyn Harbor) 78

Storm King Art Center (Mountainville) 81

Hans Van de Bovenkamp Sculpture Garden (Tillson) 85

Upstate New York

City of Poughkeepsie Sculpture Park 88

Empire State Plaza Art Collection (Albany) 91

Albright-Knox Art Gallery (Buffalo) 93

Griffis Sculpture Park (East Otto) 96

Stone Quarry Hill Art Park (Cazenovia) 98

Pennsylvania

Abington Arts Center Sculpture Garden(Jenkintown) 100

Lehigh University (Bethlehem) 103

Morris Arboretum (Philadelphia) 105

Ursinus College, Berman Museum of Art (Collegeville) 107

Washington, D.C.

Hirshhorn Museum & Sculpture Garden 109

Kreeger Museum 114

More Sculpture Attractions in the Northeast 115

Sculpture Parks in the Midwest

Map of Sculpture Park Locations 128

Illinois

University of Chicago 129

Northwestern University, Sculpture Garden (Evanston) 130

Ravinia Festival (Highland Park) 132

Governors State University, Nathan Manilow Sculpture Park (University Park) 134

Mitchell Museum, Cedarhurst Sculpture Park (Mt. Vernon) 136

Iowa

Des Moines Art Center 139

Iowa State University, Art on Campus Program (Ames) 142

Kansas

Wichita State University, Edwin Ulrich Museum of Art 144

Michigan

Cranbrook Academy of Art Museum (Bloomfield Hills) 146

Minnesota

General Mills Art Collection (Minneapolis) 148

Walker Art Center, Minneapolis Sculpture Garden 151

Missouri

Laumeier Sculpture Park (St. Louis) 155

Nelson-Atkins Museum of Art, Henry Moore Sculpture Garden (Kansas City) 160

Nebraska

University of Nebraska, Sheldon Memorial Art Gallery Sculpture Garden (Lincoln) 163

Ohio

Columbus Museum of Art 166

Wisconsin

Bradley Sculpture Garden (Milwaukee) 168

Fred Smith's Wisconsin Concrete Park (Phillps) 170

More Sculpture Attractions in the Midwest 171

Sculpture Parks in the South

Map of Sculpture Park Locations 180

Alabama

University of Alabama Sculpture Tour (Tuscaloosa) 181

Birmingham Museum of Art, Charles W. Ireland Scuplture Garden (Birmingham) 182

Florida

Florida International University (Miami) 184

Louisiana

K & B Plaza, Virlane Foundation Collection
(New Orleans) 187

North Carolina

Appalachian State University, Rosen Outdoor Sculpture
Competition (Boone) 189

South Carolina

Brookgreen Gardens (Murrells Inlet) 190

Tennessee

Chattanooga State Technical Community College Sculpture
Garden 192

University of Tennessee Sculpture Tour (Knoxville) 195

Texas

Connemara Conservancy Foundation (Dallas) 197

Dallas Museum of Art 198

Southern Methodist University, Elizabeth Meadows Sculpture
Garden (Dallas) 200

Museum of Fine Arts, Cullen Sculpture Garden
(Houston) 202

The Chinati Foundation (Marfa, near El Paso) 205

More Sculpture Attractions in the South 208

Sculpture Parks in the West and Southwest

Map of Sculpture Park Locations 216

Arizona

Scottsdale Center for the Arts 217

California

Stanford University Museum of Art, B. Gerald Cantor Rodin
Sculpture Garden (Palo Alto) 218

Oakland Museum 222

UCLA Franklin Murphy Sculpture Garden (Westwood) 225

Los Angeles County Museum of Art 228

Norton Simon Sculpture Garden (Pasadena) 230

Westin Mission Hills Resort, Rancho Mirage 232

La Quinta Sculpture Park 234

California Scenario (Costa Mesa) 235

California State University at Long Beach 237

University of California at San Diego, Stuart Collection
(La Jolla) 239

Colorado

Museum of Outdoor Arts (Englewood) 241

New Mexico

Albuquerque Museum of Art 243

Shidoni Foundry, Galleries and Sculpture Garden
(Santa Fe) 245

Washington

Western Washington University (Bellingham) 247

Warren G. Magnuson Park, NOAA (Seattle) 250

More Sculpture Attractions in the West and Southwest 252

Resources 265

Photo Credits 269

Index 273

Preface

This guide to sculpture parks and gardens is the culmination of a three-year search to ferret out the country's rich repositories of outdoor sculpture. Surprisingly, given the spectacular nature of these outdoor locations, the remarkable variety of sculptural offerings, and the popularity of these parks with the public, this is the first book to be published that treats the world of sculpture gardens as a distinct artistic category.

All the sculpture parks we present here are open to the public, although some are seasonal attractions that typically close in the winter. The guide is separated into four geographic regions—the Northeast, the Midwest, the South, and the West and Southwest. Maps at the beginning of each region will help sculpture devotees to plan their itineraries so that two or more parks can be covered in a day or weekend. Each regional section concludes with suggestions for additional outdoor sculpture attractions and folk art presentations that are not strictly parks but that merit visits for their distinctive qualities.

The sculpture garden entries describe highlights of the sculpture collections, the history, and sponsorship of the gardens and offer anecdotes about the sculptors and their works. A list of the sculptors whose work is on display is also included. If facilities for picnicking are available, this is noted. Finally, the entries give the hours the collections are on view and travel directions.

Since this is the first book to discuss sculpture parks and gardens as their own distinctive artistic grouping and no comprehensive listing of sculpture parks was available to the authors, it is possible that worthy sculpture installations have been omit-

ted. Perhaps subsequent editions of this book will add entries that may have been missed.

Every effort has been made to provide the most up-to-date information on the hours museums and parks are open, but schedule changes make it advisable to check to be sure the park will be open when you want to visit.

We hope this guide will encourage art lovers to visit and appreciate these extraordinary outdoor spaces.

Introduction

Sculpture gardens are wondrous blends of nature with artistic achievement. These open-air showcases present sculpture in natural settings that both dramatize and harmonize works of art; strategically placed ponds, waterfalls, grassy mounds, and groves of trees add to the pleasure of viewing sculpture. Variations of light and shadow, wind and weather, and the changing seasons bring fresh and ever-changing images.

Sculpture gardens invite you to stroll on the grass, stalk individual pieces, and contemplate the works close at hand and from a distance. They offer the twin delights of construction and nature, presenting intriguing contrasts of soaring man-made objects enveloped in landscapes of flourishing greenery. Even the most precisely manicured gardens have an informality and a sense of freedom not duplicated in a museum. What a dramatic and pleasing experience it is to see a colorful abstract steel construction framed by a lacy pine forest or to view a heroic bronze in a grassy open field, set among trees and flowers. These are experiences that can be enjoyed by families with small children; clearly youngsters and their parents can stroll, picnic, and play among some of the world's finest artistic creations.

In America, sculpture gardens are a relatively recent phenomenon. Cemeteries, with elaborately decorated headstones, mausoleums, and monuments, set in wide swaths of green, were the first public gardens that featured sculpture. These cemeteries were alternatives to the traditional cloistered graveyards tucked in and around churches. The first public cemetery was established in 1831 at Mount Auburn, in Cambridge,

Massachusetts. Philadelphia's Laurel Hill and Brooklyn's Green-Wood followed in the mid-1840s. These urban oases, with rolling hillsides, arching trees, streams, winding paths, and ponds were a magnet for local residents and a destination point for tourists. As Victorians ventured forth for their afternoon strolls, tour guides pointed out decorative gravestones, monuments, and tombs. The spacious landscapes were a boon for the residents of the increasingly crowded cities, and they foreshadowed the development in the 1850s of the large public urban parks such as New York's Central Park, Philadelphia's Fairmount Park, Forest Park in St. Louis, and Golden Gate Park in San Francisco.

After the Civil War, Americans began to take greater interest and pride in their cities. Civic leaders and the newly affluent urban gentry launched efforts to beautify their cities with art, particularly works honoring Civil War heroes. On tours of Europe the patrician class marveled at the way sculpture embellished Paris, Vienna, and Rome. Returning home, they were eager to replicate in their own cities the artistic splendor they admired in the Old World. The Civil War also infused small-town America with a zest for statuary to honor both the fallen and the surviving veterans of that terrible conflict. Virtually every village square has a memorial dedicated to its heroes.

A definitive moment in American sculpture and urban design occurred in 1893 when the World's Columbian Exposition brought to Chicago the nation's most renowned sculptors, architects, and painters. The Chicago Exposition, which displayed classically designed buildings and sculpture, attracted millions of visitors and sparked the City Beautiful movement. Artists and architects trained in the French Beaux Arts tradition, such as Augustus Saint-Gaudens, Daniel Chester French, Richard Morris Hunt, and Stanford White, translated into the American sensibility a neoclassical architectural and sculpture style called the American Renaissance. This style, with its message of civic grandeur and culture, was an ideal medium to convey the pride and aspirations of the upper class in the newly prosperous cities. These ornate, columned, and steepled buildings are very much in evidence today in hundreds of city

halls, libraries, and other public buildings constructed in the years before World War I.

The City Beautiful movement also spurred the building of urban parks. Just as civic buildings were designed to accentuate the growing power and affluence of cities, so too the parks were amenities that conveyed the sense of a grand metropolis. Drawing again on the European tradition, in which sculpture was used to highlight and adorn gardens, America's civic leaders enthusiastically supported private and public efforts to place statuary in the parks. The new public parks offered recreational outlets for waves of immigrants; park sculpture, depicting the

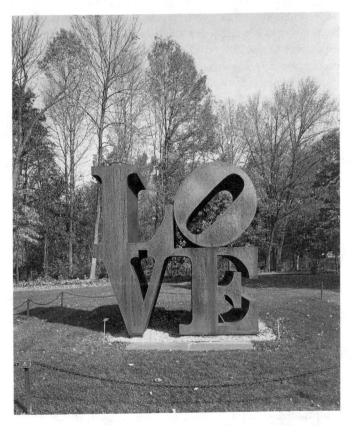

Robert Indiana, *Love* (1970), Indianapolis Museum of Art, IN

nation's leaders and significant historical events, sent a cultural and patriotic message the upper class was eager to convey to its immigrant population.

Today's Sculpture Gardens

Sculpture gardens as we know them today originated with Brookgreen Gardens in South Carolina in 1931. Brookgreen, the legacy of sculptor Anna Hyatt Huntington, was built by her wealthy husband Archer to display her works and those of artists who were steeped in the classical tradition. It is the only sculpture garden in America that limits its collection to classic, figurative sculpture. All the sculpture at Brookgreen would have been fitting adornments for the Beaux Arts buildings constructed in the early years of this century. Time stands still at Brookgreen, offering a glorious peek into a bygone era.

The second oldest sculpture garden, established in 1939 when New York City's Museum of Modern Art moved to its current location on West 53rd Street, is a frisky departure from the classic tradition. When MoMA was established in 1929, it was decidedly avant-garde. The museum acquired and promoted works by a new wave of artists who had broken from the classic mold. Pablo Picasso, David Smith, Joan Miro, Gaston Lachaise, and their colleagues were, and continue to be, the points of interest. In contrast to the pastoral setting of Brookgreen, the MoMA garden was, and remains today, a tiny space in a throbbing megalopolis. Brookgreen and MoMA were the only sculpture gardens in existence before World War II. Not until the 1960s did sculpture gardens begin to proliferate throughout the country.

Since then, sculpture gardens have come into their own. They can now be found in twenty-eight states and the District of Columbia, from Washington State to Florida; the greatest number are located in the Northeast. The most notable gardens established in the 1960s were Storm King (upstate New York), Western Washington University (Bellingham), the Bradley Family Foundation Sculpture Park (Milwaukee), the Hirshhorn Sculpture Garden (Washington, D.C.), and the Putnam Collection at Princeton University. The 1970s produced stand-

out collections of outdoor art at PepsiCo (suburban New York City), the Laumeier Sculpture Park (St. Louis), and the Manilow Sculpture Park (University Park, Illinois).

A driving force for creating new sculpture gardens is the need for large, open spaces to display massive contemporary sculpture. These new works cannot be shown to their best advantage within the confines of museums. Thus, museums and universities increasingly look to their grounds as ideal locations to present modern, oversized works.

The 1980s were a time of unprecedented growth in the number of sculpture parks; more than thirty were established in the decade. Economic prosperity triggered philanthropic gifts. Local and state Percent for Art programs earmarked funds for art in new construction and remodeling projects. Even modestly endowed small colleges found innovative ways to bring sculpture to campus. Most notable are the "sculpture tours" put together by colleges in the South and Midwest. These tours, which place art temporarily on campus, give small schools an opportunity to expose students to some of the finest works being produced today. The outstanding sculpture gardens created in the 1980s include the Wurtzburger and Levi Sculpture Gardens at the Baltimore Museum of Art, the Stuart Collection at the University of California at San Diego, the General Mills and Walker Art Center collections in Minneapolis, and the Henry Moore Sculpture Garden at the Nelson-Atkins Museum of Art in Kansas City.

Despite the straitened economy of the 1990s and dwindling contributions from philanthropists and the government, some two dozen new sculpture gardens have been established. These new ventures are typically more modest efforts; several are galleries that sell outdoor pieces. An outstanding addition to the sculpture park scene in the 1990s was the opening to the public of Kykuit, on the Rockefeller estate in North Tarrytown, New York.

Several sculpture gardens are on the drawing board. One of the most ambitious is planned for the Skirball Museum at Hebrew Union College in Los Angeles. Others in the planning stage are being sponsored by the University of Texas at San

Antonio, Pasadena City College, the Museum of Contemporary Art in Chicago, and the Fresno Art Museum. The Los Angeles County Museum of Art is undertaking a major expansion.

The vast majority of today's sculpture parks were the products of a single patron of the arts, such as Chicago's Lewis Manilow and Leigh Block, New York's Rockefeller family and Frieda Schiff Warburg, Pennsylvania's Philip Berman, and California's Iris and Gerald Cantor, Norton Simon, and James DeSilva. These and other generous arts philanthropists focused their largesse on museum and university collections. Corporate sculpture parks—General Mills, PepsiCo, and K & B Plaza— are, not surprisingly, sponsored by major consumer products companies that gain prestige and public relations value from their association with the arts.

Several parks were established by sculptors. Isamu Noguchi created a garden at his studio as a gift to New York City residents. Mark di Suvero used neighborhood kids in New York City

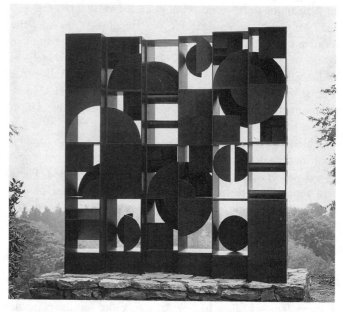

Louise Nevelson, *Atmosphere & Environment VI* (1967), Kykuit, The Rockefeller Estate, North Tarrytown, NY

to transform a waterfront wasteland near his studio into a park. Robert Butler in the Berkshires and Hans Van de Bovenkamp in upstate New York fashioned dramatic outdoor sculpture displays in bucolic country settings. J. Seward Johnson, Jr., sponsors a sculpture complex that includes a fine arts foundry and an expansive, woodsy setting for his pieces and those of other sculptors. On an entirely different scale is Walter De Maria's *Lightning Field* in New Mexico, an environmental installation that creates spectacular lightning shows.

The studios of two of America's famed classical sculptors also include sculpture gardens. Chesterwood, Daniel Chester French's summer home in the Massachusetts Berkshires, not only presents French's works but also sponsors exhibitions of contemporary pieces. Augustus Saint-Gaudens' home in Cornish, New Hampshire, is an important site for devotees of late-nineteenth-century Beaux Arts sculpture. Here, too, contemporary work is also featured.

The Challenge of Maintaining Outdoor Collections

Outdoor collections, which are buffeted by weather, pollution, and vandalism, are much more vulnerable to damage than are collections protected within museum walls. Responsible curators are constantly on the alert for rust, corrosion, bird droppings, and moisture, all of which hold the potential for severely marring the works. Vandalism and graffiti are more prevalent and difficult to combat outdoors, away from the watchful eyes of security guards. New challenges are also encountered with the popularity of oversized and kinetic works, and pieces constructed from exotic materials, such as polystyrene and resins. Then, too, some of the newer works, from the 1980s, were created by artists who have an incomplete understanding of weights and metal construction. Built-in design flaws and inadequate welding to support the weight are particularly thorny problems for conscientious curators.

Problems with vandalism vary widely; museum collections and the cloistered corporate collections have the least to fear

from spray paint and carving knives of vandals. But the large, unsupervised parks, such as Laumeier, must be ever vigilant to protect their works. Even well-tended and relatively isolated institutions such as Stanford University have the occasional problem. In 1994 Stanford's *Gay Liberation* by George Segal was vandalized. Yet the University of Chicago, surrounded by some of the worst slums in America, has experienced few, if any, attacks on its outdoor collection.

Determining the appropriate approach to maintaining outdoor sculpture is a tricky business. Conservation continues to be more art than science. Conservation techniques are controversial, and curators are continually adapting traditional preservation methods and experimenting with new processes. What's considered graceful aging? What are the warning signals for decay? Should visitors be allowed to touch and climb on the pieces? When should works be brought indoors? Curators wrestle with these questions on a regular basis. Their decisions are dictated by such diverse factors as the funds available for preservation, attitudes of the trustees, and the competence and commitment of professional staff. It is not unusual for curators to involve the artists in key decisions regarding care and maintenance.

Two maintenance problems encountered at the Cullen Sculpture Garden at the Museum of Fine Arts in Houston illustrate the challenges faced by curators. A work by Pietro Consagra, *Conversation with the Wind,* that was designed to rotate was discovered to have a badly rusted rotary bearing. The bearing had been replaced twice, but rust continued to lock the rotary. If a new mechanism were installed, the appearance of the work would have been drastically altered. The problem was solved with a visit to the artist's studio in Rome. He simply said *Dipingerio*—"Paint it." Consagra agreed that the rotary mechanism should be reconfigured. Paint samples went back and forth across the Atlantic until just the right shade of matte gray was selected.

Another Cullen dilemma involved Mark di Suvero's *Magari,* a kinetic sculpture designed to have a rough and rusty look. The work showed signs of wear, but the application of a

protective coating would materially alter its appearance. Here the solution was to leave the piece alone and monitor regularly for serious problems.

Perhaps nowhere is the responsibility for preserving and maintaining outdoor works taken more seriously than at Cedarhurst Sculpture Park at the Mitchell Museum, in Mt. Vernon, Illinois. Curator Bonnie Speed spends many hours each month in hands-on preservation. On a monthly basis groundskeepers refer to the maintenance charts that are kept for each piece of sculpture. Cor-ten steel pieces, which are designed to rust gradually into reddish brown tones, are scrubbed with wire brushes to remove acid bird droppings and protective coats of boiled linseed oil are applied. Cedar and redwood pieces are coated with sealants to combat the damaging effects of moisture. These efforts pay off. The Cedarhurst collection simply shimmers, and the works seem to sit more proudly as a result. "Our aim is to have the sculpture returned in better shape than when it arrived," said Speed.

In their preservation efforts, curators sometimes draw on expertise far afield from the art world. For combatting rust and corrosion, Laumeier sought advice on protective coatings from a race car driver. As a Laumeier curator put it, "Auto mechanics work with cars while we work with big steel UFOs. Both are concerned with many of the same problems."

Preservation is costly, and many curators express concern over the lack of funds for the unglamorous, everyday chores of welding rusted joints, sandblasting, painting, pest control, and wood replacement. Donors can be more easily persuaded to contribute toward new works than to fund costly preservation to maintain existing pieces in good repair.

The Laumeier's Adopt-A-Sculpture program encourages donors to contribute toward the upkeep of individual sculptures. Its signature piece, Alexander Liberman's *The Way*, installed in 1980, needs more than $15,000 for sandblasting and painting to bring back its former luster. The epoxy-resin paint alone costs $100 a gallon, a considerable sum for a work that is 100 feet long and 50 feet high. Another sizable cost is the extensive scaffolding around the perimeter.

Of course, the availability of funds varies widely between sculpture parks. Laumeier is largely supported by St. Louis County, and others, such as Cedarhurst, have sizable endowments. Corporate collections that project the image of the company are likely to be well maintained.

Public Controversy

One man's masterpiece is another man's monstrosity—for one reason or another. Since no two people see art in quite the same way, it is inevitable that controversy occasionally erupts when works are installed in the public domain. In recent years, one of the most publicized storms raged over Richard Serra's massive *Tilted Arc,* an intrusive 112-foot-long, 12-foot-high sculpture of rusted steel plates that bisected Federal Plaza in New York City's lower Manhattan. Many office workers in and around the plaza felt the work was so overpowering and hostile that it made the plaza unusable. Serra argued that his commissioned work was inspired by the drab and undistinguished office buildings surrounding his piece and that its removal would destroy his sculpture. After five years of wrangling, *Tilted Arc* was dismantled and removed in 1989. The Serra dispute and dozens of other controversies over public art pit the public's larger interest, however that is defined, against the integrity of the artist's creation.

After the prolonged New York struggle, Serra ran into trouble again with his next public commission, a 48-foot-high, 140-ton sculpture slated for San Francisco's Palace of the Legion of Honor. This work elicited so much controversy that he withdrew from the project. "I've been barbecued in San Francisco, and I don't need to get fried anymore," Serra said about the bruising battle.

Another widely publicized furor arose over what constitutes a fitting memorial for the Vietnam war veterans. Texas billionaire H. Ross Perot sponsored a design competition for a memorial, but then objected when the jury unanimously selected Maya Lin's somber, sweeping memorial wall with the names of the American dead etched in the polished black granite. Perot preferred a more traditional bronze depiction of military bravery. The solution, which displeased almost everyone, was the addition

at a nearby site of a bronze tableau depicting American soldiers who fought in this wrenching conflict. Another dimension of the Vietnam memorial conflict arose when women veterans felt their contributions to the war were not being acknowledged. They raised funds on their own and commissioned sculptor Glenna Goodacre to create a 6-foot bronze statue of three military women comforting a fallen G.I. This powerful, evocative work is now part of the memorial complex.

An ongoing battle over sculpture is raging in Dallas, where the city is erecting a monumental bronze depiction of a nine-teenth-century cattle drive, complete with seventy 6-foot-high steers and three trail herders. This 4.2-acre tableau at Pioneer Plaza in downtown Dallas is being promoted as the largest bronze sculpture installation in the world, or surely the world's most momentous cow as some local detractors have tagged it. Tempers flare over the question of historical accuracy. Critics point out that Fort Worth, not Dallas, is the historical cowtown, and that this is a blatant attempt to redraw the boundary line of the American frontier. Sculptor William Easley suggested a more appropriate symbol would be "a herd of lawyers, bankers and insurance men stampeding through town."

Even small-town America occasionally gets into the public art debate. In Brookline Village in Massachusetts, artist Denise Marika created something of a storm when, as a city-approved artistic venture, she altered two crosswalk signals, using images of a nude mother and child for the *Walk* and *Don't Walk* signals. A predictable commotion over nakedness ensued. Prolonged debate was avoided since the work was scheduled to have only a limited run. Brookline artist John Bassett, when asked the meaning of the piece, quipped, "Hang on to your kid and take your clothes off."

Battles will continue to be joined over matters of propriety and taste, and the insistence of artists that they be true to their artistic visions. The issues focus most sharply when a work is commissioned for a specific site, after approval from a public body. Artists and their supporters will assert that removal of a commissioned work destroys its validity. Detractors will assert that public art should not create an antagonistic, confrontational

environment. Conflicts over the integrity of an artist's work and the public's sense of propriety are bound to continue, particularly when public funds are contributed to the installation.

Public Art and Sculpture as Civic Symbol

From the start, Americans have been ambivalent about placing art in public spaces. In the years following the American Revolution, our Founding Fathers considered statues to be pretentious and undemocratic, believing they smacked of English royalty and the popes. Indeed, it took more than a hundred years for the country to decide on an appropriate memorial to George Washington; the Washington Monument was installed in 1885.

Since the 1960s, several American cities have commissioned and prominently display monumental sculpture as a form of civic boosterism designed to telegraph a city's image. These American equivalents of the *Eiffel Tower* offer instantly recognized symbols. Contemporary sculpture-as-symbol generates local pride, individualizes a city, and attracts tourists in a fashion

Siah Armajani, Irene Hixon Whitney Bridge, Walker Art Center, Minneapolis, MN

similar to the Statue of Liberty, the Golden Gate Bridge, and the Empire State building.

The first contemporary sculpture created as a city symbol was Eero Saarinen's soaring 630-foot *Gateway Arch* (1966) that looms over St. Louis' downtown waterfront. Other well-known logos are the *Chicago Picasso* (1967), and Grand Rapids' *La Grande Vitesse* (1969), by Alexander Calder. Claes Oldenburg has produced signature pieces for two cities—his *Clothespin* (1976) for Philadelphia and, with Coosje van Bruggen, *Spoonbridge and Cherry* for Minneapolis (1988). These images seep into the public consciousness in odd ways. An amusing cover on a Chicago restaurant guide shows a grinning *Chicago Picasso* with eating utensils in its hands. Calder's Grand Rapids logo is emblazoned on the city's garbage trucks.

As cities turn to sculpture for symbols that capture their distinctive character, their citizens become increasingly aware of outdoor art and its contribution to enliven the streetscape and public areas. Not surprisingly, many of the cities that pioneered the commissioning of civic symbols took the lead in establishing Percent for Art programs, which typically set aside for art 1 percent of the funds allocated for municipal capital improvement projects. Philadelphia was the first city to establish such a fund, in 1959. By the mid-1980s many major cities had set-asides for public art.

Folk Art Installations

Outdoor folk art is a distinct artistic genre. Typically, the works were created by a single individual who was driven to express fervent patriotic or religious themes. While these installations are found in all areas of the country, they are particularly in evidence in the South and Midwest. The works are most frequently set in isolated towns and hamlets, in the backyards of the artists. Thus in many cases it takes a real trek to find them.

The artists, who are usually self-taught, use discarded materials such as bottles, bottle caps, rocks, broken tiles and headlights, and other cast-off objects. These idiosyncratic statements are extraordinary in their variety and complexity. They run the gamut from Samuel Dinsmoor's pageant of creation in his three-story

Garden of Eden, in Lucas, Kansas, to Simon Rodia's 100-foot-high, pottery-embedded *Watts Towers,* in Los Angeles, and Edward Leedskalnin's *Coral Castle,* in Homestead, Florida, that was constructed to assuage his grief over being spurned in love. Most of the works took years or even decades to construct. And each has a special story or message that the artist felt compelled to express.

Earthworks

No discussion of outdoor art would be complete without references to the massive earthworks that came into prominence in the 1970s. An early pioneer was Herbert Bayer who created *Earth Mound* in 1955 at the Aspen Institute for Humanistic Studies in Colorado. He was the forerunner for the huge environmental sculptures designed in the early 1970s by Robert Smithson, Michael Heizer, Robert Morris, Richard Fleischner, and Nancy Holt.

Reflecting the social and political turmoil of the period, many artists sought to break free from their studios and the limitations of gallery shows to work outdoors on a grandiose scale, using such unconventional materials as earth mounds and landscaping. These works explore the relationships between earth and space; many were statements of concern about the earth's fragility, the damaging effects of industrial pollution, and our vulnerability to environmental poisons. Michael Heizer's *Double Negative* and *Complex One* were created in the Nevada desert. For *Spiral Jetty,* Robert Smithson bulldozed spirals of earth into Great Salt Lake. Robert Morris' *Grand Rapids Project* transformed an eroded hillside in a recreation area into a mammoth sculpture landscape. Richard Fleischner created *Sod Maze,* a swirling circular form of sod and earth, on the grounds of a Newport, Rhode Island, mansion. And Nancy Holt used the bleak Utah desert as the site for her *Sun Tunnels.* These installations were distinct departures from traditional works in that their locations, size, and often their impermanence meant they could not be purchased.

Also in the early 1970s, environmental artist Christo was experimenting with his distinctive "wrappings." In 1971 he cre-

ated *Valley Curtain,* a gigantic swath of bright orange nylon sheeting draped over the 1,300-foot Rifle Gap in Colorado. In the mid-1970s he used white nylon for his *Running Fence,* which was strung over 24 miles and fifty-nine ranches in northern California. He went on to float brilliant pink fabric around a chain of eleven islands in Miami's Biscayne Bay in his *Surrounded Islands* for two startling weeks in the spring of 1983. These one-time, limited-run, sculpture events were in a sense performance art in that they required the cooperative effort of hundreds of hands to execute the projects. The intent, similar to that of the earthworks, is to alter people's perception of art and nature, to call attention to the earth's inherent artistic attractions.

In the 1980s, adventurous artists took to the soil, using seeds and fertilizer as their medium and the earth as their canvas. Among the pioneers and the best known of the "crop artists" is Stan Herd, a Lawrence, Kansas, farmer who in 1981 created a giant image of Santanta, the Kiowa Indian chief, in a 160-acre wheat field. Herd's best known work is *Sunflower Still Life,* a Van Gogh-like image of a table and a vase with sunflowers, which turned yellow as the summer wore on. Crop art, like farming, has its perils: a dry spell or too much rain plays havoc with the design. In 1994, Herd brought his artistry to New York City where he produced *Gateway to the Countryside,* a work that used vegetables and flowering plants on an acre of Donald Trump's property near the Hudson River on the Upper West Side. With Herd as an inspiration, fourteen upstate New York farmers have gotten into the act, creating such images as a sorghum grass maze, portraits of cows, an American flag, a quilt, and a pumpkin. Many of the earthworks, and of course all of Christo's "wrappings," and the agricultural sculpture, were designed as temporary installations. The purpose was not to create lasting objects but rather to build a record of these sensational environmental transformations. The only permanent elements are the movies, photographs, and souvenirs that document these events.

Whether the sculpture is a mammoth earthwork in the arid Western desert or a classic life-size bronze by Anna Hyatt Huntington at Brookgreen Gardens, the outdoor setting offers a

dazzling and ever-changing backdrop. The luxury of space, variations in the seasons and time of day, contrasts in color and texture between nature and man-made object, and the play of light and shadow are elements that cannot be matched in a gallery or museum. The out-of-doors brings sculpture to life; the natural world informs and enriches these artistic creations.

Sculpture Parks in the Northeast

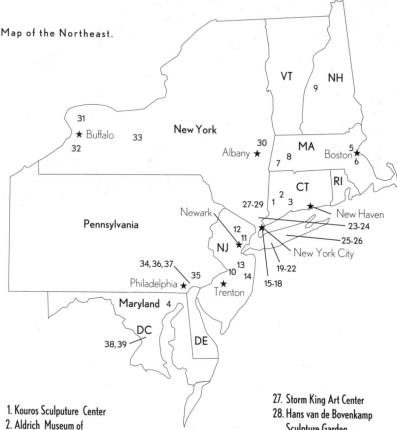

Map of the Northeast.

VT NH
 9

31
★ Buffalo 33
32

New York

Albany ★ 30
 7 8 MA Boston 5
 6

Pennsylvania

Newark 27-29 1 2 CT RI
 3
 ★ New Haven
 12 11 23-24
 25-26
NJ ★ New York City

34, 36, 37 13
 35 10 14 19-22
Philadelphia ★ 15-18
 Trenton ★

Maryland 4

DC
38, 39 DE

1. Kouros Sculputure Center
2. Aldrich Museum of
 Contemporayr Art
3. Stamford Museum & Nature
 Center
4. Baltimore Musem of Art
5. De Cordova Museum &
 Sculpture Park
6. MIT List Visual Arts Center
7. Butler Sculpture Park
8. Chesterwood Musuem
9. Saint-Gaudens National
 Historic Site
10. Grounds for Sculpture
11. Newark Museum Sculpture
 Garden
12. William Paterson College out-
 door Sculpture Collection

13. Princeton University
14. Quietude
15. Battery Park City
16. Fordham University
17. Museum of Modern Art
18. Studio Museum in Harlem
19. Noguchi Garden Museum
20. P.S.1
21. Socrates Sculpture Park
22. Brooklyn Museum, Sculpture
 Garden
23. PepsiCo
24. Kykuit, the Rockefeller Estate
25. Hofstra University
26. Nassau County Museum of Fine
 Arts

27. Storm King Art Center
28. Hans van de Bovenkamp
 Sculpture Garden
29. City of Poughkeepsie Sculpture
 Park
30. Empire Sate Plaza Art
 Collection
31. Albright-Knox Art Gallery
32. Griffis Sculpture Park
33. Stone Quarry Hill Art Park
34. Abington Arts Center
35. Lehigh University
36. Morris Arboretum
37. Ursinus College, Berman
 Museum of Art
38. Hirshhorn Museum and
 Sculpture Garden
39. Kreeger Museum

Connecticut

Kouros Sculpture Center

Ridgefield, Connecticut

Set in the horsey back country, on the border of northern Westchester, is a superb collection of predominately contemporary sculpture. The center's 70 acres of rolling countryside surround the home of Charlotte and Angelos Camillos, who show modern works at their Kouros Gallery in New York City. They created the garden a decade ago to accommodate large, difficult-to-store works by artists they represent. Today, more than 120 pieces are displayed on broad lawns, open fields, and around a landscaped swimming pool. All the works are for sale.

The wide variety in both scale and styles of sculpture is immediately evident along the sweeping drive that leads to the main house. In an expansive grassy meadow, created in a former wheat field, are two dozen large-scale works. Zero Higashida's *Perspective I*, an immense black steel and wood construction that resembles the grasping jaws of a giant, is prominently displayed near a more delicate pair of Tom Doyle's graceful wooden figures that exude a vibrant sense of movement.

Lin Emery's streamlined and polished aluminum abstract forms glisten in the sunlight. Particularly striking is her *Flower*, a 14-foot-high sculpture with two brilliant red petals that swing on the point of a gleaming curved pedestal. Engineering precision and superb craftsmanship are evident in the delicate yet sturdy aluminum pivots and joints. Emery's pieces suggest the influences of the renowned kinetic sculptors George Rickey and Alexander Calder, but they are distinctively her own.

Along the path toward the house is Marsha Pels' bronze *Felucca*. This 10-foot-long crumpled papyrus ark evokes a sense of ancient travels up the Nile.

Many smaller pieces are displayed on flagstones and on the stepped wooden terrace around the swimming pool. At poolside are several versions of Nicolas Vlavianos' sleek, industrial-looking *Magic Machine*. These stainless steel and brass interpretations of such items as a vacuum cleaner, a chain saw, and a lawn

roller offer surprisingly compatible counterpoints to the lush recreational setting. Also around the pool are Bruno Romeda's bronze circles, triangles, and squares that stand on pedestals situated to frame views of the garden.

A particularly appealing piece is Elizabeth Hill's small bronze *Scribe*. This bespectacled, definitely Westernized Buddha sits in the lotus position on a cheerfully patterned green, white, and blue cushion, the picture of alert composure. He can be seen at eye level, tucked away amid greenery in a small interior courtyard.

Sculpture is regularly added. Typically around eight new sculptors are selected each year, principally from artist referrals. Since the works are for sale, pieces on display change frequently. Sculpture prices range from around $10,000 to over $200,000. The most expensive are bronze works by Reuben Nakian, a modern master of sculpture and drawing who died in 1986. He is known for his joyful and sensuous depictions of classical mythological figures.

Sculptors represented in the collection include Matthias Allen, Bill Barrett, Kevin Barrett, Zigi Ben-Haim, Roger Berry, Tom Bills, Miriam Bloom, Juan Bordes, Benbow Bullock, James Burt, Leonard Cave, Joan Costa, Kris Cox, Robert Cronin, Tom Doyle, Lin Emery, Lawrence Fane, Johann Feilacher, Christos Gianakos, Mark Hadjipateras, Dimitri Hadzi, Maria Hall, Zero Higashida, Elizabeth Hill, Robin Hill, Jon Isherwood, Niki Ketchman, Katherine King, Michael Lekakis, Claire Lieberman, Joseph McDonnell, Mark Mennin, Laurence Metzler, Reuben Nakian, Minoru Niizuma, Manolis Paraschos, Barry Parker, Marsha Pels, Don Porcaro, Steven Rand, Robert Ressler, George Rickey, Bruno Romeda, Livio Saganic, Art Schade, James Schmidt, Jay Swift, Lee Tribe, Hans Van de Bovenkamp, Nicolas Vlavianos, Harvey Weiss, Stephen Whisler, Bruce White, and Roger Williams.

Color brochures showing representative works from the outdoor collection are available. Admission is free.

How to Get There: The center is on the Westchester-Connecticut border, an hour's drive from New York City. Take Route 684 to Brewster; then take Route 22 North to North

Salem. The road to the center is circuitous. Call the Kouros Gallery in New York City (212-288-5888) or the Sculpture Center for detailed directions.

Kouros Sculpture Center
150 Mopus Bridge Road
Ridgefield, CT 06877
203-438-7636
Hours: Noon-6:00 P.M., Fridays and Saturdays, or by appointment.

Aldrich Museum of Contemporary Art

Ridgefield, Connecticut

More than a dozen large-scale contemporary sculptures are sited around the museum and on the gently sloping acre of lawn in the rear garden. This avant-garde museum, the first in the nation devoted exclusively to contemporary art, sits in a conservative, quaint New England village that is brimming with beautifully restored mansions. The immaculate white clapboard museum building is indistinguishable from its neighbors except for the contemporary sculpture on its grounds.

This post-Revolutionary War building was purchased by art collector Larry Aldrich to house his impressive personal collection. In 1964, at the suggestion of his good friend Alfred H. Barr, Jr., director of MoMA, Aldrich opened the historic property as a museum. The garden was created in 1967.

Several minimalist works near the museum entrance offer a dramatic contrast in style and texture to the white colonial museum building. James Buchman's *Cascade*, a group of granite monoliths encased with steel bars, appears to be tilted against a tall evergreen. Duane Hatchett's *Totem Steel #3*, which sits on the small front terrace, is a friendly bug-eyed work that immediately attracts attention. The dark, muscular, geometric forms of Tony Smith's massive black steel abstract *Willy* set the tone for the contemporary works displayed on the wide back lawn.

At the far end of the garden is an intriguing untitled sculpture by Forrest Myers. It is an open structure of cubes that are outlined with aluminum tubing. The boxes take on a variety of shapes

depending on the angle of view. A lush backdrop of evergreens fills in the frames created by the tubing. The sculpture also acts as a frame for Robert Perless' orange and black *Energetics-Ground Plans/Orange I*. Its two kinetic, orange painted Cor-ten steel needles appear to be piercing Myers cubes.

Robert Bart's untitled cast aluminum spirals and arcs is another distinctive piece. It evokes any number of interpretations. From one view it resembles a deep-sea diving chamber, from another, it could be a Rube Goldberg invention for threshing wheat.

For more than thirty years, the Aldrich has championed works by contemporary artists. Larry Aldrich, son of immigrant Russian Jews, made his fortune in the fashion business. On frequent trips to Paris in the 1930s, he and his wife began collecting Impressionist and post-Impressionist works. Their plunge into contemporary art was made in the early 1950s. By 1963 their

Forrest Myers, Untitled (1968), The Aldrich Museum of Contemporary Art, Ridgefield, CT

interest in new art, particularly works from the Minimalist school, prompted them to auction off their Impressionist collection to concentrate on contemporary works.

Sculptors whose works are on the grounds include Arman, William Barrett, Robert Bart, James Buchman, Kenneth Capps, Karen Finley, Robert Grosvener, Oded Halahmy, Duane Hatchett, Sol LeWitt, Robert Morris, Forrest Myers, Robert Perless, Arnoldo Pomodoro, Richard Shore, Tony Smith, and David Von Schleggel.

There is no admission charge to the sculpture garden. An illustrated sculpture guide is provided. Food is not available, but wrought-iron chairs and tables on the terrace make comfortable seating for picnics, which the museum encourages. This is a popular meeting spot for local residents.

How to Get There: The museum is two blocks south of Ridgefield Center on Route 35. From New York, take the Sawmill River Parkway, Interstate 684, and Route 35. Access from Connecticut via Routes 7, 33 and 35.

Aldrich Museum of Contemporary Art
258 Main Street
Ridgefield, CT 06877
203-438-4519
Hours: Sculpture is always on view. Museum: 1:00 P.M. –5:00 P.M., Tuesday through Saturday.

Stamford Museum and Nature Center

Stamford, Connecticut

Many long-time Fairfield County residents think of the Stamford Museum and Nature Center as a great place for children's birthday parties. They might be surprised to learn the museum has a growing collection of contemporary outdoor sculpture. In keeping with its rustic ambience, works are displayed in natural settings in the heavily wooded 120-acre preserve.

The sculpture trail starts on the path from the lower parking lot to the museum. Pieces are nestled in groves of dense shade trees. Sunlight filtering through the greenery creates textured shadow patterns on the wood and metal sculpture. The

winding woodland trail offers sculpture surprises as works come out of hiding. Particularly striking is Ivan Biro's slatted wood sculpture, which is enhanced by the dappled sun that casts shadows on the work.

Sculptures along the trail and on the museum's patio are all contemporary and abstract. Many of the works alongside the museum are painted metal cutouts. They present a striking contrast to the rough-edged stone mansion that was once the home of New York merchant Henri Bendel.

Contemporary sculpture graces a terrace that overlooks a lawn studded with art. The dominant work on the front lawn is a two-piece, X-shaped metal sculpture, *Yellow and Blue*, by Peter Forakis. The contemporary shapes work well with a nearby classic gazebo.

Most of the sculpture was created within the last thirty years, although classic figurative works, including stone lions and a fountain with horses, are reminders of the days when the museum was an elegant country manor. The older works are displayed behind the museum, on the path to the studio school.

Ducks and geese glide along Laurel Lake, just down the hill from the main building. The serene lake and waterfall provide a graceful setting for Lila Katzen's Cor-ten steel sculpture at the lake's edge. The undulating curves of Katzen's piece catch the sunlight that reflects off the water and filters through the trees.

The museum and nature center were founded in 1936 by prominent Stamford surgeon Dr. G. R. Hertzberg as a science center for young people. The 1957 purchase of the current property allowed the museum to expand into rural north Stamford. The outdoor collection was initiated in 1987 with a grant from the National Endowment for the Arts, which enabled the museum to mount temporary exhibitions and encouraged donors to enlarge its permanent collection. The museum now has around two dozen pieces, including three works from the nearby Aldrich Museum. The complex includes an eighteenth-century farm.

The sculpture trail includes works by Ivan Biro, John Bonsignor, Gutzon Borglum, Pietro Consagra, Peter Forakis, Gilbert Hawkins, Pam Joseph, Diane Kaiser, Lila Katzen, Grace

Knowlton, Bea Perry, Robert Perless, Reuben Nakian, Peter Reginato, and Robert Rohm.

Admission fee. A sculpture map is provided.

How to Get There: From New York City, take the Hutchinson River Parkway, which turns into the Merritt Parkway at the Connecticut line. At Exit 35, turn left at the bottom of the off ramp; go 0.75 miles and turn left at the traffic light. Museum is on the right.

Stamford Museum and Nature Center
39 Scofieldtown Road
Stamford, CT 06903
203-322-1646
Hours: 9:00 A.M.–5:00 P.M., Monday through Saturday; 1:00 P.M.–5:00 P.M., Sunday. Sculpture trail is open during museum hours.

Maryland

Baltimore Museum of Art

Wurtzburger & Levi Sculpture Gardens

Baltimore, Maryland

The Baltimore Museum offers two sculpture gardens densely packed with twentieth-century masterpieces. From the broad courtyard and terraced gardens below, open vistas promise sculptural delights at every turn. The upper courtyard displays modern masters from the first half of the century; terraced pathways and the sunken garden offer more recent sculpture from the 1970s and 1980s.

The formal, tiered upper plaza is enlivened by a profusion of trees and shrubbery. A shallow, rectangular pool and small waterfall are the principal landscaping elements. The courtyard is divided into separate display areas by bluestone walls that create backdrops for the sculpture, principally figurative bronze pieces. Henry Moore's *Three Piece Reclining Figure No. 1,* a rough-surfaced bronze created in the early 1960s, is framed by the wide double-entry gates. Gaston Lachaise's voluptuous

Standing Woman (Elevation) is a smaller version of his powerful signature piece that is on view at the Hirshhorn in Washington, D.C., and at MoMA in New York City.

On the semicircular overlook that separates the upper and lower gardens, Jose de Rivera's gracefully sinuous, stainless steel *Construction 140* shimmers in the sunlight. From this vantage point the artistic treasures in the lower garden are in full view.

Along the walkways and the perimeter of the lower garden are landscaped areas distinctively designed to create the best possible setting for sculpture. Mark di Suvero's 28-foot-wide black steel *Sister Lu* sits radiantly on soft green grass framed with tall dense hedges. Joel Shapiro's untitled geometric formation of five bronze bars is enclosed in a mass of low-lying shrubs. In a small alcove off the walkway is Joan Miro's whimsically innocent bronze *Head*.

Two enormous sculptures dominate the lower garden, Alexander Calder's brilliant red and sprightly *100 Yard Dash* and Tony Smith's angular black *Spitball*. These riveting works at opposite ends of the lower garden can be seen in ever-changing perspectives along the sloping walkways.

The gardens are located within Wyman Park, on land leased from Johns Hopkins University. The 1-acre Alan and Janet Wurtzburger garden opened in 1980. Its collection features sculpture collected by the Wurtzburgers from their estate in Stevenson, Maryland. The less formal, 1.6-acre Ryda and Robert H. Levi garden opened in 1988.

In 1994, the museum opened its New Wing, which prominently features an extensive collection of Andy Warhol paintings. It is the second largest collection of Warhol paintings, after the Warhol Museum in Pittsburgh. The New Wing displays impressive works by more than seventy-five postwar American and European artists. The museum is also home to an unparalleled collection of post-Impressionist works donated by the Cone sisters, two indomitable Baltimore women whose artistic tastes were decidedly avant-garde.

Sculptors whose work is represented include Max Bill, Emile-Antoine Bourdelle, Scott Burton, Alexander Calder, Anthony Caro, Jose Ruiz de Rivera, Mark di Suvero, Raymond

Jacques Lipchitz, *Mother and Child II* (1941-1945), The
Baltimore Museum of Art, Baltimore, MD

Duchamp-Villon, Jacob Epstein, Barry Flanagan, Pablo
Gargallo, Michael Heizer, Ellsworth Kelly, Phillip King, Gaston
Lachaise, Henri Laurens, Jacques Lipchitz, Giacomo Manzu,
Gerhard Marcks, Marino Marini, Joan Miro, Henry Moore,
Mario Negri, Louise Nevelson, Isamu Noguchi, Germaine
Richier, Auguste Rodin, Joel Shapiro, Tony Smith, Fritz
Wotruba, and Ossip Zadkine.

Admission to the garden is free; admission charge for the
museum, except on Thursdays. Discreet picnicking is allowed in

the garden. No tables are provided. Ramps make the gardens accessible for wheelchairs.

The museum's cafe overlooks the garden. In the lobby are a gift shop and bookstore.

How to Get There: A short taxi ride from Penn station. The museum is within the Johns Hopkins campus, off North Charles Street at 31st Street.

Baltimore Museum of Art
Wurtzburger & Levi Sculpture Gardens
Art Museum Drive
Baltimore, MD 21218
410-396-7101
Hours: 10:00 A.M.–4:00 P.M., Wednesday through Friday; 11:00 A.M.–6:00 P.M. on weekends. Closed on major holidays.

Massachusetts

De Cordova Museum and Sculpture Park

Lincoln, Massachusetts

De Cordova's 35-acre sculpture park is in a densely wooded area at the edge of Flint Pond, in Boston's western suburb of Lincoln. Natural landscaping offers a lush and colorful foil for more than forty contemporary sculptures displayed amid picnic tables, birch trees, and walkways. The park showcases commissioned works, pieces from the museum's collection, and sculpture on long-term loan.

The museum opened in 1950 on the grounds of the estate of Julian de Cordova (1851–1945), a prominent Boston merchant and industrialist. His appetite for collecting was all encompassing: he acknowledged collecting "everything that took my fancy in every country of the world." Although most of De Cordova's personal collection has been sold, the museum retains a sizable permanent legacy, much of which is on loan to the museum's corporate contributors.

From its inception, the museum emphasized modern American art, principally by contemporary New England artists.

Recently, a $2 million fund was established to acquire contemporary works by New England artists.

To ensure continually changing presentations, De Cordova each year selects eight to ten pieces for long-term loans. Typically several dozen loaned works are on display. One piece expected to be exhibited for years to come is Mark di Suvero's *Sunflowers for Vincent*. Originally painted sunflower yellow, di Suvero had it repainted orange after he visited the site in mid-October and was struck by the brilliant autumn foliage in the background. Another long-term loan sculpture is Paul Matisse's *Musical Fence*, an engaging, interactive work whose chimes can be heard throughout the day as visitors succumb to the temptation to clang them. Paul Matisse is the grandson of the renowned Impressionist painter Henri Matisse.

The museum encourages sculptors to become involved in siting their works. For example, when Robert Ressler installed his *Step by Step*, a 20-foot-high set of wooden crutchlike forms, he chose to dramatize the size and form of the work by siting it close to a tree with a 20-foot trunk. Each year, De Cordova commissions site-specific works, some of which are impermanent environmental constructions that revert to nature. Gail Rothschild's 1992 installation, *Woman in the Nineteenth Century: A Conversation*, is a grouping of hay and wire figures ensconced in rocking chairs that will inevitably disintegrate in a few years.

De Cordova is visitor friendly, encouraging both passive and active recreation on its grounds. In mild weather, visitors picnic while artists from the museum's art school sketch the sculpture among the trees. In winter, cross-country skiers are much in evidence. Among the summer activities are lectures by exhibiting artists and pop and jazz concerts in the outdoor amphitheater.

Artists represented in the permanent sculpture collection include Carlos Dorrien, Lawrence Fane, Richard Fishman, George Greenamyer, Mags Harries, Lila Katzen, Dennis Kowal, Alexander Liberman, Ross Miller, George Rickey, Ed Shay, Konstantin Simun, David Stromeyer, Hugh Townley, and Allan Wexler.

The sculpture collection is documented in a looseleaf folder that is updated annually. It contains a map, photographs, and

explanations of the pieces. The museum also rents audio cassettes for walking tours.

No admission fee to the sculpture park. There is a bookshop, but no cafe.

How to Get There: The museum is 15 miles from Boston. From 495, take Route 2 to Route 126 South. Turn left at Baker Bridge Road (immediately following Walden Pond) and follow signs to De Cordova. From 128, take Exit 28, Trapelo Road/Lincoln; take Tapelo Road to Sandy Pond Road, and follow signs to De Cordova. From the Mass Pike, take Route 128 North, and follow the above directions.

De Cordova Museum and Sculpture Park
Sandy Pond Road
Lincoln, MA 01773
617-259-8355

Hours: Sculpture park is open year-round from 8:00 A.M. –10:00 P.M. Museum is open 10:00 A.M.–5:00 P.M., Tuesday through Friday; noon–5:00 P.M. on weekends.

Massachusetts Institute of Technology

List Visual Arts Center

Cambridge, Massachusetts

Set among the grounds of the Beaux Arts core of this urban campus are works by some of the most notable twentieth-century sculptors. The most dramatic piece is Alexander Calder's colossal four-story *The Big Sail,* a 33-ton black steel stabile that presides at McDermott Court. Viewed from any angle, including from within, this is an exciting piece.

Louise Nevelson's 20-foot-high *Transparent Horizon* is another dominating force, exemplifying her facility in constructing architectural environments. This towering Cor-ten steel sculpture, painted entirely in black, is an instructive example of why she referred to herself as an "architect of shadow."

Pablo Picasso's quixotic *Figure Decoupé* is one of the prolific artist's cutout sculptures, a style he developed in the 1950s. This 11-foot-high piece, originally created in 1958 in oil on wood, evolved from a series of ink and pen drawings of birds in flight.

Picasso used a process of engraving on concrete that allowed him to enlarge drawings to monumental scale on materials more durable than canvas. A sense of movement is achieved through the undulating lines that are incised into the curvilinear concrete shape.

Killian Court, in the center of original campus, showcases two distinctively twentieth-century works, Henry Moore's *Three-Piece Reclining Figure, Draped* and, directly across the lawn, Michael Heizer's *Guennette*. They play off one another brilliantly, as Moore's sinuous bronze figures stand in direct contrast to Heizer's eleven rigorously angular pink granite forms. Sculpture for the Wiesner Building, designed by I. M. Pei and completed in 1985, was produced in a rare collaboration between sculptors and the architect. Artists Kenneth Noland, Scott Burton, and Richard Fleischner were commissioned to

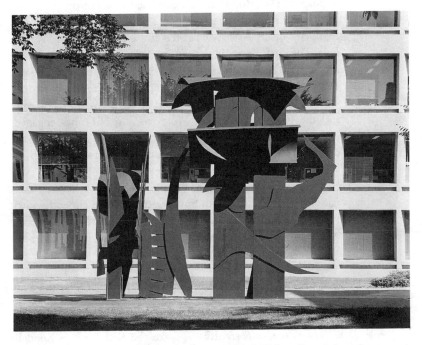

Louise Nevelson, *Transparent Horizon* (1975), MIT List Visual Arts Center, Cambridge, MA

produce works as an integral part of the building's design. Noland contributed *Here,* an enormous and colorful ceramic wall mural with horizontal bands of various color gradations and narrow cross-cutting lines. The mural creates a smooth transition between interior and exterior spaces. Burton, known for his sculpture-as-furniture, produced for the atrium two elegantly slender, curved, concrete benches that use the stair railing as a back rest for the upper bench.

For the 2.5-acre courtyard that links the Wiesner Building with the Health Sciences and Health Services building, Richard Fleischner united the space with a broad pathway, using multicolored granite pavers in geometric patterns. He also designed the landscaping and the teak and granite benches.

MIT opened the first architecture school in the nation in 1868. The 136-acre campus, built on drained tidal flats overlooking the Charles River, was originally designed by MIT grad William Welles Bosworth. Campus development proceeded in 1913 with a grand scheme, using a formal axis typical of the Ecole des Beaux Arts style exalted at the 1893 Chicago World's Fair. The first six buildings create a dignified campus, dominated by the Pantheon-like Great Dome of the Barker Engineering Library. After designing the core campus Bosworth went on to supervise reconstruction at Versailles, Fontainbleau, and the Rheims Cathedral. More recently, MIT has engaged many internationally recognized architects; the architects who designed campus buildings constitute an international Who's Who in Architecture.

Sculptors represented in the outdoor collection are Alexander Calder, Mark di Suvero, Richard Fleischner, Dimitri Hadzi, Michael Heizer, Jacques Lipchitz, Henry Moore, Louise Nevelson, Beverly Pepper, Pablo Picasso, Tony Smith, Michael Steiner, and Isaac Witkin.

No admission fee.

An illustrated walking tour booklet is available at the List Visual Arts Center. Tours emphasize campus architecture; sculpture is noted in passing.

How to Get There: By "T," take the Red Line to Kendall Square in Cambridge.

Massachusetts Institute of Technology
List Visual Arts Center
20 Ames Street
Cambridge, MA 02139
617-253-4400
Hours: Outdoor pieces on view at all times. Gallery hours: noon–6:00 P.M., weekdays; 1:00 P.M.–5:00 P.M., weekends. Gallery open September through June.

Butler Sculpture Park

Sheffield, Massachusetts

Off the beaten path, up a rocky road to the hilltops of the lush southern Berkshires, is Robert Butler's sculpture park, 40 acres of winding paths and open, grassy exhibition areas.

Butler and his wife Susan opened the park in 1991, after a four-year stint constructing pathways, an arched bridge, and the naturalized settings.

At the entrance to the cedar-planked Visitor's Center, adjacent to the parking lot, is an indoor gallery where large sculpture fits comfortably under the soaring 16-foot-high ceiling. Smaller pieces are displayed on the screened-in porch and on the deck.

A gently meandering pristine trail, marked with shimmering limestone chips, leads visitors to the thirty-five large-scale sculptures, which are nestled among the greenery and displayed in a dry limestone-lined Japanese pond.

An expansive upper meadow forms a grassy courtyard overlooking the rolling countryside, with "rooms" created to highlight individual pieces. The enthusiastic owners are meticulous in maintaining the natural quality of the landscape, thinning trees when they become too dense and ensuring the landscape's hospitality to sculpture. In 1994 they doubled their acreage, buying adjacent property to protect their Berkshire views, which offer a stunning backdrop for Butler's powerful burnished stainless steel and aluminum sculptures. His kinetic pieces are right at home among the lacy trees that frame the sculpture sites.

Butler's studio is filled with massive equipment for cutting and molding steel. Two exhibition rooms above the studio display

more than two dozen of his smaller pieces, which tend toward playful fantasies; many are industrial-size toys in gleaming stainless steel and reds and blues. All the art is for sale.

Tucked into the eaves of Butler's studio is a serene loggia, or rock garden, where antique wooden benches are arranged to offer a quiet spot to view the sculpture and the ornamental grasses that frame the garden.

No admission charge. Visitors are warmly greeted by one of the Butlers. They offer a map of the sculpture park and are available to answer questions. Susan Butler actively promotes the lively Southern Berkshire art scene and directs visitors to the more than two dozen local galleries.

How to Get There: The sculpture park is in Sheffield, 10 miles south of Great Barrington, just north of the Connecticut border and about 20 minutes east of the New York state line. From the Sheffield Post Office, drive south on Route 7 for 3.7 miles. Turn left on Hewins Street 1.5 miles to Shunpike Road. Make a sharp right, and then travel 1 mile to Sculpture Park on the left. After Hewins Street, discreet signs indicate the route through some of New England's most glorious scenery.

Butler Sculpture Park
11 Shunpike Road
Sheffield, MA 01257
413-229-8924

In the winter and at other times by appointment. Hours: 10:00 A.M.–5:00 P.M. every day in July and August; 10:00 A.M.–5:00 P.M. Friday through Monday in May, June, September, and October.

Chesterwood Museum

Stockbridge, Massachusetts

Chesterwood was the summer home and studio of Daniel Chester French (1850–1931), one of America's premier classical sculptors. In common with the handful of American sculptors of the age, French was trained in France and Italy. Using sculpture techniques honed in the European ateliers, he created a uniquely American interpretation of European styles. Along with

Richard Morris Hunt and Augustus Saint-Gaudens he ushered in the American Renaissance, the first distinctly American form of sculpture and architecture. French's beautifully preserved hilltop estate offers a peek into the artist's life and the works he produced.

French's fame as a sculptor was secured in 1875 when his *Minute Man* statue was unveiled at North Bridge in Concord, Massachusetts. By the 1890s, he was an internationally acclaimed sculptor. His best known work is his *Seated Lincoln* at the Lincoln Memorial in Washington, D.C.

French's 160-acre estate displays classical works created by the renowned sculptor and presents annual exhibitions of contemporary works, which are placed among trees, on grassy knolls, and in the studio garden, framed by seasonal flowers and closely clipped hedges. An easy trail covered with leaves and pine needles leads to a panoramic overlook where sculpture is on view. The mansion's precise formal gardens offer an elegant contrast to the densely wooded walkways.

Annual exhibitions of contemporary works run from early July through mid-October. Guest curators select about forty pieces, which are displayed in and among the landscape that French designed for his family. Everything on exhibit is for sale.

In siting the contemporary sculpture, curators are particularly sensitive to the play of light and shadow. Works placed in the glade and along the woodland walks are positioned to reflect the sunlight as it filters through the trees. This attention to the dramatic effects of lighting would have delighted French, who was so obsessed with the way light worked on his sculpture that he installed a railroad track in his studio so he could easily roll large pieces outdoors to view them in natural light. The track is still in place.

Chesterwood has nearly thirteen hundred works by French, as well as a wide array of decorative arts and furniture. All of French's work is indoors, except a bronze Abraham Lincoln replica in the formal garden. His spacious studio and rambling Victorian mansion are filled with models and casts. The house was designed by his friend Henry Bacon, architect for the Lincoln Memorial.

Admission fee. Chesterwood provides a map to the annual sculpture exhibition, and guided tours of the house and studio are offered. Picnics are allowed. A bookstore and gift shop are located on the premises.

How to Get There: Stockbridge is in the central Berkshires, next door to equally famous Lenox, host to the Tanglewood Music Festival. Stockbridge is about two hours from Boston and three hours from New York. Many road signs give directions to Chesterwood, which is in the Glendale section of Stockbridge, Route 183, on Williamsville Road.

Chesterwood Museum
Box 827
Glendale Road
Stockbridge, MA 01262
413-258-3579
Hours: 10:00 A.M.–5:00 P.M., May through October.

New Hampshire

Saint-Gaudens National Historic Site

Cornish, New Hampshire

Augustus Saint-Gaudens (1848–1907) was one of country's most beloved sculptors. He was a leader in the American Renaissance arts movement that flourished at the end of the nineteenth century. His summer home features the sculptor's works as well as summer exhibitions of some of the finest contemporary sculpture being produced in America.

Saint-Gaudens moved to Cornish in 1885 to escape the hot New York summers. He transformed the former Federal-style tavern, called "Huggins Folly," into a classical mansion patterned roughly on a country French estate. Saint-Gaudens converted a barn into a studio and built another studio on the grounds. He lavished attention on the landscape, constructing pools and fountains, planting pine and hemlock hedges, and even installing a bowling green. His design of open-air rooms, defined with white pine hedges, was the harbinger of a sculpture garden style widely in use today.

The sculptor named his estate Aspet, after the tiny Pyrenees village, near the town of Saint-Gaudens, where his father was born. The artist was born in Dublin and brought to New York as an infant when his family fled the ravages of the Potato Famine.

By the time Saint-Gaudens came to Aspet, he had completed a lengthy apprenticeship, supported largely by his skills in cameo carving. After five years in Paris and Italy mastering the techniques and styles of Renaissance sculpture, he received his first important commission in 1876, when he was selected to design the Farragut Monument, a memorial to the celebrated Civil War admiral that now stands in New York City's Madison Square Park. This one magnificent piece secured Saint-Gaudens' reputation at the forefront of American sculpture and inaugurated his long collaboration with the renowned architect Stanford White.

Aspet displays three of Saint-Gaudens' major outdoor works: a Standing Lincoln, a copy of the Adams Memorial in Washington, and a working plaster cast of the Shaw Memorial. The original bronze relief of the Shaw Memorial is on the Boston Common, opposite the Massachusetts State House. The artist worked for fourteen years on this commemoration of Colonel Robert Shaw, commander of a black volunteer army who led a heroic assault on Charleston Harbor during the Civil War.

Among Saint-Gaudens' best known sculptures is *Diana*, designed for the tower of Stanford White's Madison Square Garden and now on display at the Philadelphia Museum of Art, and his colossal Sherman Monument, now restored to all its gilded glory near the Plaza Hotel in New York City. The naked *Diana* created quite a stir among New York's inhibited elite. But his international acclaim was undiminished; he was elected a member of London's Royal Academy and inducted into the French Legion of Honor.

Saint-Gaudens attracted a following among intellectuals, and Aspet was a lively center for leading artists. The Cornish Colony, a group of talented poets, novelists, musicians, and painters—including the famed romantic landscape artist Maxfield Parrish—were drawn to the rolling New Hampshire hills and to the congenial artistic camaraderie.

A little-known facet of Saint-Gaudens prolific career was his design of coinage. President Theodore Roosevelt commissioned him to create $10 and $20 gold pieces that are much sought after by today's coin collectors.

On permanent display at Aspet are more than one hundred of Saint-Gaudens' works and four rooms with original family furnishings.

Much of the 150-acre estate is woods and wetlands. Visitors are encouraged to explore two nature trails: the Ravine Trail (0.25 mile) and the Blow-Me-Down Natural Area Trail (2.5 miles), which includes a pond, brook, wetlands, a historic grist mill, dam, and a stone bridge. Trail guides are available.

Each year a Saint-Gaudens Fellow is selected to exhibit his or her work. Recent recipients include Jene Highstein and Judith Shea.

Admission fee. Daily guided tours of the home and walking tours are provided. Self-conducted tours with audio tapes are also available. Picnicking is allowed.

How to Get There: Cornish is about two hours from Boston. Drive north on I-93 to Manchester, then take I-89 to exit 20 (West Lebanon).

Saint-Gaudens National Historic Site
Rural Route 3
P.O. Box 73
Cornish, NH 03745
603-675-2175
Hours: 8:30 A.M.–4:30 P.M., daily from the end of May through October.

New Jersey

Grounds For Sculpture

Hamilton, New Jersey

Sculpture here is splendidly showcased in woods, marshes, meadows, and ponds; on berms; and on concrete walls. Sixteen lavishly

William King, *Unitas* (1991), Grounds For Sculpture, Hamilton, NJ

landscaped acres offer panoramic views of trimmed woodlands, sparkling waterfalls, and gracious courtyards. Romantic English gardens burst with colorful seasonal plantings.

The lush, wooded setting is perfect for J. Seward Johnson, Jr.'s humorous *Dejeuner Deja Vu*, a stunning three-dimensional, life-size re-creation of Edouard Manet's famous Impressionist painting *Dejeuner sur l'Herbe (Luncheon on the Grass)*. The tableau is a picnicking trio, two primly clothed men and a beguiling nude, exuberantly relishing the woodlands and each other. Johnson faithfully reproduced Manet's masterpiece, right down to the waterfall, pond, and rowboat and the woman's vivid blue cast-off clothing. Stepping inside this famous scene the viewer experiences a jolt of intimacy with the artistically charged setting.

Johnson plans to create more three-dimensional versions of famous artistic works. For a new restaurant at the sculpture garden, slated to open in 1997, he is designing sculpture re-creations of Van Gogh's *Chair with Pipe* and a dancehall filled with Renoir's famous dancers.

These playful extravaganzas are a distinct departure from Johnson's well-known previous works that portray in life-size bronze the everyday activities of joggers, skateboarders, hitchhikers, and corporate executives. His hyperrealist style captures the flow and movement of his subjects so accurately that the works spark a double-take in viewers who are taken aback when they realize that the bronze works are not actual human beings.

Grounds for Sculpture is a not-for-profit art center that displays works from more than a dozen internationally known artists. Each summer, a few prominent artists are highlighted with special exhibitions. Recently, works by William King, Melvin Edwards, and Beverly Pepper have been featured.

The garden, on the grounds of the stockyards of the former New Jersey State Fair, is entered through an expansive modern museum. This converted barn has a vaulted ceiling and a dramatic wall of glass that allows an immediate view of the sculpture and the gardens.

Grounds for Sculpture was conceived by Johnson & Johnson heir and sculptor J. Seward Johnson, Jr., and is supported by a

private charitable foundation. Johnson purchased the site in 1987. The Johnson Atelier, a fine arts foundry adjacent to the sculpture garden, casts and fabricates works for artists, galleries, and museums. It is considered to be one of the finest foundries in the country and is renowned for its apprenticeship program.

Artists who have been featured here include Magdalena Abakanowicz, Tova Beck-Friedman, Tom Bills, Emile Benes Brzezinski, Anthony Caro, Muriel Castanis, Saint Clair Cemin, Victoria Dillon, Michele Oka Doner, Tom Doyle, Ellen Driscoll, Melvin Edwards, Heide Fasnacht, Ming Fay, Philip Grausman, Nancy Graves, J. Seward Johnson, Jr., Nathan Slate Joseph, William King, Jon Lash, Steve Linn, Robert Lobe, Elaine Lorenz, Forrest Myers, Manuel Neri, John Newman, Tom Otterness, Barry Parker, Marsha Pels, Beverly Pepper, Peter Reginato, Art Schade, Joel Shapiro, Alan Sonfist, Toshiko Takaezu, Ursula von Rydingsvard, and Herk von Tongeren.

No admission fee. A foundry tour can be arranged with advance notice. Call Johnson Atelier at 609-890-7777.

Food is available and picnicking is permitted.

How to Get There: The garden is on the outskirts of Trenton, about 75 minutes from New York City. From New York, take the New Jersey Turnpike south to Exit 7A; I95 West/Trenton to 295 North; exit at 63B (Rte. 33 West). Turn right at the fourth traffic light (Ward Avenue Extension). Proceed 0.3 miles to Fairgrounds Road (on the right). Grounds for Sculpture is 0.1 mile on the right.

From Philadelphia, take I-95 North, over the Scudder Falls Bridge, to I-295 South, Exit 63 (Rte. 33 West). Turn right at fourth traffic light, and proceed as above. Travel time is approximately 45 minutes.

By train, take New Jersey Transit or Amtrak to Trenton, followed by a 5-minute taxi ride.

Grounds for Sculpture
18 Fairgrounds Road
Hamilton, NJ 08619
609-586-0616
Hours: 10:00 A.M.–4:00 P.M., Friday, Saturday and Sunday.

Newark Museum

Alice Ransom Dreyfuss Memorial Garden

Newark, New Jersey

The Newark Museum's sculpture garden offers a peaceful respite from the gritty bustle of downtown Newark, only a block away. The cloistered 1-acre garden, enclosed within a red brick wall, is popular with young banking and insurance executives who eat brown bag lunches sitting on benches shaded by ancient, towering trees.

Sculpture is placed around the perimeter of the garden, within easy view for picnickers. The collection of nine pieces represents works predominately from the 1960s and 1970s. Clearly the most popular and amusing sculpture is George Segal's *Toll Booth Collector,* an actual Holland Tunnel toll booth that Segal coated in bronze. The toll collector inside the booth is a cast of the much-beloved, long-time director of the museum Samuel C. Miller. He is holding out his hand to collect tolls, a fitting image for museum directors who are always on the lookout for contributions.

The garden has a remarkable collection of hundred-year-old trees; a Kentucky coffee tree provided beans for coffee served in the garden to New Jersey troops during the Civil War. Graceful mature maples, copper beech, black walnut, and Japanese cherry trees offer the ambience of a bygone era.

A formerly unsightly parking lot at one side of the garden was recently reconfigured and made more hospitable with lively signage. A long vine-covered bower joins the parking area with the garden, providing an attractive new entrance to the garden.

The museum's original building, formerly a spacious home built in the 1890s, is incorporated into a major addition designed by architect Michael Graves. Newark's collection of American art ranks among the country's top ten. In the garden is a 1784 one-room school house where George Washington stopped to talk with students in 1797. Also on the grounds is a fire museum that displays an antique hose cart, pumper, and searchlight truck.

Sculptors represented in the outdoor collection include Tova Beck-Friedman, Grace Knowlton, Joel Perlman, James

David Smith,
Untitled
(1964), The
Newark
Museum,
Newark, NJ

Rosati, George Segal, David Smith, Tony Smith, Richard Stankiewicz, and Marjorie Strider.

A buffet lunch is served in the museum's charming indoor courtyard in what must be one of the most attractive settings in the city.

An outdoor stage in the garden is the site of frequent summer jazz concerts and children's shows.

Admission is free. A gift shop and a separate children's store, with educational gifts for youngsters, are part of the museum.

How to Get There: From Manhattan, take the PATH system to Journal Square; cross the platform and take another PATH train to Newark. It is a 5-minute taxi ride to the museum. For the return trip, hail a taxi to the station from Broad Street, a block away. The entire trip takes about 45 minutes.

By car from New York City, take the New Jersey Turnpike to Exit 15 West. At Route 280, exit onto King Boulevard. Turn left off King Boulevard at Central Avenue. Ample parking is available in the museum's lot, between University Avenue and Washington Street.

Newark Museum
Alice Ransom Dreyfuss Memorial Garden
49 Washington Street
Newark, NJ 07101
201-596-6550
Hours: Noon–5:00 P.M., Wednesday through Saturday.
Closed on major holidays.

William Paterson College

Outdoor Sculpture Collection

Wayne, New Jersey

This large suburban campus, rimmed with dense woodlands, is aggressively expanding its collection of outdoor art. The sculpture program, begun in 1991, is considered an essential element in campus life.

A unique feature of this collection is that, with the exception of one recently commissioned piece, all the sculpture has been acquired at minimal cost. Artists have contributed their works, although the college underwrites the installation costs, which in some cases is substantial. Tom Bills' 16-foot-high cast concrete *Who's Doubting Who* required an expensive 16-foot-deep underground concrete base to keep the piece from sinking into the grass.

A piece commissioned from New York sculptor Michel Gerard is a memorial to the beloved civic leader Mary Ellen Kramer to commemorate her contributions to the college. This 20-foot-high brushed aluminum swirling oval is set on two stacked black metal chairs that appear as stilts. Gerard's proposal was selected from among 200 proposals submitted for the commission.

One of the most colorful and whimsical pieces is Sally Minker's *Split Bench*, a seemingly typical park bench split in half, with half the slats painted blue, green, and purple and the other half painted red, orange, and yellow.

Elaine Lorenz's *Reversal* is a 10-foot-high womblike structure that encloses juniper bushes. It is irrigated with hoses

buried in the shelves in the split concrete cones. This piece and Tom Bills' *Who's Doubting Who* were adopted after having been exhibited at Socrates Sculpture Park in New York City.

Sculpture on the 250-acre campus is displayed at the visitors' entrance and on the mall between the Ben Shahn Art Center and the Student Center. Additional pieces are expected to be placed around an enormous new library and a new academic building. The college encourages students to examine the sculpture; freshmen are taken on sculpture tours as part of their orientation.

The art center has three galleries and a domed interior courtyard where students' works from the ceramic, welding, wood, and photography studios are displayed. The college presents one-person exhibitions featuring sculptors represented in the outdoor collection. The Ben Shahn Art Center is named for the eminent Depression-era painter and postermaker, who lived in New Jersey and was a friend of the college. The center has only two of Shahn's works.

The state-supported campus of 10,000 students, mainly commuters, is named for William Paterson, a New Jersey governor, signer of the Declaration of Independence, and Supreme Court justice. The grounds are part of the former estate of Garret Hobart, a corporate lawyer and U.S. vice president in the William McKinley administration. His elegant mansion has been preserved and is used for ceremonial events.

Sculptors represented in the collection include Lillian Ball, Tova Beck-Friedman, Tom Bills, Nancy Cohen, Michel Gerard, Bradford Graves, Marion Held, Albert E. Henselmann, Dave King, Lyman Kipp, Elaine Lorenz, Elliot Miller, Sally Minker, Richard Nonas, and Merrill Wagner.

A folder with individual sheets describing the sculpture and the artists is available at the Visitors' Center.

How to Get There: From New York City, take the Lincoln Tunnel and follow Route 3 to Route 46. Exit Route 46 at Riverview Drive. Turn right at Valley Road and right at Ratzer Road to the campus entrance. The drive takes about 45 minutes.

William Paterson College
Outdoor Sculpture Collection
Ben Shahn Galleries
Wayne, NJ 07470
201-595-2000

Hours: Outdoor sculpture on view at all times. Indoor galleries closed in July and August.

Princeton University

John Putnam, Jr. Memorial Collection

Princeton, New Jersey

Princeton's large, blue-chip collection of modern sculpture was given anonymously in 1968 in memory of Lt. John B. Putnam, Jr., a Princeton student killed in action in World War II. The premier Putnam collection, containing works by leading twentieth-century sculptors, could serve as the basis for a course in modern sculpture.

A work popular with students is Henry Moore's *Oval with Points*. Within a few months of installation its interior curves were burnished from students constantly touching and sitting on the work. Moore was keenly interested in the relationship between open and closed forms. He placed this piece so its oval openings frame the procession of arches that punctuate the ivy-draped campus walk in the distance. The points on Moore's oval are elongated and assertively sharp. They almost touch, much like the fingers of Michelangelo's *God and Adam* in the Sistine Chapel.

Jacques Lipchitz's *Song of the Vowels*, in the courtyard of the library, is as an informal message center for students, who plaster it with Post-It™ memos. *Song of the Vowels* is one of many of the sculptor's works that explores harps, an obsession he acquired attending harp concerts in Paris. This cubist work melds the form of harp and harpist. Its placement at the library is particularly appropriate since Lipchitz repeatedly emphasized that his work is dedicated to man's capacity for dealing successfully with the forces of nature.

George Rickey's *Two Planes Vertical Horizontal II*, a 14-foot-tall brushed stainless steel kinetic piece, highlights the artist's fascination with movement. Using techniques he developed from studying the motion of ships, Rickey weighted each of the two steel pieces so that they move effortlessly in the wind. When wind currents cooperate, the arms make a complete circle.

Louise Nevelson's 16-foot-high geometric *Atmosphere and Environment X* is a monumental surrealistic form. Its small compartmentalized areas suggest secrets and hidden messages. Commissioned when she was 70, it was the first of several Corten steel pieces she created over the next decade. Moving away from wood, plexiglass, and other synthetics was a radical departure for Nevelson. By moving into steel, Nevelson gave up a degree of spontaneity, since works completed in a foundry cannot be subsequently rearranged as was the case with wood constructions created in her studio. The patina of rusted steel is also a break from her usual palette of black, white, and gold.

In a corner by the library is George Segal's *Abraham and Isaac: In Memory of May 4, 1970, Kent State University*. It was originally commissioned for Kent State, but rejected by the university, which wanted Segal to create a statue of a naked girl confronting a solider. Instead he chose a contemporary allegory on the biblical legend of Abraham and Isaac. Even at Princeton the sculpture generates controversy, with viewers arguing over its meaning and its out-of-the-way placement.

When Alexander Calder's *Five Disks: One Empty* was being installed in 1970, a crane snapped, killing two steel riggers. When finally installed, Alfred Barr, Jr., engaged in a bit of collegiate boosterism with a proposal to paint one of the disks orange, in keeping with Princeton's colors of black and orange. By the time Calder visited Princeton in late 1971, all the disks had been painted orange. Ever tactful, Calder appeared to consider the option before giving instructions that they be repainted in black as originally intended.

The student body's affection for the collection is highlighted each spring with the Princeton Sculpture Run. Students wearing specially designed T-shirts sprint from sculpture to sculpture to celebrate the collection and reaffirm its importance to the university.

The Putnam collection was chosen by a 14-member committee that included such distinguished Princeton alumni as Alfred Barr, Jr., the first director of New York's Museum of Modern Art, and Thomas Hoving, then director of New York's Metropolitan Museum of Art. The donor stipulated that the collection have a mix of abstract and figurative sculpture and that it be placed in prominent outdoor locations throughout the campus. The first works were installed in December 1969.

Sculptors represented in the Putnam collection include Reg Butler, Alexander Calder, Jacob Epstein, Naum Gabo, Michael David Hall, Gaston Lachaise, Jacques Lipchitz, Clement Meadmore, Henry Moore, Masayuki Nagare, Louise Nevelson, Isamu Noguchi, Eduardo Paolozzi, Antoine Pevsner, Pablo Picasso (executed by Carl Nesjar), Arnoldo Pomodoro, George Rickey, George Segal, David Smith, Tony Smith, and Kenneth Snelson. Other sculptors represented on the Princeton campus include Harry Bertoia, Antoine Bourdelle, Scott Burton, A. Sterling Calder, James E. Davis, James Fitzgerald, Dimitri Hadzi, Hugh Harrell, Rudolph Hoflehner, Auguste Rodin, Bernard Rosenthal, J. David Savage, Julius Schmidt, Alberto Viani, and Christopher Wilmarth.

Princeton's museum sells a brochure that includes a sculpture map. Also available is a comprehensive catalog by Patrick J. Kelleher, director of the Princeton Art Museum when the Putnam Collection was established.

How to Get There: By car from New York or Philadelphia, take Exit 6 on the New Jersey Turnpike to reach Princeton. Regular train service to Princeton is available via the "dinghy" from Princeton Junction. The campus is a short walk from the Princeton train station.

Princeton University
John B. Putnam, Jr., Memorial Collection
Princeton, NJ 08544
609-258-3788

Hours: Outdoor collection on view at any time. Museum: 10:00 A.M.–5:00 P.M., Tuesday through Saturday; 10:00 A.M.–5:00 P.M., Sunday. Closed on major holidays.

Quietude Sculpture Garden

East Brunswick, New Jersey

Quietude is aptly named. Seemingly far removed from the hustle of suburban New Jersey, the gallery offers a serene respite from the world of shopping malls.

The gallery evolved from the personal collection of Sheila and Ed Thau, a couple who began modestly, and over the years amassed a collection that reflects their individual tastes, including a mix of figurative and abstract work, with virtually every medium represented. All the pieces are for sale.

The Thaus moved to a wilderness area of suburban New Jersey in 1978. Their collection started with a single commissioned sculpture to frame a kitchen window. Pieces were added when the garden became a focus of their attention.

The Thaus' travels to England, Europe, and Japan are reflected in the garden. Mr. Thau, an avid amateur horticulturist, supervised the installation of the lushly landscaped grounds, which include a gazebo, garden paths, a waterfall, and myriad plantings, all of which serve as backdrops for the small and medium-size sculpture. A recent addition is a Japanese garden with a footbridge and pond filled with large carp.

Over a hundred works by as many as forty sculptors are displayed on 4 acres of woodlands. Variety in form and content seems endless. Among the assortment is Elliott Miller's arched doors with carvings of bears and berries, William Fulbrecht's Surrealistic basket and table frame that appears to slide downhill, Gila Stein's bronze nude on a wood bench, and Grey Mercer's textured, black painted wood constructions.

Sculptors who exhibit here include Tova Beck-Friedman, Joe Brenman, Tom Doyle, David Floyd, Sydney Hamburger, Frederick Hund, Janet Indick, David Jacobson, Karen Kieser, Molly Mason, Grey Mercer, Elliott Miller, Harriet Moore, Sal Romano, Harold Schlar, Bernadine Silberman, Gila Stein, Hans Van de Bovenkamp, Asa Watkins, and Sassoon Yosef.

No admission fee. A walking tour map is provided. Tours are given free of charge.

How to Get There: From the north, take the New Jersey Turnpike to Exit 9, New Brunswick. After toll, bear left to Route 18 South (South Brunswick). Take Route 18 south for 2.8 miles to Cranbury (Cranbury Road); exit to the right. Proceed on Cranbury Road, South 535, 3 miles to fifth traffic light (Fern Road). Turn left on Fern Road for 0.5 mile. Two statuary Great Danes mark the entrance.

From the south, take the New Jersey Turnpike to Exit 8A. Bear right after the toll and follow sign to Route 130. At first light turn right onto Cranbury Road, North 535. Go 5.1 miles to Fern Road (pass the East Brunswick Chateau). Turn right on Fern Road. One-half mile to the garden.

Quietude Sculpture Garden
24 Fern Road
East Brunswick, NJ 08816
908-257-4340

Hours: Noon–5:00 P.M., Fridays and Saturdays, or by appointment.

New York

New York City

Battery Park City

New York (Manhattan), New York

Battery Park City is one of New York's most resplendent outdoor attractions, a rare spot where the sense of the city as an island is palpable. Along the park's pristine esplanade the views of the Hudson River, the Statue of Liberty, and Ellis Island are nothing short of spectacular.

Battery Park's sculpture areas at the World Financial Center Plaza and at South Cove, along the esplanade, are the product of an inspired collaborative effort between the architects of the massive complex and several of the country's most widely recognized sculptors.

The plaza design emerged from a close working relation-

ship between sculptors Scott Burton and Siah Armajani, architect Cesar Pelli, who designed the four office towers; and M. Paul Friedberg, the landscape architect. These four men created a unified plan drawing on the singular expertise of each of the participants. Pelli, former dean of Yale's School of Architecture and one of America's premier architects, was initially aghast at the prospect of sharing design authority with sculptors. But after several false starts, he was won over by the creative solutions that emerged from the cooperative effort. Scott Burton's long and gently stepped horizontal benches along the esplanade and his benches and table blocks are classic examples of his work. The combination of polished cut-stone surfaces and rough-textured rock offers a sensuous, tactile experience. And the benches are much more comfortable than they appear to be. The waterfront railing behind Burton's benches was designed by Siah Armajani. In keeping with Armajani's penchant for including poetry on his sculptures, lyrical passages from Walt Whitman and Frank O'Hara are embedded in the green-enameled bronze frame. Armajani also created a metal gate that resembles a rustic picket fence.

Another decidedly artistic yet utilitarian installation is Mary Miss' swooping footbridge that stretches over the river on pylons. The tightly curved steel platform, which mimics the curves on the crown of the Statue of Liberty, is perfectly in tune with the grand esplanade, designed by architect Stanton Eckstut. The structure's appearance is softened by openwork beams on the boardwalk roof and with landscaping of crushed boulders and lacy honey-locust trees. Her works here also include a jetty and lookout point.

R. M. Fischer's *Rector Gate*, a five-story ornamental bronze and steel archway, is another piece inspired by the Statue of Liberty. It has been called a space age version of the Arc de Triomphe.

Ned Smyth's *Upper Room*, a roofless temple that bridges Albany Street and the esplanade, is a series of cast concrete columns, inlaid with mosaic glass, that radiate a sense of ancient Greece and Egypt. The installation includes a massive stone table inlaid with six checkerboards and a dozen stone stools.

Battery Park's newest section is Hudson River Park, an 8-acre expanse of riverfront walkways, fountains, and playgrounds north of the World Financial Center. The standout sculpture attraction here is Tom Otterness' *The Real World,* an army of Lilliputian bronze sculptures that decorate the grounds and star in a small, circular park. His fantasy creatures sit in a clenched oversized fist, slither around a lamp post, and loll on a pair of gigantic feet, one of which is upright and the other flat as a pancake. Many of his characters that depict affluence are adorned with giant pennies. The penny motif is a trenchant social statement about the stratification of society and a pointed reference to nearby Wall Street. Otterness' appealing creatures are a magnet for children, and his most popular pieces are well burnished from constantly being fondled.

Also in Hudson River Park is a modern interpretation of an eighteenth-century English pavilion, designed by architect Demetri Porphyrios. The raised and roofed structure, supported by twelve teak posts, offers a respite from the sun and a prime vantage point for taking in the Hudson River views.

No map is provided, and the pieces are not particularly well marked. But this should not deter visitors from enjoying one of America's most successful marriages of art and architecture.

Battery Park is a 92-acre, self-contained community that feels more like a suburban enclave than a New York neighborhood. The mile-long esplanade, built on a platform that extends over the river, is popular for biking and rollerblading. Sunbathers loll on the wide lawn at the north end.

Battery Park City is owned by the state and is being built by private developers. It was created on landfill provided by excavation debris from the construction of the World Trade Center. The master plan and stringent design guidelines were developed by architects Alexander Cooper and Stanton Eckstut.

The resident portion of Battery Park is far from finished. Its eighteen apartment buildings with 5,000 apartments are the first phase of what is slated to become a complex of 14,000 apartments.

How to Get There: Take the IRT (Nos. 1, 9) Line or the BMT Line (R, N trains) to the Cortlandt Street/World Trade

Center station, or the A, C, or E train (IND Line) or PATH to Chambers Street/World Trade Center. Cross West Street on the enclosed North Pedestrian Bridge, which connects the World Trade Center and the World Financial Center.

Fordham University

New York (Manhattan), New York

Outdoor sculpture became a integral part of Fordham's West Side campus in 1994 when 2 acres of dreary pavement were transformed into a lush, grassy refuge overlooking Columbus Avenue. This hideaway, two stories above the street, offers a country-quiet setting that is in marked contrast to the bustling academic scene below. Here groups of students sunbathe, study, and laze along pristine walkways. In good weather, the occasional class convenes on what is arguably the best kept lawn in Manhattan. Serenity is protected by security guards who maintain an unobtrusive vigil at the garden edges.

The elevated swath of green, dotted with trees and flowers, runs the long block between Columbus and Amsterdam Avenues. On the Columbus, or eastern side, square marble display areas are devoted to special exhibitions. Bright blue mesh benches and a canopied lattice walkway provide an ideal foil for the intensely manicured grass. The eclectic architectural styles of the tall apartment buildings that ring this preserve could comprise a catalog of residential urban design.

Fordham presents between two and four sculpture exhibitions annually. Artists are drawn from the ranks of well-known sculptors from here and abroad.

Fordham's permanent sculpture collection is showcased on the lower level along 62nd Street, just west of Columbus Avenue. Sculptors represented here include Chaim Gross, Lila Katzen, Masami Kodama, Leonardo Nierman, and Frederick Shrady.

How to Get There: Take a West Side subway (IRT Line, Nos. 1 or 9; IND Line, A, B, C, or D train) to the 59th Street Station. Walk one block West to Columbus Avenue. The most convenient entrance is through the street-level garden on 62nd Street, just west of Columbus.

Fordham University
Robert Moses Plaza
62nd Street, West of Columbus Avenue
New York, NY
212-636-6530
Hours: 10:00 A.M.–6:00 P.M., every day.

Museum of Modern Art

Abby Aldrich Rockefeller Sculpture Garden

New York (Manhattan), New York

This venerable outdoor sculpture space, a last-minute addition to the Museum of Modern Art, is a star attraction for the renowned museum.

More than a dozen works by the most prominent modern sculptors are displayed in MoMA's garden. The pieces are artfully placed around planted squares amid reed-thin birch trees that soar above beds of vivid green ivy. Two slim rectangular reflecting pools, punctuated with foaming water jets, both divide the spaces and connect them. Sculpture is displayed in small enclosures within the larger areas; each of the five areas has a distinctive shape. This small urban garden generates a sense of calm in the tumult of thousands of visitors who visit the museum each day.

The garden is dominated by Auguste Rodin's monumental *Monument to Balzac* and Gaston Lachaise's generously proportioned *Standing Woman*. This erotic and voluptuous sculpture epitomizes Lachaise's exuberant enthusiasm for the female form. The Parisian sculptor worked as a jewelry designer in René Lalique's studio. He came to New York in 1912 to pursue Isabel Nagel, a Bostonian he met on the banks of the Seine. Art historians attribute his familiar oversized, powerful female images to his obsession with Nagel, whom he married in 1917 when she finally obtained a divorce.

Pieces are sited so they do not compete with each other for attention. Alexander Calder's black steel stabile seems perfectly placed near Claes Oldenburg's white steel *Geometric Mouse*. Jacques Lipchitz's attention-grabbing *Figure* peers straight through the gar-

View of the Abby Aldrich Rockefeller Sculpture Garden, Museum of Modern Art, New York NY

den with its piercing, deep-set eyes. Picasso's squat bronze *She-Goat* stands singularly alone, despite the close proximity of several larger works. At the garden's east end, large abstract sculptures by David Smith, Tony Smith, and Joel Shapiro form a trio, with the differences in form and texture creating harmony rather than dissonance. At the far wall, Henri Matisse's four-panel bronze relief directs the eye to the garden's outer perimeter.

Founded in 1929, the MoMA moved to its present building in 1939. The outdoor sculpture area was conceived only weeks before the museum opened, when plans were revised to allow the garden to encompass the empty area behind the new museum. The design was little more than a gravel-covered suburban backyard. Sculpture was framed with free-standing screens; ginkgo and white birches provided minimal landscaping. At the time no model existed for a modern urban sculpture garden. MoMA's legendary director Alfred Barr, Jr., and its curator of architecture John McAndrew created the design from scratch.

The garden's current configuration was designed in 1953 by architect Philip Johnson, founder of MoMA's Department of Architecture. Johnson's high-walled garden, which he calls a "roofless room," was patterned on St. Mark's Square in Venice, and it is one of his best known and beloved works.

The museum's ground floor was extended as part of the 1984 expansion. The glassed-in Garden Hall that overlooks the garden was added so that the outdoor sculpture can be seen while riding the escalators. The garden was refurbished in 1989.

MoMA's garden is named for Mrs. John D. Rockefeller, Jr., who founded the museum with two other women. For twenty years, Mrs. Rockefeller was the guiding light behind the museum and was instrumental in establishing its international reputation. The museum is on the site of Mrs. Rockefeller's former home.

Sculptors represented include Ronald Bladen, Emile-Antoine Bourdelle, Scott Burton, Alexander Calder, Herbert Ferber, Hector Guimard, Bryan Hunt, Gaston Lachaise, Jacques Lipchitz, Aristide Maillol, Henri Matisse, Henry Moore, Elie Nadelman, Claes Oldenburg, Pablo Picasso, Eduardo Paolozzi, Auguste Rodin, Joel Shapiro, David Smith, Tony Smith, William Tucker, and Polygnatos Vagis.

The garden can be entered only through the museum, which has an admission fee. The museum has a cafeteria, an expensive restaurant, and an enormous bookstore.

How to Get There: The museum located is between Fifth Avenue and Avenue of the Americas. By subway, take E or F (IND Line) train to Fifth Avenue at 53rd Street; N or R (BMT Line) train to Seventh Avenue at 49th St; B, D, or F (IND, BMT lines) train to Rockefeller Center.

Museum of Modern Art
11 West 53rd Street
New York, NY 10019
212-708-9400
Hours: 11:00 A.M.–6:00 P.M., Saturday through Tuesday; noon–8:30 P.M., Thursday and Friday. Closed on Wednesday. Sculpture garden is closed if it is raining.

Studio Museum in Harlem

New York (Manhattan), New York

The Studio Museum's new sculpture garden is the only one in the country dedicated to African-American artists. The 1995 inaugural exhibition features contemporary works by prominent black sculptors. Most of the pieces were created in the 1990s.

The narrow outdoor space, a block-long alley between two blank five-story walls, presented a formidable challenge for selecting pieces and positioning them. The garden's appearance of length is minimized by a raised platform at the far end. A triangular glass-enclosed entry to the garden in the center of the museum allows many of the works to be seen from within the museum.

Barbara Chase-Riboud's graceful *Middle Passage* is a 5-foot-tall green marble H-shape, with rounds of cord wrapping the center rung. Chase-Riboud lives in Paris and her works are widely shown in Europe. She is also a writer and has published two books on President Thomas Jefferson and his relationship with his black slave Sally Hemmings. The museum hosted book parties for both publications.

Helen Evans Ramsaran's *Sanctuary* is a grouping of stylistic bronze trees that have a white patina that resembles bones. The

9-foot-tall trees are set in pairs on black bases. The work, an interpretation of traditional ceremonial sites, reflects Ramsaran's extensive travels in Africa and South America and her study of ancient civilizations.

Another tall slender grouping is Robert Craddock's *Introject*, eight wooden, 5-foot-tall columns, embellished with burn scars and carvings, that resemble Zulu totem poles. This work is said to be Craddock's translation of the Amedeo Modigliani sculptures that use motifs from African carvings. Craddock is a psychotherapist and a curator at the Jamaica Art Center in Queens.

Chakaia Booker creates works from discarded objects, such as rubber tires, many of which were collected in Harlem. In her *Untitled (Male Torso That Left His Path)*, she covered the wooden sculpture form with tires held in place by black metal screws. The round face has rather sinister eyes and a gaping mouth.

Another sculpture created from discarded materials is Nari Ward's *Ascension,* a washing machine topped with a stack of washing machine agitators coated with tar, bottles, feathers, shoes, and scraps of clothing. It appears to be light-hearted and exuberant, although the tar and feathers clearly refer to a dark period in the black experience.

John Outterbridge's *Window with Wall* is a 16-foot-long wall. It includes lettering that says "The Struggle Continues." This piece was originally displayed in the border town of Tia Juana, Mexico, and is a commentary on national borders and the way they divide people. For many years Outterbridge was curator of the Watts Towers Arts Center in Los Angeles.

The opening exhibition is titled "The Listening Sky," a reference to a line in the James Weldon Johnson poem that is known as the Negro national anthem. It will be on display through the summer of 1996; future exhibits are expected to be mounted on a yearly basis, with works on loan and from the museum's permanent collection.

The garden's opening in September was the culmination of a ten-year struggle to establish the outdoor exhibit space. For years the neglected city-owned lot was filled with garbage and debris. Pleas from the museum for a city clean-up fell on deaf ears until Mayor Koch visited the museum in 1984. Thereafter, the city

Overview of the Isamu Noguchi Garden Museum, Long Island City, NY

moved rapidly to clear away the 8-foot-high piles of garbage and brought sunken lot to grade level. Local contractors donated gravel for the flooring. Corporate sponsors and city funds were used for concrete paving and a small bamboo garden.

The museum was founded in 1967 and moved to its current location in 1979 when the New York Bank for Savings donated the five-story building. Its collection includes nineteenth- and twentieth-century African-American art and twentieth-century Caribbean and African art and artifacts.

Sculptors represented in the garden include Chakaia Booker, Elizabeth Catlett, Barbara Chase-Riboud, Robert Craddock, Richard Hunt, Tyrone Mitchell, John Outterbridge, Helen Ramsaran, John Scott, and Nari Ward.

Admission fee.

How to Get There: The museum is between Lenox and Seventh avenues, directly across the street from the Adam Clayton Powell, Jr., State Office Building. By subway, take the IRT No. 2 or No. 3 train to 125th Street, and walk half a block west.

The Studio Museum in Harlem
144 West 125th Street
New York, NY 10027
212-864-4500
Hours: 10:00 A.M.–5:00 P.M., Wednesday, Thursday, and
Friday; 1:00 P.M.–6:00 P.M. on weekends.

The Isamu Noguchi Garden Museum

New York (Long Island City, Queens), New York

Isamu Noguchi (1904–1988) was one of the most prolific sculptors of the twentieth century and a titan in contemporary park design. His civic and corporate plazas are among the most treasured outdoor areas in America. Yet none of these works has his stamp as indelibly etched as the garden museum he created for his own works in Long Island City. This idyllic space where over 250 of Noguchi's pieces are on display was one of the first museums in America dedicated to a single artist.

This sculpture garden, enclosed by walls of broad-leafed Boston ivy, is so peaceful and serene that it seems a world apart from the grimy warehouse district it inhabits. More than a dozen Noguchi sculptures are on view in the garden. They are set amid clusters of trees and shrubs; contrasting rock and gravel accents complete the tranquil tableau. A towering garden centerpiece is a massive ailanthus tree. Known in China as the Tree of Heaven, it is the featured tree in the novel *A Tree Grows in Brooklyn*. Its puny relatives can be seen sprouting along the highway divides on urban expressways. Here, its dark grainy bark and angular limbs reflect the texture, color, and form of the granite Noguchi sculptures that dominate the landscape. Ivy encases the tree trunk to a height of over 10 feet.

Renowned the world over for his gardens, Noguchi designed this one with the precision and purity that characterize his sculpture. Noguchi's American and Japanese heritage is reflected in his garden; Americans perceive the pristine space as Japanese in origin, while Japanese visitors think of it as a Western design. Calvin Tomkins, in a 1980 *New Yorker* article,

observed that Noguchi's "career has been a dialectic between tradition and innovation, craft and technology, geometric form and organic form, weight (stone) and weightlessness (paper), the rough and the finished, Japan and America."

Born as Sam Gilmour to an American mother and Japanese father, Noguchi spent his childhood in Japan and returned to the United States in 1918. His father was a poet and art critic; his mother, of Scotch-Irish and American Indian descent, was a Bryn Mawr–educated writer and teacher. After high school Noguchi apprenticed to Mt. Rushmore sculptor Gutzon Borglum, who told him he lacked talent. He turned to the study of medicine for several years, before realizing sculpture was to be his life's work. He moved to Paris, where the legendary sculptor Constantin Brancusi became his mentor.

By the 1930s Noguchi's talents and explorations were being spread in many directions. He traveled the world visiting ancient ruins, including Stonehenge and Machu Picchu. He studied brush drawing, calligraphy, and pottery in the Far East, created sets for the preeminent dancer and choreographer Martha Graham, designed his first environmental installation, and by the end of the decade sculpted *News*, his last piece with recognizable figures, for the exterior of the Associated Press Building at Rockefeller Plaza.

In 1961 Noguchi moved his studio and home to an abandoned photo-engraving plant in an industrial area in Long Island City. In the 1970s, he renovated an adjoining plant for his stone, metal, and wood sculptures. Using more than $2 million of his own funds, he converted the complex into a museum, a garden, and a new factory wing to display his largest sculptures. Visitors were first admitted by appointment in 1983. Two years later the museum opened to the public on a regular basis.

For nearly two decades Noguchi divided his time between his Long Island City studio and museum and his studio on the island of Shikoku, on an inlet of Japan's Inland Sea, in a village of stonecutters and fishermen. His Shikoku complex, including a restored two-hundred-year-old samurai house and a one-hundred-year-old sake factory, was enclosed with a high circular wall constructed from stone leftover from his sculptures. The

studio with its rough-hewn beams and ancient wide plank floors was a world away from his studio on the East River in Queens. In fashioning his pieces, Noguchi favored tools used in the industrial crafts rather than machine fabrication.

Noguchi's reputation is based on both his individual sculpture and his pioneering and often controversial designs for gardens, playgrounds, terraces, and urban plazas. Most of his work is cut from stone, cast in bronze, carved in wood, or created from paper. Among his better known installations are the Beinecke Library courtyard at Yale, the sunken plaza at Chase Manhattan Bank in New York, and the UNESCO garden in Paris.

Displayed inside the museum are many of Noguchi's smaller masterworks, as well as drawings and architectural models of many of his unbuilt projects, Akari lamps, furniture, and stage designs created for Martha Graham.

Admission fee.

A small museum shop features Akari lamps and books by and about the artist.

How to Get There: On weekends, round-trip shuttle buses depart hourly from the Asia Society, 70th Street and Park Avenue, 11:30 A.M.–3:30 P.M.

From Manhattan by subway, take the N train (BMT Line) to the Broadway station in Queens; walk toward the East River, down Broadway for approximately 15 minutes to Vernon Boulevard.

From Manhattan by tram, take the aerial tramway at 60th Street and Second Avenue to Roosevelt Island; board a free bus to the bridge; walk on Vernon Boulevard for 15 minutes.

From Manhattan by car, take the Queensborough Bridge, lower level, to first right-hand exit off bridge, at Crescent Street. Proceed to 43rd Avenue; turn right, and follow Vernon Boulevard to 33rd Road.

The Isamu Noguchi Garden Museum
32-37 Vernon Boulevard
Long Island City, NY
718-204-7088

Hours: 11:00 A.M.–6:00 P.M., Wednesday, Saturday, and Sunday, April through November.

P.S. 1 Museum

Institute for Contemporary Art

New York (Long Island City, Queens), New York

With the opening of its outdoor sculpture installation in the fall of 1996, P.S. 1 will join the Noguchi Garden Museum and Socrates Sculpture Park as the third leg of Long Island City's outdoor sculpture triangle. This sprawling warehouse district, a short subway ride from Manhattan, was for many years an outpost where large spaces and cheap rent were the main attractions. It is now a thriving artist colony.

P.S. 1, the oldest school building in Queens, was abandoned and left to decay until 1976 when its large, light-filled rooms were recycled as display spaces for artists who had yet to make it in the big-time art world across the river. The museum gradually become recognized as a sponsor of high-quality contemporary exhibitions, and it now draws artists with international reputations; a major show of Polish sculptor Magdalena Abakanowicz's works was presented at the museum.

After two decades of struggling with outmoded facilities, crumbling floors, and leaky windows, P.S. 1 is getting the attention it deserves. The $5.7 million renovation begun in 1994 is bringing the building up to modern standards. Included in the reconstruction is a "sculpture compound" in the former schoolyard and parking lot. A wide triangular sculpture area, with open-air rooms enclosed within high concrete walls, will be the museum entrance.

Outdoor sculpture space is being constructed with a view toward maximum flexibility in its use. Five sculpture courts will serve double duty as performance spaces. Sculptures will sit on a base of compacted gravel blended with pulverized bluestone. This surface can be easily and cheaply reconfigured to accommodate the placement and removal of large art works.

One group of controversial works that were on display for several years outside the museum will be reinstalled. South Bronx artist John Ahearn was commissioned by the city to create sculpture for a new Bronx police station. He cast full-size impressions of three well-known neighborhood residents—a

brawny teenage basketball player, a painfully thin, AIDS-stricken young man with his dog, and a spirited, hopeful high school girl. The works were widely criticized by the community as being a hostile representation of their neighborhood. Ahearn, a white sculptor who lived compatibly for years in the overwhelmingly black area, immediately agreed to remove the works, and they eventually came to the P.S. 1 schoolyard. These emotionally powerful pieces, on display at the Socrates Sculpture Park during P.S. 1's renovation, will be stationed at the museum entrance.

Renovation plans call for a studio wing for visiting artists, a bookstore and a cafe.

Admission to the sculpture compound is free; admission charge for special exhibitions in the museum.

How to Get There: By subway, take the E or F train (IND Line) to Queens 23rd Street–Ely Avenue station, exit at 21st Street. By the No. 7 train (IRT Line), go to 45th Road–Courthouse Square. By the G train (BMT Line), go to 21st Street (Van Alst). By bus, take the Q67. By car, take the Queensborough (59th Street) Bridge; turn right at Queens Plaza on Jackson Avenue. Museum is just south of Court Square and the highly visible Citicorp building.

P.S. 1 Museum
Institute for Contemporary Art
46-01 21st Street
Long Island City, NY 11101
718-784-2084

Socrates Sculpture Park

New York (Long Island City, Queens), New York

This gritty park, devoted to large-scale contemporary works, is the inspiration of the internationally acclaimed sculptor Mark di Suvero. He founded the park on a 5-acre industrial site next to his studio. This formerly abandoned dump on the East River is a testament to the triumph of art over urban decay.

Spectacular views of Manhattan's skyline, directly across the river, accentuate the contrasts between artistic endeavors and capitalist enterprise. Its superb riverfront location offers a unparalleled showcase for some of the most avant-garde works being produced today. Di Suvero's stature as an artist makes Socrates a beacon for emerging sculptors, and it is one of the few places where newcomers can present their works before a wide audience of curators and collectors. The park's biannual shows are magnets for curators from around the country who seek to keep abreast of developments in the world of contemporary sculpture. The park has featured over a hundred sculptors; the list of participating artists constitutes a virtual Who's Who of contemporary sculptors of large-scale works.

Socrates has no permanent collection, although several of di Suvero's distinctive works-in-progress can always be seen just beyond the park's fence. This icon of contemporary sculpture typically uses industrial materials, such as vertical steel I-beams and jutting steel girders, to create monumental constructions with bold lines that slash through space. Di Suvero was among the first American sculptors to fabricate pieces from industrial salvage materials, and he is considered by many to have inherited David Smith's mantle as the country's most influential contemporary sculptor.

The emphasis at Socrates, which is named for the philosopher, is strictly on the sculpture. Typically, around twenty sculptures, many of them colossal in size, are on display. The setting is all the more startling because it is just a two-block walk to the serenely cloistered Isamu Noguchi Garden Museum.

The park is landscaped with minigroves of pine, sycamores, and other lacy-leafed trees. A winding path along the waterfront offers panoramic views of soaring apartment buildings on Manhattan's posh Upper East Side. Trees and foliage planted along the street boundary will eventually block the unsightly view of its harsh industrial warehouse neighbors. The raised plantings are enclosed with cement blocks, many of which have alphabet letters resembling children's blocks. At water's edge a series of swinging silver metal barbells, mounted on tall poles, emit clear bell-like sounds as they rotate with the wind.

In creating the park, di Suvero enlisted manual labor from neighborhood youngsters and raised $200,000 from private donors. Over several years, hundreds of volunteers removed car hulks, garbage, and industrial debris. Gaping potholes were filled and fencing installed. The park was founded in 1986 on land leased from the city and is supported largely through private contributions. Its future on the prime waterfront development site was in jeopardy until 1994, when the city's Parks Department took over maintenance responsibilities. This semiofficial municipal recognition gives the park a more established institutional presence.

Sculptors chosen to exhibit at Socrates are usually suggested by other artists. A few of the artists who have shown here include Vito Acconci, John Ahearn, Tom Bills, Eduardo Chillida, Tom Doyle, Lauren Ewing, Linda Fleming, Peter Forakis, Jene Highstein, Grace Knowlton, Richard Mock, Jesus Bautista Moroles, John Morse, Beverly Pepper, Robert Ressler, Tony Smith, Richard Stankiewicz, and Bill Tucker.

This is strictly a do-it-yourself adventure. Brochures are not available, and the works are unlabeled. Tours are not offered on a regular basis. The lack of information leaves the visitor free to make independent judgments without the customary guideposts relating to a sculptor's reputation.

No admission fee. This is a community venture where climbing on the sculpture, picnicking, and dogs are permitted. Children play ball with their parents, and the keynote is freedom of movement and joy in the creative process.

How to Get There: By subway, take the N train (BMT Line) to Broadway; walk eight blocks toward the East River. By car, follow Grand Central Parkway to Hoyt Avenue; turn left on 21st; turn right on Broadway and travel three blocks to the East River. From Manhattan: Take the 59th Street Bridge (upper roadway) to 21st North Exit; turn left on Broadway and travel three blocks to the East River. Street parking is usually available.

Socrates Sculpture Park
Broadway at Vernon Boulevard
Long Island City, NY 11106
718-956-1819
Hours: 10:00 A.M. to sunset. Open year-round.

Brooklyn Museum

Frieda Schiff Warburg Sculpture Garden

New York (Brooklyn), New York

Brooklyn's sculpture garden offers a journey into New York's architectural past. The collection of ornamental fragments created by skilled stonemasons offers a peek into the grandeur of buildings long-vanished from the New York scene. This is the only sculpture garden in America devoted exclusively to architectural fragments.

The garden is adorned with expansive shade trees and comfortable benches placed strategically to afford intimate views of the ornaments. Nestled among plump pillows of ivy are beautifully carved cast-off fragments in terra cotta, limestone, cast iron, marble, and brass. They reflect the high level of craftsmanship and the wide variety of building materials used in New York in a bygone era. Although these remnants are placed out of their original context, they are poignant reminders of the care with which earlier generations decorated their environment.

The collection features bas relief heads, roaring lions, angelic children, heroic medallions, and grotesque masks carved by anonymous nineteenth- and twentieth-century stonecutters as well as works by such major sculptors as Karl Bitter, Gutzon Borglum, and Daniel Chester French. The collection was given a substantial boost when Manhattan art dealer Ivan Karp's Anonymous Art Recovery Society donated dozens of architectural details from demolished buildings.

Artifacts include a clock figure from the demolished Pennsylvania Station, railings from the Police Gazette Building, remnants from Coney Island's Steeplechase, and the original capitals or roof decoration from the Bayard Building, designed by Louis Sullivan, who is considered by many to be the father of the skyscraper. Most of the artifacts were once part of the New York City scene, although a notable exception is a carved keystone from Al Capone's notorious Four Deuces Club in Chicago.

The garden was donated by Walter Rothschild in the late 1950s in memory of his mother-in-law. Rothschild's father-in-law Felix Warburg, scion of German Jewish bankers, was a pre-

eminent philanthropist and the model for Daddy Warbucks in "Little Orphan Annie." The Warburgs' involvement in the arts in New York is legendary. They were important contributors to the Metropolitan Museum of Art and the Metropolitan Opera.

The Museum sells a pamphlet about the garden's architectural fragments.

An admission fee to the garden can be avoided by entering from the Museum's parking lot. The Museum has a cafe.

How to Get There: Take the No. 2 or No. 3 train (IRT Line) to Eastern Parkway. From Manhattan's East Side, take the No. 4 train (IRT Line) and transfer at Nevins Street. By car, take Flatbush Avenue to Grand Army Plaza; follow Eastern Parkway to Washington Avenue and turn right. There is metered parking on the street and a large parking lot behind the museum.

Brooklyn Museum
200 Eastern Parkway
Brooklyn, NY 11238
718-638-5000
Hours: 10:00 A.M.–5:00 P.M., Wednesday through Sunday.

New York City Region

Pepsico

The Donald M. Kendall Sculpture Gardens

Purchase, New York

PepsiCo's suburban Westchester County headquarters is home to an important collection of more than forty major outdoor pieces that are ideally placed on 144 immaculately landscaped acres. Just an hour from midtown New York City, PepsiCo's elegant, sanitized grounds are far removed from the bustle and grit of Manhattan.

The manicured private thoroughfare to the office complex features several powerful sculptures. Looming near the entrance is Richard Erdman's mysterious *Passage*. It is carved from a 450-ton slab of marble, thought to be the world's largest sculpture created from a single piece of Roman travertine. Nearby is George Rickey's gracefully shimmering *Double L Excentric Gyratory II,*

which takes on an endless variety of shapes as its two giant L-shaped limbs twist slowly on the slightest breeze.

Near the building entrance stands Claes Oldenburg's 47-foot-high *Giant Trowell II,* a perfect symbol for these intensely cultivated grounds. The mammoth garden tool is typical of Oldenburg's penchant for enlarging everyday objects to a size that gives them an extraordinary presence. Near Oldenburg's trowel is George Segal's evocative *Three People on Four Benches,* a pair of women and a lone man who seem to be waiting patiently, perhaps for a bus. The sculpture captures precise details of dress, manner, and mood because it was created by wrapping actual people in quick-drying gauze. The gauze creates a hollow mold from which the sculpture is cast. The trio, executed in Segal's signature chalk white finish, is an irresistible photo opportunity for visitors who cuddle up and chat with the figures.

PepsiCo's sculpture collection, initiated in 1965, spans the modern era, from the father of modern sculpture, Auguste Rodin, to such present-day icons as Alexander Calder and Isamu Noguchi. The bulk of the collection represents works from the 1960s through the mid-1980s. PepsiCo president Donald Kendall was the spark behind the sculpture collection.

Kendall likened his corporate collector role to that of the European monarchs: "Until the French Revolution, the aristocracy were the arbiters of taste and protectors of artists. Today, corporations have taken over the traditional role of the landed gentry as buyers of important art, giving artists unprecedented creative opportunities and benefiting the public at the same time."

PepsiCo's headquarters, on the grounds of a former polo club, were designed by Edward Durrell Stone, one of the two architects of the original Museum of Modern Art. The seven concrete buildings, banded in bronze-tinted glass, are unified by a cross-shaped courtyard, whose sunken gardens provide intimate settings for small sculptures that are set on pedestals in ponds and fountains and amid the extensive greenery. Cavorting in the fountain spray in a courtyard pool is English sculptor David Wynne's *Girl with a Dolphin.* The artist's child-friendly, massive marble *Grizzly Bear* crouches watchfully over the serene lake in the rear sculpture area.

Tucked into a grassy tract at the far end of the park is Robert Davidson's grouping of three tall red cedar totems, brightly decorated with ancient mythological symbols from the Haida Indians who lived on islands south of Alaska. The British Columbia–born sculptor grew up in a Haida fishing village but was unaware he was an Indian until informed by his uncle who overheard him cheering on the cowboys against the Indians in a Western movie. Working with anthropologists, Davidson and his Haida mentor Bill Reid uncovered the nearly lost art of the Haida Indians.

Arnoldo Pomodoro is represented with two imposing works. His *Triad*, three enormous bronze and Cor-ten steel columns, soars above the low-slung office complex in a modern version of classic columns. Deeply grooved in characteristic Pomodoro fashion, they expose webs of sprockets and other industrial-looking objects. The sculptor's huge circular *Grande Disco* is a complementary piece that resembles a cross section of one of the *Triad* columns. The dazzling polished bronze surfaces with dark jagged gashes and intricate interior gear teeth are studies in contrasting shapes and textures.

The original landscape, designed by Edward Durrell Stone's son, Edward, Jr., was redesigned in 1981 by the world-renowned landscape architect Russell Page. He introduced hundreds of plants and groves of trees and fashioned winding gravel walkways that meander through the garden. The revamped garden reflects Page's vision that each sculpture is a flower.

The golf course–quality grounds include a fantasy lake, with hundreds of strutting Canadian geese.Rectangular pools with floating lily pads are flanked by a double row of flowering Mt. Fuji cherry trees. A birch tree grove, planted so precisely it recalls a French Impressionist painting, offers a dramatic backdrop for famed British sculptor Barbara Hepworth's *Meridien*. This piece, commissioned by the City of London to adorn a building, was acquired by PepsiCo when the building was demolished.

Sculptors represented include Judith Brown, Alexander Calder, William Crovello, Robert Davidson, Jean Dubuffet, Richard Erdman, Max Ernst, Alberto Giacometti, Gideon Graetz, Barbara Hepworth, Henri Laurens, Jacques Lipchitz, Seymour Lipton, Aristide Maillol, Marino Marini, Joan Miro,

Henry Moore, Louise Nevelson, Isamu Noguchi, Claes Oldenburg, Arnoldo Pomodoro, Art Price, Bret Price, George Rickey, Auguste Rodin, Victor Salmones, George Segal, David Smith, Tony Smith, Kenneth Snelson, Asmundur Sveinsson, and David Wynne.

Security is tight, but the guards are welcoming. Attractive wooden benches invite visitors to linger. Tables and benches are available for picnicking. Dogs are allowed on leash.

A detailed map of the sculpture and the grounds is provided at the garden entrance.

How to Get There: From Manhattan, take the Henry Hudson Parkway to the Cross County Parkway east. Follow the Hutchinson River Parkway northbound to Exit 28 (Lincoln Avenue, Portchester). Turn left at the end of the exit ramp onto Lincoln Avenue, and proceed 1 mile to first traffic light. PepsiCo is on the right.

PepsiCo
The Donald M. Kendall Sculpture Gardens
Anderson Hill Road
Purchase, NY 10577
914-253-2900
Hours: 9:00 A.M.–5:00 P.M., every day.

The Rockefeller Estate

Kykuit Sculpture Gardens

Pocantico Hills, North Tarrytown, New York

Kykuit (pronounced "Kai-cut"), completed in 1913, was the center of family life for three generations of the Rockefeller family. Formerly a hilltop used by the Mohegan Indians to send smoke signals, the Dutch traders named it Kykuit, or lookout. The view from Kykuit's entrance, straight through the mansion to a wide terrace, rolling hills, the Hudson River, and the Palisades at a distance, is simply breathtaking. This unencumbered vista, stretching 2 miles to the Hudson and beyond, could be a romantic landscape right off the easel of one of the great Hudson River School painters.

Kykuit's public opening, in May 1994, created a sensation in New York's art world. Tours were fully booked months before

the opening, and all through the summer. And this is one case where the hype matches the experience.

The circular entrance drive is dominated by the towering, three-tier marble *Oceanus Fountain*, a copy of the original in the Boboli Gardens in Florence. In Roman myth Oceanus was the father of river gods and a symbol of the power of water. No doubt its prominent placement at Kykuit is a reference to the majesty of the Hudson River.

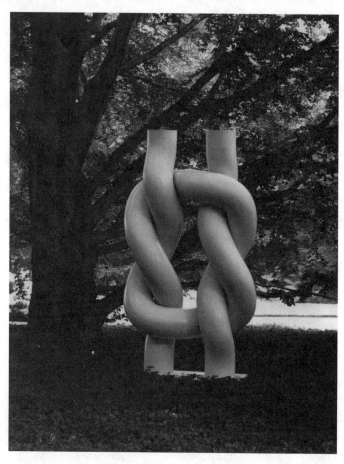

Shinkichi Tajiri, *Granny's Knot* (1968), Kykuit, The Rockefeller Estate, North Tarrytown, NY

Nelson A. Rockefeller's passion for modern sculpture is first in evidence at the mansion's entrance, where Constantin Brancusi's *Grand Oiseau* and Alberto Giacometti's *Headless Woman* are framed by graceful arches. He personally supervised the placement of more than seventy modern sculptures, moving pieces as little as 2 inches to get his ideal arrangement. In his will, he requested that his collection remain at Kykuit.

The enclosed formal garden just south of the mansion, and the stepped terraces and ponds below, were designed by the acclaimed landscape architect William Welles Bosworth; Kykuit's landscaping today remains virtually unchanged from Bosworth's 1906 design. Inspired by the romantic English gardens of the period, it is an exquisite setting for modern sculpture. Aristide Maillol's massive bronze *Bather Putting Up Her Hair* presides at the center of the precisely partitioned Beaux Arts garden. The perimeter is defined with stone walls, hedges, and shrubbery. Sculpture is used as a focal point at the end of clear, straight sight lines. Gardens close to the house are geometric, while lands in the distance have a pastoral parklike setting.

Framing the teahouse on one side of the formal garden are two whimsical Reg Butler bronze sculptures, *Girl with a Vest* and *Manipulator*. A narrow rill, or water channel, inspired by one at the Alhambra in Spain, bisects the garden and flows from the teahouse to the garden's center.

Beyond the garden and terraces are three joining circular pools where Henry Moore's bronze *Nuclear Energy* is set off to advantage with a backdrop of dense shrubbery. This 4-foot-high maquette is a third of the size of the original. Another Moore piece, the powerful bronze *Knife Edge:-Two Piece,* is displayed prominently at the entrance to the rose garden.

In the far grounds, near the winding entrance drive, is Shinkichi Tajiri's intriguing *Granny's Knot,* a pair of twisting forms in white polyester resin and fiberglass, tucked into the shade of a grove of copper birches.

Surely nowhere else in the world is a putting green adorned with masterworks from five internationally renowned sculptors. Imagine practicing your putting strokes in the shadow of Gaston Lachaise's *Man,* Louise Nevelson's *Atmosphere and Environment,*

VI, Aristide Maillol's *Night,* Marino Marini's *Horse,* and Alexander Calder's *Large Spiny!*

Nelson Rockefeller's 1960s collection of resolutely modern sculpture blends well with the more traditional pieces collected in an earlier period by his father. Classic marble columns, statues of Venus, Aphrodite, and Apollo, and Chinese Foo lions seem completely at home with the modern abstract works.

A drawback of the supervised tours, at least for sculpture buffs, is that the guides are so thorough in describing the Rockefeller mansion that insufficient time is left to fully take in the extraordinary outdoor collection. Tantalizing views of the sculpture and gardens tempt the visitor to stray from the organized tour; guides warn that vigilant security guards will herd adventurers back into the fold.

Except for Kykuit's 87 acres and 800 acres donated to a state park in the 1980s, the original 4,000-acre estate remains in the Rockefeller family. John D. Rockefeller, Sr., bought the original 400-acre parcel in 1893. The Georgian four-story, forty-room fieldstone manor was commissioned by John D. Rockefeller, Jr., and completed in 1913. Architects were the patrician New York firm of Delano and Aldrich. When John, Sr., died in 1937, his son moved into the mansion. It was Nelson's home from 1961 until his death in 1979. The former vice president and four-time New York governor willed his modern art collection and his portion of the 87-acre family property to the National Trust for Historic Preservation. The Rockefeller Brothers Fund maintains the property. Tours are administered by Historic Hudson Valley (914-631-8200).

Rockefellers still live on the estate. The homes of David and Laurance, and Nelson's widow Happy, are hidden from view, but the "playhouse," with tennis courts and a pool, can be seen from the main house.

Nelson Rockefeller's collection of more than one hundred paintings, prints, sculpture, Picasso tapestries, Leger rugs, and oversized Andy Warhol portraits of Nelson and Happy are on view in the narrow basement tunnel. The tour includes the coach house, horse barn, and tack room.

Sculptors represented in the outdoor collection include

Robert Adams, Karel Appel, Jean Arp, George Grey Barnard, Max Bill, Karl Bitter, Constantin Brancusi, James Buchman, Reg Butler, Alexander Calder, Mary Callery, Lynn Chadwick, Peter Chinni, Raymond duChamp-Villon, Benni Efrat, Sorel Etrog, Rudulf Evans, Herbert Ferber, Richard Fleischner, Lucio Fontana, Alberto Giacometti, Etienne Hajdu, Will Horwitt, Jean Ipousteguy, George Kolbe, Gaston Lachaise, Alexander Liberman, Jacques Lipchitz, Evelyn B. Longman, Aristide Maillol, Gerhard Marcks, Umberto Mastroiani, Marino Marini, Clement Meadmore, Balsadella Mirko, Henry Moore, Elie Nadelman, Masayuki Nagare, Louise Nevelson, Isamu Noguchi, Ezra Orion, Eduardo Paolozzi, Pablo Picasso, Arnoldo Pomodoro, Gio Pomodoro, Bernard Reder, George Rickey, James Rosati, Frederick George Richard Roth, Janet Scudder, Jason Seley, David Smith, Tony Smith, Kenneth Snelson, Wendy Taylor, Shinkichi Tajiri, E. M. I. Tonetti, Willy Weber, and Fritz Wotruba.

A bookstore and gift shop are located at nearby Philipsburg Manor, a property maintained by the Sleepy Hollow Restoration. A map noting locations of the outdoor collection is being prepared.

How to Get There: Tours leave from Philipsburg Manor, on Route 9 in North Tarrytown. Visitors are taken by minivan to the mansion. By car (from New York City), take the Gov. Thomas Dewey Thruway (Rte. 87 North) to Tarrytown (Exit 9); then follow Route 119 west to Route 9. Or take the Sawmill River Parkway to Route 287 and then follow Route 119 west to Route 9. By boat, New York Waterway offers day cruises from New York City that leave from the West 38th Street pier. The trip takes 50 minutes. For reservations, 800-533-3779. By train, take the Metro-North's Hudson line from Grand Central Terminal to Tarrytown, New York, and a short taxi ride to Philipsburg Manor (the departure point for two-hour tours).

The Kykuit Sculpture Gardens
Pocantico Hills
North Tarrytown, NY
Tour reservations: 914-631-9491
Hours: Reservation-only escorted, two-hour tours from nearby Philipsburg Manor leave every 20 minutes. From

10:00–3:00 P.M. on weekdays, 10:00 A.M.–4:00 P.M. on weekends. Open April through October. Closed on Tuesday.

Hofstra University Sculpture Park

Hempstead, New York

Hofstra's luxuriant arboretum is the backdrop for the university's outstanding outdoor sculpture collection. More than forty sculptures are placed throughout 238 acres of greenery, among soaring trees, and along broad winding paths between campus buildings.

Many of the pieces are campus focal points. Henry Moore's formidable *Upright Motive No. 9*, a larger-than-life bronze on a pedestal, dominates a crossroad where students lounge along a circular low-brick wall. An academic note is sounded with J. Seward Johnson, Jr.'s bronze *Creating*, a lifelike image of a balding professor sitting crossed-legged under a tree poring over his notes. Lin Emery's aluminum *Tree* is a towering sculpture, with red and silver saucer-shaped wings that rotate with the wind. Antoni Milkowski's 28-foot-long set of interlocking brushed steel cubes resembles a giant gray caterpillar.

The largest part of the collection is on the south side of the Hempstead Turnpike. But the north side features two popular figurative works. Tucked away in the trees is *Boston*, a full-size bronze of a Boston-bound hitchhiker by J. Seward Johnson, Jr. The other is a bronze likeness of the pugnacious Casey Stengel, the much-beloved hero of New York baseball fans.

Outdoor sculpture came to the campus in 1968 with the installation of Manolo Pascual's *Knight*, a 10-foot-tall welded steel figure in a coat of mail studded with nails. The collection began in earnest in 1985, when the Sky Island Club donated thirty sculptures to honor Hofstra's fiftieth anniversary.

Hofstra opened as a college in 1935 on the grounds of the estate of William S. Hofstra, a late nineteenth-century lumber baron. His home, now Hofstra Hall, and 15 surrounding acres formed the nucleus of the private college. It is now a university with twelve thousand students.

Mr. Hofstra's Dutch ancestry is much in evidence on campus in the spring, when thousands of colorful tulips take over the

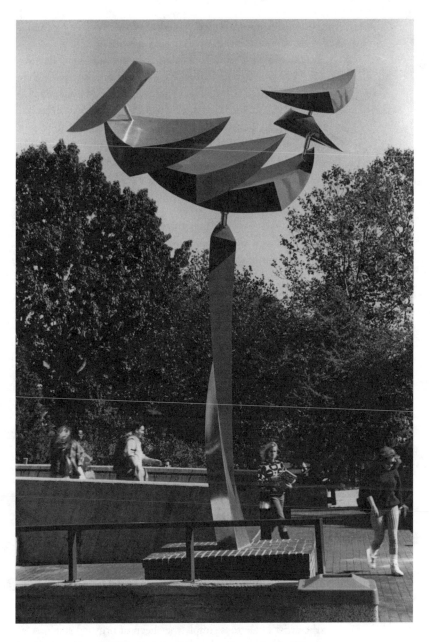

Lin Emery, *Tree* (1991), Hofstra Museum, Hempstead, NY

grounds. The campus is richly landscaped with sixty-five hundred trees representing more than 225 species.

Sculptors whose work is in the permanent outdoor collection include Richard Barks, Penny Chaplain, Lin Emery, Arthur Gibbons, Richard Henrik, David Jacob, J. Seward Johnson, Jr., William King, Abram Lassaw, Phyllis Mark, Antoni Milkowski, Henry Moore, Constantino Nivola, Manolo Pascual, Dolly Perutz, Bernard (Tony) Rosenthal, Bill Shanhouse, Rhoda Sherbell, and Robert White. Sculptors whose work are on long-term loan include St. Clair Cemin, Jimmy Ernst, Seymour Lipton, and Joel Perlman.

The museum's large collection of art can be seen in four galleries and in campus buildings throughout the campus.

The outdoor collection is documented in a booklet that contains a walking tour.

How to Get There: From New York City, take the Grand Central Parkway east to Meadowbrook Parkway (south) to exit M4 (westbound) onto Hempstead Turnpike. The campus is 1 mile from M4 exit.

Hofstra University Sculpture Park
Hempstead, New York 11550
516-463-6606
Hours: Collection is on view at all times.

Nassau County Museum of Fine Arts

Roslyn Harbor, New York

Nassau County's outdoor sculpture collection is such a little-known treasure that even on the most perfect fall days only a handful of visitors stroll the grounds of the 145-acre former Gold Coast mansion.

The first sculpture encountered, Roy Lichtenstein's exuberant *Modern Head,* sets the tone for the collection. This 31-foot-tall, sharply angled, geometric abstraction by Pop Art's leading exponent is reminiscent of a Cubist interpretation of a human head. While Lichtenstein's paintings emphasize red, yellow, and blue, here the artist's palette is simply the sheen of brushed steel.

At the garden entrance a series of formal hedge-framed

rooms create a sense of privacy and serenity, a particularly graceful setting for the figurative pieces on display. Attractively patterned brick pathways add to the pleasure.

Contemporary sculpture is featured along the rim of a wide meadow at the rear of the mansion, in the wooded areas away from the museum and alongside a naturalized pond. Allen Bertoldi's playful *Wooden Duck*, commissioned for the center of the pond, casts ever-lively shadows on the water and along the pond edges. Elyn Zimmerman's *Triad*, a 10-foot-tall granite monument, is located along the northern perimeter of the grounds. Richard Serra's *Equal Elevations—Plumb Run, 1983*, three 40-foot-long plates of Cor-ten steel, dominates the far rim of the museum's property. Serra was awarded a prize by the Japan Art Association for this piece, installed at the museum in 1994.

Allen Bertoldi's *Homage to Noguchi*, often referred to as the doughnut, is one of several Bertoldis on display. The artist worked at the museum in the late 1970s, and many of his loaned pieces were given to the museum after his death in the early 1980s.

The permanent sculpture collection was begun in 1989 when a private board took over the museum from the county. PepsiCo and Storm King were used as models for landscaping and sculpture placement.

The museum is the former home of vertebrate paleontologist and naturalist Childs Frick, son of the industrialist and art patron Henry Clay Frick. The Fricks hired British architect Sir Charles Carrick Allom to alter the original 1893 design created by Odgen Codman, Jr., for Lloyd Stephens Bryce. William Cullen Bryant, the esteemed editor and poet, was the original owner. Childs Frick and his family lived in "Clayton" until Frick died in 1965. Nassau County bought the estate in 1969 to establish the museum.

Sculptors represented in the outdoor collection include Charles Arnoldi, Allen Bertoldi, Fernando Botero, Xavier Corbero, Jose de Creeft, Mark di Suvero, Charles Ginnever, Adolph Gottlieb, Chaim Gross, Richard Hunt, Anna Vaughn Hyatt Huntington, Roy Lichenstein, Marino Marini, Reuben Nakian, Barnett Newman, Richard Nonas, Richard Serra, Richard Tucker, and Elyn Zimmerman.

Fernando Botero, *Man on Horseback* (1984), Nassau County Museum of Fine Art, Roslyn Harbor, NY, on extended loan from the Metropolitan Museum of Art, New York City

Admission fee to the museum; outdoor sculpture can be viewed without charge. No regularly scheduled tours, but they are available on request.

Picnicking is permitted on the grounds. Box lunches are available at the museum cafe. The museum has a gift shop and bookstore. A brochure detailing the placement of the outdoor collection is being prepared.

How to Get There: Take the Long Island Expressway to Exit 39N (Glen Cove Road North). Go approximately 2 miles to Northern Boulevard (Rte. 25A) and turn left. At the second light, turn right into entrance to museum.

Nassau County Museum of Fine Art
Northern Boulevard and Museum Drive
Roslyn Harbor, NY 11576
516-484-9337

Hours: Sculpture garden is open 9:00 A.M.–5:00 P.M., except

New Year's Day, 4th of July, Thanksgiving, and Christmas. Museum: 11:00 A.M.–5:00 P.M., Tuesday through Sunday.

Storm King Art Center

Mountainville, New York

Storm King is the largest and best known sculpture park in America. Its 400 acres of gently sloping hillsides in the foothills of the Catskills offer a bucolic setting for this premier collection of sculpture. The scope of this immense collection is sensed immediately, with major works asserting their grandeur along the winding entrance roadway.

The park entrance is dominated by *The Arch,* Alexander Calder's final large-scale work, completed in 1975. This awesome 56-foot-high black stabile, the museum's signature piece, invites visitors to enter its spaces and marvel at its monumental scale. His "stabiles" were so named by sculptor Jean Arp, after the French artist Marcel Duchamp tagged his swinging wire-connected pieces "mobiles." Calder considered his huge pieces to be part of the landscape; many are large enough to walk through, and some can even accommodate a drive-through.

Storm King opened in 1960 with works of a decidedly local character, primarily the Hudson River School. The museum came to national prominence in 1967 when it pulled off a sculpture coup with the purchase of thirteen David Smith (1906–1965) bronze and steel works from the sculptor's Bolton Landing studio at Lake George. Trustees of Smith's estate were initially hesitant to sell such a large number of works to a fledgling museum. Tipping the scales for Storm King were its wide open spaces, an environment that Smith had always favored for his sculpture. This visionary purchase brought to Storm King the largest collection of Smiths in the country. These pieces from the 1940s offer a retrospective of the intensely productive middle period of the artist's work.

Smith is considered among the most important sculptors of the twentieth century. He studied at the Art Students' League in New York City and in the late 1930s was a part of the WPA Federal Art project. He was a pioneer in using welded steel wires

and rods, tapping expertise gained in a summer stint as a metal-worker at a Studebaker factory. Smith viewed welding as a vigorous symbol of the worker's struggle. His witty use of found metal objects created a unique sculpture style, and his work is considered a turning point in the history of sculpture. In the mid-1950s, when Jackson Pollock was painting pictures without frames, Smith was making a comparable statement in sculpture by abandoning the traditional pedestal.

The blockbuster Smith acquisitions transformed the museum into a showcase for outdoor works. From this nucleus, the collection has grown to over one hundred pieces, primarily abstract welded steel sculptures representing many of the most prominent sculptors of the last three decades.

Storm King continues to acquire contemporary sculpture. A recent acquisition is Polish sculptor Magdalena Abakanowicz's 200-foot-long *Sarcophagi in Glass Houses*, four wooden sarcophagi each sheltered in a glass house. Another recent purchase is Ursula von Rydingsvard's massive *For Paul*, a richly textured, cedar vessel-like form that resembles a womb. In 1991 Richard Serra created for Storm King *Schunnemunk Fork*, four huge steel plates installed over a 10-acre site.

One of the most popular works is Isamu Noguchi's monumental granite *Momo Taro*, commissioned by the museum in 1977 and considered to be one of the artist's finest works. As a setting for this piece Noguchi created a hill that fits so well in the landscape that it appears to be a natural element. The 40-ton sculpture of rough and polished stone is named for a Japanese folk hero who sprang from a peach pit. Noguchi's masterpiece is a magnet for visitors who sit, stand, and clamber all over it. The sun-warmed stone evokes a womblike nest when it is entered. *Momo Taro* is one of only two pieces exempted from the "do not touch" rule. The other is Siah Armajani's *Gazebo for Two Anarchists: Gabriella Antolini and Alberto Antolini*, a 32-foot footbridge connected by two birdcage gazebos.

The Armajani sculpture, an updated interpretation of the traditional American covered bridges, stands apart on an open field. It is named for the brother and sister anarchists, and reflects Armajani's interest in political idealism. Gabriella,

tagged by the press as "the dynamite girl" for transporting explosives, was imprisoned in Italy along with her brother in 1918. The gazebos reflect their confinement; the bridge represents Armajani's sense that harmony is achieved when individuals voluntarily work together.

Five towering Alexander Calder stabiles are set apart on their own hillside. Constructed in the mid-1970s, near the end of the artist's life, the giant steel sculptures, painted in vivid reds, blues, and blacks, create a distinctive grouping that appears totally at home on the grassy incline. These works, on long-term loan from the artist's estate, are a colorful part of the panoramic vista.

In addition to the large permanent collection and the major pieces on extended loan, the Art Center sponsors annual exhibitions. In recent years, such prominent sculptors as Ursula von Rydingsvard, Alice Aycock, Siah Armajani, William Tucker, and Mia Westerlund Roosen have been featured. In 1996, Storm King will present an exhibition of Mark di Suvero's soaring metal sculptures.

Storm King was founded in 1958, a propitious moment just

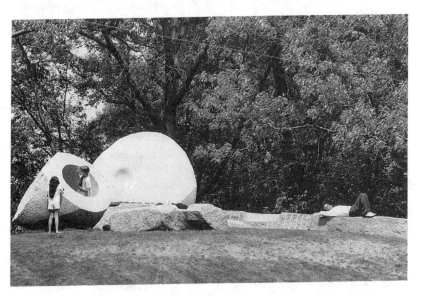

Isamu Noguchi, *Momo Taro* (1977), Storm King Art Center, Mountainville, NY

before the art boom of the 1960s. The Ralph E. Ogden Foundation purchased the rustic, Normandy-style chateau and grounds from the estate of Vermont (Monty) Hatch. The home's generously proportioned rooms, trimmed in richly burnished wood, create a warm setting for small pieces and special exhibitions. Ogden, the owner of a Mountainville hardware factory, was a long-time friend and neighbor of Hatch, a partner in the New York law firm of White & Case.

Storm King is the second oldest large-scale sculpture park in the country, after Brookgreen Gardens in South Carolina. The founders took as a model Sir William Keswick's sheep farm in Glenkiln, Scotland, which is home to many Henry Moore sculptures. Landscape architect William A. Rutherford adapted the grounds to accommodate sculpture.

Sculptors whose work is represented include Douglas Abdell, David Annesley, Siah Armajani, Alice Aycock, Saul Baizerman, Max Bill, Manuel Bromberg, Thom Brown, Alexander Calder, Kenneth Campbell, Kenneth Capps, Anthony Caro, Dorothy Dehner, Mark di Suvero, Kosso Eloul, Henri Etienne-Martin, Sorel Etrog, Herbert Ferber, Richard Friedberg, Roland Gebhardt, Charles Ginnever, Adolph Gottlieb, Emilio Greco, Robert Grosvenor, Gilbert Hawkins, Barbara Hepworth, Hans Hokanson, Alfred Hrdlicka, Richard Hunt, Jim Huntington, Patricia Johanson, Menashe Kadishman, Lyman Kipp, Jerome Kirk, Grace Knowlton, Fritz Koenig, Joseph Konzal, Alex Kosta, Sol Lewitt, Alexander Liberman, Tomio Miki, Henry Moore, Robert Murray, Forrest Myers, Mario Negri, Louise Nevelson, John Newman, Isamu Noguchi, Ann Norton, Claes Oldenburg, Anthony Padovano, Nam June Paik, Eduardo Paolozzi, Beverly Pepper, Joel Perlman, Karl Pfann, Josef Pillhofer, Peter Reginato, George Rickey, Mia Westerlund Roosen, Hans Schleeh, Richard Serra, Yehiel Shemi, Richard Shore, Charles Simonds, Yerassimos Sklavos, David Smith, Kenneth Snelson, Richard Stankiewicz, Michael Steiner, Jan Stern, David Stolz, Tal Streeter, George Sugarman, Erwin Thorn, Michael Todd, Lee Tribe, Ernest Trova, Ursula von Rydingsvard, David von Schlegell, Gerald Walburg, Isaac Witkin, James Wolfe, and Fritz Wotruba.

Admission fee.

Picnic tables under the trees are grouped at the front entrance, adjacent to the parking lot for buses. On weekends, May through October, box lunches are sold under a white tent located near the parking lot.

The museum shop sells an illustrated catalog of the collection. Visitors receive a map with helpful visual aids when entering the facility.

How to Get There: Storm King is in the Hudson River Valley, 55 miles north of Manhattan, 7 miles south of Newburgh.

From New York City, cross the Hudson River on the upper level of the George Washington Bridge. Drive north on the Palisades Parkway to Exit 9 West, I-87 (New York State Thruway). Travel north on I-87 to Exit 16, at Harriman. Follow Route 32 north for 10 miles. Follow signs to Storm King. The entrance is on the left.

Storm King Art Center
Old Pleasant Hill Road
Mountainville, NY 10953
914-534-3190
Hours: 11:00 A.M.–5:30 P.M. daily, April 1 through November 15.

Hans Van De Bovenkamp Sculpture Garden

Tillson, New York

Hans Van de Bovenkamp is an ebullient and prolific sculptor who created an idyllic sculpture garden and working studio in the foothills of the Catskills. He was a founding member of the highly popular "10 Downtown Artists," a group who opened their New York City studios to the public in the late 1960s through the late 1970s. His sculpture garden, founded in 1991, is a natural extension of this earlier effort to encourage the public to learn about and appreciate sculpture.

For his expansive garden, Van de Bovenkamp bulldozed low-lying swampy sections of his 50 acres of rolling countryside to form three large ponds. Dredged materials were molded into berms that create focal points for the sculpture and plantings. The largest and most visible pond is surrounded by a profusion of wild

flowers and giant Balinesian pots that overflow with chives, parsley, and squash. This enchanting natural setting offers a colorful foreground for his large and dramatic steel constructions displayed in the distance. He sees the ponds as visual rooms; placing sculpture next to them, he says, "makes magic."

A singular feature of Van de Bovenkamp's sculpture garden is its emphasis on Buddhist and Hindu themes and styles. After many trips to Bali over two decades he took the plunge and created a Balinese paradise at the edge of a long clear water pond. His three extraordinary Balinesan pavilions, or cottages, were designed in Bali and shipped here in massive containers. The pavilions are set in a curved grouping that reflects the way they are arranged in Bali, where families typically prefer small separate quarters, with children, parents, and grandparents each having their own cottages. Kitchen and dining areas in these family compounds are distinct spaces, set apart under separate roofs. Here too, one pavilion is devoted to a kitchen and dining area.

The spectacular classic cantilever-roofed pavilions have distinctive orange terra cotta roof tiles, teak beams, and intricately carved supporting columns. The structures are supported by enormous bamboo roof poles. Woven bamboo matting covers the exterior walls. Broad connecting teak terraces unify the complex and create a welcoming sense of community. It is easy to conjure up an inviting Balinese scene, with children scampering between the pavilions on the wide connecting terraces. While architecturally the pavilions are pure Balinese, Van de Bovenkamp's eclectic world religious views are expressed in the hand-carved exterior beams, which depict mythological symbols such as monkeys, snakes, and birds. Swinging in the breeze around the pavilions are long, colorful Balinese flags that traditionally are flown to appease the gods.

Inner courts in the pavilion display Van de Bovenkamp's large collection of Buddhas and Hindu statues. A trio of dark gray, shaggy hemp-roofed Hindu ancestral shrines clutch the pond's edge and offer a focal point for all three pavilions.

This is an extraordinarily welcoming place, where visitors are encouraged to touch the pieces, talk with the artist, and learn about the process of creating sculpture. The garden's casual

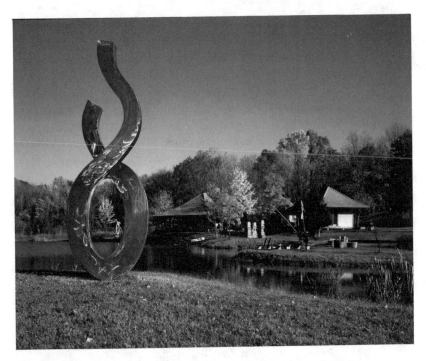

View of Balinesian pavilions at the Hans Van de Bovenkamp Sculpture Garden, Tillson, NY

ambience contrasts sharply with the formality of its neighbor Storm King, where the sculpture is meant to be observed but not disturbed.

At Van de Bovenkamp's studio visitors can watch sculptors in action as they fabricate their works. Artists, who come from here and abroad to work and learn, are housed on the grounds in charming duplex apartments.

The sculpture collection includes a wide range of styles. Prominently displayed are Van de Bovenkamp's massive burnished steel works, as well as a large but delicate gate adorned with sculptured birds and painted abstract steel forms. A distinctive grouping of Kurt Laurenz Metzler's rusted steel figures enliven the upper meadow.

Van de Bovenkamp was born in Holland and spent much of

his childhood under the Nazi occupation. His family moved to Canada in the late 1950s, driven by a fear of Communism and Russian occupation. He is an architect who was drawn to sculpture in college when he assisted sculptor Richard Jennings in fabricating large outdoor fountains. He is well known for his kinetic metal fountains, with tipping buckets, swaying arms, and waterwheels.

Other sculptors whose work is shown include Anthony Cafritz, Milton Hebald, Joseph Kurhajac, Pascal Knapp, Ezio Martinelli, and John Stoney.

No admission fee.

Since the garden is also a working artist's studio, Van de Bovenkamp asks that visitors call before they visit.

How to Get There: From New York City, take the upper deck of the George Washington Bridge to the Palisades Parkway. Take the Palisades Parkway to the New York State Thruway (Rte. 87 North) to exit 18, in New Paltz. Go west through New Paltz and over the bridge. Take the first right turn after the bridge and go 1/2 mile, bearing right at the fork. Drive 5 miles down Springtown Road.

Hans Van de Bovenkamp Sculpture Garden
661 Springtown Road
Tillson, NY 12486
914-658-8363
Hours: Telephone ahead to schedule a visit.

Upstate New York

City of Poughkeepsie Sculpture Park

Poughkeepsie, New York

The internationally acclaimed sculptor Anthony Caro and a pioneering local gallery owner, Lorraine Kessler were the sparks behind this small sculpture park, which opened in a low-income neighborhood in 1993. All the works in the park were created by participants in Caro's Triangle Artists workshop.

The London-born sculptor is thought by many art critics to be England's successor to Henry Moore, for whom he was an assis-

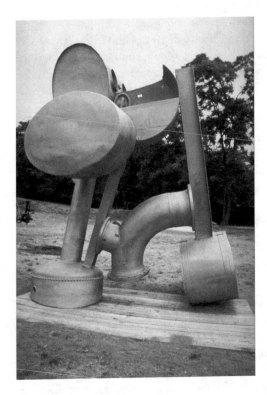

John Hock, *Mashomack Molasses* (1992), City of Poughkeepsie Sculpture Park, Poughkeepsie, NY

tant in the early 1950s. Many of Caro's early works had the reclining forms so characteristic of Moore. In the 1960s Caro's abstract welded pieces catapulted him into the front line of modern sculptors. He was an inspiring teacher, and his St. Martin's School of Art in London was internationally recognized.

The Poughkeepsie sculptures reflect Caro's formidable talents as a teacher. Caro maintains a home in Poughkeepsie, and for several years his Triangle Artists group conducted two-week workshops for artists and sculptors from around the world. Painters took their works home with them, but sculpture is much less mobile, and many of the pieces stayed behind.

Lorraine Kessler, a local gallery owner, learned of the abandoned treasures and set out to feature the works on a lot next to her gallery that she leased from the city for $1 a month. Caro helped in designing the park, and the sculptors returned to

Poughkeepsie to advise on installing their works.

With the help of Caro's assistant, sculptor Jon Isherwood, Kessler gathered together the sculptures and moved them to the new park. Many pieces had deteriorated and needed polishing and welding. Some were too large to move and had to be dismantled and rewelded at the new site. Local truckers and crane operators were persuaded to donate their time and equipment. Kessler raised funds to construct wooden sculpture bases and to prepare a descriptive brochure and signs. A local garden club contributes plants. Kessler calls the park a "miracle"; the entire project cost $7,500 to complete.

The park contains nine permanent, large abstract steel welded pieces. All were donated by the sculptors who participated Caro's workshops. Each piece is carefully sited to accommodate the small space.

Neighborhood children are encouraged to play in the park and on and around the sculpture. And they do, with great enthusiasm. Climbing, sliding, and sledding on the pieces are allowed. The sculpture bases are a popular venue for picnic lunches.

Kessler is something of an anomaly in the gallery world. She moved to this low-income neighborhood in 1991, at a time when bullet-fire was an everyday occurrence. Kessler seeks to demystify art, which she feels should be available to everyone. Her artists' works are priced accordingly; most clients, she says, earn under $30,000 a year.

Artists represented in the outdoor collection include Douglas Bentham, Shaun Cassidy, Clay Ellis, John Foster, Mark Garofalo, Peter Hide, John Hock, Jon Isherwood, and Ken Macklin.

How to Get There: From New York City, take the George Washington Bridge to the Palisades Parkway and travel north to the end of the parkway. Cross the Bear Mountain Bridge and turn left onto Route 9D. Take Route 9D to its end and make a right and then a left turn onto Route 9 North. Exit at Main Street; then turn right and drive four blocks to the sculpture park.

City of Poughkeepsie Sculpture Park
c/o Lorraine Kessler Gallery
196 Main Street

Poughkeepsie, NY 12601
914-452-7040
Hours: Park is open at all times.

Empire State Plaza Art Collection

Albany, New York

New York Governor Nelson A. Rockefeller was one of America's preeminent collectors of modern art, and his passion for modern sculpture triggered the creation of what must be the most lavishly adorned civic plaza in the country. The Albany Mall is a 1960s time capsule for monumental pieces created by leading artists of the period.

Much of the outdoor collection is sited along the granite pathways of the broad mall, on either side of a long rectangular pond. Square-clipped trees add a pastoral effect. The pool's gurgling water jets offer at least psychological relief during the hot summer months; picnic tables running the length of the mall are a lunchtime boon for state workers. Sculpture also graces entrances and corners of the soaring modern government buildings in the 20-acre complex. The mall is anchored by the ornately decorated State Capitol, which offers a welcome contrast to the starkly modern office facades.

The most dramatically sited work is Alexander Calder's *Triangles and Arches,* a grouping of massive black steel triangle forms poised on white pontoons in the long rectangular pool. The pointed arches, resembling cathedral spires, are counterpoints for the Gothic towers of the Cathedral of the Immaculate Conception, whose image is often reflected in the arched glass building walls nearby.

Prominently featured on the mall is George Sugarman's brilliant yellow *Trio,* a 32-foot-long installation of swirling aluminum curves. Bright colors are a signature for Sugarman, and this vibrant piece does much to enliven the flat surfaces of the enormous open space. Poised along the pedestrian walkway, it offers ever-changing views depending on the angles at which it is seen: from one perspective it appears as coiled ovals, from

another it seems to be a series of X and U shapes.

Off to one side, at the far end of the mall, is Francois Stahly's teakwood *Labyrinth*, an assemblage of arches and benchlike forms with interlocking pieces. This welcoming environment invites the viewer to wander through its many shapes and parts. The large installation was created in the artist's studio in Provence, France; before shipping the work to Albany, Stahly spent many months rearranging its elements to get the precise configuration he wanted.

Another major installation is five playful figures from David Smith's *Voltri–Bolton Landing Series*. The group was originally placed along a gray marble wall on the mall, but was moved indoors to the Corning Tower to minimize damage from exposure. The figures are part of the twenty-five-figure series the artist conceived in a prolific month spent at the 1962 Spoleto Festival. The figures are made from flat sheets of steel and metal forging tools, such as tongs, pincers, and hooks, that Smith found in Voltri, a suburb of Spoleto. The figures have a lightness in form and a grace that makes them seem almost kinetic.

In addition to the outdoor sculptures, the Empire State Collection includes paintings, small sculptures, and tapestries. These treasures were amassed as part of an extensive Albany urban renewal project. Governor Rockefeller was among the first public officials to allocate a percentage of construction funds to purchase art. Selections were made by a prestigious Art Commission; the governor had veto power over selections but never used it, undoubtedly because his hand-picked commission was well aware of his artistic tastes.

New York City was the international capital for contemporary art in the mid-1960s, a time when Abstract Expressionism was in its heyday. The commission favored artists working in this genre, even though abstract art, which did not have wide public acceptance, could and did spark political controversy. Most of the sculpture was purchased from New York galleries rather than commissioned. The $2.7 million cost for purchasing and installing the works is surely one of the great art bargains of the period.

Sculptors whose work is represented in the outdoor collection

include Ronald Bladen, Roger Bolomey, Alexander Calder, Mary Callery, Herbert Ferber, Naum Gabo, Dimitri Hadzi, Will Horwitt, Donald Judd, Ellsworth Kelly, Lyman Kipp, Alexander Liberman, Seymour Lipton, Robert Mallary, Clement Meadmore, Antoni Milkowski, Forrest Myers, Louise Nevelson, Isamu Noguchi, Gyora Novak, Claes Oldenburg, Beverly Pepper, George Rickey, James Rosati, Bernard (Tony) Rosenthal, Julius Schmidt, George Segal, Jason Seley, David Smith, Tony Smith, Francois Stahly, George Sugarman, Peter Voulkos, and James Wines.

How to Get There: From New York City, take the first Albany exit (23) off the New York State Thruway (I-87) and follow signs to Empire State Plaza. Underground parking is available.

Empire State Plaza Art Collection
Governor Nelson A. Rockefeller Empire State Plaza
Albany, NY 12242
518-473 7521
Hours: On view at all times.

Albright-Knox Art Gallery

Buffalo, New York

The Albright-Knox Art Gallery is an internationally recognized center for modern art. Its small interior sculpture garden displays fourteen pieces by some of the best known masters of modern sculpture. Most of the works were created in the 1960s. Sculpture in the minimally landscaped courtyard can be viewed comfortably from within the glass-enclosed gallery exhibition spaces.

David Smith's burnished stainless steel *Cubi XVI* is one of twenty-eight monumental pieces in his Cubi series, created in the early 1960s. The series is among his last works before his death in an automobile crash in 1965. Smith's hollow squares and a rectangle that balance precariously on each other and on two slim rectangular bases resemble a colossal human form. While the piece seems to float effortlessly, it is actually a very heavy sculpture.

Reuben Nakian's black steel abstract *Mars and Venus*, completed in 1960, was one of the artist's first works after he moved from figurative to abstract forms. In 1916, Nakian won

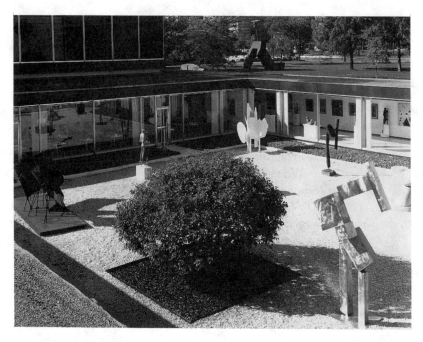

View of the Albright-Knox Art Gallery Sculpture Garden, Buffalo, NY

an apprenticeship to the famed sculptor Paul Manship on the basis of his impressive sketchbook. For three years he shared a New York studio with Gaston Lachaise, who instructed him in techniques for stone cutting and plaster casting. The fluid sense of this enormous work of pipes and large complex forms in sheets of steel reflects the sculptor's background as a master of drawing.

The most recent sculpture in the collection is Louise Nelson's white painted aluminum *Drum*, created in 1976. Nevelson was an assistant in 1932 to the noted muralist Diego Rivera, who introduced her to pre-Columbian art. Subsequent trips to Mexico and Guatemala fueled her interest in the art and architecture of ancient civilizations, an influence very much in evidence in her work. Nevelson characterized white as a "festive" color. *Drum*, with its angular pointed shapes, jagged edges, and rounded forms, is a distinct departure from the intricately crafted

wood constructions for which she is widely known.

The outdoor collection is notable for its variety in terms of sculpture materials and styles. Max Bill's generously rounded granite *Construction for a Ring* offers a counterpoint to Fritz Wotruba's rectangular blocks in his limestone *Seated Figure*. Isamu Noguchi's spare and firmly grounded bronze *The Cry*, with its focus on an oval resembling a mouth, contrasts with George Rickey's supersleek, swaying stainless steel needles in *Peristyle: Five Lines*.

The Albright-Knox, founded in 1862, is one of the oldest museums in the country. Its collection has been on display in its stately Greek Revival–style building since 1905. The sculpture garden opened in 1962 as part of a new wing designed by architect Gordon Bunshaft of Skidmore, Owings, and Merrill. The gallery has world-class collections of modern American and European art. More than half its extensive permanent collection was donated by Seymour Knox, long-time president of the gallery.

Artists represented in the garden include Kenneth Armitage, Leonard Baskin, Max Bill, Reg Butler, Ansera Cascella, Lucio Fontana, Masayuki Nagare, Reuben Nakian, Louise Nevelson, Minoru Niizuma, Isamu Noguchi, George Rickey, David Smith, and Fritz Wotruba. On the spacious lawn at the gallery's entrance are works by Beverly Pepper, Tony Smith, and Kenneth Snelson.

Admission fee to museum and sculpture garden. The museum has a restaurant that overlooks the garden, a bookstore, and gallery shop.

How to Get There: Drive west on the New York State Thruway (I-90) to Route 33 West. Turn right on Route 33 to Route 198 West. Continue on Route 198 West to the Elmwood Avenue South/Art Gallery exit. Turn right onto Elmwood Avenue. At the second stop light, turn left at the Gallery.

Albright-Knox Art Gallery
1285 Elmwood Avenue
Buffalo, NY 14222
716-882-8700
Hours: 11:00 A.M.–5:00 P.M., Tuesday through Saturday; noon–5:00 P.M., Sunday.

Griffis Sculpture Park

East Otto, New York

Here, in western New York, is a paradise for children of all ages, a DisneyWorld of sculpture without the long lines and litany of restrictions. Children are invited to scamper up the sculpture tower and play hide and seek among 4-foot-tall bronze mushrooms, a giant crab, and other improbably oversized renditions of the animal realm. For the energetic there are 42 hiking trails that cover 10 miles of the 400-acre preserve.

Panoramic views of wildflowers and meadows can be seen from the wide grassy paths, mowed by sculptor-proprietor Larry Griffis to conform to the meanderings of his guests. The ever-present sculpture is set among the tall grasses, trees, and four naturalized ponds. More than half the two hundred pieces were conceived by Griffis, an effusive and joyful man with improbable gray muttonchops that frame his broad smile and twinkling eyes.

The large acreage is broken into two distinct areas, each with its own entrance and parking. A pond and fountain mark the entrance to the main site. Here Larry Griffis presents his *Ten Aluminum Bathers,* a cheerful assemblage of sensuous Amazons relishing nature. Also at the entrance is a group of Griffis' aluminum insects, *Dragon Fly, Caddis Fly,* and *Wasp,* that set the tone for this paean to the animal kingdom. At the smaller East Hill Ashford site, with an entrance farther down the road, is a collection mostly of Larry Griffis' monumental works. More than a dozen towering, welded figures such as *Flat Man, Clown,* and *Lady in Waiting* dominate the rolling hillsides.

This is a family affair. Larry Griffis lives on the property. Sons Larry and Mark contribute their works to the sculpture collection, and Simon is the executive director. The park was established in 1967, after the Griffis family returned from a trip to Italy, where Griffis was studying the lost-wax process for creating sculpture. The inspiration for the park was triggered by a family visit to the serene ruins of Hadrian's Villa, outside Rome. As Griffis watched his children cavort among the ruins, free of signs prohibiting such playful activity, plans for his own park took shape.

The park is owned and managed by the Ashford Hollow Foundation for the Visual and Performing Arts, which Griffis directs. Funds to purchase the former farm were donated by Griffis' mother, Ruth Griffis, in memory of her husband, L. W. Griffis, Sr. Support also comes from local and state arts funds. At the foundation's headquarters in Buffalo are a foundry, gallery, and living and studio spaces for artists.

Griffis is an activist on behalf of New York State artists. For years he has been at odds with the prestigious Albright-Knox Art Gallery in Buffalo over what he considers to be their reluctance to exhibit local artists. Griffis seeks out regional artists to show on the grounds.

Sculptors whose work is represented in the collection include Dennis Baraclough, Roberly Ann Bell, John Bjorge, Joe Bolinsky, Clark Crolius, Al Frega, Leon Gerst, Larry Griffis, Larry W. Griffis III, Mark Griffis, Richard Gustin, Duayne Hatchett, Joe Jackson, Ann Lorraine Labriola, Billie Lawless, Dan Neuland, Wes Olmstead, Tony Paterson, Joe Perone, Mike Priesner, Ferdinand Santana, Julie Siegel, Peter Snyder, James Surls, Frank Toole, Steven Weinberger, and Glenn Zweygardt.

Admission free; donations are encouraged. Tours by appointment. An extensive map that pinpoints the sculpture and natural attractions is provided at the parking lot gate.

Among the few restrictions are camping, tree cutting, swimming, and radios. Dogs are allowed, although they must be leashed at the ponds. Picnicking is encouraged. The park has a snack shop.

How to Get There: Take Exit 58 off I-90 south of Buffalo; then Route 438 East to Route 219 South to East Otto, which is between Springville and Elliotville, 20 miles north of Salamanca. Signs mark the long route up a steep hill. A sign will tell you if you've gone too far.

Griffis Sculpture Park
67-A Mill Valley Road East
Otto, NY 14729
716-257-9344
Hours: 9:00 A.M.–dusk, May 1 to November 1. Not plowed in winter.

Stone Quarry Hill Art Park

Cazenovia, New York

Panoramic vistas are the hallmark of this 75-acre park in central New York state, created by a couple who are devoted to sculpture and to the scenic grandeur of the hilltop setting.

Dorothy and Robert Riester donated their land and home, including its furnishings, art library, studio, and barn, to Stone Quarry to ensure that this magnificent site will be preserved as a natural setting and as a showcase for sculpture. Here visitors have a 50-mile vista, across Oneida Lake to the foothills of the Adirondacks.

Stone Quarry emphasizes the symbiosis between sculpture and nature. Works are placed to highlight the compatibility between artistic objects and the natural environment. Sculpture in wooded areas is not immediately in view, but tucked into the landscape to be discovered. Seasonal variations bring out the ever-changing relationships between man-made and natural objects. Dariusz Lipsky's sculpture of welded steel and huge boulders is striking when snow-covered in winter and offers a dramatically changed view when the stippled light of summer filters through the thick trees.

The natural setting includes nineteenth-century farm fields, alive with wildflowers and crops, hedge rows, hardwood and evergreen forests, ponds, and wetlands. Leading down from a thriving hilltop perennial garden are trails into the woods, where Dorothy Riester's ceramic and metal sculptures are displayed.

Sculptor Enrique Saavedra Lopez-Chicheri's *Blizzardo Diablo* memorializes the harsh 1993 blizzard that dumped 44 inches of snow in the area. This metal, concrete, and wood construction resembles a teeter-totter. On one end is a bucket with drain holes. In winter the bucket fills with snow, forcing down that side of the teeter-totter; when the snow melts the side flips up again.

Other artists with work in the permanent collection are Evan and Milan Lapka, and Rodger Mack. The park also exhibits works on loan, and annual shows augment the collection. Typically, around two dozen sculptures are on display.

Gail Scott White, *Dora and Lucy Discuss Freud*, Stone Quarry Hill Art Park, Cazenovia, NY

The park opened in 1992. Facilities include Art Barn, a working space for artists, and Art Shed, a gallery opened in 1994. Stone Quarry offers organized trail walks, workshops, and lectures. Visitors are encouraged to walk, hike, picnic, photograph, and explore the park's natural resources.

No admission fee, except for special events.

How to Get There: Cazenovia is in central New York State, 26 miles east of Syracuse and 30 miles west of Utica. The park is 1 mile east of the historic village of Cazenovia. Take Exit 34A off I-90, to Route 481 South; follow Route 81 South to Route 20.

Stone Quarry Hill Art Park
Stone Quarry Road
Cazenovia, NY 13035
Hours: Daily, 10:00 A.M.–5:00 P.M. Closed in May.

Abington Art Center Sculpture Garden

Jenkintown, Pennsylvania

Abington's sculpture garden surrounds the stately brick Alverthorpe Manor, former home of Lessing Rosenwald, an early Sears Roebuck & Co. executive and avid art collector who donated his estate to Abington Township in 1970. Twenty-seven acres of woodlands encircle 3 acres of lawns and trees.

The sculpture garden opened in 1990 when the museum recognized that the outdoors is its premier gallery space. Sculptors chosen in open, juried competitions are given $3,000 honoraria to help support the creation of new works.

The centerpiece of this fledgling sculpture garden is *A Reclamation Garden*, a singularly ambitious work by Winifred Lutz, begun in 1992. On a wooded, 1-acre plot, Lutz is molding a rustic, naturalized sculpture, using fallen trees, leaning saplings, twigs, and ground cover found on the site. She created doors by weaving wisteria vines around gracefully arched saplings, constructed a giant ottoman from twigs and leaves, and amassed dead tree trunks and branches for a giant vee-shaped sculpture. Lutz is also restoring a nineteenth-century arched stone portal for a frame to view the landscape. Near the portal Lutz designed a 12-foot-high circular stone, lidless tower. She identifies important trees with stone markers; poetic text and botanical data are sandblasted into the markers. Stone benches, steps and paths are also being added. The installation is expected to be completed at the end of 1995, at which time nature will once again take charge; the sculpture elements will evolve as storms, natural decay and regeneration alter Lutz's artistic vision. The objective is not permanence, the focus is on the beauty inherent in natural settings.

A new sculpture arrival that was specially built for Abington by Ursula von Rydingsvard is *Hannah's Horizon*, a low 40-foot-long work of laminated cedar beams that looks something like a

Winifred Lutz, *Stone Tower*, part of *A Reclamation Garden* (1994),
Abington Art Center, Jenkintown, PA

ruin. It has been sprayed with graphite powder and resembles a slate wall. This construction will be the garden's cornerstone for the next four years.

Von Rydingsvard's sculpture is part of the Garden Matrix program that will bring ten new sculpture pieces to Abington on temporary exhibition over the next four years.

The Rosenwald mansion is a community facility for art classes and workshops. A gallery wing is used for small-scale art exhibits.

Artists who have exhibited at Abington include Magdalena Abakanowicz, Alice Aycock, Tom Bills, Susan Crowder, Joyce de Guatemala, Fritz Dietel, Melvin Edwards, Elizabeth Egbert, Aaron Goldblatt, George Greenamyer, Ron Klein, Nicholas Kripal, Stacy Levy, Daniel Loewenstein, Arlene Love, Jesse Moore, Barry Parker, Bryan Steinberg, Patrick Strzelec, Jude Tallichet, William Tucker, Mary Ann Unger, Ursula von Rydingsvard, Roy Wilson, and Andrew Wolff.

No admission fee. The grounds are always open; visitors who arrive when the museum is closed can open the gate to the right of the center's entrance. A box hanging on the gate holds sculpture garden maps. Picnickers should bring their own provisions.

Tours, lectures, and workshops are available for a modest charge. The gift shop steers clear of the standard museum offerings.

How to Get There: Abington is about a half-hour drive north of downtown Philadelphia, off Routes I-76, I-676, and 1 (Roosevelt Expressway.) Take Old York Road (Rte. 611) to Jenkintown and turn right on Meetinghouse Road. Abington is a short distance on the right.

Abington Art Center Sculpture Garden
515 Meetinghouse Road
Jenkintown, PA 19046
215-887-4882

Hours: Sculpture garden is open during daylight hours. Art Center hours: 9:00 A.M.–5:00 P.M., weekdays; 9:00 A.M.–4:00 P.M., on Saturday. Closed on holidays.

Lehigh University

The Muriel and Philip Berman Sculpture Collection

Bethlehem, Pennsylvania

The Blue Ridge Mountains northwest of Bethlehem create an appealing frame for the university's three sculpture gardens, which were donated by the formidable sculpture patrons Muriel and Philip Berman. The Bermans have been to sculpture in Pennsylvania what Marco Polo was to the New World—they put it on the map.

Mature trees and wide grassy areas offer a variety of landscapes to show off the more than two dozen outdoor works, many colossal in size, that are displayed around the campus. Philip Berman insists that sculpture should elicit a response. In his view, "If people are indifferent, art has failed." There is much to respond to at Lehigh.

The bulk of the university's outdoor collection is in the courtyard of the lower campus, a 3-acre enclosed space where small and medium-size sculpture is displayed. This tranquil space is ideal for strolling the walkways and eating lunch. In good weather classroom lectures are held outdoors. The generous space also lends itself to major social events and reunion weekends.

The collection includes massive pieces, such as Ephraim Peleg's *Three Rings,* giant steel rings sitting on a slant, and Glen Zweygardt's *Passage,* a series of massive angular beams that support a slim overhead ladder.

Three of Ernest Shaw's works, *Steel and Stone, Steel Form,* and *Two Columns,* are a study in the composition of large rectangular forms. Shaw abandoned medicine and psychiatry for sculpture; one cannot help but speculate on how these forms were molded by the artist's training as a physician and psychiatrist.

Among the abstract figurative works is Herb Seiler's bronze *Seated Woman on Rock* and Leo Sewell's *Hippos,* which is constructed from found objects. Also intriguing is Herbert Simon's *Pyramid II,* a low-slung, aluminum zig-zag construction.

Lehigh University, with a student body of eight thousand, was founded in 1868 as an engineering school; its course offerings now

Ephraim Peleg, *Three Rings* (1980), Lehigh University Art
Galleries, Bethlehem, PA

include liberal arts, education, and an art program. A new art cen-
ter with a theater and galleries is on the drawing board.

Sculptors whose work is represented include Tom Althouse,
Harry Bertoia, Dick Caswell, Joyce de Guatemela, John Ferguson,
Richard Gottlieb, Ephraim Peleg, Stephen Porter, John Riek, Buky
Schwartz, Herb Seiler, Leo Sewell, Ernie Shaw, Herbert Simon,
Paul Sisko, Tom Sternal, Igael Tumarkin, Mary Ann Unger, and
Glen Zweygardt.

How to Get There: From Philadelphia, take Route 9 (northeast
extension of the Pennsylvania Turnpike) to I-78 at Allentown; then
travel east to Bethlehem, off Route 22. Or take Route 309 North,
directly to Bethlehem. Visitor parking is available around the
Martindale Library, between Packer Avenue and Asa Drive.

Lehigh University
The Muriel and Philip Berman Sculpture Collection
Bethlehem, PA 18015
610-758-3615
Hours: Sculpture on view at all times.

Morris Arboretum

University of Pennsylvania

Philadelphia, Pennsylvania

The magnificent Morris Arboretum, the foremost in the nation, is a short 20-minute drive from downtown Philadelphia. Although the emphasis here is botanical, sculpture is an integral part of the setting, not merely an afterthought. The small permanent collection and the larger group of works on long-term loan have been sited with meticulous care. Sculpture creates focal points within the garden and links the landscaping and sculpture in a way that highlights both artistic features.

Morris' signature piece is George Rickey's *Two Lines*, a burnished, stainless steel kinetic sculpture with two 30-foot, needle-like arms that move gracefully with the wind. Rickey is internationally recognized for his sleek, shimmering, precisely engineered pieces that seem to float effortlessly in the breeze. His knowledge of air currents was gained as a youth in Scotland where he became adept at adjusting sails on his family's sailboat. *Two Lines* sits at the highest point in the arboretum, the former site of the Morris' private mansion, "Compton."

Two whimsical, never-fail hits for youngsters are Charles Layland's *Cotswold Sheep*, two-dimensional Cor-ten steel cutouts of sheep that graze beside the winding entrance road, and Lorraine Vail's *American Bull*, a 5-foot bronze frog surrounded by low-lying clumps of bamboo.

Another child's delight is a grouping of colorful, larger-than-life metal sculptures by George Sugarman. Painted in black, red, and blue, they simply beg to be climbed on and used for hide-and-seek. Placed on a broad lawn, they seem to appear out of nowhere along a curved pathway.

The collection originally featured two rustic wooden benches by Thomas Sternal on the hill near the Visitors Center. Only one is now recognizable; the other decayed and is barely visible, buried under a mass of prickly vines. Sternal is unfazed by the loss, seeing it as an inevitable consequence of using degradable materials.

In addition to the permanent collection, the arboretum fea-

tures emerging sculptors, whose works are usually on display for two years.

Of the twelve pieces in the permanent collection or on long-term loan, all but one was created within the last fifteen years. The exception is *Mercury at Rest,* a classical cast bronze copy of a sculpture unearthed at Herculaneum in the late 1800s. The original *Mercury* dates from the fourth century B.C. This is the only remaining piece from the original collection of John T. Morris and his sister Lydia, who established the arboretum on their summer estate in 1887.

The 92-acre public garden, a part of the University of Pennsylvania since 1932, was established by the Morrises, a Quaker family whose wealth came from the I. P. Morris Company, a firm that fabricated steel ship engine parts. The historic Victorian landscape is a premier botanical research and teaching facility. The sixty-eight hundred labeled trees are spread through meadows and woodlands; specialty areas include the Rose Garden, Swan Pond, English Park, and Asian gardens. The arboretum is currently restoring the only extant freestanding Victorian glass fernery.

Artists whose work is represented include Christopher Cairns, Linda Cunningham, Robert Engman, Israel Hadany, Charles Layland, Michael B. Price, George Rickey, Buki Schwartz, Thomas Sternal, George Sugarman, and Lorraine Vail.

Admission charge.

The former carriage house and stable are now the Visitors Center and gift shop, which is stocked mainly with flora-related books and gift items.

Guided tours are given at 2:00 P.M. on weekends. Picnics are not allowed.

How to Get There: Located in the Chestnut Hill section of Philadelphia, travel north on the Pennsylvania Turnpike (I-276) to Exit 25; follow signs for Germantown Pike East; go 4 miles to Northwestern Avenue. Left on Northwestern about 1/4 mile.

Morris Arboretum
University of Pennsylvania
100 Northwestern Avenue
Philadelphia, PA 19118
215-247-5777

Hours: 10:00 A.M.–4:00 P.M., weekdays and winter weekends; 10:00 A.M.–5:00 P.M., weekends April–October. Open most holidays. Closed Thanksgiving Day and from December 24 through January 1.

Ursinus College

Philip and Muriel Berman Museum of Art

Collegeville, Pennsylvania

Tucked away on a small college campus in suburban Philadelphia is the world's largest private collection of works by Lynn Chadwick. The famed British sculptor is thought by many to be England's foremost sculptor, a title long held by the late Henry Moore.

Twelve of Chadwick's distinctive, larger-than-life bronze figures are spread throughout the 140-acre campus. These graceful, regal figures convey a sense of strength and dignity and create a strong symbol for the college. Their characteristic geometric-shaped heads and angular bodies reflect the artist's early career as an architect. Presiding as individuals and in pairs and groups, they offer a dramatic contrast to the stone campus buildings.

In addition to the Chadwicks sited outdoors, Ursinus has 137 of the sculptor's maquettes in the Berman Museum. Indeed, the school is so rich in Chadwicks that the college donated its signature piece, *Jubilee*, to the Jerusalem Museum.

The three dozen sculptures in the outdoor collection, all donated by Philip and Muriel Berman, are clustered around Main Street, the Berman Museum, and down a broad sloping lawn at the far edge of campus. An expanded sculpture area is being planned for a wooded area just north of the college buildings.

Since the outdoor collection began in 1978, sculpture has played a lively role in the student life of this predominately pre-medical, science-oriented college. Students have adorned Chadwicks with white paper face masks, strewn flowers on several of the figures, and wrapped them in blankets in the winter.

On the plaza near the entrance to the museum are two contemporary granite and marble sculptures by Jon Isherwood, who studied with and worked for Anthony Caro. These pieces were

constructed at a 1993 sculpture workshop in Allentown sponsored by Mr. Berman. Several dozen artists, some from England and Canada, attended the workshop. Berman supplied them with 300 tons of granite and marble, and an equal amount of scrap metal, and instructed them to "go wild." And go wild they did, since more than sixty sculptures were created in the three weeks the artists were his guests.

The campus front yard is dominated by Mary Ann Unger's *Temple*, a 13-foot-high white aluminum open dome. On the broad lawn at the back of the campus is Glenn Zweygardt's *Upheaval II*, a powerful steel construction made from wreckage left by Hurricane Agnes in 1980.

The Bermans continue to build the Ursinus collection and that of other Pennsylvania institutions. Within a 100-mile radius of the Ursinus campus, they initiated sculpture collections at the Morris Arboretum, East Stroudsburg State University, and Kutztown University and gave an extensive array of sculpture to the city of Allentown. Museums as far away as South Bend, Indiana, and Mt. Vernon, Illinois, are similarly indebted to the Bermans for sculpture donations. Philip Berman, a prosperous trucking firm owner and proprietor of an Allentown department

Lynn Chadwick, *Seated Couple on a Bench* (1984), Ursinus College, Collegeville, PA

store, attended Ursinus for a year before dropping out to earn a living during the Depression.

Sculptors whose work is represented include Zigi Ben-Haim, Lynn Chadwick, Joyce de Guatemala, Harry Gordon, Paul Harryn, Jon Isherwood, Michael Price, Herbert Seiler, Thomas Sternal, Igael Tumarkin, Mary Ann Unger, and Glenn Zweygardt.

A map of the collection is available from the museum.

How to Get There: From the Pennsylvania Turnpike, exit at Valley Forge, Exit 24. Just beyond toll gates take the second exit, Route 202, and go a quarter of a mile south to Route 422 West. Travel 8 miles on Route 29 to the Collegeville exit. Turn right on Route 29 North. Go 2.5 miles to the third traffic light, turn left on Main Street. The campus is approximately one-half mile up the hill on the right. From Philadelphia, take the Schuylkill Expressway, exit on Route 202 South, and follow the directions above.

Ursinus College
Philip and Muriel Berman Museum of Art
Main Street
Collegeville, PA 19426
215-489-4111, ext. 2354

Hours: Outdoor sculpture on view at all times. Museum open 10:00 A.M.–4:00 P.M., Tuesday through Friday; noon–4:30 P.M. on weekends.

Washington, D.C.

Hirshhorn Museum and Sculpture Garden

Washington, D.C.

In a city positively brimming over with historic statues, memorials, fountains, military tributes, and national symbols, modern sculpture is not a primary focus. But here in the nation's capital is an internationally acclaimed sculpture garden, one that represents major trends in modern art, with world-recognized works, predominately from the 1950s and 1960s. Heroic bronzes by Auguste Rodin and Henry Moore set the tone for the collection.

At the garden entrance is Moore's monumental polished bronze *Two Piece Reclining Figure: Points.* Five other Moores are represented in the collection. Rodin has his own grassy rectangular enclosure, which features *The Burghers of Calais* and *Monument to Balzac,* along with three of his other works. Rodin is considered to be the first "modern" sculptor in the sense that he pioneered the distortion of the human form to express emotions. In so doing he broke through the strictures of academic classicism that had prevailed in the world of sculpture until his time. Both *The Burghers of Calais* and *Monument to Balzac* demonstrate Rodin's revolutionary approach in representing the human form. A part of Rodin's genius was his ability to twist to the extreme his sculpture subjects to create emotional tension, while managing to retain a natural appearance in the sculpture forms.

An intriguing contrast to Rodin's familiar and brooding Balzac is a contemporary interpretation of the French novelist by Judith Shea. Her *Post-Balzac,* created in 1991, is a simple bronze man's coat that stands on a pedestal. This is the only piece in the collection that represents the current decade. Shea's empty coat is meant as an invitation for viewers to fill in the personality blanks. Shea views her figureless forms as "voids like empty containers into which the viewer is free to project personal psychological responses." A graduate of the Parsons School of Design, she was a clothing designer. While researching medieval armor for a lecture at the Metropolitan Museum, she started casting metal. She subsequently developed a process for casting cloth by saturating it in hot wax.

Gaston Lachaise's *Standing Woman (Heroic Woman)* is one of the garden's many icons of modern sculpture. She towers over her realm just as she does in the garden at MoMA in New York City. Lachaise's women, with their pendulous breasts and fecund stomachs, are instantly recognized fertility symbols. Lachaise worked for the sculptor Paul Manship, whose enormous gilded bronze *Prometheus* dominates the lower plaza of New York City's Rockefeller Center.

Henri Matisse is represented with four related bronze murals that document the sculptor's artistic progression. The

earliest, created in 1909, shows the clearly detailed musculature of a woman's back, arms, and hands. The later murals are increasingly more abstract; the final, highly stylized 1930 panel features a rich and severe cascade of hair flowing along the woman's spine, with her figure only suggested.

The three-level, rectangular sunken garden, renovated by landscape architect James Urban in 1993, offers a prime space for displaying sculpture. Garden terraces and open rooms at street level trigger an irresistible urge to progress along the wide granite-paved pathways for a closer look at the art. Sculpture is placed along tall granite walls and among grass and trees. A pristine lily pond in the lower courtyard frames two enormous Henry Moore sculptures. This lower level is enlivened with a brilliant blue Alexander Calder stabile.

The museum's collection was amassed by financial tycoon Joseph H. Hirshhorn, a child immigrant from Latvia. The col-

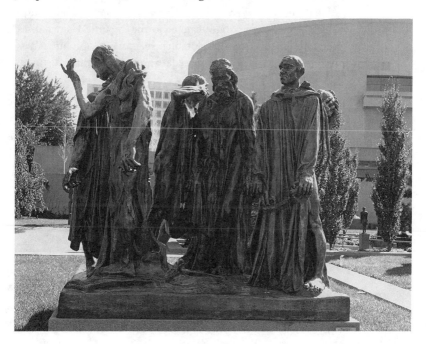

Auguste Rodin, *The Burghers of Calais* (1886), Hirshhorn Museum and Sculpture Garden, Washington, D.C.

lection at his home in Greenwich, Connecticut, was one of the finest in America. In 1966 he donated these works to the Smithsonian, along with $1 million, to aid in the construction of the new museum.

The cylindrical building with a hole in the middle, designed by architect Gordon Bunshaft, is widely viewed as the largest sculpture in the Hirshhorn collection. This enormous, unorthodox structure that is so compelling in its own right was not designed as a friendly environment for sculpture. Bunshaft favored stark, severe buildings, enlivened only with minimalist sculpture, preferably Zen-inspired gardens by his long-time colleague Isamu Noguchi.

Despite Bunshaft's preferences the circular museum plaza now displays an array of sculpture by leading American artists. Two abstract, black constructions that play particularly well together are Alexander Calder's *Two Discs* stabile and Claes Oldenburg's *Geometric Mouse: Variations, Scale A.* Oldenburg's whimsical Mickey Mouse ears echo the gigantic Calder discs. Kenneth Snelson's fragile-looking six-story aluminum *Needle Tower* soars skyward. A more sedate grouping of three distinctly

Henry Moore, *Three-Piece Reclining Figure No. 2,* The Kreeger Museum, Washington, D.C.

individualistic David Smith works own the lawn between Oldenburg and Snelson.

Sculptors represented in the sculpture garden include Alexander Archipenko, Arman, Jean Arp, Saul Baizerman, Leonard Baskin, Emile-Antoine Bourdelle, Reg Butler, Alexander Calder, Anthony Caro, Tony Cragg, Willem DeKooning, Thomas Eakins, Jacob Epstein, Max Ernst, Lucio Fontana, Elisabeth Frink, Pablo Gargallo, Alberto Giacometti, Dimitri Hadzi, Barbara Hepworth, Richard Hunt, Jean Ipousteguy, Menashe Kadishman, Ellsworth Kelly, Gaston Lachaise, Henri Laurens, Jacques Lipchitz, Aristide Maillol, Giacomo Manzu, Gerhard Marcks, Marino Marini, Raymond Mason, Henri Matisse, Joan Miro, Henry Moore, Reuben Nakian, Claes Oldenburg, Pablo Picasso, Germaine Richier, Auguste Rodin, Judith Shea, David Smith, Tony Smith, Kenneth Snelson, Paul Suttman, William Tucker, John Van Alstine, Issac Witkin, Fritz Wotruba, and Francisco Zuniga.

Admission to the garden and the museum is free. The museum has a bookstore and gift shop. The sculpture garden is easily accessible for the handicapped with wide, gently sloping ramps leading to the three levels.

The museum does not have a restaurant; an excellent lunch can be had across the Mall in the West Wing of the National Gallery. Or an outdoor option is a picnic on The Mall, watching the football and frisbee players on their lunch breaks.

How to Get There: The garden is directly across from the Hirshhorn, midway between the Washington Monument and the Capitol, in central Washington, D.C., and a short walk from the L'Enfant Plaza Metro stop.

Hirshhorn Museum and Sculpture Garden
Smithsonian Institution
Eighth and Independence Avenue, S.W.
Washington, D.C. 20560
202-357-2700
Hours: Sculpture garden, 7:30 A.M. to dusk year-round. Museum, 10:00 A.M.–5:30 P.M., every day except Christmas.

The Kreeger Museum

Washington, D.C.

This newly opened cultural attraction in the nation's capital offers a small but impressive outdoor collection of modern sculpture, richly displayed on an expansive domed marble terrace. Docent-led tours of this formerly private home were initiated in 1994 and gained instant popularity. Several weeks' notice is generally required to book a tour.

The Kreeger mansion, in one of Washington's poshest neighborhoods, was designed by Philip Johnson in the mid-1960s. It is probably the largest and most lavish three-bedroom home ever constructed. From the outset the overriding goal was to create the perfect setting for the Kreeger's extensive art collection. In the 1960s, Johnson's interest in designing private homes had waned, but he accepted this commission at least in part because he was searching for a way to properly display his own art collection. The mansion's gallery-size rooms with inlaid teak floors, the wide sculpture terrace, and the vast expanse of glass overlooking the wooded grounds all contribute to showing the works to their best advantage. Particularly striking is a fern-filled interior garden with flaming red bougainvillea cascading down one wall. The vaulted ceilings were designed to create superb acoustics for the Kreegers' frequent musical events that were regularly attended by Washington's political and cultural elite.

The outdoor sculpture collection is seen most dramatically from the large rectangular dining room. From this vantage point the columned travertine terrace looks its most expansive. Henry Moore's towering bronze *Standing Figure Knife-Edge* is a dominating presence. Jacques Lipchitz's bronze *Hagar in the Desert* depicts the story in Genesis of Abraham and Sarah's expulsion of Hagar and Ishmael into the desert. The interwoven forms, with the despairing Hagar gently brushing hair from Ishmael's face, is the Jewish sculptor's poignant plea for compassion.

David Lloyd Kreeger was born in New York City to Russian immigrant parents. A lawyer in President Franklin Roosevelt's New Deal, he made his fortune as a principal in GEICO, the Government Employees Insurance Corp. He and

his Spanish-born wife, Carmen, were luminaries on the Washington cultural scene for more than four decades.

The upstairs rooms are filled with paintings by such modern masters as Claude Monet, Paul Cezanne, and Camille Pissarro and small bronze sculptures by Auguste Renoir. The floor below features a collection of African masks and artifacts and a playful set of caricatures by Joan Miro. A room devoted to large expressionist paintings includes works by James Rosenquist and Larry Poons.

Sculptors whose works are displayed on or near the terrace include Jean Arp, Allen Harris, Jacques Lipchitz, Henry Moore, Isamu Noguchi, George Rickey, Paolo Soleri, Francesca Somaini, and Lucien Wercollier.

Admission by donation.

How to Get There: A 15-minute taxi ride from central Washington, D.C., just beyond the American University.

The Kreeger Museum
2401 Foxhall Road, N.W.
Washington, D.C. 20007
202-337-3050

Hours: Tours at 10:30 A.M. and 1:30 P.M., Tuesday through Saturday, by reservation only.

More Sculpture Attractions in the Northeast

Connecticut

Cavalier Galleries in Stamford displays around forty large-scale steel and bronze figurative and abstract works in the sculpture garden next to its gallery at Landmark Square. The rock-lined sculpture area is a former skating rink. The gallery also sponsors, in conjunction with local business groups, annual three-month exhibitions of outdoor sculpture at the Stamford Town Mall and in downtown Greenwich and Westport. These shows run from the end of April through July. The gallery represents the artists whose works are shown, and all are for sale.

One of Isamu Noguchi's best known installations is his sunken court at the entrance to the **Yale University's** Beinecke Rare Book and Manuscript Library in New Haven. This stark, Zen-like, white marble garden contains three forms: a cube poised on one point, a circle standing on its edge, and a pyramid. The cube is said to represent the concept of chance or perhaps the future, while the circle, the shape of sun, suggests energy. The pyramid, reminiscent of temple garden sand mounds, conveys a vision of ancient cultures. Each of the forms is slightly less than a perfect rendition of its shape: the circle and cube have notches and each sits just slightly askew, and the pyramid is not perfectly triangular. The marble paving stone floor is etched with curving patterns, said to refer to Einstein's theorem on the effects of gravitation on the space-time continuum. As with most of Noguchi's works, a mix of Japanese and Western artistic traditions is clearly evident.

Maryland

Bethesda's business district that fans out from the Metro Station is filled with outdoor sculpture, thanks to a zoning resolution enacted in the early 1980s that allows increased building density for developers who install works of art. Within a several block radius are some forty pieces, placed from the Chevy Chase Garden Plaza, along Wisconsin Avenue to the Bethesda Gateway building and the Artery Organization headquarters. Seven works by Martin Puryear adorn Chevy Chase Garden Plaza, including a fountain, pavilion, benches, and a stair tower. At Bethesda Crescent, Stephen Antonakos constructed a dramatic red neon sculpture at the tower's roofline. The neon shines ever more brightly as darkness descends; at night the building is floodlighted in blue. At Bethesda Place, Ned Smyth used water as his theme, which is particularly appropriate in view of the New Testament references to Bethesda as a public bath and the site of miraculous cures. Smyth's plaza sculptures were designed to create a serene resting spot. Water is also the theme for Elyn Zimmerman's installation in the small plaza of One Bethesda Center. Her waterfall features richly textured granite blocks, a square pool of

gurgling water, and a water trough that serves as the back of a bench. More than twenty artists have outdoor works within the core of the business district.

Massachusetts

The Berkshires

The bucolic Berkshires are a cultural magnet for artists and performers. They are host to the Jacobs Pillow dance group and the summer home of the Boston Symphony Orchestra at Tanglewood. Outdoor sculpture is very much in evidence during the summer season. At least two Berkshire country inns display sculpture on their grounds. The **Williamsville Inn,** on Route 41 in West Stockbridge, displays about three dozen outdoor works by New England sculptors, including marble and steel abstractions, welded farm implements and figurative bronze birds and animals. Pieces are sited among the trees and shrubs and on the inn's broad lawn. Works are all for sale. Exhibitions run from late May through October. (For more information, call 413-274-6118.)

Gedney Farm in New Marlborough, on Route 57, offers outdoor sculpture exhibitions from July to October. Crafted by local artists, more than a dozen colorful metal sculptures dot 40 acres of rolling fields around the low-lying reconstructed farm buildings at this popular inn. (For more information, call 413-229-3131.)

Several Berkshire sculptors display works on their own grounds. The **River Studio and Foundry,** in Middlefield, is the studio of Andrew DeVries, a young sculptor who works principally in bronze. His works depict graceful, elongated women and powerfully athletic men. DeVries welcomes visitors. He talks about his art and the complex process of casting bronze. Located on River Road, 3.4 miles south of Route 143, the studio is open from July to September. (For more information, call 413-238-7755.)

Frederick Hund, curator of the Williamsville Inn sculpture garden, also maintains a studio behind his house in New Marlborough. Hund's primarily stone and bronze pieces are dis-

played in his gallery and in the meadow just below the studio. (For more information, call 413-528-5774.)

Stanley Marcus, a retired college art professor, displays welded cast aluminum sculptures on the lawn of his home in the Central Berkshires. His works mix serious craft with droll humor. Marcus welcomes visitors by appointment. (For more information, call 413-623-5819.)

Another Berkshires sculpture attraction is the **John Stritch Sculpture Garden** in Hinsdale. His whimsical metal sculptures, constructed from discarded farm machinery, are displayed in a 3-acre garden surrounding his home, studio, and gallery. Stone walls, fountains, and waterfalls are backdrops for his work. The garden is a half-hour drive from Lenox or Stockbridge on Route 143, about 1 mile from the intersection of Route 8 and Route 143. (For more information, call 413-655-8804.)

New York

New York City

Several New York City cultural institutions offer outdoor sculpture exhibitions in the summer and fall. Typically the pieces are large scale, and they often break new ground in terms of design, materials, and approach.

The esteemed **Metropolitan Museum of Art,** at 83rd Street and Fifth Avenue in Manhattan, presents summer exhibitions of distinguished large-scale sculptures in the Iris and B. Gerald Cantor Roof Garden. A major attraction on the hedge-enclosed terrace is the gorgeous scenery in Central Park five floors below. The museum provides a pamphlet describing the artistic treasures. The museum is closed on Monday. (For more information, call 212-535-7710.)

Also in Manhattan, a few blocks from SoHo's relentlessly contemporary galleries, is the half-acre **Elizabeth Street Sculpture Garden.** Owner Allan Reiver transformed a trash-laden former schoolyard into a charming garden that displays his ever-changing collection of antique garden ornaments, statuary, and architectural pieces, including a large assortment of French cast-iron statuary. The visitor may encounter antique London

phone booths, French marble statuary, Coney Island bathhouse ornaments, and cast-iron bridges and fountains. Most articles are for sale. The garden, at 210 Elizabeth Street between Prince and Spring Streets, is enclosed with an open-mesh fence and locked gates, which the staff will open upon request.

A second Elizabeth Street sculpture garden opened in 1994 on Manhattan's Upper East Side at the corner of 63rd Street and Second Avenue, on top of a Transit Authority electrical substation. This garden is smaller and more formal, but no less charming than its sister garden on Elizabeth Street. Fruit trees and stone urns, cast-iron benches, and marble pieces surround a small terrace and patio where visitors can linger in this urban oasis. Admission is gained by ringing a bell.

In downtown Manhattan at the **Louise Nevelson Plaza** is the famed sculptor's *Shadows and Flags,* a group of seven twisting black Cor-ten steel abstract forms mounted on poles. The tall swirling sculptures, installed in 1977, are set at the edges of a concrete triangle that is hemmed in with office towers. The largest piece, 40 feet tall, is a dramatic contrasting accent for the adjacent and ponderous fourteen-story Federal Reserve Bank, designed to resemble Italian Renaissance palazzi. The plaza is at the juncture of Maiden Lane and William and Liberty Streets.

On Roosevelt Island, the **Sculpture Center** presents a group show in the lower level of the Motorgate, just under the Roosevelt Island Bridge to Queens. Take the Roosevelt Island tram from Second Avenue and 59th Street in Manhattan and a local bus to the bridge. (For more information, call 212-879-3500.)

In Brooklyn, **Long Island University** sponsors annual outdoor sculpture exhibitions just across the street from the Metrotech Center, at 1 University Plaza. By subway, take the Nos. 2, 3, 4 or 5 (IRT Line) train to Nevins Street and walk two blocks to Flatbush and DeKalb avenues.

On Staten Island, **Snug Harbor Culture Center** offers annual outdoor sculpture exhibitions on its beautifully landscaped grounds. The complex, founded in 1801 by the son of a notorious pirate, was a retirement home for sailors until the mid-1960s when the 80-acre estate was purchased by the city. Architect Minard Lefever designed the early buildings, which are among the best

collections of Greek Revival architecture in the nation. Sculpture is on display from mid-June to late October. Take the Staten Island Ferry and the S40 bus to the center.

Wave Hill, in the Riverdale section of the Bronx, offers a panoramic view of the Hudson River and the Palisades. The house was built in 1843 as the summer residence for jurist William Lewis Morris. It has been home to Mark Twain, Theodore Roosevelt, and Arturo Toscanini. Opened as a nature center in 1975, its 28 acres include landscaped gardens and greenhouses. The center's early sculpture programs featured leading lights in modern sculpture. Financial constraints now limit the exhibition schedule, although its artistic offerings continue to be of extremely high quality. Recent shows have featured Jene Highstein, Robert Irwin, and Robert Ressler. Open from mid-May to mid-October: 9:00 A.M.–5:30 P.M. weekdays, except Monday; open late on Thursday. Admission is free on weekdays; admission charge on weekends and holidays. By train, take MetroNorth to the Riverdale Station; walk uphill to the center. By bus, take the Liberty Lines Express Bus. (For more information, call 718-652-8400.) The address: 249th Street and Independence Avenue. For exhibition schedule call 718-549-3200.

Long Island

In Brookville, Long Island, less than a 15-minute drive from the Nassau County Museum, is **Long Island University's** 400-acre **C. W. Post** campus. The collection, on loan except for Vito Acconci's *Face of the Earth,* presents a wide variety in types of art, materials, techniques, and approaches. An illustrated sculpture map is available at the Hillwood Art Gallery. Take the Long Island Expressway (I-495) to Exit 39N, Glen Cove Road; travel nearly 3 miles to Northern Boulevard and turn right. After 2 miles, signs for the campus will appear.

In The Hamptons, on the Island's East End, are two notable outdoor sculpture attractions. The **Elaine Benson Gallery** in Bridgehampton is one of the few establishments that stands above the seasonal fads in this chic summer enclave. Benson presents half a dozen shows per season in her 1-acre sculpture garden and in the gallery. All the works are for sale.

Openings for her shows generally benefit local charities and are "must" events on the social calendar. Abstract and representational work in steel, bronze, aluminum, and stone play hide-and-seek among the trees and shrubs. Appropriately, much of the art seems tailor-made for the poolsides of affluent summer transplants. The gallery is open daily, except on Wednesday, from noon to 6:00 P.M., May through mid-September. On Montauk Highway (Rte. 27).

Fanciful concrete sculpture can be viewed in nearby Water Mill at **Mihai Popa's** home and sculpture garden on Scuttle Hole Road. Popa, who made a dramatic escape from Communist Romania in 1966, converted a shack and a barn into his home and museum. His home is an arresting two-story elliptical wood structure wrapped in a cobalt blue corrugated veneer that is tagged locally as the "Ark of Scuttle Hole." Displayed on the grounds is his *The Species*, a group of fifteen abstract concrete forms that Popa says relate to man's role as caretaker of the earth and the need to live in harmony. In the grouping is a 15-foot-high "tree of life," abstract animal forms and *Adam and Eve*. The complex is at the juncture of Scuttle Hole and Millstone Roads, about 1 mile north of Route 27 (Montauk Highway).

Upstate New York

The **Katonah Museum of Art** in Westchester County presents sculpture exhibitions in its small semicircular garden, under a lacy canopy of towering Norwegian spruce trees. The museum has no permanent collection, but sponsors half a dozen shows each year in its two galleries. Two or three outdoor sculpture exhibits are mounted each year. The museum, at Jay Street on Route 22, is an hour's train ride from Grand Central Terminal on the Brewster North line. (For more information, call 914-232-9555.)

In the Catskills, about a half-hour drive from Hans Van de Bovenkamp's sculpture garden, is **Opus 40**. It is the product of one man's obsession—a monumental stone earthwork with multilayered terraces, pedestals, pools, ramps, and a 14-foot-tall bluestone column. This was the life work of Harvey Fite, a sculptor and art professor at nearby Bard College. For 37 years, Fite fashioned a 6-acre environmental sculpture in an abandoned bluestone quarry.

Using a hand-cranked winch and a derrick to lift stones as heavy as 9 tons, he cleared rubble to make way for the terraces and pedestals for his figurative sculpture. He estimated it would take forty years to complete; three years short of the fortieth anniversary, in 1976, he was killed in a fall at the quarry, at the age of 72. Open from Memorial Day through October. *Opus 40* is in Saugerties, at 7480 Fite Road, 5 miles south of Woodstock. (For more information, call 914-246-3400.)

Also in the Catskills, a few miles west of Woodstock, in the tiny hamlet of Shady, is an enchanting terraced 1-acre sculpture garden created by potter and gallery owner **Elena Zang**. Smaller works are nestled in flower gardens around her working studio. Larger pieces adorn the open lawn, a wooden bridge and a gurgling brook. Works by such well-known artists as Ursula Von Rydingsvard, William Tucker, Hans Van de Bovenkamp, and Mary Rank have been presented in the garden. The pieces are for sale. The annual sculpture show runs from July to October. A small sign on the left-hand side of the road marks the gallery entrance, at 3671 Route 212. (For more information, call 914-679-5432.)

Potsdam College of the State University of New York has eleven large-scale outdoor pieces. William King's *Book* is an amusing oversized aluminum image of a reader. Another work on an academic theme is Takeshi Kawashima's version of a classroom with two right-angle concrete walls enclosing a concrete table and seats. Dennis Oppenheim's large kinetic work was installed with a lavish fireworks celebration in 1984. A map with descriptions of the pieces is available on campus at the Roland Gibson Gallery. (For more information, call 315-267-2481.)

Poughkeepsie/Dutchess County

Vassar College has three outdoor sculpture areas, the largest of which is the Hildegarde Krause Baker Sculpture Garden, an L-shaped space that holds the college's permanent collection, including works by Anthony Caro and Isamu Noguchi. Smaller pieces are featured in the Briarcombe Sculpture Courtyard. A 6-foot-tall, multicolored piece by Vassar alumna Nancy Graves adorns the Blanchette Hooker Rockefeller Entry Pavilion

Courtyard. The Art Museum is just past Vassar's main gate. The Vassar campus is on Raymond Avenue in Poughkeepsie, off Routes 44 and 55. (For more information, call 914-437-5632.)

Each summer in the **Dutchess County** countryside, more than a dozen farmers create "crop art" on their farmlands. Using stalks of corn, pumpkins, flowers, gourds, seeds, and fruit, they design images that burst into maturity in October, at the end of the growing season. Some of these agricultural works of art can be seen from the road; all are visible from the air. A list of the artists and their locations is available from the Dutchess County Tourist Promotion Agency, 3 Neptune Road, Poughkeepsie, NY 12601. (For more information, call 914-463-4000.)

Pennsylvania

The **University of Pennsylvania** campus in Philadelphia is festooned with art. More than forty outdoor works by nineteenth- and twentieth-century sculptors are part of the permanent collection, and a dozen more are on long-term loan. Of particular interest are eight works by Alexander Sterling Calder, the father of Alexander Calder, that were purchased in the 1920s. The sculpture is clustered along Locust Walk and Chestnut Street. A map of the works is available at the campus Art Museum.

Allentown has been the home of Philip and Muriel Berman since 1947, when they purchased the local Hess Department Store and built it into a nationwide chain. In 1971, after years of civic and cultural philanthropy in Allentown, they began placing contemporary outdoor sculpture around the city. Allentown's collection now contains more than sixty pieces, which are displayed in city parks, at intersections, along parkways, and at Cedar Crest College. In 1995 the Bermans created a sculpture garden on the grounds of Lehigh Valley Hospital, donating one hundred stone and metal works.

Other beneficiaries of the Berman's largesse include **Kutztown University** and **East Stroudsburg State University**. Kutztown's collection, on the 325-acre campus in the Pennsylvania Dutch country, midway between Allentown and Reading, features eleven sculptures by Leon Derst, Ernest Shaw, Paul Sisco, and

Tom Sternal. East Stroudsburg, a sprawling university nestled in the foothills of the Poconos, has six large-scale contemporary sculptures sited in strategic locations across its 103-acre campus.

In **Johnstown**, the *James Wolfe Sculpture Trail* was created for the Centennial of the 1889 Johnstown Flood. Working with local steelworkers and using the city's steel mills as his studio, sculptor James Wolfe created ten large-scale steel sculptures, eight of which are sited along a 1.5-mile trail at the foot of one of the steepest inclines in America. Two more pieces are on the hillside below the Inclined Plane observation deck and opposite the Bethlehem Steel offices on Walnut Street. Initially many steelworkers greeted the works with skepticism, but they were won over by Wolfe's infectious enthusiasm and "homeboy" demeanor. The bottom of the Inclined Plane can be reached by Routes 56 and 403; the top is accessible from Route 271.

Just across the Allegheny River from downtown **Pittsburgh** is Allegheny Landing, a sweeping modern riverfront sculpture garden framed by two old-fashioned yellow bridges that date from the early part of the century. The garden's privately commissioned pieces, which interpret the city's industrial and labor history, include two of Ned Smyth's large marble mosaics, *Piazza Lavora* and *Mythic Source,* and George Sugarman's playful aluminum installation, *Pittsburgh Variations,* brightly colored in green, blue, yellow, and orange. Isaac Witkin's massive and silvery fluid *The Forks* celebrates the convergence of the three rivers only a few feet upstream. Also in the collection are a pair of J. Seward Johnson, Jr.'s hyperrealistic bronze figures of blue-collar workers. The decorative path at water's edge is a popular spot for joggers, bikers, and dog walkers. Allegheny Landing is just a few minutes' walk from the Warhol Museum.

No listing of the sculpture attractions in Pennsylvania would be complete without mentioning the extensive Civil War memorials at **Gettysburg**. This remembrance of the three-day Battle of Gettysburg in 1863 encompasses 1,300 bronze and granite monuments commemorating the largest battle ever fought in the United States. The first monument was erected in 1867 by veterans of the First Minnesota Infantry. The last was completed in

1982. Gettysburg is off Highway 30, and Routes 116 and 34. Directions are well-marked within the city.

Rhode Island

A **Newport** mansion is the site of Richard Fleischner's earthwork *Sod Maze*, an installation of four concentric circles of mounded turf with a single path to the center. Constructed in 1974, it resembles the stone mazes embedded in the floors of medieval cathedrals, in contrast to the more commonly thought-of labyrinth topiary mazes. It is 142 feet in diameter; turf is mounded to a level of 18 inches. This work is on the grounds of **Chateau-sur-Mer**, on Bellevue Avenue. The mansion belongs to the Preservation Society of Newport County.

Vermont

The **Southern Vermont Art Center**, about an hour's drive north of Bennington, in Manchester on West Road, is on a 375-acre estate that is listed on the National Register of Historic Places. The spacious grounds are home to the Boswell Botany Trail and a sculpture garden, where around forty pieces are sited on a meadow, rolling lawns, and at the entrance driveway. (For more information, call 802-362-1405.)

Outdoor sculpture can also be found in Manchester at the **Wilburton Inn**, a historic property that was converted to an inn in 1946. About a dozen sculptures, including an Easter Island head and a temple, are sited on the 20-acre grounds. Most are works by artists who live or vacation in Vermont. The inn is on River Road. (For more information, call 802-362-2500.)

Washington, D.C., and its Suburbs

First Lady Hillary Rodham Clinton reinstituted the sculpture exhibitions in the First Lady's Garden at the **White House** that were originally conceived by Jacqueline Kennedy. Mrs. Clinton's preference for large-scale modern works was evident in the first

of four 4-month-long shows in 1994, which featured a dozen sculptures by prominent American artists. The sculpture is placed just outside the Colonnade windows, where it can be seen by the thousands of tourists who trek through the White House each day.

Another superb modern outdoor sculpture collection is on the lawn outside the East Wing of the **National Gallery of Art,** just across The Mall from the Hirshhorn Museum and Sculpture Garden. The gallery's entrance is dominated by Henry Moore's three-story *Knife Edge Mirror Two Piece.* Sculptors whose works sit on the grassy areas surrounding the gallery include Jean Arp, Joan Miro, Isamu Noguchi, George Rickey, James Rosati, Joel Shapiro, and Tony Smith.

Across the Potomac from Washington, D.C., near historic Old Alexandria, Virginia, is a spectacle of constructed ruins. Canal Center Plaza, a modern waterfront office complex, presents *Promenade Classique,* huge marble slabs fashioned into colossal human lips and eyes—modern-day relics resembling leftovers from an ancient civilization. In the plaza fountain huge marble lips gush water and a three-story bronze arrow slashes the spray, appearing to pierce the earth's skin to bring forth water. Looking out to the Potomac is a satirical rendition of huge artifacts posed in a garden grotto. Voluptuous marble lips dribble water and enormous eyes stare dolefully toward the river. At the water's edge is a scaled-down version of the Washington Monument obelisk, which on a clear day can be seen in the far distance. This fantasy environment was created by Paris-based sculptors Anne and Patrick Porier, in collaboration with American landscape architect M. Paul Friedberg. Benches are placed along the waterfront and picnicking is encouraged. From Washington, D.C., take Washington Memorial Drive beyond National Airport to Alexandria. Turn left, toward the water, at First Street. By Metro, take the Blue or Yellow line to Braddock Road and walk toward the water. The complex is on North Fairfax Avenue.

Sculpture Parks in the Midwest

Map of the Midwest regions

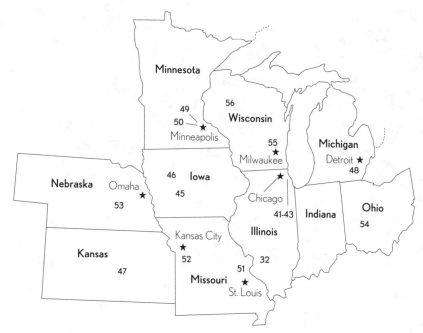

40. Univeristy of Chicago
41. Northwestern University
42. Ravinia Festival
43. Governors State Univeristy, Sculpture Park
44. Mitchell Museum, Cedarhurst Sculpture Park
45. Des Moines Art Center

46. Iowa State University
47. Wichita State University, Museum of Art
48. Cranbrok Academy of Art
49. General Mills Art Collection
50. Walker Art Center, Minneapolis Sculpture Garden
51. Laumeier Sculpture Park

52. Nelson-Atkins Museum of Art, Henry Moore Sculpture Garden
53. University of Nebraska
54. Columbus Museum of Art
55. Bradley Sculpture Garden
56. Fred Smith Fred Smith's Wisconsin Concrete Park

Illinois

University of Chicago

Hyde Park, Illinois

The university's artistic heritage is inextricably linked to the seminal 1893 Columbian Exposition, a historic celebration that brought together America's architects and sculptors who were translating classic European styles into an American sensibility. Augustus Saint-Gaudens and Daniel Chester French led the list of prominent sculptors who flocked to Chicago to display their talents. The Exposition was a launching pad for modern American architecture and sculpture. Chicago's campus buildings of that day were constructed of Indiana bluestone, a material that takes on a patina that resembles the Gothic buildings of Europe.

The centerpiece of the University of Chicago's outdoor sculpture collection is Henry Moore's famed *Nuclear Energy*, a 12-foot bronze sited near the Enrico Fermi Institute, where the Manhattan Project produced the first nuclear reactor in 1942. In creating this work Moore was inspired by a collection of medieval helmets. The sculpture resembles both a human head and a mushroom-shaped cloud. It was dedicated by Mrs. Enrico Fermi, widow of the Nobel prize-winning nuclear physicist who directed the famed Manhattan Project that developed the atomic bomb.

Most of the collection is placed around the Cochrane-Woods Arts Center and the Smart Museum of Art. The grassy quadrangle between the two buildings features Scott Burton's functional furniture-as-sculpture, a polished red granite bench and table. It faces Arnoldo Pomodoro's *Grande Radar*, an 8-foot-tall deeply carved polished bronze construction. A companion Pomodoro, *Grande Disco*, is on display at the Medical School, a few blocks away. Also on the quadrangle is an eclectic grouping that includes distinctly modern and abstract works by John Henry, Richard Hunt, and Buky Schwartz.

Sculpture is also placed near the medical school, the law school, and Albert Pick Hall and along the grassy Midway, where the ferris wheel was introduced at the Columbian Exposition. Chicago sculptor Lorado Taft's enormous steel-

reinforced concrete *Fountain of Time* dominates the Midway's western edge. Completed in 1922, this 110-foot-long wall is made of 4,500 pieces, cast in steel-reinforced concrete, that depict such basic themes as birth, love, poetry, and war. Surprisingly, given the university's vulnerable location in one of Chicago's most impoverished and crime-ridden neighborhoods, there is little evidence of vandalism or graffiti.

The core of the university's modern outdoor art collection was donated in the 1960s by the family of Nathan Cummings, a Chicago industrialist who founded Consolidated Food Corporation. Donations include works by Antoine Poncet, Sorel Etrog, and Arnoldo Pomodoro.

Other sculptors represented include Kenneth Armitage, Jordi Bonet, Scott Burton, Peter Calaboyias, Ruth Duckworth, Johan Dyfverman, Virginio Ferrari, John Henry, Richard Hunt, Jene Highstein, Dennis Kowalski, John David Mooney, Henry Moore, Antoine Pevsner, Ablin Polasek, Buky Schwartz, Sara Skolnik, Lorado Taft, and Wolf Vostell.

A walking tour map is available at the Visitors Center in Ida Noyes Hall, 1212 East 59th Street.

How to Get There: South of Chicago's Loop, just off South Lake Shore Drive. Take South Lake Shore to Cornell Drive. Turn right on East 59th Street at Woodlawn Avenue for visitors' parking. On public transportation, take Metra from Randolph and Michigan station to the 59th Street stop; walk four blocks west to Ida Noyes Hall.

University of Chicago
Ida Noyes Hall
Hyde Park, IL
312-702-9636
Hours: On view at all times.

Northwestern University Sculpture Garden

Evanston, Illinois

This small but choice all-bronze collection, with a dozen works by some of the most acclaimed modern sculptors, adorns the pedicured gardens of the Mary and Leigh Block Gallery. The

sculpture garden, opened in 1989 in the performing arts complex, overlooks Lake Michigan.

Chicago architect John Vinci created the two-tiered sculpture garden on a landfill, using ivy and flower beds, glens, and grassy knolls as settings for these major works. Arnoldo Pomodoro's deeply etched bronze *Cilindro Costruito* rises majestically atop a steep hill that students nicknamed "Mt. Pomodoro."

Two large works by British sculptor Barbara Hepworth are impeccably sited to maximize the views through their off-center openings. The sculptures are placed so that each can be seen through the circular openings in the other. Nestled in a grove of weeping willows, Hepworth's *Two Forms* frame the ever-changing views of nature.

Jean Ipousteguy's surrealistic *Man Going Through a Door* is a favorite with children, who shriek when confronting the scary image of a man trying to push his way through a block of bronze. This is the only figurative piece in the collection.

Dadaist icon Jean Arp's sensually rounded, free-form *Resting*

Jean Ipousteguy, *Man Going through a Door* (1966), Northwestern Univesity, Evanston, IL

Leaf is best seen at sunset when its biomorphic shape is reflected on the glass facade of the concert hall. Throughout his life Arp wrote poetry and his art reflects imagery drawn from the unconscious. He insisted that his works were not forms abstracted from nature, but rather natural forms of his own invention.

The garden is a popular lunchtime spot for students, who sprawl around the works. In the evening, the sculpture garden's upper deck is lighted and several pieces are spotlighted.

Northwestern's Fine Arts Museum was founded in 1980 by Chicago philanthropist and Inland Steel magnate Leigh Block and his wife Mary. They donated sculpture from their garden in Santa Barbara, California.

Sculptors whose work is represented include Jean Arp, Virginio Ferrari, Barbara Hepworth, Jean Ipousteguy, Jacques Lipchitz, Joan Miro, Henry Moore, Arnoldo Pomodoro, and Antoine Poncet.

There is no admission charge.

Picnicking is allowed, and so are dogs. Private tours can be arranged.

How to Get There: Evanston is a northern suburb of Chicago, on Lake Michigan. In Evanston take Sheridan Road to South Campus Drive at Northwestern to "Arts Circle." Parking stickers available at the Block Gallery. Stickers are not needed after 5:00 P.M. or on weekends.

Northwestern University Sculpture Garden
Mary and Leigh Block Gallery
1967 South Campus Drive on the Arts Circle
Evanston, IL 60208
847-491-4000
Hours: Sculpture garden is always open. Block Gallery: noon-5:00 P.M., Tuesday and Wednesday; noon-8:00 P.M., Thursday through Sunday.

Ravinia Festival

Highland Park, Illinois

An eclectic sculpture garden enlivens the grounds of Ravinia, the Midwest's premier music festival and summer home of the

Chicago Symphony. Sculpture adorns grassy areas, decorates fountains, and offers intriguing geometric shapes on the perimeter of the performance spaces.

This collection did not spring from a curator's vision, but grew as patrons contributed pieces. Most were donated in the mid-1970s and early 1980s by Ravinia devotees who migrated to Chicago when their children left the nest. The eighteen pieces include minimalist steel assemblages, figurative bronze pieces, geometric stainless steel works, and well-crafted garden ornaments. Many have musical themes, such as *Girl with the Violin*, *The Harpist*, *Concerto*, and *Dancing Figure*. Among the highlights of the collection is Richard Hunt's *Music for a While*, a gift from the sculptor that sits at the far end of the meadow. This muscular, round-edged, Cor-ten steel sculpture evokes images of plants and animals.

Ecstasy, a 26-foot-tall bronze by the prolific Chicago sculptor Virginio Ferrari, profiles two gleaming lovers in the elongated style of Brancusi and Giacometti.

Sorel Etrog's towering bronze *Survivors Are Not Heroes* is alive with the symbols of ancient cultures. Triangles and circles, topped with a menacing sledgelike form, trigger speculation about the prospects for human survival.

Sculptors represented include Joseph Burlini, Robert Cook, Sorel Etrog, Virginio Ferrari, Gidon Graetz, John Henry, Richard Hunt, Sylvia Shaw Judson, Dennis Kowal, Kenneth H. Kraft, Abbott Pattison, Albin Polasek, Sam Radoff, John Waddell, and Zelda W. Werner.

A sculpture guide, with a map and photographs, is available at the office.

How to Get There: Highland Park is north of Evanston and Chicago. From Chicago, take the Edens Expressway (I-94) and Route 41 to the Ravinia exit. Shuttle service is provided from the large parking lot. Bus service through Keeshin Buses and train service by the Metra/Chicago and NorthWestern North Line is also available.

Ravinia Festival
1575 Oakwood Avenue
Highland Park, IL 60035
708-433-8800

Hours: Access is limited to ticket-holders for performances. Events at Ravinia are generally held mid-June through Labor Day.

Governors State University
Nathan Manilow Sculpture Park
University Park, Illinois

Only sculptures of enormous size can hold their own against the seemingly endless vista of stark midwestern prairie. Tall coarse grasses provide the setting for twenty-three powerful minimalist sculptures on this 300-acre college campus. Broad gravel and grass pathways leading to the sculpture are bordered by native grasses, some clipped to expose new green growth, others allowed to flourish undisturbed. In winter, the sculpture assumes a breathtaking presence against the broad, flat expanse of snow.

Mark di Suvero was the first sculptor to present his work here, and three of his characteristic welded steel-beam constructions are on view in a vast field behind the university. His *For Lady Day* was created on site from parts of a railroad tank car. The cylindrical tank accommodates as many as ten children, who gleefully play hide-and-seek in and around the sculpture. Nearby is di Suvero's *Prairie Chimes*, an exuberant giant red sculpture whose tubular metal pieces clang musically in the wind.

Di Suvero's third piece is his monumental *ISIS*, on long-term loan from the Hirshhorn Museum in Washington, D.C., where it sat for many years hemmed in on a small plaza. Now the piece has all the room it needs. A 65-foot-long I-beam supports a suspended ship's prow that seems oddly at home in the wide expanse of prairie grass. The work's title is a double reference—to the fabled Egyptian goddess and an acronym for the Institute of Scrap Iron and Steel which contributed the piece to the Hirshhorn.

The bleak landscape is particularly hospitable to illusions of outer space. Jene Highstein's concrete *Flying Saucer*, a UFO-like object with blackened "reentry" marks, simply reeks of foreign intruders. Its rounded boulders, plunked down in the meadow, seem to have come from somewhere outside our gravitational

field. Jerry Peart's *Falling Meteor* is a more playful interpretation of the perils of the planet. Its jagged-edged, welded circular steel forms appear to have fallen from space.

Bruce Nauman's concrete *House Divided*, titled as a reference to Lincoln's Civil War quote, is an eerie and somber work. At first glance the "house" resembles a typical rural structure, perhaps a farmer's toolshed. A look inside reveals an ominous partition of the house into two triangles. One triangle has three square openings into a stark interior. Sunlight from the openings create geometric figures of light and shadow on the walls and floor. The other triangle is sealed. This abrupt, exclusionary division generates a highly unsettling, almost fearful, sensation. *House Divided* sends a vivid message about the perils of estrangement.

From *House Divided* the path leads to John Henry's joyous *Illinois Landscapes No. 5,* a 125-foot-long, bright yellow metal construction. With its outstretched arms it resembles a colossal child gamboling on the grass.

Vito Acconci's *House of Cars,* a battleship gray pop-culture construction, is a favorite for kids. It includes a sign composed of tiny metal reflectors that flashes "Live Out of This World," a motto that is not explained. Six gutted automobiles are piled two deep to create three rooms, which contain a refrigerator, stove, sink, toilet, shower head, and a steel mattress. A steel grille resembles a table. With hook-ups for water and electricity, this could be a home; in fact, Acconci's first version of *House of Cars,* erected in San Francisco, became a homeless shelter.

Mary Miss' immense environmental installation titled *Field Rotation* features eight rows of telephone poles embedded in the flat grass that lead to a sunken wood enclosure. A raised geometric sculpture in the center is a splendid place for picnics.

The park is named for Nathan Manilow, who owned the farm on which the park is sited. He was a civic leader, although not an art collector. His son Lewis, who initiated the park and was a prime force in developing the sculpture collection, is influential in Chicago art circles.

Sculptors whose work is represented include Vito Acconci, John Chamberlain, Mark di Suvero, Charles Ginnever, John Henry, Jene Highstein, Richard Hunt, Terry Karpowicz,

Clement Meadmore, Mary Miss, Bruce Nauman, John Payne, Jerry Peart, Martin Puryear, Joel Shapiro, Edwin Strautmanis, and Dan Yarbrough.

A detailed map is provided. Also available is an illustrated book describing the collection.

How to Get There: The park is 35 miles south of the Chicago Loop. Take Dan Ryan Expressway south to I-57, shortly after 95th Street. At Sauk Trail, exit on the east bound ramp, proceed several blocks to Cicero, and turn right. Follow signs to campus.

Nathan Manilow Sculpture Park
Governors State University
University Park, IL 60466
847-433-8800
Hours: Open year-round.

Mitchell Museum

Cedarhurst Sculpture Park

Mt. Vernon, Illinois

Cedarhurst could well be the model for a new breed of contemporary sculpture parks. With a shoestring budget and lots of ingenuity, Cedarhurst displays some of the finest sculpture being produced today.

The Cedarhurst collection, begun in 1991, is on the 85-acre former estate of John R. Mitchell. He died in 1971, leaving no heirs, after making a fortune in oil, banking, and broadcasting. In his time the estate's many trees were purposely overgrown to hide the mansion from public view. When the sculpture park was initiated, trees were trimmed of limbs to a height of about 7 feet. They still look lush and well tended, but now allow long, clean sight lines for viewing the sculpture.

The park augments its small permanent sculpture collection with long-term loans. Initially it tapped nearby Laumeier Sculpture Park. But, now, Cedarhurst casts its net farther afield, attracting works on loan from such internationally known art dealers as New York's Andre Emmerich and Leo Castelli, and from the avant-garde Socrates Sculpture Park. Cedarhurst's success in attracting important contemporary works builds on a

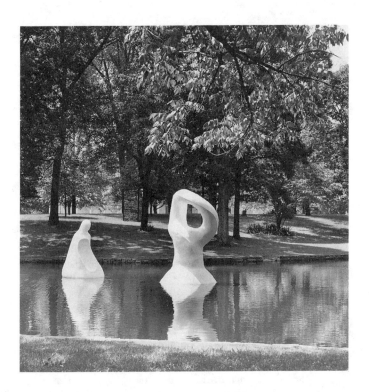

Martha Enzmann, *Dancers*, Mitchell Museum, Mt. Vernon, IL

convergence of interests: the park seeks sculpture for its spacious grounds; sculptors who create massive works seek places to display them. Cedarhurst's meticulous attention to the preservation of its sculpture is undoubtedly an added attraction for artists and gallery owners.

Sculpture is usually on loan for a two-year period, giving Cedarhurst the opportunity to offer a continually changing collection. While the high costs of installing and removing pieces means they often overstay the initial commitment period, the grounds can accommodate many additional works. Thus, the collection can continue to grow without displacing sculpture on display. As Cedarhurst curator Bonnie Speed sees it, "We have a dynamic collection, an open-air gallery where visitors can't use the excuse of saying they've seen it, because they haven't."

Curator Speed scours the country seeking pieces and devising inexpensive ways to bring works to the park. She finds low-cost shippers and inveigles the local power company to provide cranes for placing the sculpture. But the park does not stint when it comes to properly siting the sculpture. Artists are often brought at Cedarhurst's expense to advise on the placement of their works. And they are consulted frequently on preservation concerns. Cedarhust's success with this new approach to presenting sculpture is drawing increasing attention from other sculpture-hungry curators.

Dominating the museum's entrance is John Kearney's *Kimball,* a monumental draft horse, constructed from chrome car bumpers. It commemorates the courage and strength of the early settlers. This work, and his other car bumper constructions at Cedarhurst, a 17-foot-tall *Giraffe,* and a 5-foot *Gorilla,* are particular favorites of children.

Featured at the entrance drive is an intricate and lacy, white steel sculpture, *Sabine Women I.* Created by Alexander Liberman from gas storage tanks and sheet steel, it is imaginatively placed on a grassy knoll, framed by a circular backdrop of wispy trees and bushy pines.

A playful, new acquisition is Martha Enzmann's *Dancers,* a shy, slouching abstract woman and a robust man with a stylized lasso, constructed of fiberglass-covered polystyrene and painted with white epoxy boat paint. The dancers floating in a pond are connected by an underwater cable, which allows the woman to fly straight to the man or saunter about the pool, depending on wind direction and velocity. The sculptor's background as a performance artist is clearly evident.

Among works on long-term loan is Keith Haring's *Untitled (Three Dancing Figures),* a larger-than-life trio of exuberant, high-kicking children in brightly painted yellow, blue, and red aluminum. The initially gleeful image of children at play turns ominous on closer inspection as a child's thrusting arm can be spied in the interior of the piece. Haring is known predominately for his paintings; his instantly recognized, vividly animated stick figures are icons of the 1980s.

Bruce Johnson's *Big Bang,* a group of redwood and copper

logs balanced on the giant inverted redwood trunk, is also on loan. Johnson's instructions for installing this enormous piece were so carefully detailed that it took only an afternoon to complete its complicated assembly. The sculpture glistens from oil applied to preserve the wood, an example of Cedarhurst's rigorous attention to maintenance.

Also on loan is Antoinette Ayres *From Here to There*, an immense cedar tepee-shaped structure. Lined in beeswax, with pine needles on the interior floor, the piece offers an aromatic cocktail when the sculpture is entered through a slit in the tepee.

There is no admission fee.

A self-guided tour booklet that includes a map is available at the small gift shop. Picnicking is not encouraged. A snack bar is planned.

Cedarhurst sponsors a chamber music series and an annual autumn craft fair.

How to Get There: Mt. Vernon is about an hour and a half drive from downtown St. Louis. Take Highway 64 East to the Mt. Vernon exit.

Cedarhurst Sculpture Park
Richview Road, P.O. Box 923
Mt. Vernon, IL 62864
618-242-1236
Hours: 10:00 A.M.-5:00 P.M., Tuesday through Saturday; 1:00 P.M.-5:00 P.M., Sunday. Closed on national holidays.

Iowa

Des Moines Art Center

Greenwood Park

Des Moines, Iowa

Des Moines' sculpture park is a far cry from the traditional setting of grassy expanses, winding paths, and cultivated flower beds. The emphasis here is on massive environmental sculpture. Four internationally recognized artists have created works that incorporate the natural elements of the city's 81-acre

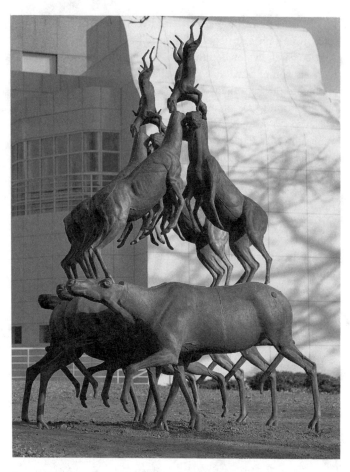

Bruce Nauman, *Animal Pyramid* (1990), The Des Moines Art
Center, Des Moines, IA

Greenwood Park. The artists selected distinctive natural settings
and sculpted the land to create view corridors and other features
that draw attention to the park's beauty.

Richard Fleischner chose a secluded site near the historic
Sylvan Theater for his installation. To highlight woodland scenes
within the park, Fleischner arranged bronze screens and gray gran-
ite stone markers along natural sight lines. "I'm setting up imagi-
nary picture frames around what look like English paintings of the

park," Fleischner explained in describing his work. His intent is to sharpen the focus on nature, to dramatize its beauty.

Richard Serra's massive *The Standing Stones* is six angular granite blocks placed in an area larger than a football field. Each stone marks a 5-foot change in elevation. As with the Fleischner work, the sculpture is a composition designed to focus on the natural setting and direct the viewer's eye to the landscape.

Bruce Nauman's *Animal Pyramid* relates both to the landscape and the Art Center building. The triangle of balancing caribou, elk, and foxes exudes an aura of fantasy, bringing to mind children's stories of magical and mythical beasts. Their "skinned" appearance may be a reference to the use of animals for food as well as for sport.

Mary Miss, in her *Discovery Wetlands Project*, is renovating a long-neglected 6-acre lagoon and pavilion at the far south edge of the park. Rather than simply combating the forces of erosion, the city took a more adventurous tack by tapping an environmental artist to enhance the natural beauty of the site. Working with local conservation and garden groups, she is enlivening this area and making it more hospitable. The lagoon is being restructured, and the pavilion and walkways are being redesigned to preserve the wetlands. A natural prairie constructed around the lagoon's perimeter will protect against flood erosion and act as a filter for pollutants. Public access is provided with graded pathways through the wetlands. While this may sound more like a public works project than a sculpture, the artistic components are clearly evident in the sensitive design. When completed, residents will once again be able to ice skate on the pond.

The city's original master plan called for as many as a dozen environmental sculptures. It was scaled back after the devastating 1993 flood soaked the grounds and damaged the Art Center. A capital campaign for adding sculpture was shelved while funds are being raised for structural repairs. The grounds include a rose garden and amphitheater. The sculpture park is a joint effort of the museum, the city, and the Iowa State Historic Preservation Bureau.

Museum admission fee; sculpture can be seen without entering the museum. Restaurant and museum shop in the Art Center. Picnic tables on the grounds.

How to Get There: The Art Center is west of downtown Des Moines, at Grand Avenue and Polk Boulevard. From downtown, take I-235 West to Polk Boulevard; turn left.

Des Moines Art Center
4700 Grand Avenue
Des Moines, IA 50312
515-277-4405
Hours: Outdoor sculpture on view at all times. Museum: 11:00 A.M.-5:00 P.M., daily; 11:00 A.M.-9:00 P.M., Thursday; noon-5:00 P.M., Sunday. Closed on Monday.

Iowa State University

Ames, Iowa

Iowa State's art program was initiated in the 1930s when sculptor Christian Peterson was invited to Iowa by American Gothic painter Grant Wood, head of the state's WPA program. Peterson, the first university sculptor-in-residence, remained on campus until his death in 1958. His 4-foot-tall plaster of the renowned black agronomist George Washington Carver, an 1897 alumnus, is one of the most beloved pieces in the collection.

The most startling pieces, and the logo for the university's collection, are the *G-Nomes,* four 12-foot-tall terra cotta figures brandishing chromosome wands that stand atop the four corners of the new molecular biology building. Sculptor Andrew Leicester worked with architects Hansen Lind Meyer Inc. to incorporate these and other science-oriented pieces into the design of the $30 million research and teaching facility, which opened in 1992.

The *G-Nomes* are an integral part of the sprawling three-story building's modern brick architecture. At the building corners, bricks designed in DNA helixes trail down to a mosaic tile of a DNA molecule on the atrium floor. The G-Nome Project includes entrance reliefs, a mosaic floor, medallions in the atrium, and a porcelain tile work in the auditorium lobby floor. *Forbidden Fruit,* an oversized and updated goddess figure, reinterprets the ancient snake symbols for rebirth, with split strands

of DNA. The Ames campus benefited greatly from the state's Percent for Art law, passed in 1978. Under this program one-half of 1 percent of construction and remodeling costs for state buildings are set aside to purchase art. The state program is considered to be one of the best public art programs in the country. All of the G-Nome Project, a dozen sculptures, and nearly one hundred murals and oils were made possible through this million-dollar program.

The university is strongly committed to the educational aspect of its collection. Through walking tours and lectures, students and visitors are challenged to make their own judgments. A college flyer on the *G-Nomes* insists, "This information sheet is intended to be used in addition to viewing the art on campus. At no time should this sheet be used as a substitute for experiencing the art in person!"

Sculptors represented in the collection include Robert Andersen, Tom Askman, John Beckelman, Chris Bennett, Stephen DeStaebler, George Greenamyer, Richard Haas, John Douglas Jennings, William King, Mark Knuth, Andrew Leicester, Beverly Pepper, Christian Petersen, Frederic Rennels, Julius Schmidt, Eric Sealine, Karen Strohbeen (and Bill Luchsinger), Nellie Vern Walker, Dale Wedig, and Bruce White.

Admission is free.

A brochure, with a walking tour map and descriptions of the pieces, is available from the University Museums office. A major exhibition with a detailed catalog is expected in 1995.

How to Get There: Ames is about a 40-minute drive due north of Des Moines, on I-35, in the center of the state. Enter the sprawling campus at the Scheman Building, just off Beach Avenue and Lincoln Way.

Iowa State University
University Museums Art on Campus Program
290 Scheman Building
Ames, Iowa 50011
515-294-3342

Hours: Most of the collection can be seen at any time; pieces at the entrances and inside campus buildings are on view during working hours.

Kansas

Wichita State University

Martin Bush Outdoor Sculpture Garden
Wichita, Kansas

More than fifty large-scale sculptures by leading twentieth-century artists are on display throughout the spacious 320-acre university campus.

A highlight of the collection is Joan Miro's *Personnages Oiseaux,* a brilliantly colored, whimsical mural in glass and marble that adorns the Edwin Ulrich Museum of Art. On a distinctly different note is William King's *Power Tennis: En Garde and Forehand,* two elongated aluminum tennis players who are so vibrant they look as if they were actually engaged in a spirited tennis game. The duo stand off by themselves along Perimeter Road.

Other dramatic works are Pop Art sculptor Robert Indiana's *LOVE,* the instantly recognized symbol of the 1960s, and Fernando Botero's *Man with Cane: Woman with Umbrella,* a stolidly middle-class bronze pair who seem to be contemplating a campus stroll. Botero was born in Colombia and lives in Paris; both European and South American influences are clearly evident in his unique, voluptuously obese forms.

Student favorites include John Kearney's stainless steel and chrome *Grandfather's Horse,* constructed from automobile bumpers; Francisco Zuniga's *Three Women Walking,* a bronze tableau of three full-bodied women in flowing skirts; and Henry Moore's gracefully sinuous *Reclining Figure (Hand).*

The university continues to add to its collection. The newest piece is Cork Marcheschi's *Flint Hills Apparition,* which echoes the low rolling landscape of Kansas in brightly glowing neon, aluminum, and acrylic. This 59-foot-long piece hangs at a glass-enclosed pathway between the museum and the art center. Long, wavy overhead lines in pink, green, and purple are accentuated with yellow and blue balls. The San Francisco artist was selected in a competition that asked sculptors to design works that would be vibrant from both close up and far away, and

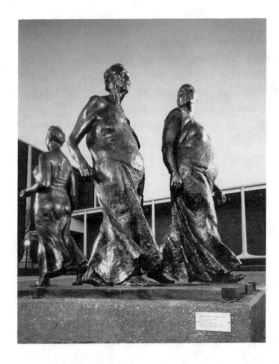

Francisco Zuniga, *Three Women Walking* (1981), Wichita State University, Wichita, KS

equally compelling during the day and at night. Marcheschi's painted aluminum curves are illuminated with neon tubing. The work can withstand the harsh Kansas weather and winds of up to 80 miles per hour.

As part of the university's 1995-1996 centennial, it commissioned a cast of an existing piece by Carl Milles that stands in the Carl Milles Garden in Stockholm. Milles visited Wichita frequently when he was associated with Cranbrook Academy in Michigan. The commissioning of a Swedish artist is particularly appropriate in view of the large Swedish-American population in Wichita.

University Vice President Martin H. Bush was the spark behind the collection. A sculpture enthusiast, he spearheaded efforts to establish the outdoor collection in 1972. He persuaded local collectors to contribute pieces and obtained high-quality contemporary pieces at reduced prices from the artists themselves. To fund the initial purchases, he tapped university patrons for

donations, which were matched with a portion of student activity fees. Bush was instrumental in siting all the works.

Architecturally, the university's old and new buildings are unified by the use of red brick on the facades. The university is known for its business school and as a center for aviation research; it publishes the annual aviation safety report.

Sculptors whose work is represented include Douglas Abdell, Arman, Kenneth Armitage, Leonard Baskin, Daniel Ben-Shmuel, Fernando Botero, Doris Caesar, Lynn Chadwick, Jo Davidson, Jose deCreeft, Donald DeLue, Charles Grafly, Chaim Gross, Dmitri Hadzi, Milton Elting Hebald, Barbara Hepworth, Robert Indiana, Luis Jimenez, John Kearney, William King, Boris Lovet-Lorski, Aristide Maillol, Cork Marcheschi, Gerhard Marcks, Joan Miro, Henry Moore, Louise Nevelson, Bernard Reder, George Rickey, Hugo Robus, Auguste Rodin, Theodore Roszak, Louis Sullivan, Ernest Trova, William Zorach, and Francisco Zuniga.

The sculpture is labeled. A color illustrated map of the sculptures is available. Volunteers give guided tours by appointment.

How to Get There: Wichita is in the south central section of the state, 140 miles southwest of Topeka and about 35 miles north of the Oklahoma border. The university is north of Highway 54, just east of I-135, between McKinley and McDonald parks.

Wichita State University
Martin Bush Outdoor Sculpture Garden
Wichita, KS 67260
316-689-3017
Hours: Collection is on view at all times.

Michigan

Cranbook Academy of Art Museum

Bloomfield Hills, Michigan

Nordic influences are paramount on the Cranbrook campus. The academy was designed by the famed Finnish architect Eliel Saarinen. The dominant sculpture presence is that of the distin-

guished Swedish sculptor Carl Milles, who studied with Auguste Rodin in Paris. Milles came to Cranbrook at the urging of Saarinen. He was resident sculptor and head of the academy's sculpture department for two decades, from 1931 to 1951, when he was offered a studio at the American Academy in Rome. Cranbrook's collection of sixteen works by Milles is the largest outside the Milles Garden in Stockholm.

Milles worked primarily in bronze. His fascination with water is evident in the several fountains, which depict figures from Nordic ocean folklore, the Bible, and Greek myth. He began his career as a cabinet maker. In Paris between 1897 and 1904, Milles showed his work at the Paris Salon. Before coming to Cranbrook he was a professor at the Royal Academy of Art in Stockholm.

In addition to the Milles' sculptures, there are more than a dozen works by contemporary artists, all of whom either studied or worked at Cranbrook. Students of Milles who have works on campus include Bernard (Tony) Rosenthal, Harry Bertoia, and Marshall Fredericks. Other sculptors who worked at Cranbrook and have their works on display are Michael Hall, Paul Manship, Jussi Mantynen, Walter Nichols, Richard Nonas, Francis Rich, and Peter Voulkos. The Milles pieces are permanent features on campus; many of the modern works are on long-term loan.

Cranbrook, once a rundown farm, was purchased in 1904 by newspaper baron George Booth and his wife Ellen. With Eliel Saarinen's vision, the 315-acre property was transformed into a striking landscape of fountains, ponds, and streams. Saarinen's teenage son Eero lived on campus with his father, and he designed much of the furniture in what is now the museum's Saarinen House. The architect was tapped for the project after being introduced to Booth by Booth's son Henry, an architecture student at the University of Michigan where Saarinen was a visiting professor.

The sculpture is sited so that it relates to the architecture. Some pieces are mounted in fountains; others are focal points at the end of pathways. Many figures are displayed on architecturally designed pedestals.

Cranbrook was named for Booth's ancestral village in

England. The Booths, ardent Anglophiles, modeled Cranbrook on an English country manor. Apart from the English-style garden, artfully decorated with classical sculpture, there is an Oriental garden and sunken bog gardens. In addition to the mansion, they constructed Christ Church Cranbrook and an outdoor Greek-style theater that is integrated into the gardens. Man-made Kingswood Lake supplies water for a nearby mill. The Booths used a gondola for lake excursions. Now students canoe on the water, which offers a thriving habitat for swans, ducks, and geese.

The private academy started in the 1920s as a boys' boarding school. It now offers classes from kindergarten through high school, plus graduate work in art. The Academy of Art was the final addition, although it was the first project the Booths conceived when they set out to create the educational and artistic enclave.

Admission free; fee for guided tours. Picnicking is not allowed.

How to Get There: Cranbrook is 18 miles north of downtown Detroit, between Lone Pine and Long Lake Road.

Cranbrook Academy of Art Museum
1221 N. Woodward Avenue
Bloomfield Hills, MI 48303
810-645-3323

Hours: 10:00 A.M.-5:00 P.M., daily; 11:00 A.M.-4:00 P.M. on Sunday, May through August; 1:00 P.M.-5:00 P.M. daily, and 11:00 A.M.-3:00 P.M. on Sundays in September; noon-4:00 P.M. on weekends in October.

Minnesota

General Mills Art Collection

Minneapolis, Minnesota

In the land of Wheaties and Betty Crocker is a premier collection of modern American sculpture. This 85-acre corporate headquarters, in the Minneapolis suburb of Golden Valley, was once an apple orchard and truck farm.

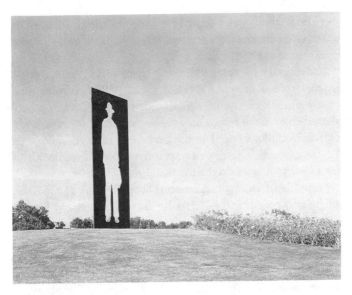

Jonathan Borofsky, *Man with Briefcase* (1987), General Mills, Inc., Minneapolis, MN

The formerly flat countryside was molded into gently sloping hillsides and berms to accommodate seventeen outdoor sculptures. Gently curving paths of pink and gray paving stones set in a geometric pattern soften the rigidly corporate look of the headquarter's buildings, designed by Skidmore, Owings, and Merrill in 1958. Outdoor pieces were first commissioned in 1968, a time when corporations began using sculpture to humanize the starkly modern architecture of the period.

The signature work is Jonathan Borofsky's *Man with Briefcase*, a 30-foot-high Cor-ten steel cutout that dominates the landscape. Its rigid and rusted steel frame silhouettes an ever-changing panorama of sky and clouds. This commissioned piece created a stir when it was installed in 1987; many women objected to its macho image, while a few men believed it satirized business executives.

Elyn Zimmerman's *Morbihan* is a study in contrasting textures. The sculptor fashioned a tall cluster of rough-hewn rose granite slabs intersected with slices of highly polished dark gran-

ite. The textural contrasts are heightened by the circular bed of gravel chips on which the sculpture sits, and by the two airy pine trees that frame the work.

Overlooking a pond is Richard Artschwager's *Oasis*, a granite construction designed as tiered seating. Wide platforms lead to a high-backed throne that sits atop a series of irregularly shaped steps. *Oasis* represents an ironic reversal; in this case, the oasis is not a lush refuge in the desert, but hard granite placed amidst greenery. This piece compels the viewer forward with an invitation to preside on the throne.

Another friendly installation is Scott Burton's *Picnic Table*, a light gray concrete table, 13 feet in diameter. The table is in the form of a cone, with the tip of the cone seeming to balance precariously on the circular 20-foot base. Burton was a pioneer in creating functional public art, such as benches, tables, and chairs. His sculptural forms are so practical that his work often goes unrecognized as sculpture. His table at General Mills is a magnet for workers who bring chairs to dine alfresco.

Jackie Ferrara's 65-foot-long *Stone Court* is constructed from gray limestone paving stones. Broad steps frame a 24-foot-high wall, and free-standing stools are set between the steps. This piece is a departure from her typical interlocking wooden structures in a Mayan motif, but it clearly evokes the Indian sensibility that is her trademark. General Mills uses the piece for corporate functions, and it is a popular picnic spot.

General Mills commissioned Siah Armajani to design a long, covered bridge at the corporate parking lot to protect employees and visitors from the harsh Minneapolis winters. The bridge of glass, steel, wood, and sheet metal has sections that resemble small houses, and tall vee-shaped glass openings create an inviting entrance to the buildings. The variety of shapes and the twists and turns along the route distinguish this walkway from the typical pedestrian tunnel. The bridge's appearance changes throughout the day as sunlight is reflected at different angles. Artfully installed lighting emits a glow on the bridge in the evening.

The well-tended grounds, with fields of grass, arrays of flowers, and serene ponds, were designed by William A.

Rutherford, the landscape architect for Storm King. Rutherford favors natural settings as opposed to formal gardens and uses landscaping to enhance the sculpture.

Sculptors in the collection include Siah Armajani, Richard Artschwager, Steve Beyer, Andrea Blum, Jonathan Borofsky, Scott Burton, Pietro Consagra, Jackie Ferrara, Richard Fleischner, Jene Highstein, John House, Chuck Huntington, Mel Kendrick, Philip Larson, John Newman, Richard Serra, and Elyn Zimmerman.

The outdoor collection is documented in a brochure that includes a map.

How to Get There: General Mills is a 10-minute drive from the Walker Art Center, at the crossroads of Highway 169 and I-394.

General Mills, Inc.
General Mills Boulevard
Minneapolis, MN 55440
612-540-7269
Hours: Open to the public at all times.

Walker Art Center

Minneapolis Sculpture Garden

Minneapolis, Minnesota

The Walker Art Center has one of the finest collections of contemporary outdoor sculpture in the country. It is showcased in small, classic settings and in open, informal areas. Photo opportunities abound; a picturesque basilica in the distance provides a classical backdrop for many of the large-scale contemporary works.

The standout hit of the collection is *Spoonbridge and Cherry,* a gigantic quixotic creation of the husband-wife team of Claes Oldenburg and Coosje van Bruggen. Rising from a free-form pool is an improbable pale gray spoon that balances an eternally glistening deep red cherry. The sheen is produced by water flowing down the cherry's sides. The sculpture is the symbol for Minneapolis and a frequent setting for wedding photos.

Spoonbridge is classic Oldenburg; his international reputation

is based on his wild exaggeration of such everyday objects as lipstick, clothespins, hamburgers, and ice cream cones. Oldenburg is part of the Pop Art genre, artists who infuse mass-produced articles of popular culture with extraordinary significance. His pedestrian objects writ large challenge viewers to consider the implications of contemporary culture. As Oldenburg sees it, "Art should be literally made of the ordinary world. Its space should be our space; its time our time; its objects our ordinary objects; this reality of art will replace reality."

Towering at the garden entrance is Martin Puryear's *Ampersand*, two 14-foot-high gray granite columns, each tapered at one end to form a cone. One column is set cone-side down; the other with the cone pointing skyward. These massive pieces echo the formality of the garden, yet undercut its formalism "by standing symmetry on its head," as Puryear expressed it. He was a

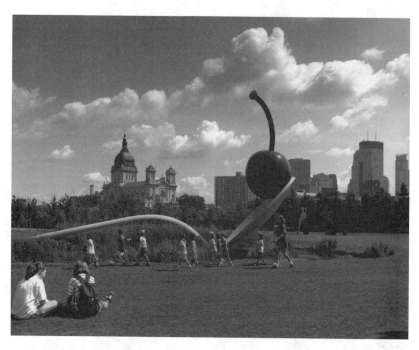

Claes Oldenburg and Coosje van Bruggen, *Spoonbridge and Cherry* (1985-1988), Walker Art Center, Minneapolis, MN

Peace Corps volunteer in Sierra Leone, where he was drawn to sculpture after a career as a painter. He is one of the few widely recognized contemporary black sculptors.

Most of the sculpture at the Walker is contemporary and was purchased in the 1980s. A particularly striking commission is Jackie Ferrara's *Belvedere*. Hundreds of precisely fitted cedar planks are fashioned into a T-shaped deck, with benches at one end and a 10-foot-high open gateway at the other. Slits in the gateway create lively patterns of light and shadow. *Belvedere* is a popular resting spot and a performance space.

The Walker's original 7.5-acre formal sculpture garden emerged from a dried-up lakebed next to the Walker Art Center and the Guthrie Theater. Opened in 1988, it was inspired by the sixteenth-century Boboli Gardens at the Pitti Palace in Florence. Carefully designed vantage points allow the sculpture to be seen clearly. Attractive benches at frequent intervals encourage visitors to linger.

The classic gardens are laid out in four 100-foot squares, tree-enclosed roofless rooms, each of which contain two or more large sculptures. In one square, three titans of minimalist sculpture—Ellsworth Kelly, Richard Serra, and Tony Smith—are represented with massive steel constructions. In another is Jenny Holzer's *The Living Series*, twenty-eight white granite benches, each inscribed with an idiosyncratic Holzer aphorism, such as "There is a period when you know you have gone wrong but you continue. Sometimes there is a luxurious amount of time before anything bad happens." The inscribed benches conform to Holzer's notion of how art should be viewed: "I realized that people don't like to stand and read in galleries and I thought they should be able to sit down."

The sculpture garden was expanded by nearly 4 acres in 1992. Landscape in the new section features an open sculpture plaza and winding paths. Borders of the garden are delineated with closely spaced hedges. The long rectangular sculpture plaza, with a carnelian granite floor and a high brick wall, offers an ideal setting for the center's temporary exhibitions. Featured in recent exhibitions have been such luminaries as Magdalena Abakanowicz and Joel Shapiro.

The cultural complex is joined to the business district and Loring Park with a dramatic 375-foot-long footbridge designed by Siah Armajani, an artist acclaimed for his structural sculpture. The double-arched Whitney Bridge spans an intrusive 16-lane highway. Its two steel arches, one swooping skyward and its duplicate sweeping downward, create a vibrant sense of motion. The garden side of the bridge is painted light yellow, the color of happiness and a tribute to Jefferson's Monticello. The downtown side is baby blue, Armajani's antidote for Minnesota's long, gray Minnesota winters. Lines of poetry specially written for the bridge by the American poet John Ashbery were cast in bronze and embedded in the wooden floor. Architecture critic Paul Goldberger called the bridge a "loving tribute to the two great types of monumental bridges, suspension and truss, which Mr. Armajani has in effect woven together to create a new visual form."

Also on the grounds is the Cowles Conservatory, a 250-foot-long tripartite, six-story glass cage with towering palms, topiary arches, and a profusion of flowers. The centerpiece is architect Frank Gehry's 25-foot-tall *Standing Glass Fish* that sparkles in a serene pool amid floating water lilies.

The Walker was established as a museum in 1879 by Thomas Barlow Walker, a Minneapolis lumberman and civic benefactor. The current museum building, opened in 1971, was designed by Edward Larrabee Barnes. Landscape architect Peter Rothschild designed the original sculpture garden; its expansion was designed by landscape architect Michael Van Valkenburgh.

The garden is an inspired public-private collaboration between the city's Park and Recreation Board, which owns the garden and oversees maintenance and security, and patrons of the Walker who raised funds for construction and the sculpture. The garden is a prime Twin Cities attraction and a magnet for more than a million visitors a year.

Sculptors whose work is represented include Kinji Akagawa, Siah Armajani, Saul Baizerman, Scott Burton, Deborah Butterfield, Alexander Calder, Anthony Caro, Tony Cragg, Mark di Suvero, Jackie Ferrara, Barry Flanagan, Lucio Fontana, Frank Gehry, Charles Ginnever, Brower Hatcher, Jene

Highstein, Jenny Holzer, Ellsworth Kelly, Georg Kolbe, Philip Larson, Eric Levine, Sol Lewitt, Jacques Lipchitz, Giacomo Manzu, Marino Marini, Henry Moore, Reuben Nakian, David Nash, Isamu Noguchi, Claes Oldenburg and Coosje van Bruggen, Martin Puryear, George Segal, Richard Serra, Judith Shea, Peter Shelton, Jonathan Silver, Tony Smith, Richard Stankiewicz, and Ursula von Rydingsvard.

Admission to the garden is free. On weekends, April through October, free guided tours leave from the Cowles Conservatory at 1:00 P.M.

The museum's restaurant is open for lunch Tuesday through Sunday; a lunch cart is stationed at the front entrance during the summer.

How to Get There: The Walker sculpture garden is within walking distance of downtown Minneapolis. Follow Nicollet Mall to Grant Street; proceed west to Loring Park; cross park to the Whitney Bridge at its west end. By bus, MTC routes 1, 4, 6, 12, and 28 all serve the garden. From St. Paul and the north and west suburbs, take the Hennepin/Lyndale Avenue exit off either I-94 or I-394.

Walker Art Center
Minneapolis Sculpture Garden
Vineland Place
Minneapolis, MN 55403
612-375-7600
Hours: Sculpture garden, 6:00 A.M.-midnight, daily. Museum, 10:00 A.M.-8:00 P.M., Tuesday through Saturday; 10:00 A.M.-5:00 P.M. Sunday.

Missouri

Laumeier Sculpture Park

St. Louis, Missouri

Easygoing hospitality is a keynote of this top-flight sculpture park, set in 96 acres of suburban St. Louis County. Laumeier was one of the first parks in the country to embrace contempo-

rary sculpture, a particularly adventurous commitment for a public park supported by local taxpayers.

The hallmark of Laumeier's collection is Alexander Liberman's *The Way*, a stadium-size abstract in vivid red steel tubing. Constructed from oil drums, it towers 50 feet over an open grassy field. This bold geometric construction was a gift from the artist, and its image is emblazoned on many of Laumeier's promotional materials.

Liberman's fame as an artist was secured in 1959 with a show of his photographs at MoMA in New York City. His career as a sculptor was launched the same year when his mastery of the welder's torch literally sparked his imaginative talent for large-scale steel sculpture. He fashioned works from cheap and readily available industrial objects, such as cast-iron boilers and discarded gas tanks. Liberman achieved his position in the top rank of contemporary sculptors with a 1977 show at Storm King. Art critic John Russell, reviewing the exhibition, referred to his work with gas tanks and pipes as "phallic artillery." Liberman has expressed the hope that viewers will have a sense of exaltation akin to that felt by parishioners in ancient cathedrals and mosques. His enormous sculptures have a buoyant quality that belies their tremendous mass and weight.

Laumeier was a pioneer in commissioning site-specific works. Judith Shea's *Public Goddess*, at the museum entrance, presides at the center of an elaborately sensual, heart-shaped rose garden, constructed to represent the heartland of America. The voluptuous, headless *Goddess* stands tall on her pedestal, enclosed with fine-gauged fencing that reaches to her waist. In many of her recent works Shea blends historical and modern concepts; here the headless figure, set in an American setting, could be a reference to the goddess figures of ancient Egypt.

Beverly Pepper's *Cromlech Glen* is two mammoth grassy mounds resembling breasts of an earth mother. Small recessed wooden steps traverse the steep incline. The expanse of towering grass is an ideal performance space and picnic area. This installation is similar to ones she created in Dallas and Barcelona, and utterly unlike the metal sculptures for which she is better known. Pepper, a native New Yorker, has lived for many

years in Italy. Her work reflects pilgrimages to churches, ancient temples, and theaters. A singular influence was a 1960 trip to Angkor Wat, where she saw statuary strangled in massive tree roots. "I left a painter and came back as a sculptor," is how she described the trip.

Laumeier's woodlands and open areas are dotted with a growing collection of environmental constructions. David Nash's *Black Through Green* is a slash of weathered black logs set out in wide steps as a path in the woods. Meg Webster's *Pass* is an extensive ecological rendering of Missouri's historic natural environments. She created a wildflower field, ponds, a swamp, and a stream, all as natural settings. These artifacts of nature were not designed as immutable installations, but as evolving constructions that reflect the effects of weather. The forms and materials will eventually fade into the dense natural landscape.

Mary Miss and Jackie Ferrara created dramatic wooden sculptures, set majestically among the trees. Miss' *Laumeier Project*, created in 1985, is one of the most popular in the park. It covers an acre surrounding a large abandoned concrete pool.

Alexander Liberman, *The Way* (1972-1980), Laumeier Sculpture Park, St. Louis, MO

A long pine boardwalk leads to open lattice structures that overlook the pool. Overhead trellises, combined with the airy openness of the construction, give it a vaguely Oriental flavor. Ferrara's stepped, red cedar pyramid is a powerful, Mayan-like sculpture. The piece was expected to last no more than two years, but cedar is a durable wood, and it is still going strong, eight years later. When snow covered, the stepped sculpture seems softened and completely in tune with its setting.

A special delight for children is Vito Acconci's *Face of the Earth III,* a large circular concrete and sod construction that represents the human face. Youngsters scamper along the gently stepped perimeter, jump in the depressions created by the facial features, and use the sculpture as a playground.

Laumeier's most recent acquisition is Joyce Scott's *From When We Came?* a high-flying beaded African woman giving birth to four babies as she swings in the archway near the museum. The title refers to the possible origins of humanity. The brightly colored supporting wires and the figure's vividly patterned clothing evoke the image of a stained glass window. Scott worked with local high school students, who chiseled totem-style figures from coal, set them in the sculpture, and helped in collecting and assembling the piece.

Laumeier is a leader in attempting to accommodate sight-impaired visitors. More than a dozen "blind maquettes," or scaled-down versions of large pieces, are set on knee-high concrete pedestals for fingertip exploration.

Laumeier was founded in 1976, when St. Louis banker and art patron Adam Aronson transformed the former country estate of Mathilda and Henry Laumeier into a lavish sculpture garden. Museum headquarters are in the Laumeier's 1916 Tudor-style limestone mansion. The park's success confounded local skeptics who doubted that sculpture could draw the public. Now one of the Midwest's most popular parks, it attracts 350,000 visitors annually.

The collection was initiated with St. Louis sculptor Ernest Trova's donation of forty of his works. Trova is known the world over for his elegant *Falling Man* series, highly polished robotlike male figures, usually standing or encircled in a wheel. One of the

distinctive *Falling Man* sculptures is the centerpiece of the garden pool just below the mansion's terrace.

The museum presents four exhibitions a year on contemporary sculpture, drawings, paintings, ceramics, and photography. A wide variety of educational and cultural events, such as concerts, outdoor films, and dance performances, are presented on the outdoor stage.

Sculptors represented include Vito Acconci, Alice Aycock, Fernando Botero, Anthony Caro, Mark di Suvero, Walter Dusenbery, Jackie Ferrara, Ian Hamilton Finlay, Richard Fleischner, Charles Ginnever, Andy Goldsworthy, Dan Graham, Nancy Graves, Michael Heizer, Hera, Jene Highstein, Richard Hunt, Jerald Jacquard, Donald Judd, Jun Kaneko, William King, Alexander Liberman, Donald Lipsky, Giacomo Manzu, Carl Milles, Mary Miss, Robert Morris, Clark Murray, David Nash, Louise Nevelson, Dennis Oppenheim, Beverly Pepper, George Rickey, Tony Rosenthal, Joyce Scott, Richard Serra, Judith Shea, Robert Stackhouse, Richard Stankiewicz, Michael Steiner, Ernest Trova, William Tucker, Ursula von Rydingsvard, David von Schlegell, Meg Webster, and Isaac Witkin.

No admission fee. An illustrated map is provided for self-guided tours. Video and audio cassette guides are also available. Free public tours on Sunday at 2:00 P.M., May through October. Group tours can be arranged. Picnicking is encouraged. Dogs permitted on leash.

How to Get There: The park is a 15-minute drive from downtown St. Louis, in Sunset Hills, South County. Take U.S. 40 or I-44 to Lindbergh Boulevard, south to Rott Road and west to the north gate, or follow Rott Road as it winds around to the west gate. The park is 1 mile southwest of 1-44.

Laumeier Sculpture Park
12580 Rott Road
St. Louis, MO 63127
314-821-1209
Hours: 8:00 A.M. until half an hour after sunset, every day. Museum: 10:00 A.M.-5:00 P.M., Tuesday through Saturday; noon-5:00 P.M. on Sunday. Closed on Thanksgiving, Christmas, and New Year's Day.

Nelson-Atkins Museum of Art

Henry Moore Sculpture Garden

Kansas City, Missouri

This is a Henry Moore extravaganza. The Nelson-Atkins collection of Moore's monumental bronze sculptures is the world's largest, except for the sculptor's works at Hoglands, Moore's studio and seventeenth-century farmhouse in Much Hadham, England.

Henry Moore (1898-1986) is perhaps the best known sculptor of the century. He was widely praised in England, although surprisingly, this adulation did not translate into a knighthood. He was incredibly prolific; with the possible exception of Alexander Calder, his works are in more public spaces than any other sculptor. His enduring human shapes, many in the form of a nurturing mother with child, are instantly recognized. Moore's sensuous amoebalike forms and voluptuous reclining females are unforgettable images and vivid testament to his boundless creativity. While his genius is distinctly his own, the influences of other modern giants can be seen in his works; the distorted female forms reflect Picasso, and many of his shapes are reminiscent of the surrealistic fantasies of Joan Miro and Yves Tanguy. His study of Mexican art and Mayan and Toltec statuary is reflected in many of his pieces.

The bulk of the Henry Moore collection came to the Nelson-Atkins in 1986, when Wichita oil magnate George Ablah and his wife dispersed their Moore collection, then the most extensive in the world, with more than a hundred works. Kansas City acquired its collection through the largesse of the Hall Family Foundation, a local charity formed by the founders of Hallmark Cards.

The foundation purchased fifty-three Moores, including ten monumental sculptures, nineteen working models, and twenty-five bronze-cast maquettes. The Nelson-Atkins collection also includes three pieces acquired from other sources. The massive sculptures are placed in a specially designed 17-acre garden that is part of a 36-acre city-owned park just south of the museum.

Claes Oldenburg and Coosje van Bruggen, *Shuttlecocks* (1995), Nelson-Atkins Museum of Art, Kansas City, MO

The garden, opened in 1989, was designed by Vermont landscaper Daniel Urban Kiley and University of Virginia School of Architecture Dean Jacquelin Taylor Robertson. In creating the design, they toured European sculpture gardens and visited Moore's studio in the English countryside.

The garden would surely have pleased Moore, a classic modernist who favored placement of sculpture in open areas among rustic elements of rocks and trees. His sculpture is displayed in the woods along meandering limestone paths on either side of the grassy central rectangular mall and on terraces close to the museum. The informal, pastoral setting in the gently rolling terrain evokes the meadowed landscape of the sculptor's home. Many of the works are hidden from immediate view by groves of trees. Strategic placement allows each piece to speak with an individual voice. Several works are mounted on low pedestals and

slabs, inviting visitors to come close and touch them. The setting is particularly enticing in the spring, when fifty thousand naturalized daffodils burst into bloom.

Moore died in England just months before the Nelson-Atkins acquisitions were announced. But he did have a hand in siting an earlier sculpture, *Sheep Piece,* two romping, woolly creatures in bronze. It still stands where Moore designated in 1976, at the far end of the garden. The 6-ton, 18-foot-tall, abstract sculpture, originally intended as a scratching post for English sheep, is one of Moore's most popular pieces. It was created as a gift for a neighbor whose sheep grazed on the sculptor's land in Much Hadham. Because of its size and weight, it was brought to the city by barge. This work was acquired thanks to a local farmer, who directed that funds from his estate be used by the city to acquire a sculpture that paid homage to the city's pioneering spirit.

A recent stunning addition to the museum's outdoor collection is *Shuttlecocks,* created in 1994 by Claes Oldenburg and Coosje van Bruggen. Four enormous painted badminton shuttlecocks made of aluminum and fiberglass-reinforced plastic are poised around the museum—near the entrance, on the terrace, and on the upper and lower lawns. The playful, seemingly light-as-air feather shuttlecocks appear to have just floated earthward from a cosmic badminton game. This husband-and-wife team of Oldenburg, the sculptor, and van Bruggen, a writer and art historian, is a singular blending of talents. Earlier works by Oldenburg include such memorable large-scale icons as *Batcolumn* in Chicago and *Flashlight* in Las Vegas. Oldenburg delves beneath of surface to expose, as he says, a "parallel reality."

Oldenburg's works are known the world over. Art critic Calvin Tomkins wrote that Oldenburg's works "appear to have a widespread appeal even to the sort of people who might be expected to hate them. He has become a popular artist, without compromising his own anti-establishment, anti-heroic vision, and that, of course, gives art critics the willies."

The Beaux Arts-style museum building was opened in 1933. Its original garden plan was scuttled by the Great Depression. The museum is widely known for its collection of Oriental art.

Admission is free. A map pinpoints locations of the sculpture. The museum has a bookstore and a restaurant.

How to Get There: The garden borders Brush Creek Boulevard, Oak Street, Rockhill Road, and the museum; one-half mile northeast of Country Club Plaza. ATA Metro bus system provides frequent service on three lines. Trolleys run from downtown to Country Club Plaza, near the Sculpture Garden on the northbound trip.

Nelson-Atkins Museum of Art
Henry Moore Sculpture Garden
4525 Oak Street
Kansas City, MO 64111
816-561-4000
Hours: 10:00 A.M.-5:00 P.M., Tuesday through Saturday; 1:00 P.M.-5:00 P.M., Sunday. Sculpture garden is open every day during daylight hours.

Nebraska

University of Nebraska

Sheldon Sculpture Garden

Lincoln, Nebraska

The Lincoln campus is host to three dozen predominately modern sculptures created by internationally celebrated artists. The garden opened in 1970 with five major works, and is continually expanding. This was among the first gardens designed specifically to display sculpture, and it serves as a model for many other outdoor sculpture installations.

Most of the sculpture is in the rectangular garden behind the Sheldon Art Gallery. The garden's sunken court and a series of broad terraces offer an endless variety of perspectives for viewing the art. Several massive pieces are displayed in open areas, away from the gallery.

Fittingly, the collection includes Daniel Chester French's *Abraham Lincoln*, a bronze figure of the Great Emancipator with head bowed and hands clasped, that was cast from the plaster

maquette now in the Sheldon Gallery. It is a smaller version, just over 3 feet, of the oversized 8-foot-tall Lincoln that presides at the state capitol building. French's most famous Lincoln is his seated version at the Lincoln Memorial in Washington, D.C.

Another early modern master is Gaston Lachaise's generously proportioned *Floating Figure*. With giant legs extended and her ample arms outstretched, she appears to float effortlessly over the high ground near the gallery. For many years the Lachaise figure was suspended above a reflecting pool; it was moved to the nonaquatic setting in 1993 when Director George Neubert realized that the loftier, garden setting enhanced the figure's remarkable fluidity.

Nearby is Elie Nadelman's *Man in the Open Air*, a nude man in bowler hat and bowtie, quizzically leaning against a barren tree. The figure was created in 1915 when the artist first arrived from Poland.

Mammoth works of more recent vintage, by Mark di Suvero, Michael Heizer, and Richard Serra, are placed elsewhere on campus. Di Suvero's *Old Glory* is a favorite with students. This spare grouping of space-jabbing I-beams is painted appropriately in red to accompany the blue sky and white clouds. Heizer's *Prismatic Flake Geometric*, a 35-foot-long elegant canoe-shaped form, captures a Native American sensibility. Created in 1991, the piece is a departure from the enormous earthworks for which the sculptor is best known.

Serra's decidedly muscular *Greenpoint* dares the visitor to enter the interior space contained within two 16-foot-tall steel plate semicircles that tilt slightly inward, giving a somewhat menacing feel to the work. The 40-ton piece is named for the Brooklyn, New York area where Serra has his warehouse studio.

A more sedate recent sculpture is Judith Shea's *Shield*, a bronze dress, perhaps on a display form since the human body is nowhere indicated. Judith Shea's background in the fashion industry undoubtedly influenced this classical bronze work. Its male counterpart, a bronze coat titled *Post-Balzac*, is at the Hirshhorn sculpture garden in Washington, D.C.

A commission by Claes Oldenburg and Coosje van Bruggen will be installed in 1996 at the main campus entrance,

linking "town and gown." It is expected to become a logo for both the university and for Lincoln. Entitled *Torn Notebook*, the steel and aluminum sculpture sprouts a 20-foot-high spiral arising from the ground; several 10-foot-high torn and furled notebook pages erupt from the spiral. The twisted spiral binding shape is a reference to the vicious Nebraska tornadoes. The outline of the pages conforms to the shape of Nebraska. The Swedish-born Oldenburg turned away from abstract art in the early 1950s and became a leader in the Pop Art movement that took as its theme objects from everyday life. He is renowned for his humorous monumental creations.

Sculpture is very much a part of the academic scene; it is an important part of the prestigious Museums Study program, as well as in art and architecture courses. Students create strong bonds with the sculpture, stimulated in part by its introduction during freshman orientation.

Campus landscaping is so impressive and extensive that the campus was inducted into the statewide arboretum in the early 1990s. The campus is colorful year-round, with flowering bulbs in spring, brilliantly hued summer perennials, fall foliage, and winter evergreens. Trees, bushes, and flowers are labeled, and the university provides a walking map of its extensive gardens.

The garden is named for Mary Frances Sheldon and her brother Adams Bromley Sheldon, Nebraskans who were principal donors for the construction of an art gallery.

Sculptors represented on campus include Alice Aycock, Saul Baizerman, Mark di Suvero, Daniel Chester French, Charles Ginnever, Juan Hamilton, Michael Heizer, Bryan Hunt, Jim Huntington, William King, Lyman Kipp, Gaston Lachaise, Jacques Lipchitz, Bruno Lucchesi, Richard Miller, Robert Murray, Elie Nadelman, Reuben Nakian, Claes Oldenburg and Coosje van Bruggen, Sam Richardson, Bernard (Tony) Rosenthal, Julius Schmidt, Richard Serra, Judith Shea, David Smith, Tony Smith, Louis Sullivan, Donald Sultan, Michael Todd, William Tucker, Brian Wall, and William Zorach.

No admission fee. A detailed map is available at the Art Gallery for self-guided tours.

How to Get There: The campus abuts downtown Lincoln to the north, at Q Street, between 10th and 16th streets.

University of Nebraska
Sheldon Sculpture Garden
12th and R Streets
Lincoln, NE 68588-0300
402-472-2461
Hours: Open year-round.

Ohio

Columbus Museum of Art

Columbus, Ohio

The museum's outdoor collection of abstract and figurative sculptures by esteemed modern masters is first encountered at the entrance, where the angular and linear contemporary works offer a distinctive foil for the elaborate Italian Renaissance museum building.

Stephen Antonakos' huge and colorful *Neon for CMA* presides at the building entrance. Nearby is Alexander Calder's 12-foot-tall black iron *Intermediate Model for the Arch.*

Prominently featured is Henry Moore's abstract human form *Three Piece Figure Draped,* which dominates the expansive lawn near the museum. On another section of the lawn are Robert Murray's bright turquoise stainless steel *Wasahaban* that resembles a piece of folded cloth and David Deming's abstract stainless steel *Terrestrial Guest.*

A highlight of the museum's sunken garden is a reflecting pool festooned with lilypads. The garden and landscaped sculpture areas were designed in 1979 by Britain's preeminent garden architect Russell Page; a 1992 renovation recaptured Page's original signature style, which typically features bubbling water and generous flower displays. White roses around the periphery of the garden bloom throughout the summer. Red maples provide color in the fall.

A popular work within the garden is John Geofrey Neylor's

Streams, a stainless steel fountain in the shape of a wave, which simulates the comforting musical whish and roar of tidal movements.

Looming over the garden is the Broad Street United Methodist Church, an old limestone building that provides a compatible contrast with the quiet elegance of the contemporary sculpture garden.

The museum, the first to be established in Ohio, was founded in 1878. It holds the largest collection of paintings by George Bellows, a native of Ohio.

Artists represented include Stephen Antonakos, Emille-Antoine Bourdelle, Lynn Chadwick, David Deming, Jackie Ferrara, Chaim Gross, Barbara Hepworth, William King, Bruno La Verdiere, Aristide Maillol, Giacomo Manzu, Gerhard Marcks, Clement Meadmore, Henry Moore, Robert Murray, John Geofrey Neylor, George Rickey, Kenneth Snelson, Ernest Trova, and Laura Ziegler.

Admission fee. Handicapped accessible. A cafe overlooks the sculpture garden.

Aristide Maillol, *La Montagne* (1937), Columbus Museum of Art, Columbus, OH

How to Get There: Columbus is in the center of the state, on Route 71, approximately 100 miles northeast of Cincinnati. The museum is 10 blocks east of downtown Columbus, at the corner of Washington and Broad Streets in the "Discovery District."

Columbus Museum of Art
480 E. Broad Street
Columbus, OH 43125
614-221-6801
Hours: 11:00 A.M.-4:00 P.M., Tuesday through Friday; 10:00 A.M.-5:00 P.M., Saturday; 11:00 A.M.-5:00 P.M., Sunday; Thursday open until 9:00 P.M.

Wisconsin

Bradley Sculpture Garden

Milwaukee, Wisconsin

Many of the world's finest sculptors from the 1960s and 1970s are represented in this 40-acre landscaped English garden. Focal points on the lavish grounds are a large free-form lake and a graceful wooden footbridge. Other attractions include a waterfall, rose garden, and hundreds of mature trees and shrubs. This is an exquisite setting for the collection of more than sixty pieces of sculpture.

Brilliantly colored abstract works around the garden's outer perimeter entice the eye and contrast wonderfully with the mass of greenery. Floating in the lake is Marta Pan's red polyester *Floating Sculpture No. 3.* Along the outer rim are George Sugarman's rollicking circular yellow aluminum *Trio,* Mark di Suvero's red steel *Lover,* John Henry's yellow aluminum *Pin Oak,* and Alexander Liberman's vivid red *Axletree.* Linda Howard's *Sky Fence,* a triangular-shaped aluminum piece with slats of vibrant blue, is in the far distance beyond the lake.

Four Barbara Hepworth pieces placed near the lake present an opportunity to study the contrasting forms, styles, and textures created by this premier English sculptor. Her bronze *Sea Form* is a potent example of her characteristic oval and circular

openings that provide endless variations on the play between the sculpture and its surroundings. Hepworth, a key figure in England's abstract sculpture movement, was married to sculptor Ben Nicholson and was a long-time friend and associate of Henry Moore. Like Moore, she had a keen interest in the human figures, although her style was more abstract than his. Hepworth began sculpting in the 1930s, but was very much an outsider for nearly three decades. Not until the 1960s were her artistic accomplishments widely recognized; she was named a Dame of the British Empire. Hepworth died in 1975 in a fire at her studio near the Cornish fishing village of St. Ives, now the site of a museum devoted to her works.

Gerhard Marcks' satirical *Bremen Town Musicians* sits on a pedestal near the rose garden. This four-level piece with a donkey as its base and a crowing rooster on top was the first piece acquired in the collection in 1962.

The sculpture garden was established on the estate of Harry Lynde Bradley and his wife, who were generous art patrons in Milwaukee. Mr. Bradley was a founder of Allen-Bradley Co., a leading manufacturer of electric controls and components. The garden is now managed by the Bradley Family Foundation.

Sculptors represented in the collection include Alexander Archipenko, Barankenya, Max Bill, Barney Bright, Robert Burkert, Samuel Buri, Aldo Calo, Ephraim Chaurika, Lindsay Daen, Mark di Suvero, Sorel Etrog, Charles Ginnever, Duayne Hatchett, Bernhard Helliger, John Henry, Barbara Hepworth, Linda Howard, Ellsworth Kelly, Lyman Kipp, Bernard Kirschenbaum, Israel Kondo, Alexander Liberman, Heinz Mack, Gerhard Marcks, Clement Meadmore, Antoni Milkowski, Henry Moore, Lemon Moses, Robert Murray, Masayuki Nagare, Isamu Noguchi, Marta Pan, Beverly Pepper, George Rickey, John Rood, James Rosati, Ernest Shaw, Arlie Sinaiko, Tony Smith, George Sugarman, William Underhill, and Isaac Witkin.

Admission fee. Small charge for the tour given by docents from the Milwaukee Art Museum.

How to Get There: The garden is just east of Route 43, close to Lake Michigan. Directions are provided when tour reservations are made.

Bradley Sculpture Garden
2145 West Brown Deer Road
Milwaukee, WI 53217
414-276-6840
Hours: Open by reservation only; tours can be arranged (except in the winter) for any day of the week, with ten days advance notice.

Fred Smith's Wisconsin Concrete Park

Phillips, Wisconsin

Tucked away in a rural village near the Chequamegon National Forest in northern Wisconsin is a festival of concrete sculpture, all created by a single artist. Fred Smith was a lumberjack who created an enormous and singularly personal collection of folk art. His concrete statues extol American events, virtues, and phenomena. They depict historical events involving Native Americans and local settlers as well as animals and mythic characters of local and national significance. Titles such as *Deer Family, Lumberjack, American Flag,* and *Angora Cat* suggest the flavor of his subjects. *From the Movie Ben-Hur* is a massive tableau of the movie's chariot race. *Barbecue* celebrates Cleveland's victory in the 1948 World Series.

Smith started his 16-acre park in 1949, when he retired from lumberjacking. Just as more famous artists such as Louise Nevelson constructed sculpture from found objects, Smith scavenged broken glass, reflectors, and mirrors to decorate his concrete figures. He fashioned more than two hundred monuments, creating the park "as a gift for all the American people." Smith was so personally tied to his work that he refused to sell his statues, even when offered substantial sums. He felt his life's work belonged together, both as a collection and as a statement.

He worked until 1964, when he suffered a stroke. After his death in 1976, the Kohler Foundation bought Concrete Park when it became clear that Wisconsin's harsh winters and a decade of neglect were conspiring to decimate his unique artistic accomplishments.

Restoration had barely begun in 1977 when a severe wind

storm damaged more than 70 percent of Smith's concrete statues, destroyed his studio, and uprooted his carefully planted trees. Many of the works had to be reassembled after conservators discovered the wooden cores were rotten. When the restoration was completed in 1978, the Kohler Foundation gave the park to the county. Nearly ten thousand tourists a year, many from abroad, flock to this remarkable northern Wisconsin folk art collection.

Admission is free. Picnicking is permitted. A Chamber of Commerce pamphlet describes the park and the sculpture.

How to Get There: The park is off Highway 13 in rural Phillips, two hours from Duluth, five hours from Madison, an hour from Wausau, and about three hours from the Twin Cities.

Fred Smith's Wisconsin Concrete Park
Phillips, WI
715-339-4100 (Chamber of Commerce)
800-269-4505 (Price County Tourism)
Hours: Open to the public year-round.

More Sculpture Attractions in the Midwest

Illinois

Chicago's **Museum of Contemporary Art** is currently engaged in a massive construction program that will provide a facility four times larger than its current building. The new museum is on the site of the former National Guard Armory, four blocks north of the present museum, on Chicago Avenue just east of Michigan Avenue. The museum, expected to open in July 1996, will have a 1-acre terraced sculpture garden overlooking Lake Michigan.

Just outside Evanston, in Skokie, colorful flags mark the entrance to the **Skokie Northshore Sculpture Park.** The city transformed a barren North Shore channel embankment into a graceful sculpture park that welcomes strollers, bikers, joggers, dog walkers, and bench sitters. The channel's edge is marked with thriving prairie grasses. Several hundred trees were planted to

attract native birds. The half-mile-long, 200-foot-wide park has nine large-scale pieces, primarily by emerging artists. All are on long-term loan. Vandalism is kept to a minimum by watchful park devotees who call City Hall when even minor damage to the sculpture is observed. The park, which is open at all times, is on McCormick Boulevard, between Main and Dempster streets.

An hour's drive from Chicago, at Ottawa, is a gigantic modern-day version of the ancient Native American effigy mounds. Here, prominent land sculptor **Michael Heizer** was commissioned to create his *Buffalo Rock Effigy Trumuli*, in an effort to reclaim lands decimated by strip mining in the 1930s. On a 200-acre plateau above the Illinois River, Heizer fashioned five giant animal forms in the stricken landscape. Taking a page from the ancient moundbuilders, he created colossal images of a frog, catfish, water spider, snake, and a turtle. These forms, 1,000 feet long, 25 feet wide, and up to 18 feet in height, are spectacular in scope. This is the largest sculpture built in the United States since Mt. Rushmore was carved in the 1930s. Using existing hills and depressions, Heizer designed the animals to minimize the need for earth moving. Before work on the sculpture could begin, million of gallons of acid water were treated and discharged and hundreds of tons of limestone applied to neutralize the soil. The effigy mound site abuts the Buffalo Rock State Park, one of four state parks within a 10-mile radius. The site is on I-80, midway between Chicago and Peoria.

Indiana

The prime attractions at the **Indianapolis Museum of Art**'s Alliance Sculpture Garden are two oversized pieces by native son and noted Pop artist **Robert Indiana**. The square, double-level *Love*, a sculpture recognized around the world and one of the most widely copied symbols of protest during the war in Vietnam, is set apart in a grassy area. A more approachable Indiana work is *Numerals 0-9*. Exuberant, two-color, 8-foot-square, 4-foot-thick aluminum numbers sit on a large open granite site near the museum. The ten numbers resemble oversized children's blocks. (For more information, call 317-923-1331.)

Iowa

Perhaps the oldest sculpture grounds in this country are the effigy mounds in northeastern Iowa, which archeologists date back to about 1300 A.D., long before the Europeans brought their artistic traditions to the New World. At **Effigy Mounds National Monument,** on the Iowa-Wisconsin border, these burial grounds have been partially preserved. Ten mounds of earth, each nearly the size of a football field, are massed to form ten "marching bears." Out of an estimated fourteen hundred effigy mounds, only fifty-three remain today; most have been plowed under for cornfields. They can be seen on an 11-mile trail along the Upper Mississippi River. The mounds are huge: *Great Bear,* for example, is 137 feet long and 70 feet wide. The effigies, in the shapes of birds, turtles, and sometimes humans, typically appear in symmetric groupings. Archeologists speculate that they were constructed by now-extinct Indian tribes. Walking tours are scheduled four times a day, between Memorial Day and Labor Day. The park is on Route 76, 5 miles north of McGregor and across the Mississippi River from Prairie du Chien, Wisconsin. (For more information, call 310-873-3491.)

Kansas

Samuel Perry Dinsmoor's massive folk art environment is one of the most original in the country. A Civil War veteran, school teacher, and farmer, Dinsmoor bought a half-acre lot in Lucas, Kansas, in 1905 and spent twenty years constructing his 11-room limestone "Rock Log Cabin" and "Garden of Eden." He created 150 pieces of sculpture on biblical themes, using tons of wet cement that he molded over chicken wire. Dinsmoor completed his masterpiece in 1929, three years before his death. It is the principal tourist attraction in Lucas, population 500. Lucas is on State Highway 18, about 6 miles north of I-70. The installation is at Second and Kansas streets; hours are 10:00 A.M.-6:00 P.M., daily, March through November, and 1:00 P.M.-4:00 P.M. in the winter. (For more information, call 913-525-6395.)

Michigan

One of **Isamu Noguchi**'s most dramatic works is his fountain in Hart Plaza in Detroit's downtown Civic Center. Initially commissioned in the early 1970s to design a fountain, the sculptor gradually gained responsibility for the entire 8-acre plaza. From a distance, the massive fountain resembles a rocket launching pad, evoking a sense of modern industrial technology. Noguchi said its purpose is to "recall and commemorate the dream that has produced the automobile, the airplane and now the rocket, a machine become a poem." Two enormous stainless steel legs support the massive 24-foot-high tubular ring which sits at the center of a shallow circular granite basin. The computerized fountain can be adjusted to emit everything from a fine mist to a giant column of water. At the plaza entrance is another of Noguchi's futuristic-looking pieces, a 120-foot-high twisting aluminum pylon. The plaza includes a stepped pyramid with a theater and an amphitheater that doubles as a skating rink. The plaza is on the Detroit River, within sight of Renaissance Center.

Also in Detroit is **Tyree Guyton**'s Heidelberg Project, named for a rundown area of abandoned buildings where drugs and prostitution were rampant. In 1986, Guyton began decorating an empty house with cast-off utensils, implements, clothing, and other pieces of urban debris. He then moved on to adorn the sidewalks and streets, creating brilliantly colored designs, resplendent with polka dots, stripes, and other attention-grabbing patterns. Local residents claim his efforts helped turn this once-dangerous area into a safe neighborhood. The Detroit Institute of Arts sponsored an exhibition of his work in 1990. The installation is in and around the 3600 block of Heidelberg Street, off Gratior Avenue (Rte. 3), three blocks south of Mark, just east of downtown Detroit.

Nebraska

Jim Reinders' *Carhenge*, in Alliance, is an updated historical reference to Stonehenge, the mysterious neolithic construction begun around 2700 B.C. Reinders, an engineer who lived in England for

many years, was awestruck by Britain's ancient construction. When he returned to Alliance for a visit in 1987, he built his own Stonehenge using discarded automobiles from the 1950s and 1960s. Cars were tipped, front-end first, into pits and packed with dirt. Eight compact cars were then hoisted skyward to be used as horizontal lintels to bridge the gaps between the vertical behemoths. Finally, the cars were painted battleship gray. This satirical look at America's love affair with the automobile also seems to be one man's protest against conspicuous consumption. It is also a generational litmus test; older people usually take a quick look and drive on, while those under 30 step from their cars to examine the phenomenon and question its significance. Alliance is in western Nebraska, at the intersection of Routes 385 and 2.

Along Nebraska's Interstate 80 is the **500-Mile Sculpture Garden,** nine enormous sculptures that grace highway rest stops. As part of the 1976 bicentennial celebration, Nebraska firms contributed $500,000 to purchase and install these works. The sculptures are placed at rest stops at Omaha, Platte River, Blue River, York, Grand Island, Kearney, Brade, Ogallala, and Sidney. Unlike art displayed in most museums, these abstract sculptures are meant to be played with, touched, and climbed on by children.

Ohio

Andrew Leicester's *Cincinnati Gateway,* the entrance to Cincinnati's Sawyer Point Park, is a colorful and playful complex of flags, bridges, stylized animal sculptures, and inviting public spaces. Constructed as part of the city's 1988 bicentennial celebration, the installation features a long earth mound along the river topped with a wavy walkway whose floor charts the Ohio River's course from its origins in Pittsburgh to its terminus at the Mississippi River in Cairo, Illinois. Bright blue posts are topped with humorous winged pigs, a reminder of the city's earlier role as the capital of pork and a witty variation on the winged lions that top columns in Venice's Piazza San Marco. The pig theme enraged many city residents who preferred to finesse the city's smelly slaughterhouse origins. Another animal motif plays out on Leicester's bridge, with suspension cables that emerge from the

mouths of fishes. The park, in downtown Cincinnati, is on the Ohio River, at Eggleston Avenue at Pete Rose Way.

Twenty miles north of Cincinnati, on Route 128, is **Pyramid Hill Sculpture Park and Museum,** a brand new park established by retired attorney and investor Harry Wilks. The 250-acre park is on the site of the largest hardwood forest in the world. Natural attractions include over 600 species of giant oak, maples, ash, beech, and hickory trees, rolling meadows, lakes, and lush flatlands that lead to the Great Miami River. Each of the four lakes has a floating fountain. The park, which opens to the public in the spring of 1996, will feature three monumental contemporary works placed on 75 acres of the site. Wilks is putting together a permanent outdoor collection of contemporary sculpture and plans to hold competitions for the display of works by emerging artists. Within the large complex are hiking trails, gardens, and an arboretum. The facility is open during daylight hours, from spring through the fall. Pyramid Hill is at 1763 Hamilton Cleves Road, Hamilton, Ohio 45013. (For more information, call 513-868-8336.)

Springfield is home to **Ben Hartman's** *Hartman Rock Gardens.* His historically diverse rock sculptures include models of the White House and Independence Hall, a scene from the Oregon Trail, boxer Joe Louis, the Dionne Quintuplets, and many religious scenes. The gardens are located at 1905 Russell Avenue, at McCain and Russell streets.

Mac Worthington's Art In the Woods is the artist's private studio and 3-acre showcase for his work. Swirling aluminum and steel constructions, many on a dancing theme, seem to flow in an almost kinetic fashion. The studio, at 5935 Houseman Road in Ostrander, is 30 miles northeast of Columbus. (For more information, call 614-294-0100.)

South Dakota

For many Americans the best-known outdoor sculpture installation is **Mt. Rushmore National Memorial,** in Keystone, South Dakota. Each year two million people visit the Black Hills to see sculptor Gutzon Borglum's colossal sculptures of Presidents

Washington, Jefferson, Lincoln, and Teddy Roosevelt carved into Mt. Rushmore. Borglum began his monumental task in 1927 when President Calvin Coolidge declared Mt. Rushmore a national monument. He worked on the project intermittently, depending on funds and weather, until his death in 1941. His son Lincoln continued the project until the end of that year, but no work has been done since. Although this energetic engineering feat is largely ignored by art critics, some consider it a forerunner to the earthworks movement begun in the late 1960s by such avant-garde artists as Robert Smithson, Walter De Maria, and Michael Heizer. Mt. Rushmore is just outside Keystone, 25 miles southwest of Rapid City. (For more information, call 605-574-2515.)

Seventeen miles south of Mt. Rushmore is the **Crazy Horse Mountain Memorial,** begun by Korczak Ziolkowski in 1947 and carried on by his family after his death in 1982. Work on this colossal commemoration of the famed Indian chief will continue for years to come. When completed, the memorial of Crazy Horse will be 641 feet long and 563 feet high. The grounds include a museum. (For more information, call 605-673-4681.)

Wisconsin

Folk artists found a particularly appreciative audience in Wisconsin in the 1920s and 1930s when Catholic priests and laymen created amazing religious and patriotic installations with the barest of materials. **Father Mathias Wernerus,** a Catholic priest, built *Dickeyville Grotto,* a complex series of caves adorned with sculpture based on such Catholic themes as the Virgin Mary, the Crucifixion, and the Holy Eucharist. He worked with inexpensive, readily available materials such as cement, broken glass, cups, stone, and porcelain figurines. The *Patriotic Shrine,* with statues of Columbus, Washington, and Lincoln, commemorates the founding of the country. A Carrara marble eagle sits atop a three-tiered fountain; a series of anchors symbolize hope. Dickeyville is open year-round during daylight hours. It is on Route 151 in southwestern Wisconsin, not far from Dubuque, Iowa. (For more information, call 608-568-7519.)

The *Dickeyville Grotto* so inspired **Paul and Matilda Wegner** that they established their own *Peace Monument* and *Little Glass Church*, in Cataract, Wisconsin, northeast of La Crosse. The Wegners, German immigrants and farmers, visited Dickeyville in 1929, shortly before its completion. In the 1930s they constructed more than 30 free-standing sculptures, a meditation garden, a church, and a roadside pulpit, all surrounded by a decorative fence. The concrete installations are adorned with designs in glass and crockery. The outdoor museum and public park, which are open during daylight hours year-round, are maintained by Monroe County. Cataract is 10 miles north of Sparta on Highway 71, just west of its intersection with Route 27.

In Rudolph, **Father Philip J. Wagner** and **Edmund Rybicki** began their installation in the 1930s by landscaping a 12-acre potato field with trees and shrubs and constructing a maze of walkways. Their grotto incorporates a series of biblical scenes depicted on sheets of tin. Proverbs are spelled out in pinholes in the tin and back lighted with colored bulbs. Grotto shrines are adorned with glass tile and an unusual opalescent glass. The monumental *Wonder Cave,* densely planted with flowers and vines, sits in a grove of sheltering trees. Wagner and his helpers were so absorbed in building the grotto that they neglected to build the church that the bishop had asked for. In 1949, the La Crosse bishop ordered Wagner to halt work on his grotto and build the church, which was completed a year later. After Wagner's death, Rybicki continued building until he was killed in a boating accident in 1991. The grotto, on Route 34, is 120 miles north of Madison and 15 miles west of Stevens Point, on the grounds of St. Phillip the Apostle Church.

Tom Every built his *The Fancy,* a complex monument and history of electric inventions, out of materials gathered from his salvage business. He used over 2,000 tons of salvage in creating his monumental sculptures. This installation is on Highway 12, south of Baraboo and north of Madison.

Additional information about these Wisconsin sculpture sites can be obtained from the **John Michael Kohler Arts Center** in Sheboygan. The center is an advocate for grass-roots artists. (For more information, call 414-458-6144.)

Sculpture Parks in the South

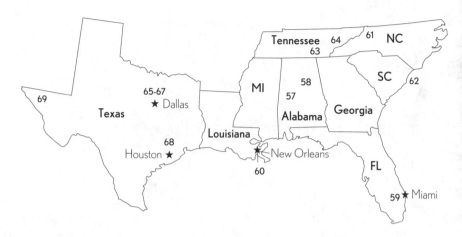

57. University of Alabama
 Sculpture Tour
58 Birmingham Museum of Art
59. Florida International University
60. K & B Plaza
61. Appalachian State University
62. Brookgreen Gardens

63. Chattanooga State Technical
 Community College Sculpture
 Garden
64. University of Tennessee
 Sculpture Tour
65. Connemara Conservancy

66. Dallas Art Museum
67. Southern Methodist University,
 Sculpture Garden
68 Museum of Fine Arts, Cullen
 Sculpture Garden
69. The Chinati Foundation

Alabama

University of Alabama Sculpture Tour

Tuscaloosa, Alabama

The Alabama Biennial is a showcase for contemporary sculpture. Every two years since the inaugural exhibition in 1991, this pastoral campus comes alive with about twenty new works created by sculptors from all over the country. Works selected for this juried exhibition must have been produced within the two years before their appearance on campus and be constructed from materials that withstand exposure to the out-of-doors.

Shows are mounted in March, just as the spring blossoms burst into color. The exhibitions stay on campus for fourteen months. The university selects works in a variety of artistic styles so that students can learn about a wide range of approaches to creating outdoor sculpture. Most of the pieces are placed at the center of the campus. Works are lighted, giving viewers a chance to see the variations in color and texture that emerge in night light.

The university's plunge into sculpture was sparked by an anonymous endowment in the early 1980s. Funds languished in an escrow account for a decade as lawyers wrangled over how the university should implement the bequest. The endowment is now being used to build the university's permanent collection through the purchase of two sculptures from each exhibition.

For each show, the university prepares a color brochure with photographs of the pieces and statements from the sculptors describing their works.

Sculptors whose works have been purchased include Andrew Arvanetes, George Beasley, Be Gardiner, and Billy Lee.

How to Get There: Tuscaloosa is a one hour drive southwest of Birmingham on I–59. Directions to the university are well-marked. Take the McFarland Boulevard exit off I–59; turn right onto McFarland (Highway 82) and travel just beyond the University Boulevard underpass. Turn onto University Boulevard. Turn right at 6th Street. At the first stop sign, Capstone Drive, turn left. The gallery is one-and-a-half blocks down on the right.

University of Alabama
Department of Art
Tuscaloosa, AL 35487-0270
205-348-5967
Hours: Sculpture is on view at all times

Birmingham Museum of Art

Charles W. Ireland Sculpture Garden

Birmingham, Alabama

Birmingham's sculpture garden is one of the few designed by a
sculptor. Opened in 1993, it is the creation of New York sculptor Elyn Zimmerman. It incorporates spectacular water-related
installations by her and by Valerie Jaudon.

Zimmerman designed three distinctly separate outdoor
sculpture areas. The central courtyard's Red Mountain Garden
is a large shady landscaped terrace just outside the dramatically
bowed three-story gallery window. Broad ramps on either side of
the bluestone terrace lead to the upper plaza and down to the
lower gallery.

Red Mountain terrace is dominated by Valerie Jaudon's *Blue
Pools Courtyard.* Two rectangular pools, inlaid with blue, green,
and black ceramic tiles set in a curving, mosaic pattern, are
framed by a geometric-shaped brick and bluestone patio. Lush
plantings include boxwood, magnolia, dogwood, and azaleas;
in spring the garden is festooned with masses of white blossoms.
On permanent display are works by internationally known
artists Fernando Botero, Anthony Caro, Barbara Hepworth,
Jacques Lipchitz, Beverly Pepper, and Auguste Rodin.

The sunken lower gallery, designed for temporary installations, can be adapted to fit any number of placement schemes.
Flexibility is achieved with drains, watertaps, and a grid of electric outlets located beneath the gravel floor. Lower gallery walls
were purposely kept plain so they can be repainted and resurfaced according to the preferences of guest artists.

A large upper plaza, designed for oversized pieces, is
bounded by a wisteria-covered pergola and features

Zimmerman's *Lithos II*, a monumental waterfall and pool of textured granite set in the curved wall of the garden. Water flowing over the massive, rough-hewn granite blocks enlivens the stone surfaces with reflected light. Lithos is the Greek word for stone. Zimmerman took her inspiration for the piece from visits to local quarries where she was intrigued with the bands of stratified colored stone on the quarry walls. The waterfall is flanked by Leyland Cypress trees. Other sculptors featured in this area include Mel Chin, Doug Hollis, Sol Lewitt, and George Sugarman.

Zimmerman is nationally recognized for her massive environmental installations. Her individualist, rugged stone courtyards, plazas, and gardens are distinctive elements at the Dade County Courthouse in Florida, Chicago's O'Hare Airport, and the National Geographic Society in Washington, D.C. All incorporate stone as a sculpture element and as a building material, and all include ponds and stepped terraces. Her works invite the viewer to be a part of the scene, to touch and experience the sensuality of the stone and water.

The 1993 museum renovation and expansion was designed by architect Edward Larrabee Barnes. The museum holds the largest collection of Wedgwood pottery outside England.

The sculpture garden honors the late Charles W. Ireland, former chairman of the museum board.

Admission is free. The museum has a restaurant.

How to Get There: The museum in downtown Birmingham is across Eighth Avenue North from City Hall and Linn Park. By car, use the 22nd Street exit from I-20 and I-59.

Birmingham Museum of Art
Charles W. Ireland Sculpture Garden
2000 8th Avenue North
Birmingham, AL 35203
205-254-2565
Hours: 10:00 A.M.-5:00 P.M., Tuesday through Saturday; noon-5:00 P.M. on Sunday.

Florida

Florida International University

Miami, Florida

A spectacular private outdoor art collection, one of the finest in the country, became accessible in 1994 when it was moved—lock, stock, and stabile—to Florida International University. Fifty-four major works, on display for years at a secluded and exclusive condominium complex, now adorn the formerly bleak campus, which was built on an abandoned airport with only a control tower as a landmark.

The sculpture was given on long-term loan by Martin Z. Margulies, a real estate developer whose passion for modern sculpture led him to create a sculpture oasis on Grove Isle, just south of Miami. In moving his sculpture to the mainland, Margulies was motivated in large part by his desire to have a wider audience for the collection. Margulies' tastes are so eclectic that virtually every style of contemporary sculpture is represented, although the emphasis is on Minimalist works.

This outstanding cultural resource is regularly tapped as a teaching tool: architecture students sketch the complex shadows in Anthony Caro's *Ruanda*; musicians study sounds emanating from Tony Rosenthal's kinetic *Marty's Cube*; and fledgling engineers are informed by George Rickey's *Two Lines Up Oblique II*, whose ball bearings allow it to swing gracefully in the wind.

Alexander Liberman's *Argosy*, a three-story bright red construction of upended steel cylinders, is the collection's signature work. It is the first piece that comes in view on entering the campus.

The bulk of the collection on the 300-acre campus is clustered around the plaza just outside the art museum. Richard Serra's *Steel Pole and Plate* is a metal plate held up with a steel pole at a 45-degree angle. Lloyds of London insisted that metal clips be added for stability before agreeing to insure the work.

Another huge and memorable work is Alexander Calder's red-orange *Lion*, which was one of the artist's last pieces. It

weighs 2,500 pounds, but looks light enough to have been made of paper.

Mark di Suvero's Cor-ten *Bojangles* is uncharacteristically modest in size for this sculptor of momentous works. It was constructed in the mid-1960s when an accident confined di Suvero to a wheelchair, limiting his reach to the 6-foot height of the sculpture. Its swinging pieces resemble calligraphy, perhaps an influence from di Suvero's childhood in China where his parents fled from Fascist Italy during World War II.

Tony Rosenthal's black steel *Marty's Cube* is a campus talisman; students touch it on the way to exams, and even some professors consider it a good luck piece. Its distinctive sound when twirled inspired the Music Department's chairman to compose a work based on its harmonies. The sculpture is a replica of Rosenthal's *Alamo* that stands at an intersection near Cooper Union in New York City. Margulies liked it so much that he commissioned the piece and it carries his name.

Other irresistible works are Barry Flanagan's *Large Leaping Hare*, a rabbit with fully extended legs atop an open-work pyramid of square pipes, and Frank McGuire's *Bus Stop II*, a vivid blue environmental steel construction that includes a director's chair. Another notable piece is Michael Heizer's *Elevated, Surface, Depressed*, a 52-foot-long, three-level assemblage of volcanic rock framed in aluminum.

A surefire campus hit is Jonathan Borofsky's 24-foot-high *The Hammering Man at 2,938,405*. This motorized bronze cutout, whose hammer strikes with precise and unceasing regularity, was created as a tribute to the industriousness of the American worker. In a recent student election the piece was plastered with posters proclaiming a slate of candidates that "will work harder than the Hammering Man." The young politicians were probably unaware that *Hammering Man* was recently found to need a stronger motor to support his hammering arm.

Isamu Noguchi's sculptures are among Margulies' favorites. He purchased Noguchi's granite *Man* at auction after IBM rejected this commissioned work because of its phallic context. In a spirited auction Margulies outbid an anonymous bidder, who turned out to be Noguchi. The sculptor wanted the piece

for his own museum but dropped out when the price became too lofty. The collection also holds Noguchi's bronze *Judith: Tent of Holofernes.*

Louise Nevelson's steel *Night Wall II* creates shadows that give the shallow piece impressive depth. This work, and many others, bear the scars of salt water from their previous island location. FIU is very much concerned about conserving its collection and brings experts to campus to consult on appropriate measures to preserve the works.

Donald Judd's untitled Cor-ten steel sculpture was designed to have its pieces rearranged. Judd insisted that sculpture should interfere with space and alter the viewer's spatial perceptions. In keeping with Judd's vision, the work is placed to force pedestrians to change course and move around the work.

Sculptors whose work is represented include Douglas Abdell, Alan Averbuch, Jonathan Borofsky, Alexander Calder, Anthony Caro, Willem De Kooning, Mark di Suvero, Jean Dubuffet, Raymon Elozua, Barry Flanagan, Charles Ginnever, Michael Heizer, John Henry, Jene Highstein, Jenny Holzer, Donald Judd, Gary Kleiman, Sol Lewitt, Alexander Liberman, Frank McGuire, Joan Miro, Louise Nevelson, Isamu Noguchi, Joel Perlman, George Rickey, Tony Rosenthal, Ulrich Ruckriem, Italo Scanga, Richard Serra, Tony Smith, Kenneth Snelson, Michael Todd, and William Tucker.

Maps of the collection are available at the museum. Tours can be arranged.

How to Get There: FIU is on S.W. 107th Street in Sweetwater, a suburban community in west Miami. Once on campus, follow signs to the museum.

Florida International University
The Art Museum's ArtPark
University Park, PC 110
Miami, FL 33199
305-348-2890
Hours: On view at all times.

K & B Plaza

Virlane Foundation Collection

New Orleans, Louisiana

K & B Plaza, corporate headquarters for the large southern drugstore chain, is one of the most grandly adorned office plazas in America. Towering figures and abstract sculptures, created principally in the late 1970s and early 1980s, are set in the minimally landscaped corporate mall. More than thirty sculptures are placed around the square, seven-story corporate headquarters. They create a startling contrast to the austere curtained walls of the prosaic office facade.

Henry Moore's bronze *Reclining Mother and Child* is the keynote of the collection. This characteristically mammoth piece expresses the tender bond between mother and child and does much to soften the wide open plaza.

Scott Burton and Pedro Friedeberg, both well known for their distinctive furniture sculpture, are represented with works on the plaza. Burton's *Right Angle Chairs* and *Settee*, with their hefty granite upright forms, seem to emphasize the angular rigidity of the building. Friedeberg's playful *Three Hand and Foot Benches*, with palms of the hands formed for seats, is a more welcoming resting spot. The sculptor typically uses wood for his sculpture; these were his first pieces made in bronze.

Kenneth Snelson's *The Virlane Tower* is similar to an even larger piece on display in the plaza of the Hirshhorn Museum in Washington, D.C. This 45-foot-high geometric sculpture in thin steel tubing creates the illusion of a pattern of six-pointed stars. Its graceful linear forms seem to effortlessly probe the sky.

The only sculpture in the plaza when the building was constructed for John Hancock Insurance in 1963 was Isamu Noguchi's *The Mississippi*, commissioned for the site. The sculptor worked closely with the building's architects, Skidmore,

Owings, and Merrill, in fashioning the rugged 18-foot-tall fountain of textured granite.

The Virlane Foundation is the cultural arm of the K & B drugstore chain. K & B owner Sydney Besthoff III is a leading cultural light in New Orleans. The Noguchi sculpture, which he had meticulously restored, piqued his interest in sculpture. Besthoff became a sculpture devotee after George Rickey persuaded him to underwrite a show of the artist's kinetic works.

Sculptors represented in the outdoor collection include Siah Armajani, Leonard Baskin, Umberto Boccioni, Scott Burton, Lynn Chadwick, Lin Emery, Sorel Etrog, Pedro Friedeberg, Elizabeth Frink, Charles Ginnever, Masao Gozu, Robert Graham, Barbara Hepworth, Linda Howard, Jean-Robert Ipousteguy, Menashe Kadishman, Ida Kohlmeyer, Jacques Lipchitz, Seymour Lipton, Allan McCollum, Frank McGuire, Henry Moore, Jesus Bautista Moroles, Masayuki Nagare, Isamu Noguchi, Arnoldo Pomodoro, George Rickey, Harris Rubin, Michael Sandle, George Segal, Arthur Silverman, Kenneth Snelson, and Ossip Zadkine.

A catalog, with descriptions and photographs of the works, is available.

How to Get There: The plaza is located at Lee Circle, where a landmark statue of Robert E. Lee faces north, watching for the Yankees to return. Lee Circle, at fringe of central business district, is ten blocks south of French Quarter on the St. Charles streetcar line.

K & B Plaza
The Virlane Foundation Collection
Lee Circle
1055 St. Charles Avenue
New Orleans, LA 70130
508-586-1234
Hours: On view at all times.

North Carolina

Appalachian State University

Rosen Outdoor Sculpture Competition

Boone, North Carolina

The Blue Ridge of the Appalachian mountains, near the borders of Virginia and Tennessee and about two hours from even a small city, is the improbable location for vibrant and ever-changing exhibitions of large-scale contemporary sculpture.

These exhibitions are modeled on the sculpture tours pioneered at the University of Tennessee at Knoxville. Works are installed in May, in time for the annual Appalachian Summer Festival of the Arts, and remain on view for nine months.

Boone's isolated mountain location, approachable only by tortuous two-lane roads, makes the presence of these artistic resources all the more remarkable. In common with the sculpture tours on Tennessee community college campuses in Chattanooga and Morristown, professors use the outdoor sculpture as an integral part of the classwork.

Each year ten emerging and midcareer sculptors are selected to display their works. Thus, graduating seniors are exposed to forty contemporary pieces during their years at Boone. These works enrich the cultural life of the university's eleven thousand students and are an attraction for the large and sophisticated summer population.

The sculpture program, begun in 1987, was initiated and continues to be supported by Doris and Martin Rosen, active members of the summer community in and around Boone who donate prize money for the juried show. In recent years, jurors for the competition have been sculptors of national reputation, including Jesus Bautista Moroles, John Henry, Jerry Peart, and James Drake. All finalists receive honoraria, which are typically used to install and remove their works. One finalist receives the $7,000 Rosen Award.

Works are clustered in a large grassy area about the size of a large-city block around the campus cultural center that includes buildings for music, the arts, and a performing arts center.

The university produces a catalog and map for each show, which is available at the Catherine Smith Gallery.

How to Get There: Boone is the northwest corner of North Carolina, near the Tennessee border, off U.S. 421.

Appalachian State University
Rosen Outdoor Sculpture Competition
Boone, NC 28608
704-262-3017

Hours: Sculpture on view at all times, from June through February.

South Carolina

Brookgreen Gardens

Murrells Inlet, South Carolina

Brookgreen Gardens is the indisputable mecca for figurative American sculpture. The animal kingdom and children are the stars of this collection that features sculpture from the Beaux Arts to the Art Deco period. Eagles, fighting bulls, coiled snakes, rhinos, hyena, deer, boy and fawn, boy and panther, boy and frog, girl with dolphin, wild boars, jumping squirrel, flying wild geese, an alligator fountain, and poised figures of jaguars and lions, elk, and penguins—all are part of this remarkable menagerie that was the inspiration of patrician New Yorkers Archer Milton Huntington and his wife, Anna Hyatt Huntington (1876-1973), a widely recognized sculptor whose works predominate in the garden.

Brookgreen was the first sculpture garden in America, opened to the public in 1932. It hugs the Carolina coastline, a short drive south from Myrtle Beach. The garden is a spectacular artistic resource in the midst of the lush, golf-crazed seashore resort towns along what is known as the Grand Strand. The garden's 300 landscaped acres display 530 sculpture pieces by 235

artists. A separate wildlife park contains a 90-foot-high netted aviary, otter pond, alligator swamp, fox and raccoon glade, and an aviary for owls, hawks, and other birds of prey.

The Huntingtons spent seven years searching for a winter retreat to help combat Mrs. Huntington's tuberculosis. She died in 1973 at age 97. Huntington, the home-educated son of railroad, hardware and shipping magnate Collis P. Huntington, purchased four former rice and indigo plantations totaling 6,635 acres (later expanded to over 9,000 acres) to provide a setting for his wife's work. Almost immediately the Huntingtons enlarged their vision to include works by many other notable figurative sculptors of the period.

During the Depression years of the 1930s, the Huntingtons' acquisitions were a boon to struggling artists; in its first six years, the Brookgreen added 197 art works. The collection continues to be enlarged through purchase and donation. Brookgreen exhibits only its own sculpture and does not lend from its collection. The Board of Trustees which manages Brookgreen, has launched a $30 million capital campaign for expanding facilities to accommodate the increasing number of visitors.

Anna Huntington's reputation is based largely on her animal sculptures, although her best known work is the 1910 equestrian statue of *Joan of Arc* that presides over Riverside Drive at 93rd Street in Manhattan. Her soaring *Fighting Stallions*, one of the first and among the largest pieces ever to be cast in aluminum, adorns the highway entrance. Sixty of Huntington's sculptures are displayed at Brookgreen.

Among Huntington's most popular pieces is *Don Quixote*, in part because the story of its genesis is legendary. An emaciated steed, so impaired he was propped up with a sling, was the model for the work. Many observers doubted he would survive the modeling sessions. Quite the contrary. Perhaps inspired by all the attention or by pride in his artistic value, he regained his spirit and lived on for several more years.

Anna Huntington acquired her love of animals from her paleontologist father. She studied and worked in France for several years, supporting herself with her earnings as a sculptor. She met her husband in 1921 when he commissioned her to design

a medal for the Hispanic Society of America, of which he was a founder.

The plantation grounds are picture book "southern," with graceful magnolias, majestic oaks, dogwood, and Spanish moss. Paths meander through the pastoral setting, past Dogwood Pond and Palmetto Garden. Sculpture is set in wall nooks, poised at fountains, centered in pools, and nestled in plantings. April is the peak period for the garden, when a spectacular display of azaleas and dogwood is in full bloom.

Besides Anna Hyatt Huntington, other leading artists whose work can be seen include Karl Bitter, Gutzon Borglum, Alexander Stirling Calder, Jo Davidson, George Demetrios, Sally James Farnham, James Earle Fraser, Daniel Chester French, Jonathan Scott Hartley, Malvina Hoffman, Gaston Lachaise, Frederick W. MacMonnies, Albino Manca, Paul Manship, Elie Nadelman, Frederic Remington, Randolph Rogers, Augustus Saint-Gaudens, Louis Saint-Gaudens, John Quincy Adams Ward, Adolph Alexander Weinman, Gertrude Vanderbilt Whitney, and William Zorach.

Admission fee.

How to Get There: A little over an hour's drive (75 miles) north of Charleston, on Route 17, between Myrtle Beach and Georgetown.

Brookgreen Gardens
U.S. Highway 17 South
Murrells Inlet, SC 29576
803-237-4218
Hours: 9:30 A.M.-4:45 P.M., daily, except Christmas.

Tennessee

Chattanooga State Technical Community College Sculpture Garden

Chattanooga, Tennessee

Far removed from the mainstream of contemporary sculpture, this rural southeastern Tennessee college, with a 95-acre campus of

Philip Nichols, *Receptor Series Number V*, Chattanooga State Technical Community College Sculpture Garden, Chattanooga, TN

rolling lawns drained from swampland of the Tennessee River, offers a spacious setting for its growing collection of outdoor sculpture.

Chattanooga's ambitious outdoor sculpture program took its inspiration from the "Knoxville Group." Although organized independently, it often features works being shown in the University of Tennessee-Knoxville tour.

In common with sculpture exhibitions at other Tennessee community colleges, this program is driven by the energy and vitality of a single member of the art faculty. Professor Denise Frank initiated the sculpture garden because "there was an appalling shortage of art on campus, indoors or outdoors." She believed the college was incomplete without works of art and recognized that the outdoor exhibitions at other Tennessee schools offered a model for bringing art to the campus inexpensively.

Sculpture at Chattanooga is more than an adornment of the modern low-slung campus buildings; it is an integral part of the curriculum for the students at this science-oriented two-year college. English teachers assign sculpture for descriptive writing exercises, and psychology students are asked to ponder the meanings of the works. Enthusiastic students strew flowers on their favorite pieces and also stand guard at the sculpture when grade school children visit the campus.

Pieces in the permanent collection reflect wide variations in styles. Barri Harper's *From the Catbird Seat* is an elevated black steel enclosure with a figure resembling a prisoner in the cage. More expansive is Deborah La Grasse's *Spectre Ship*, slender curving ribs of steel conceived by the artist on a sea voyage in northern Europe. Be Gardiner's pink marble *Lazarus and Persephone Cornerstones* depicts resurrection themes from both East and West: the Christian concept of Jesus raising Lazarus from the dead and the Eastern regeneration myth of Persephone who traveled to earth from the underworld for six months of the year.

Sculpture exhibitions were started in 1991 and now typically feature about two dozen works. On opening nights a nationally recognized sculptor gives an address and conducts student workshops. Participating artists have included John Henry and James Surls. The permanent collection, begun in 1992, features nine works.

The sculpture garden's impact goes beyond the campus, with the sponsorship of "sculptours" for community groups. A color catalog is available at the Hunter Museum in Chattanooga and at galleries and shops throughout the city.

Sculptors represented in the permanent collection include Jim Collins, Tony Dileo, Be Gardiner, Barri Harper, Deborah La Grasse, Evan Lewis, Philip Nichols, Dan Millspaugh, and Dennis Peacock.

How to Get There: The college is on U.S. 58, just north of downtown, and immediately south of Chickamauga Dam. Visitor parking is available at the Omniplex Technology Building. If space is not available, campus security directs visitors to parking.

Chattanooga State Technical Community College
4501 Amnicola Highway
Chattanooga, TN 37406
615-697-4400
Hours: On view at all times.

University of Tennessee Sculpture Tour

Knoxville, Tennessee

The University's pioneering efforts to bring outdoor sculpture to southern campuses is the work of sculptor and art professor Dennis Peacock. He initiated the "sculpture tours," temporary exhibitions of large outdoor works. The success of UT's program spawned similar sculpture tours at small colleges in the southeast and as far away as Michigan, New York, and Pennsylvania.

The original sculpture tour was a last-minute addition to the World's Fair held in Knoxville in 1982. Peacock had been itching to create exhibit space for large-scale pieces, particularly for artists who worked outside the larger cities. Using the World's Fair as the hook, he persuaded the university to host an outdoor sculpture exhibition just twenty days before the fair opened. As Peacock worked feverishly to mount this major sculpture presentation, the graphics designer for the brochure labeled it a "sculpture tour."

These sculpture tours, typically administered by a single member of the art faculty, have a big payoff in terms of exposing students to art; they are an excellent teaching tool, and they help to encourage an artistic sensibility in students.

Sculpture at UT is arranged along a 2-mile route, on about 5 acres of the 417-acre campus. The sculpture, created in a wide variety of approaches and materials, is highly visible. Enormous constructions of wood, painted steel, aluminum, and stone offer a level of visual excitement on campus that could be generated in no other way.

UT's sculpture tour began as an annual exhibition, but is now biennial because of the enormous workload for the small staff. The modest budget is augmented with donations of materials, student labor, and private funding. The program's popular-

ity with artists has led to a substantial backlog of sculptors who want to exhibit on the tours. Sculptors work with the grounds crew to install their works. Artists receive small stipends to help cover expenses.

As the sculpture tour concept was adopted by other colleges in southeastern Tennessee, works toured for as long as four years, going from campus to campus. Now, several community colleges recruit sculptors on their own, and UT is less involved in the travel circuit.

The university has an annual $10,000 fund to purchase works from the exhibitions for its Reese Collection, named in honor of Jack Reese, the UT chancellor who initiated the sculpture tours. The collection owns works by Jim Buonaccorsi, Blane De St. Croix, Al Frega, Duane McDiarmid, John Payne, and Glenn Zweygardt.

A catalog and map for the sculpture tour are available at the Ewing Gallery, the University Memorial Center, and the Knoxville Tourist Center.

How to Get There: South of I-40 from the Seventeenth
Street Exit. For guest parking permits, call 615-974-3114.
University of Tennessee, Knoxville
Sculpture Tour
Knoxville, TN 37996
615-974-4267
Hours: On view at all times.

Texas

Connemara Conservancy Foundation

Dallas, Texas

The seemingly limitless expanse of the Texas sky is fully evident
at the Connemara Conservancy, a 72-acre nature preserve of
thick native grasses, a trickling creek, and an enormous meadow
in the north Dallas suburb of Plano. Established in 1981, the
conservancy encompasses a 50-acre meadow, a pecan grove, and
20 acres of terraced and rolling hillside. It is a protected area
held in trust as a natural, unspoiled tract.

Each year the conservancy selects artists to create outdoor
works on the site. This is one of the few places where sculptors
can work in an expansive outdoor setting. Ten grants of $1,300
are given to individuals or teams of artists, architects, and land-
scape architects. The modest stipend covers travel, materials,
and installation. During the first week in March, as works are
being installed, artists live in a nearby farmhouse. Pieces remain
on site through May, when they are dismantled. The only
restrictions are no fires, no large earthworks, and no digging, and
the land must be returned to its natural state.

The sculpture program was started to draw visitors to the site
and to heighten the appreciation of nature and the need to pre-
serve natural settings. More than seven thousand visitors a year
come to experience the out-of-doors and ponder the meaning of
the temporary constructions placed on the landscape.

Picnics, aimless wandering, bird-watching, and naps are all
encouraged.

No admission fee.

How to Get There: Located in the far north of Dallas, in Collin County, take Central Expressway (U.S. 75) north to Exit 34 (McDermott Dr.); from there travel west (left under the freeway) 1.6 miles; then turn left and travel 1.5 miles. Connemara is the large field on the left after crossing the creek.

Connemara Conservancy Foundation
6625 Ridgeview Circle
Dallas, Texas 75240
214-934-0835
Hours: Sculpture on view March through May.

Dallas Museum of Art

Dallas, Texas

This 1-acre sculpture garden was opened in 1984 as part of the museum's ultramodern, block-square complex in downtown Dallas. Most of the seventeen works were created in the 1960s and 1970s.

Edward Larrabee Barnes designed the museum and sculpture garden. His Minimalist style downplays landscaping elements, but water is a key feature in the garden. The six outdoor sculpture areas are defined by a series of canals supplied with water from four limestone water walls. Oak trees figure prominently in the jasmine-covered grounds. Scored limestone paving blocks that match the color of the building add texture to the design. The bland garden walls provide a neutral background for displaying the sculpture.

The garden's entrance off the museum features Claes Oldenburg's enormous *Stake Hitch,* an oversized hitch used to stake a tent. A giant rope reaches to the barrel vaulted ceiling. Visitors walk through the hitch to reach the garden. The renowned Minimalist sculptor was born in Sweden, grew up in Chicago, and started his career as a journalist. In the early 1960s he was a leader of the Pop Art generation and is known for his exaggerated images of American culture.

The most massive work in the collection is Mark di Suvero's four-story red steel *Ave,* which proved to be an irresistible lure for

Barbara Hepworth, *Sea Form (Atlantic)* (1964), Dallas Museum of Art, Dallas, TX

children, who used its metal bars as a slide until the museum made it off-limits for climbing due to concerns over liability.

Two major commissioned pieces are Ellsworth Kelly's huge gray abstract stainless steel sculpture from his *Rocker* series, which is installed at the reflecting pond, and Scott Burton's polished stone *Granite Settee,* which invites visitors to take a rest break. The bench is so well integrated into the garden setting that it frequently goes unnoticed as a work of art. This fluid design, constructed of organic textured granite, reveals the work of a master sculptor.

The museum is part of the Arts District, which is anchored by the museum, Symphony Hall, the Dallas Theatre Center, and the Dallas Arts Magnet High School. Directly across from the sculpture garden is the turn-of-the-century First Methodist Church, which serves as a contrasting accent to the rigorously contemporary architecture.

The museum is strongly represented in contemporary, African, and pre-Columbian art.

Artists whose works are on display outdoors include Scott Burton, Miguel Covarrubias, Mark di Suvero, John Henry, Barbara Hepworth, Ellsworth Kelly, Aristide Maillol, Henry Moore, Matt Mullican, Beverly Pepper, Richard Serra, Tony Smith, Kenneth Snelson, James Surls, and Mac Whitney.

No admission fee. Tours are available

How to Get There: The museum is in the heart of the city's art district, in downtown Dallas, at the corner of Woodall Rodgers Service Road and North Harwood.

Dallas Museum of Art
Sculpture Garden and Education Courtyard
1717 North Harwood
Dallas, Texas 75201
214-922-1200

Hours: 11:00 A.M.–4:00 P.M., Tuesday and Wednesday; 11:00 A.M.–9:00 P.M., Thursday and Friday; 11:00 P.M.–5:00 P.M., weekends. Closed on Thanksgiving, Christmas, and New Year's.

Southern Methodist University

Elizabeth Meadows Sculpture Garden

Dallas, Texas

SMU's small outdoor collection was not envisioned as a comprehensive overview of twentieth-century works, but rather as a display of masters that represents major trends in modern sculpture. The eleven pivotal pieces run the artistic gamut from Auguste Rodin's massive marble *Eve in Despair* (1915) to Isamu Noguchi's steel and stone *Spirit's Flight* (1979). The sculptures are set in a half-acre garden on the grass and around brick walkways. Large oaks and a rectangular pool and fountain complement the sculpture.

Noguchi's *Spirit's Flight* is a four-sided helix commissioned for the prominent site at the art center's entrance. It was installed

under Noguchi's supervision. Bronze maquettes of the piece are awarded to outstanding art students who win Meadows Awards. Many of the sculptures depict human forms. The variety of artistic approaches in presenting these forms is a minicourse in styles of modern sculpture. Auguste Rodin's earlier-mentioned *Eve in Despair*, one of his rare works in marble, is a powerful, veiled female figure emerging from the marble block; it has the master's characteristic touch. Distinctly different approaches to the human form are seen in Jacques Lipchitz's abstract *La Joie de Vivre*, Henry Moore's voluptuously rounded *Three-Piece Reclining Figure*, and Fritz Wotruba's angular *Figure with Raised Arms*.

Aristide Maillol's lead casting of his classic *Three Graces* was created by the artist for his own garden. The sculpture of three nude figures seemingly absorbed in conversation is probably the best known work in the collection.

A clear change of pace is Pop artist Claes Oldenburg's humorous *Geometric Mouse II*, based on Walt Disney's Mickey Mouse. Mickey's ears, looming large over the Cor-ten and aluminum body, are recognized instantly as belonging to the beloved cartoon icon.

SMU's campus benefits from the artistic largesse of Dallas oil financier Algur H. Meadows. The Meadows Museum houses his collection of Spanish paintings, donated in 1965. They are considered the finest outside the Prado in Madrid. In 1969, he funded the half-acre Elizabeth Meadows Sculpture Garden in honor of his wife.

Sculptors whose work is represented include Jacques Lipchitz, Aristide Maillol, Giacomo Manzu, Marino Marini, Henry Moore, Isamu Noguchi, Claes Oldenburg, Auguste Rodin, David Smith, and Fritz Wotruba.

Seven of the garden's outdoor pieces are documented in a novel brochure designed as an educational aid for children.

How to Get There: SMU is 10 minutes from downtown Dallas, north on I-75 to Mockingbird; from there, travel west on Mockingbird to Bishop Boulevard. The museum is at the intersection of Bishop and Binkley. Museum visitor parking is available and clearly marked.

Southern Methodist University
Elizabeth Meadows Sculpture Garden
6101 Bishop Boulevard
Dallas, TX 75275
214-768-3272
Hours: The collection is on view at all times.

The Museum of Fine Arts, Houston

The Lillie and Hugh Roy Cullen
Sculpture Garden

Houston, Texas

Isamu Noguchi's serene 1-acre sculpture garden offers a peaceful oasis amid the towering office buildings that loom beyond its concrete walls. The garden is infused with the sensibilities of art and nature that are Noguchi's hallmark.

Simplicity is the keynote. Wide paths of red carnelian granite wind around islands and berms of grass. Native pines, sycamore, water oaks and magnolia trees create harmony with the sculpture. The garden's concrete walls, which vary in height between 2 and 14 feet, some tilting at dramatic angles, are sculptural elements that offer dramatic backdrops for the human-scale pieces. Open vistas show off the large sculpture, while the enclosed spaces offer intimacy for viewing smaller pieces.

Among the most popular works, and the logo for the collection, is Alexander Calder's rust red *The Crab* which seems to scratch playfully on the paving stones. Mark di Suvero's kinetic steel *Magair* pivots on touch. The four-part Henri Matisse bronzes, the *Backs,* document the twenty-year development of the artist as he continually simplified forms, until the final frame which powerfully conveys its message with a minimal image.

The sculpture garden was commissioned in 1978, but was not completed until eight years later. Noguchi's initial island design, inspired by a visit to Houston shortly after a flood, was rejected, as was his second scheme for a sunken garden. He had no more success when he presented a walled enclosure scheme that was widely

Alberto Giacometti, *Large Standing Woman I* (1960), The Museum of Fine Arts, Houston, TX

criticized by both local citizens and professionals. Plans were shelved for several years until a new plan with modified walls and contours was unveiled in 1983. This design won approval in 1984 and construction began the following year. Despite the glitches, Noguchi was pleased with the completed garden. In a 1986 interview, the world-renowned sculptor said:

> I am pleased, especially with the contradictions in the garden. It is not exactly a walled site, although there are walls. It's not exactly open and yet everyone can walk in from almost any direction. I feel there is a kind of conversation going on between the trees, walls, spaces, people and sculptures. It is an alive place.

When asked his wish for the garden, Noguchi replied, "Not to be a repository of gifts." The garden is designed to accommodate thirty sculptures; temporary exhibitions round out the collection. Considering that 1-acre sites typically accommodate no more than six large pieces, it is an amazing feat that this small garden can gracefully display so many pieces.

The garden is named to honor Lillie and Hugh Roy Cullen, a founding family of modern Houston who contributed mightily to culture projects in Texas and donated $2.8 million for the garden.

Artists represented in the collection include Emile-Antoine Bourdelle, Louise Bourgeois, Alexander Calder, Anthony Caro, Pietro Consagra, Mark di Suvero, Lucio Fontana, Alberto Giacometti, Dewitt Godfrey, Robert Graham, Barbara Hepworth, Bryan Hunt, Ellsworth Kelly, Jim Love, Aristide Maillol, Marino Marini, Henri Matisse, Mimmo Paladino, Auguste Rodin, Joel Shapiro, David Smith, and Frank Stella.

Admission fee. Museum docents conduct garden tours. The museum has a cafe.

How to Get There: In central Houston, near the Medical Center and Rice University.

The Museum of Fine Arts, Houston
The Lillie and Hugh Roy Cullen Sculpture Garden
1001 Bissonnet Street
Houston, Texas 77005
713-639-7300
Hours: 9:00 A.M.–10:00 P.M.

The Chinati Foundation

Marfa, Texas

The sculpture legacy of the renowned Minimalist sculptor Donald Judd is set in an isolated cattle town on the desolate plains of southwest Texas, near El Paso. Here Judd spent two decades transforming an Army base into his own artistic vision.

Marfa, as the compound is known, is the very antithesis of a traditional sculpture garden. It takes its cue from the vast open spaces; the indigenous landscape of the gray native Texas grasses and acres of scrub brush provide the austere setting. Grazing cattle keep the grass trimmed.

In the late 1970s Judd, with assistance from the New York City-based Dia Foundation, purchased an abandoned Army base that had been used to hold German prisoners of war in World War II. The purchase of Fort D. A. Russell included twenty-nine ramshackle buildings on 340 acres. Judd redesigned many of the buildings on the base, replacing floors, dividing spaces, and installing large square windows to bring the indoors and outdoors together. Leaky flat roofs on two long utility sheds were replaced with semicircular corrugated steel, giving the buildings the look of the old Quonset huts of World War II. Judd's Minimalist aesthetics are reflected in the former gymnasium, now called the Arena, where he installed stark bands of concrete in the floor to make a border for large rectangles of gravel.

Judd also purchased and renovated three buildings in the town. A refurbished railroad depot displays sculptures by fellow Minimalist John Chamberlain. A former ice plant was transformed into symposium space, and an old locker is now studios for artists-in-residence.

Judd was the high priest of Minimalism. After building his career as a painter, he moved to sculpture in the early 1960s. He used industrial materials and forms and rejected the traditional sculpture processes of casting and carving. He is recognized for his box shapes, which are shown singly or in groups, stacked or strewn across the floor and the vast spaces of the compound. Interior spaces fascinated Judd, and the insides of his boxes can always be seen.

The most prominent outdoor work is a massive assemblage of Judd's boxes. Fifteen sets of boxes, in groupings that vary in size from a single box to an arrangement of six, are spread out over nearly a mile on a north-south axis. These boxes set in the vast expanse of the arid Texas plain are vivid testaments to Judd's insistence that his art be seen within the environment for which it was created.

Also displayed at Marfa is Claes Oldenburg's giant horseshoe titled *Monument to the Last Horse*. Outsized horseshoe nails in the form of a hammer and sickle jab through the upper curve of the free-standing horseshoe. From one angle the horseshoe takes the form of a question mark. The piece was a gift to the Foundation from Oldenburg and his wife and co-artist Coosje van Bruggen. Its fabrication was financed through the sale of eight smaller renditions of the horseshoe.

Donald Judd, The Chinati Foundation, Marfa, TX

A 1995 addition to the outdoor collection is Anders Kruger's *Home of the Brave*, a 30-foot wall of red Mexican brick that stands at the edge of the property, paralleling the Mexican border. It was a gift from Kruger, an artist-in-residence, and one of many sculptors who have come to Marfa to study and create sculpture.

Judd was well known for his railing against art dealers and museums. He believed that museum collections and temporary exhibitions fail to appropriately display artists' works—and that for art to be fully understood, it must be placed in an environment that is as carefully constructed as the work of art itself. At Marfa, Judd had free rein to do precisely this.

The art complex opened to the public in 1986. Marfa is only one part of the Judd legacy. At his home, approximately 60 miles from Marfa, is an extensive collection of his works and those by John Chamberlain, Claes Oldenburg, Larry Bell, Yayoi Kusama, and John Wesley. Also on view at his home is vintage furniture by Gustav Stickley, Gerrit Rietveld, Alvar Aalto, and Mies van der Rohe; and hundreds of Indian artifacts. Judd's estate and the Chinati Foundation hold one of the world's largest permanent installations of contemporary art.

In an odd confluence of art and fashion, designer Calvin Klein used Marfa as the setting for advertising photographs to promote his home furnishings line of sheets and bedding. A bed designed by Judd was swathed in Calvin Klein sheets and featured in an ad.

How to Get There: Marfa is 200 miles southeast of El Paso, 60 miles from the Mexican border. Air flights to Marfa available from El Paso; from Dallas, flights go to Alpine, 26 miles east of Marfa. Amtrak's Sunset Limited stops in Alpine three days a week.

The Chinati Foundation
1 Cavalry Row
P.O. Box 1135
Marfa, Texas 79843
915-729-4362
Hours: 1:00 P.M.–5:00 P.M., Thursday through Saturday, and by appointment.

More Sculpture Attractions in the South

Alabama

Two outdoor sculpture sites in Birmingham pay tribute to very different heroes in the city's history. At the *Sloss Furnaces National Historic Landmark*, **Tony Buchen** and **Jeralyn Goodwin** have created *The Exiles,* a tribute to laborers who toiled in the steel-working trades. On this 32-acre site sculptors forged a group of 12-foot-high free-form shapes from Cor-ten steel that suggest the bent backs of the steel workers who stoked the blast furnaces to make pig iron. In Kelly Ingram Park, sculptor **James Drake** commemorates the civil rights marchers with works that depict incidents that occurred in the park in 1963. *Fire Hosing of the Marchers, Children's March* and the newest, *Police Dog Attack,* are poignant reminders of the civil rights struggle. Each statue stands along Freedom Path.

North of Birmingham, in Cullman, Bavaria-born Benedictine monk **Joseph Zoettle** created *Ave Maria Grotto,* a 4-acre park filled with 150 miniature buildings, shrines, and monuments. His grotto, listed on the National Register of Historic Places, is maintained by the Benedictine brothers of the St. Bernard Abbey. For fifty years Zoettle worked on a miniature replica of St. Peter's in Rome and renditions of other biblical and historic sites. The grotto is adorned with broken glass, tile, and bottles. Open every day, 8:00 A.M.-5:00 P.M., except Christmas. The site is at 1600 St. Bernard Drive, S.E., just east of Cullman, on U.S. 278. (For further information, call 205-734-8291.)

Florida

Miami's **Bayfront Park** is pure Noguchi. It is the largest Isamu Noguchi-designed park in this country. It was created in the 1980s amid such prolonged and heated controversy between the sculptor and the city that for years Miami preferred to downplay its existence. Now recognized as a prime cultural asset, the city is

giving the 32-acre park the attention it deserves. Built on a land-fill, the park includes a large amphitheater, a fountain, and the Challenger Memorial, a tribute to the crew of the tragic space mission. The entrance is at 301 Biscayne Boulevard, between N.E. Third and N.E. Fourth avenues.

The late **Edward Leedskalnin,** of Homestead, is one of the most widely recognized folk artists in the country. A stonemason from Latvia, he immigrated after being jilted by his 16-year-old sweetheart, Agnes. *Coral Castle,* an elaborate 10-acre coral environment, is his tribute to her. Everything is made of coral: the fantasy castle and tower, the throne rooms, a child's playground, barbecue, and moon fountains. The tower and walls contain a thousand tons of coral. The installation, which is listed on the National Register of Historic Places, is particularly impressive because coral is highly porous and difficult to shape. This popular tourist attraction, 25 miles south of downtown Miami, is at the intersection of U.S. 1 and S.W. 286th Street at 28655 South Dixie Highway. Open daily from 9:00 A.M.-6:00 P.M. (For further information, call 305-248-6344.)

Georgia

Among the most prominent of the accessible folk artists is retired preacher **Howard Finster,** who lives in Pennville, outside Summerville, on Route 27. For his religiously centered *Paradise Garden,* he transformed acres of swampland around his lawn mower and bicycle repair shop into a sculpture environment. From bottles and bicycle parts and objects from the town dump he constructed a 30-foot-high tower. His garden includes concrete walls and paths embedded with broken tools, dolls, and clocks. Summerville is near the Alabama border in Georgia's northeast corner.

Another notable Georgia folk artist was **Eddie Owens Martin,** a.k.a. St. EOM, who created *The Land of Pasaquan,* which means "the place where the past and the present and the future and everything else comes together." Martin came from a sharecropper's family. He was a street hustler in New York City and told fortunes in a Times Square tearoom. When he inher-

ited a 4-acre plot in the 1950s, he returned home and began his masterpiece, constructing two-story temples and pagodas, heroic nude male statues, totems, and walls with floral patterns. Most of the objects are concrete, painted with the brightest paint he could find. His works are widely documented in art publications. Open weekdays by appointment. (For information, contact the Pasaquan Preservation Society, 404-568-2263.) Pasaquan is just outside Buena Vista, at the intersection of Routes 26 and 27. Buena Vista is a short drive from Columbus, which is on the Alabama border.

North Carolina

Three North Carolina hamlets have their own artists-in-residence. **Clyde Jones** lives just south of Chapel Hill, in Bynum—population 50. His installation, which he calls *Haw River Animal Crossing or Jungle Boy Zoo*, is an assemblage of animals made from tree stumps and roots. He welcomes visitors, particularly children, but he has no telephone so this would be a drop-in sort of visit.

Volles Simpson, a resident of Lucama, builds giant windmills adorned with such figures as a horse-drawn buggy, a bicycle rider, and many types of airplanes. His largest piece is four stories tall. The works are painted with tractor enamel in patriotic red, white, and blue. From Wilson (North Carolina), go south on Route 301 to Contention Creek; just before Route 117, turn right on Wiggins Mill Road; drive about 7 miles to the installation, which is on the left, at the intersection of five roads. (For further information, call 919-239-0679.)

Quentin J. Stevenson of Garysburg was a fur trapper who became adept at finding fossils, Indian arrowheads, petrified wood, Civil War relics, and unusual rocks and minerals while looking for signs of beaver and muskrat. He built his lodge when he retired, embedding his treasures in cement on the inside and outside walls and in free-standing concrete plaques and sculptures. Garysburg is just north of Roanoke Rapids, 5 miles east of I-95, on the Virginia border. (For further information, call 919-536-3985.)

Works from all these artists have been presented at the **High Museum** in Atlanta, 1280 Peachtree St. N.E. (For further information, call 404-733-4200.) For folk art enthusiasts who seek to ferret out Southern artists, the museum is a useful resource. Other resources include the **North Carolina Museum of Art** (for further information, call 919-839-6262) in Raleigh and the **Folk Art Society of America** (for further information, call 804-355-6709) in Richmond, Virginia.

Oklahoma

Oklahoma's contribution to off-beat outdoor art is the late **Ed Galloway's** *Totem Pole Park*, showcasing the "world's largest totem pole." This brightly painted 90-foot-high, walk-in totem carved with stylized images of lizards, birds, and chieftains in full regalia is a memorial to the American Indians. Other totems are in the forms of a giant arrowhead, a bird, and various animals. The park benefits from its proximity to the Will Rogers Memorial; the Rogers County Historical Society manages both the park and the Rogers Memorial. *Totem Pole Park* is in Foyil, Oklahoma, in the back country on Highway 28A, near Claremore, northeast of Tulsa.

Tennessee

Chattanooga's **River Gallery Sculpture Garden** offers a superb view from a high bluff overlooking the Tennessee River. Landscaping includes wide lawns, winding walkways, and a circular inner courtyard, where more than a dozen works are artfully spaced to complement each other. The garden displays a small permanent collection and temporary exhibitions of pieces that are for sale. Picnicking is permitted; box lunches are available at the Bluff View Inn, just steps from the garden. The gallery provides a walking tour map. The garden, at 214 Spring Street (for further information, call 715-267-7353), is two blocks from downtown Chattanooga and a short walk from the Hunter Museum of Art.

In Nashville, **Cheekwood**, the museum of the Tennessee Botanical Gardens and Fine Arts Center, has about a dozen

works of modern sculpture, plus about twenty pieces of statuary on its 55 acres of lushly landscaped grounds. The outdoor collection, started in the 1970s, is set among woodlands and gardens, with fountains and pools as dramatic backdrops. Cheekwood is at 1200 Forrest Park Drive, 8.5 miles southwest of downtown Nashville, adjacent to the Percy Warner Park and Golf Course. (For further information, call 615-585-2600.)

Walters State Community College, in the rural Smoky Mountain town of Morristown, 30 miles northeast of Knoxville, has for many years mounted biennial sculpture shows on its 137-acre campus. The "sculpture tours" are modeled after the highly successful temporary exhibitions pioneered at the University of Tennessee at Knoxville. The college is establishing a permanent collection with gifts and purchases. The lushly planted sculpture garden courtyard has fallen victim to an aggressive college building program, but the college administration is committed to continuing the exhibitions once the expansion is completed. (For further information, call 615-585-2600.)

Texas

The **University of Houston** is in the vanguard of an ambitious citywide effort to beautify Houston with public art. On its 600-acre main campus are nearly two dozen outdoor pieces, mainly from the 1960s forward, by such leading sculptors as Scott Burton, Charles Ginnever, Menashe Kadishman, William King, Clement Meadmore, Jesus Batista Moroles, and Reuben Nakian. A map of the collection can be obtained from the Blaffer Gallery. Tours can be arranged.

Houston is also an important mecca for idiosyncratic folk art environments. It is home to **John Milkovisch's** *Beer Can House,* **Howard Porter's** *OK Corral,* **Cleveland Turner's** *Flower Man's House,* and **Victoria Herberta's** *Pigdom,* a "shrine to swine," or "hog heaven." **The Orange Show** in Houston is the switchboard for information. The Orange Show itself is a colorful and whimsical exhibition space, created by self-taught artist and postman **Jeff McKissack** as a homage to the nutritional value of oranges. This regional group, dedicated to preserving folk art environments, can

be contacted at 713-926-6368. These folksy installations are all located inside the I-610 loop that circles downtown Houston and can easily be visited in a day-long tour.

Amarillo's distinctive artistic statement is **Cadillac Ranch,** 1 mile west of town. Ten vintage model Cadillacs, circa 1948 to 1962, are buried head down to their midsections. Arranged in a straight line, with their exaggerated tail fins pointed skyward, all are tilted at precisely the same angle. The message here, in this car-dependent west Texas outpost, is America's love affair with the gas guzzlers. Cadillac Ranch was the inspiration of the San Francisco art collective Ant Farm and financed in the early 1970s by Stanley Marsh III, a Texas oil and media mogul. At its twentieth anniversary in 1994, Marsh had all the cars painted white and gave magic markers and cans of spray paint to guests so they could add graffiti. The mix of colors changes frequently; a recent photo showed the cars painted alternately red and blue, with the last Cadillac a red, white, and blue rendition of the Texas flag. The installation is on the eastbound service road of I-40, at the Soncy/Helium exit, and can easily been seen from the Interstate. (For further information, call 806-372-5555.)

In Dallas, near Love Field, is an environment created by **Willard "The Kid" Watson,** who acts the part, strutting in cowboy hats, boots, and fancy shirts. In 1970 he started decorating his front yard with found objects and sculpture. Now it is a forest of statues, many of which incorporate chicken bones. Watson's wife makes clothes to drape the more risque statues. His neighbors were at first so incensed by the art that they refused to speak to him at church on Sunday. Now they are reconciled, perhaps because his works are displayed in galleries. The address is 6614 Kenwell, Dallas.

Another Old West theme is being played out in downtown Dallas in Williams Square, at the Las Colinas office center. In the vast courtyard, framed by three office towers, sculptor **Rob Glen** has created a huge assemblage of larger-than-life galloping horses that seem perfectly in scale with the surrounding office complex. Their prancing hooves kick up water in a stream cut through the granite prairie. These spirited mustangs, poised at water's edge and cavorting in the stream, return a semblance of

the wild Texas range to metropolitan Dallas. This sculpture installation could be seen as a Texas interpretation of the monumental fountains in Europe.

Virginia

The interior sunken garden of the **Virginia Museum of Fine Arts** in Richmond features nine sculptures surrounded by flowering trees and seasonal flowers. A concrete block fountain with rushing water symbolizes Richmond's location on the falls of the James River. A mirrored glass wall that reflects the works of art is an added attraction. The museum is at 2800 Grove Avenue. (For further information, call 804-367-0822.)

West Virginia

The 50-acre **Huntington Museum of Art,** in Huntington, has a sculpture courtyard designed by the famous Bauhaus architect Walter Gropius in 1970. There are a dozen outdoor works, including pieces by Seymour Lipton and George Rickey. Huntington is on the Kentucky border, about 60 miles west of Charleston, on Route 64. The museum is at 2033 McCoy Road. (For further information, call 304-529-2701.)

Sculpture Parks in the West and Southwest

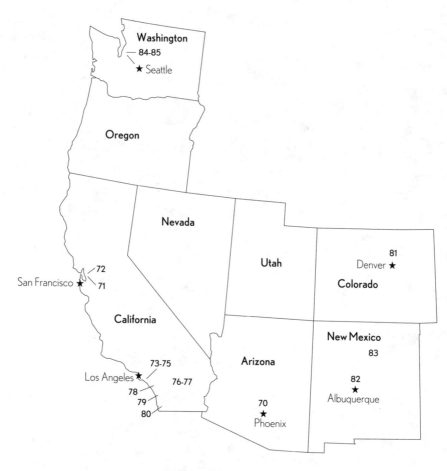

70. Scottsdale Center for the Arts
71. Stanford University
72. Oakland Museum
73. UCLA Sculpture Garden
74. Los Angeles County Museum of Art

75. Norton Simon Sculpture Park
76. Westin Resort Hotel
77. La Quinta Sculpture Park
78. California Scenario
79. California State University at Long Beach

80. University of California at San Diego,
81. Museum of Outdoor Arts
82. Albuquerque Museum of Art
83. Shidoni Foundry
84. Western Washington University
85. NOAA

Arizona

Scottsdale Center for the Arts

Scottsdale, Arizona

In the country club suburb of Phoenix, a lavishly planted sculpture garden adorns Scottsdale's bustling civic center and commercial mall. Sculpture is prominently placed on landscaped berms, in flower beds and along grassy walkways. The garden offers a soothing contrast to Scottsdale's arid desert environment. This expansive green oasis, embellished with fountains and ponds, is modeled on ancient Muslim horticultural designs.

The joining of water and sculpture is a persistent theme throughout the garden. Phoenix artist Jose Bermudez's two-story steel triangles, *Mountains and Rainbows,* is the focal point of an irregularly shaped pond and the centerpiece for the Center for the Arts. Rainbows frequently peek through its circular cutouts. Other pool sculptures are Abbott Pattison's bronze *Woman with Fish,* an upended woman who appears to be spearing three small fish, and Dale Wright's welded iron *Don Quixote.* Bennie Gonzales' stone *Fountain of Youth,* installed during construction of the mall, was funded in part through contributions from Scottsdale school children.

Louise Nevelson's *Windows to the West* also sits at the center of a pool. Her characteristic black boxes-within-a-box are set off dramatically by water jets that spew gurgling streams of white spray. While Nevelson is the most widely known sculptor in the Scottsdale collection, local residents are more likely to single out George-Ann Togonini's figurative *The Yearlings,* a bronze trio of prancing colts, as the high point. This piece is adjacent to "Old Town," where many of Scottsdale's art galleries are located.

Kenji Umeda's pink marble *Allurement of a Journey* is a starkly simple Oriental construction that towers over the landscape.

The sixteen sculptures owe their presence to the town's active art acquisition policy, which dates from the early 1970s, and, later on, to the city-funded Percent for Art program.

Scottsdale's Civic Center includes City Hall, a library, and the Scottsdale Center for the Arts, a complex of art galleries and

theaters. The mall has restaurants, shops, and a hotel. The sculpture garden, established in 1975, wends its way in and around these buildings. Park benches are placed strategically throughout the grounds.

Sculptors represented include Michael Anderson, Bill Barrett, Jose Bermudez, Bennie Gonzales, Barry Hunnicutt, David Kraisler, Louise Nevelson, Abbott Pattison, Steve Rand, Raymond Phillips Sanderson, Gary Slater, George-Ann Tognoni, Kenji Umeda, John Waddell, Robert Winslow, and Dale Wright.

A sculpture map is available at the mall. Picnicking is permitted.

How to Get There: Scottsdale is northeast of Phoenix. The civic center is two blocks east of Scottsdale Road, one block south of Indian School Road.

Scottsdale Center for the Arts
7383 Scottsdale Mall
Scottsdale, AZ 85251
602-994-2301
Hours: Sculpture on view at all times.

California

Stanford University Museum of Art

B. Gerald Cantor Rodin Sculpture Garden

Stanford, California

The Rodin Sculpture Garden is the jewel of Stanford's impressive outdoor sculpture collection. The university's Rodin holdings, the most comprehensive in the United States, are surpassed only by those of the Musée Rodin in Paris. These magnificent bronze sculptures are the core of a campuswide sculpture garden which includes works by leading twentieth-century artists.

The best known of the two dozen sculptures by the acclaimed French artist Auguste Rodin (1840-1917) is *The Gates of Hell*, prominently featured at the entrance to the museum's Cantor Gallery.

The Gates of Hell was acquired after long negotiations with the

French government, which finally allowed the bronze cast to be made in 1977. This is the fifth cast of the famed work and the only one made with the lost-wax process, a method of preserving fragile works in bronze that has been used for nearly five thousand years. Because bronze is heavy and expensive, large works are generally hollow rather than solid. Using the lost-wax process, the original clay model is converted into a plaster or rubber form, which is then covered with wax and a coating of clay. The clay pieces are baked and the wax "burns out" through a hole, leaving a precise negative mold. Molten bronze is then poured into the spaces left by the wax.

The Gates of Hell, which depicts hell as chaos, draws its subject matter from Dante's fourteenth-century *Divine Comedy,* a work that was popular with intellectuals in late nineteenth-century France. It was commissioned by the French government as a "decorative panel" for a decorative arts museum that was never built. Rodin's structural model was Ghiberti's fifteenth-century baptistry doors of the Cathedral in Florence. The work was not completed before Rodin's death, and many art historians doubt that it could ever have been completely finished given the complexity of the forms and the design. Several of the sculpted figures in *The Gates of Hell* are renowned as individual works, including *The Thinker, Eve, The Prodigal Son,* and *Crouching Woman.*

The garden is named for financier B. Gerald Cantor, an unparalleled Rodin enthusiast who donated the bulk of his collection to Stanford in 1974 with the understanding that the university would build a garden to display the sculpture.

The 1-acre garden, dedicated in 1985, was designed by architect Robert Mittelstadt. Its inspired design replicates the intimacy of the Parisian setting in which the sculptures were originally exhibited, and at the same time is attuned to the Romanesque architecture of the adjacent museum.

A broad sloping terrace offers an orderly progression for viewing the sculpture. Artful spacing of the pieces allows each work to stand independently without interfering with its neighbor. Five sculptures at the north end are framed invitingly by reed-thin cypress trees, while the massive *Gates of Hell* stands before a large stone backdrop created expressly for the piece. Gravel paths and formal flower beds add to the French country

Auguste Rodin, *The Gates of Hell*, The B. Gerald Cantor Rodin Sculpture Garden at the Stanford University Museum of Art, Stanford, CA

garden setting. The garden is dramatically transformed at night with an unusual system of underground lighting that permits the Rodin sculptures to be uplighted, re-creating the candlelight setting of the artist's studio.

The Rodin collection's tightly contained setting contrasts with the informal settings for the campuswide outdoor collection that graces courtyards, outdoor cafes, and plazas. These works, more than twenty in all, were largely produced in the last three decades. They are surprisingly compatible with the hundred-year-old Romanesque Revival buildings and the romantic English landscape created by Frederick Law Olmsted, the father of American urban park design and, with Calvert Vaux, the designer of Central Park in New York City.

An outstanding trio of large bronze works stands near the university's Cummings Art Building—Joan Miro's *Oiseau,* Arnoldo Pomodoro's *Facade,* and Henry Moore's *Large Torso: Arch.* Alexander Calder's *The Falcon,* with its curving painted steel plates, offers a modern counterpoint to the wide and formal arches of the law school. Among the more playful pieces is Kenneth Snelson's *Mozart I,* a frolicking assemblage of stainless steel rods that seem to float in space.

Not all the contemporary sculpture is popular with students and faculty. Josef Albers' *Stanford Wall* is generally disliked, not for its content but because it is an irritating pedestrian barrier that blocks the view of nearby buildings.

More popular is George Segal's bronze *Gay Liberation,* an amiable, life-size grouping of a gay and a lesbian couple around a park bench. But even Segal's work has its detractors; in 1994, the sculpture was vandalized with black paint.

Sculptors represented include Josef Albers, Bruce Beasley, Beniamino Bufano, Alexander Calder, William Couper, Aristedes Demetrios, Dmitri Hadzi, Carla Lavatelli, Jacques Lipchitz, Joan Miro, Henry Moore, Arnoldo Pomodoro, Antoine Poncet, Auguste Rodin, George Segal, Kenneth Snelson, Francois Stahly, William Wetmore Story, and Jack Zajac.

A sculpture map is available. Free garden tours are given on Sunday.

The museum closed after the 1989 earthquake and is expected to reopen in 1996.

How to Get There: Stanford University is less than an hour's drive south of San Francisco, off Highway 101 or Route 280, west of Palo Alto. Visitor parking is available at the Art Museum on Lomita Drive, off Museum Way.

Stanford University Museum of Art
B. Gerald Cantor Rodin Sculpture Garden
Lomita Drive and Museum Way
Stanford, CA 94305
415-723-4177
Hours: The Rodin Sculpture Garden and the campuswide collection on view at all times.

Oakland Museum

Oakland, California

Gertrude Stein might reconsider her famous quip about Oakland that "there isn't any there there" if she were to visit the city's aggressively modern, decidedly urban museum. The museum features some two dozen pieces of contemporary outdoor sculpture, but the most impressive sculptural element is the building itself, which was designed as a modern version of the Hanging Gardens of Babylon.

Galleries in the pyramid-shaped museum open to terraces and outdoor spaces that are connected with pathways and stairs. Terraces are formed by the gallery's roofs, a design that has been widely used as a model for other museums. The museum's architects were the first to solve the engineering challenge of creating sufficient load-bearing capacity to hold the weight of the garden and the sculpture.

The terraces create a mazelike structure that draws visitors down the wide, graceful steps and around corners. Sculpture is encountered at every turn. Each terrace has several "rooms," defined with shrubs and low concrete retaining walls. The sense of anticipation is heightened as one glimpses the tops of sculpture not yet fully in view. At the lower level, the terraces culminate in a formal garden, the Great Court. The inspired landscaping, conceived by landscape architects Dan Kiley and Geraldine Knight Scott, includes evergreens, fruit trees, and brightly colored flowers.

Eero Saarinen was selected as the museum's architect after voters approved a bond issue for its construction in 1961. His pyramid design was completed by his associate, Kevin Roche, after Saarinen died suddenly from a brain tumor.

Much of the sculpture was commissioned for specific locations. David Gilhooly's ceramic *Hippo Pond* rests in a pond on the lower level, outside the cafe. Alongside is Bruce Beasley's cast lucite abstract animal figure, *Tragamon,* a prehistoric-looking triangular creature with large eyes.

Bay Area sculptor Peter Voulkos is a pioneering ceramist known for his use of collage in pottery and plates. His *Mr. Ishi*

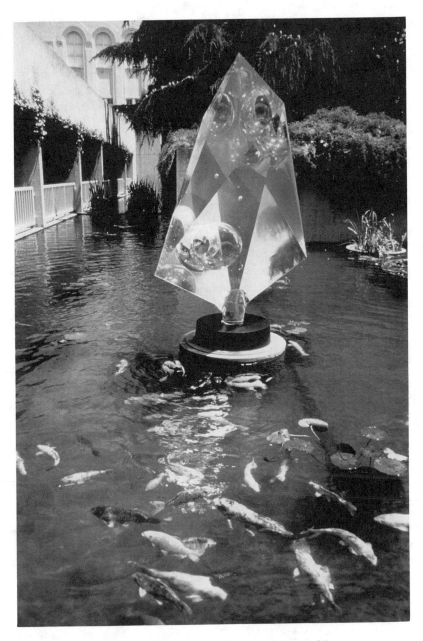

Bruce Beasley, *Tragamon* (1972), Oakland Museum, Oakland, CA

is a large, dark, metal cylinder whose color and undulating shape contrast dramatically with the stark beige concrete of the museum's exterior.

George Rickey's eye-catching kinetic *Two Red Lines II* sways gracefully in the breeze on the central quadrangle lawn, near a more sober installation of mounds and slabs by San Francisco sculptor Stephen de Staebler.

The museum's 10th Street entrance is enlivened by Ruth Asawa's large copper wire abstractions. In a secluded niche on the way to the museum's upper level is a colorful figure by the noted ceramist Viola Frey.

Directly across the street, at Lake Merritt Channel Park, is the 22-acre Oakland Sculpture Project which is managed by the museum. A dozen large-scale sculptures are on view amid scenic walks, bicycle paths, and picnic facilities. Such internationally known artists as Mark di Suvero, Michael Heizer, and Fletcher Benton have pieces on display. The park is safe to visit, although vandalism is a problem and many of the pieces are covered with graffiti.

Sculptors represented include John Abduljaami, David Anderson, Robert Arneson, Ruth Asawa, Melinda Barbera, Bruce Beasley, Fletcher Benton, Allen Bertoldi, Michael Bigger, J. B. Blunk, Roger Bolomey, David Bottini, Tom Browne, Beniamino Bufano, Ruth Cravath, Stephen De Staebler, Mark di Suvero, Claire Falkenstein, Viola Frey, David Gilhooly, Matt Glavin, Betty Gold, Michael Heizer, Robert Howard, Dennis Leon, John Mason, Theodore Odza, Robert Treat Paine, Harold Perisco Paris, George Rickey, Henry Rollins, John Roloff, Michael Todd, Peter Voulkos, Gerald Walburg, Brian Wall, and Jack Zajak.

The museum has a restaurant, snack bar, bookstore, and museum shop.

How to Get There: The museum is in downtown Oakland, one block east of the Lake Merritt BART Station and four blocks east of Highway 880, the Nimitz Freeway.

Oakland Museum
1000 Oak Street
Oakland, CA 94607
510-238-2200

Hours: Sculpture garden is on view during museum hours: 10:00 A.M.-5:00 P.M., Wednesday through Saturday; noon-7:00 P.M. on Sunday. Admission fee except on Sunday 4:00p.m.-7:00p.m.

University of California at Los Angeles

Franklin D. Murphy Sculpture Garden

Los Angeles, California

This staunchly modern collection is part and parcel of college life at UCLA. Bookbags and bikes rest on the sculpture bases while college classes and groups of students gather around the masterworks that are assembled in the quadrangle and on the wide brick courtyard around the Wight Art Gallery and Macgowan and Bunche Halls. The manicured garden and undeniably powerful sculpture are fitting complements to chic affluence of neighboring Beverly Hills and Westwood.

UCLA's modern sculpture runs the gamut in style, period, and materials, from Auguste Rodin's muscular, towering bronze *The Walking Man* (1905) to Anthony Caro's assemblage of horizontal steel forms in *Halfway* (1971); from Gaston Lachaise's hedonistic bronze *Standing Woman (Heroic Woman)* (1932) to David Smith's geometric burnished steel shapes in *Cubi XX* (1964); from Jean Arp's rounded *Hybrid Fruit Called Pagoda* (1934) to George Rickey's kinetic aluminum needles in *Two Lines Oblique Down (Variation III)* (1970-1974).

Cubi XX is one of a series of twenty-eight sculptures that David Smith produced over a four-year period in the early 1960s; they are his last major body of work. *Cubi XX's* rectangles seem to balance precariously as they graze a center platform. Reflective surfaces add to the sense of weightlessness. The Cubi series is a departure from the sculptor's previous pieces, which incorporate found metal objects into the design. In experimenting with the designs for the Cubis, Smith spray painted cardboard cutouts on paper to formulate the arrangements of the geometric forms. The results were then translated into burnished steel.

Two of Jean Arp's biomorphic bronze sculptures are on display; five additional pieces are in storage. At the rim of the

quadrangle is *Ptolemy III*, which bears a resemblance to the ventricles of a giant human heart. Created in 1961, near the end of the artist's life, it has a more open, linear quality than the massive free-form shapes for which he is widely known. *Hybrid Fruit Called Pagoda* reflects Arp's early fascination with natural forms. Arp was a poet as well as a sculptor, and references to fruit appear frequently in both these art forms.

Jacques Lipchitz's heroic *Bather* is the last in a series of Bathers created between 1915 and 1925. It brings together the curves and lines of Cubism and has a distinctly African sensibility. The sculptor's *Song of the Vowels,* inspired by musicians from the Paris Symphony Orchestra, is featured prominently on the mall near the Wight Gallery. Its title is taken from an ancient Egyptian song that used only vowels and was sung to placate the forces of nature. This piece, originally created for a mountain vineyard setting in the south of France, is a tribute to man's power over nature.

The 5-acre garden was conceived in the early 1960s, when the North Campus was developed to accommodate a growing student body. It was the inspiration of former UCLA Chancellor Franklin D. Murphy and Ralph D. Cornell, who for more than three decades was the principal landscape architect for the Westwood campus. They transformed a dusty parking lot into a gently rolling landscape, with grassy areas and winding pathways.

The sculpture was painstakingly sited by Murphy and Cornell. Sight lines and balance were key considerations. Full-scale plywood and cardboard models of the sculpture were moved around the site to achieve the precise harmony they were looking for. Variations in view corridors were achieved by altering elevations in the garden. Over the nearly thirty years since the garden was established the redwoods, junipers, and pines planted around the perimeter have matured, creating a sense of enclosure.

Dr. Murphy promised the Regents that all the sculpture would be donated and not require university funds. The core collection of fourteen sculptures, including Henry Moore, David Smith, Jacques Lipchitz's *The Bather,* and Barbara Hepworth's *Oval Form,* were donated in 1967 by David E. Bright and his wife Dolly Bright Carter. The UCLA Art Council, alumni

Gerhard Marcks, *Maja* (1942), UCLA Franklin Murphy Sculpture Garden, Westwood, CA

classes, and local philanthropists continue to add pieces. When the garden was dedicated in 1967 it contained thirty-one sculptures; today it holds sixty. The garden was named for Dr. Murphy when he left UCLA in 1968.

Sculptors whose work is displayed include Alexander Archipenko, Jean Arp, Leonard Baskin, Bruce Beasley, Fletcher Benton, Emile-Antoine Bourdelle, Alberto Burri, Alexander Calder, Anthony Caro, Aldo Casanova, Lynn Chadwick, Leo Cherne, Pietro Consagra, Sorel Etrog, Claire Falkenstein, Eric Gill, Robert Graham, Dimitri Hadzi, Barbara Hepworth, Richard Hunt, Gaston Lachaise, Henri Laurens, Jacques Lipchitz, Anna Mahler, Aristide Maillol, Gerhard Marcks, Henri Matisse, Robert Muller, Reuben Nakian, Isamu Noguchi, George Rickey, Giorgio Amelio Roccamonte, Auguste Rodin, Bernard (Tony) Rosenthal, David Smith, Elden Tefft, George Tsutakawa, William Tucker, William Turnbull, Vladas

Vildziunas, Peter Voulkos, Jack Zajac, William Zorach, and Francisco Zuniga.

A brochure with a map of the sculpture garden is available at the Visitors Center and at the Wight Art Gallery. Parking is difficult, some say nonexistent, so parking off campus is advised.

How to Get There: Enter the UCLA campus from Sunset Boulevard in Beverly Hills.

University of California at Los Angeles
Franklin D. Murphy Sculpture Garden
405 Hilgard Avenue
Los Angeles, CA 90024-1620
310-443-7038 to schedule tours
310-443-7003 for information
Hours: Sculpture always on view.

Los Angeles County Museum of Art

Los Angeles, California

California is graced with two sculpture gardens devoted to the father of modern sculpture, Auguste Rodin (1840-1917). The Rodin collections at LACMA and at Stanford University were endowed by Los Angeles businessman and philanthropist B. Gerald Cantor and his wife Iris. LACMA's garden, opened in 1988, is the newer and smaller of the two.

The centerpiece of the dozen bronze pieces in the Rodin garden is *Monument to Balzac.* The Balzac commission came to Rodin in 1891 from the novelist Emile Zola, in his capacity as president of a Parisian literary union. For seven years Rodin worked on his Balzac figure, now known the world over for its anguished portrayal of the literary titan. The plaster cast generated impassioned controversy when first exhibited in Paris in 1898, and the literary union refused to accept Rodin's interpretation. It was not cast in bronze until 1937, many years after Rodin's death.

The Rodin collection includes the *The Gates of Hell,* the famed massive bronze doorway, and three separate figures from this work. Also on display is *The Burghers of Calais,* considered by many to be the sculptor's most successful public monument.

The Cantors began collecting Rodin's works after World War II, with the purchase of a marble head. After amassing the largest private collection of Rodin sculpture, they donated more than four hundred works to over seventy museums and universities. Stanford University, the Brooklyn Museum, the Metropolitan Museum of Art, and LACMA have received the largest number.

The museum's two-level sculpture terrace, opened in 1991, contains nine large-scale contemporary pieces. Prominently featured is Alexander Calder's aluminum mobile *Hello Girls*, which sits in a curved reflecting pool. Brightly colored paddles are attached to rods mounted on triangular stainless steel bases. The paddles move gracefully in irregular patterns when jets of water from the edge of the pool hit the mobile.

Alice Aycock's multimedia *Hoodoo (Laura)*, from the series *How to Catch and Manufacture Ghosts. Vertical and Horizontal Cross-section of the Ether Wind* is another focal point. Its hypnotic whirling fan represents an imaginary machine that holds the power to self-destruct. Aycock described the work as a metaphor for the creative process. She likens the updraft from the fan as an "ether wind," a concept proposed by early physicists as an electromagnetic force that fuels the universe. The motorized piece is an amalgam of copper, sheet metal, glass heating coils, light bulbs, neon, iron, lead, and steel cables.

In 1994, the museum purchased an adjacent 9-acre property that includes an Art Deco landmark building formerly owned by Robinsons-May Company. In the planning stage is an expansion of the galleries and an additional outdoor sculpture area. The new facilities are scheduled to open in 1996.

The museum, founded in 1910, is housed in a sprawling five building complex. It receives funds from the county, but major support comes from private donors; the Cantors have been important museum supporters for more than thirty years.

Sculptors with works in the gardens include Alice Aycock, Antoine Bourdelle, Alexander Calder, Anthony Caro, Richard Hunt, Donald Judd, Ellsworth Kelly, Georg Kolbe, Alexander Liberman, Henry Moore, Auguste Rodin, and Peter Voulkos.

Admission fee. Cafe open during museum hours. The complex includes a museum shop.

How to Get There: On Wilshire Boulevard, two blocks east of Fairfax Avenue.

Los Angeles County Museum of Art
B. Gerald Cantor Sculpture Garden
5905 Wilshire Boulevard
Los Angeles, CA 90036
Hours: 10:00 A.M.-5:00 P.M., Tuesday through Friday; 10:00 A.M.-6:00 P.M. on weekends. Closed Thanksgiving, Christmas and New Year's Day.

Norton Simon Sculpture Garden

Pasadena, California

A distinguishing feature of the Norton Simon sculpture garden is its extraordinary collection of Asian art. This is the only outdoor collection in the country that prominently displays these timeless works. In addition, a fine collection of nearly two dozen works by modern masters is on view in the sculpture court and around the museum building.

The Asian garden at the museum's lower level contains twenty-two stone sculptures. With the exception of four Cambodian pieces, all the works are from India and were created between the tenth and fifteenth centuries. A majestic thirteenth-century granite *Seated Buddha* sits serenely in the lotus position at the center of a lush ivy-draped semicircle. When seen from inside the gallery, the Buddha is framed on either side by small indoor bronze works displayed on high pedestals. A grouping of eleventh-century sandstone Cambodian pieces includes an architectural column and three lingams, stylized phallic symbols of the Hindu god Siva.

The museum's modern outdoor pieces are displayed on the upper level. At the museum entrance Barbara Hepworth's bronze *Four Square (Walk Through)* sits on its own landscaped island. Also at the entrance, just beyond the Hepworth piece, is Auguste Rodin's famous bronze *The Burghers of Calais.* The outdoor collection includes four Rodin works and five massive bronzes by Henry Moore.

Three of Moore's powerful bronze sculptures are grouped

Artist Unknown, *Shiva Dakshina Murti Seated*, 14th Century, Norton Simon Museum, Pasadena, CA

around the landscaped reflecting pool that is the centerpiece of the sculpture court. At the court's far end is Auguste Rodin's vigorously animated bronze, *The Walking Man*. All the sculpture in the court is open to view, unobstructed by trees and shrubs; trees along the perimeter define the enclosure.

The garden was established in 1975 when the museum enlarged the reflecting pool and created a hillside to display sculpture. Its current building, constructed in 1969 for the Pasadena Art Museum, was taken over by Norton Simon in 1974 when the museum was near bankruptcy. The prominent California industrialist and patron of the arts, and his wife, the actress Jennifer Jones, reorganized the space to house their collection, amassed at a reported cost of over $100 million. Norton Simon died in 1992.

The museum is a major repository of sculpture from India, Nepal, Thailand, and Cambodia. It holds the most extensive collection of Cambodian art outside Cambodia. Norton Simon's interest in Oriental art, and Indian art in particular, was sparked by a visit to that country in 1971. During the following decade he acquired the collection, which from the standpoint of variety and artistic appeal, is considered one of the most comprehensive in the West.

Sculptors whose work is shown in the modern outdoor collection include Herbert Ferber, Barbara Hepworth, Henri Laurens, Jacques Lipchitz, Aristide Maillol, John Mason, Henry Moore, Robert Morris, Auguste Rodin, Richard Serra, and Michael Todd.

Admission fee. Museum tours are available by reservation. Museum shop.

How to Get There: The museum is at the corner of Colorado and Orange Grove Boulevards, at the intersection of the Foothill (Rte. 201) and Ventura (Rte. 134) freeways.

Norton Simon Museum
411 West Colorado Boulevard
Pasadena, CA 91105
818-449-6840
Hours: Noon-6:00 P.M., Thursday through Sunday.

The Westin Mission Hills Resort

Rancho Mirage, California

In the lavish resort area just south of Palm Springs is the super-luxury desert village of Rancho Mirage. Here the Westin Mission Hills Resort features sculpture on its meticulously groomed grounds. The resort's California Mission architecture, with its curved archways and earth-toned adobe, offers an elegant setting for outdoor sculpture.

The sculpture is artfully displayed around the resort's circular entrance, at the edges of the small lakes, and along the paths leading to guest rooms, restaurants, and the golf course. The sculpture can be seen on a five-minute walk, on 5 of Westin's 20 acres.

The collection is carefully tailored to the Westin clientele,

with an emphasis on conservative, high-quality work that is readily understood and appreciated. Most of the artists have national and international reputations. All the pieces are for sale, with prices ranging from $900 for a small stone cast piece, to $60,000 for large-scale metal work. Among the most popular are bronze figures suitable for display in and around water, such as Gwynne Murrill's *Cheetah* that is constantly being petted by youngsters.

This collection of some thirty, mostly large, figurative pieces, was the brainchild of Valerie Miller, a Palm Desert art dealer. A long-time member of Palm Desert's Public Art Commission, Miller convinced Westin officials that contemporary sculpture would be a tremendous draw. And she was right. Established in 1994, the collection was an immediate hit. Everyone at the resort, from the concierge who points out pieces to the guests, to the engineers who install the art, exudes enthusiasm and pride for the sculpture garden.

Westin's grounds, the most spacious of any resort in this wealthy desert enclave, are adjacent to the Mission Hills Country Club where the Bob Hope Golf Classic is played.

The sculpture garden is a recognized cultural attraction for Palm Desert, and it has spawned "cultural getaway" promotions similar to the traditional "golf getaway" weekends. It was also the catalyst for an areawide "culture link" that joins the promotional activities of the Palm Springs Desert Museum, with its popular Annenberg Theatre, the Palm Springs Playhouse, and the McCallum Theatre in Palm Desert.

Sculptors whose work is represented include George Baker, James Barnhill, Bruce Beasley, Fletcher Benton, Ken Bortolazzo, Gesso Cocteau, Michael Davis, Stephen De Staebler, Guy Dill, Dan Dykes, Mary Fuller, Dennis Gallagher, Abigail Gumbiner, John Kennedy, Jeffery Laudenslager, Joe McDonnell, DeLoss McGraw, Frank Morbillo, Gwynne Murrill, Stephen Nomura, James T. Russell, Ron Tatro, Michael Todd, and Doug Weigel.

A folder with sheets containing color photos of the sculpture and a map locating the pieces is available.

How to Get There: Depending on traffic, Rancho Mirage is around a three-hour drive from Los Angeles, using the San

Bernardino Freeway (I-10). Rancho Mirage is south of Palm Springs on Route 111. From the freeway, turn right (south) on Dinah Shore Drive and follow the signs.

The Westin Mission Hills Resort
Dinah Shore & Bob Hope Drive
Rancho Mirage, CA 92270
619-328-5955
Hours: Sculpture on view at all times.

La Quinta Sculpture Park

La Quinta, California

The spectacular purple-hued Santa Rosa Mountains are a dramatic backdrop for La Quinta, one of the newest sculpture gardens in America, opened in 1994. In keeping with the spirit of this luxurious desert vacation paradise, the grounds resemble a well-tended golf course. The sculpture park is a short drive south of Palm Desert from the Westin Mission Hills Resort in Rancho Mirage.

The dominant landscape feature in this 20-acre complex is a 3-acre free-form, palm-fringed lake. Sculpture is placed in and around the lake and along the grassy aprons bordering the broad concrete walkways. Visitors are free to roam and to touch the art; children climb on the works and have even been seen swinging from the aluminum arms of a kinetic sculpture.

More than a hundred works are displayed outdoors, and all are for sale; prices range between $5,000 and $200,000, with the exception of a Fernando Botero bronze with a $1.6 million price tag.

La Quinta displays works by local and U.S. artists, as well as those from England, Brazil, Russia, and Lithuania. Soviet dissident Ernst Neizvestny exhibited a monumental sculpture, *The Golden Child,* which will be installed in Odessa. Neizvestny is well known for tweaking Soviet authorities. After being forbidden to enter an international design competition for a sculpture to top the Aswan Dam, he secretly submitted an entry and won the competition.

Another massive work is Ty Bowman's *Tire Boys,* figures

made from flattened rubber tires that are joined to each other with chain link fencing. The soaring lines of climbing figures resemble military recruits on exercise at boot camp.

The complex includes a gallery, entertainment spaces, and a swimming pool. An art school is popular with retirees who winter in the area. La Quinta actively solicits private parties.

Since all the works are for sale exhibits change frequently. Artists represented include Bill Barrett, Rita Blitt, Fernando Botero, Ty Bowman, Edwin Darrow, Karen Giusti, Robert Mangold, Ernst Neizvestny, and Colin Webster Watson.

Admission fee. Guided tours are available.

How to Get There: From Los Angeles, the drive should take around three hours. Take I-10 (San Bernardino Freeway) east to the Jefferson exit, 15 minutes east of Palm Springs. Take Jefferson Street south to the end; turn left on 54th Street, then right onto Madison Street. La Quinta is between Airport and 58th Streets.

La Quinta Sculpture Park
57325 Madison Street
La Quinta, CA 92253
619-564-6464
Hours: 9:00 A.M.-5:00 P.M., closed from mid-June through August.

California Scenario

South Coast Plaza

Costa Mesa, California

In suburban Costa Mesa, just north of Newport Beach, is Isamu Noguchi's California Scenario sculpture garden. The preeminent sculptor's inspiration infuses this otherwise undistinguished Orange County office park.

Noguchi's 1.6-acre environment is positioned between a pair of office towers sheathed in dark green reflective glass and by two high white concrete walls. Reflections from Noguchi's pristine garden bounce on the glass panels, while the stark white walls create ever-changing patterns of light and shadow.

Within the flagstone-paved park, a sinuous waterway springs from a soaring granite triangle. Water disappears under a pyramid and meanders gracefully among the sculptural elements. Plump prickly cacti and other desert plantings adorn one side of the watercourse, while a minigrove of redwoods frame the other side. Massive rocks, some of which weigh nearly 75 tons, are embedded in the paving and appear to sprout from the center of the earth. Water gurgling over the polished rocks in the recessed artificial stream contrasts vividly with the arid sandstone pavement.

Scenario's six environments symbolize the California landscape and its dependence on water. The region's natural assets are represented by a miniature forest, desert, waterfall, stream, fountain, and a honeysuckle-covered knoll. The wondrous diversity of nature is the message, although some fanciful engineering helps create the illusion. For the babbling brook Noguchi devised an ingenious system of small copper jets, after project engineers were stumped over how to get water to flow over the stones. At the fountain, an anemometer measures wind force and shuts off water when wind is strong enough to spray the pavement.

Dominating the plaza entrance is Noguchi's *The Spirit of the Lima Bean,* a 28-ton pile of interlocking volcanolike boulders. This work pays nostalgic homage to Costa Mesa's agricultural heritage, before its transformation into a commercial center. Fields of lima beans were the source of wealth for South Coast Plaza developer Henry T. Segerstrom. The Noguchi garden was completed in 1982.

Included within South Coast Plaza is a retail center, three banks, and a restaurant. Immediately north of South Coast Plaza is Town Center, which includes the Orange County Performing Arts Center. Sited among the buildings are other major pieces of contemporary art by Jean Dubuffet, Alexander Calder, Doug Edge, Claire Falkenstein, Sheila Hicks, Jim Huntington, Carl Milles, Joan Miro, Henry Moore, Charles O. Perry, and George Rickey.

Admission is free.

How to Get There: Just north of the San Diego Freeway (I-405) at Bristol Street; south of Santa Ana Freeway (I-5) at Bristol Street.

California Scenario
South Coast Plaza
San Diego Freeway at Bristol Street
Costa Mesa, CA 92626
714-435-2100
Hours: 8:00 A.M.-midnight, every day.

California State University

Long Beach, California

Cal State Long Beach bills its sculpture as a "monumental collection," and it is surely that. Eighteen large-scale pieces are displayed throughout the sprawling 320-acre campus.

This may be the only sculpture collection in the country established as part of an international sculpture symposium. In 1965, the college invited distinguished sculptors to create outdoor works on campus. Each sculptor was paired with an industrial sponsor who offered technical assistance, materials, and access to fabrication equipment.

As a direct result of the symposium, eight sculptures were installed on campus in the summer of 1965. Japanese sculptor Kengiro Azuma teamed with ALCOA to create *Mu*, a 10-foot-high etched and engraved tower fabricated from aluminum plate and bar stock. All of Azuma's pieces have the same title, which is the Zen term for nothing. Netherlands sculptor J. J. Beljon used cast concrete for his *Homage to Sam Rodia*, a massive angular and radically stripped-down version of Rodia's spectacularly bejeweled concrete *Watts Towers* in Los Angeles. Polish-French artist Piotr Kowalski worked with North American Aviation Corporation to fashion *Now*, three inward-curving plates of stainless steel arranged in a circle. The plates were molded by an explosion of underwater dynamite charges attached to the steel. Canadian sculptor Robert Murray created *Duet (Homage to David Smith)*, delicately balanced sheets of 1-

inch-thick steel, using Bethlehem Steel shipyard's large fabrication facilities.

The university continues to add to its collection. Michael Davis explored the diversity of Long Beach's scenic attractions with three minimalist sculptures, *The Building, The Port,* and *The Island.* Each component is constructed of different materials. *The Building* is a tall slim tower of bronze and steel; *The Port* is a stone reference to the city's impressive breakwater; and in Corten steel, *The Island* suggests the man-made structures in the harbor.

In the early 1990s, Frederick Fisher designed an outdoor living room, with walls of plum and cypress trees. Adjacent to his living sculpture is Karen Hassinger's *Evening Shadows,* a construction of undulating strands of steel that resemble living trees and shrubbery.

Sculptors whose work is represented include Kengiro Azuma, J. J. Beljon, Andre Bloc, Eugenia P. Butler, Michael Davis, Woods Davy, Guy Dill, Kosso Eloul, Clare Falkenstein, Frederick Fisher, Karen Hassinger, Bryan Hunt, Robert Irwin, Gabriel Kohn, Piotr Kowalski, Rita Letendre, Robert Murray, Terry Schoonhoven, Richard Turner, and Tom Van Sant.

Picnicking is permitted; food and beverages are available from vending machines on campus.

A walking tour brochure is available at the library. Visitors are encouraged to visit on weekends because parking is a problem on weekdays. Parking can be arranged through the Parking Administration. (For more information, call 310-985-4146.)

Sculpture is sited along approximately 2 miles of landscaped pathways.

How to Get There: Cal State is in the northeast section of Long Beach, just off the Pacific Coast Highway and south of the San Diego Freeway (I-405).

California State University
1250 Bellflower Boulevard
Long Beach, CA 90840
310-985-5761
Hours: Sculpture on view at all times.

Uinversity of California, San Diego

The Stuart Collection of Sculpture

La Jolla, California

The UC campus in La Jolla, just north of San Diego, is high on a bluff overlooking the Pacific Ocean. It offers a resplendent setting for sculpture. The 1,200-acre campus is festooned with more than a dozen outdoor pieces. Stands of eucalyptus, green lawns, and canyons filled with dwarf evergreens are perfect foils for the eclectic architectural styles of the campus buildings, which include World War II barracks and postmodern designs from the 1950s and 1960s.

Several sculptures are so well integrated into the environment that they could easily be overlooked. William Wegman's *La Jolla Vista* is a spoof on scenic overlooks, complete with telescope, drinking fountain, and a bronze map, items typically included at panoramic overlooks around the world. Wegman, reminiscing about his first major outdoor piece, said, "We were walking around the campus, but kept returning to this site and I'd always think, 'Oh, what a beautiful site' and then I noticed that it was almost a parody of a beautiful site because it had the logistics of a perfect panorama, but it was filled with condos and supermarkets and overdevelopment in general. It is a parody of a photo opportunity."

Other works that may not be immediately recognized as sculpture are Terry Allen's *Trees*, Michael Asher's marble drinking fountain, Jackie Ferrara's *Terrace*, and Jenny Holzer's *Green Table*. Allen's *Trees*, three lead-encased eucalyptus trees salvaged from a grove cut down to make way for new buildings, stands as a testament to the loss of the natural environment. One tree holds a sound system that plays such pieces as *Ghost Riders in the Sky* and *Mona Lisa Squeeze My Guitar*.

Alexis Smith's *Snake Path* is a 560-foot-long slithering serpent in gray and blue tile, embedded in a gracefully meandering campus pathway. The serpent's sinuous tail wraps around the concrete path. Its head and venomous fangs reach out to the library terrace.

Richard Fleischner's *La Jolla Project* is more obviously sculpture. Seventy-one blocks of pink and gray granite are arranged as free-standing columns, archways, doors, and other architectural shapes. They are placed on a lushly wooded lawn at Galbraith Hall and serve as frames through which to view the surrounding trees and natural elements.

A recent addition is New York artist Elizabeth Murray's enormous wooden boot. The boot appears to have been kicked off by a colossus running through the eucalyptus grove. It is surrounded by large abstract jewel-toned rocks that seem to have been scattered by the fleeing giant.

Students greatly favor Niki de Saint Phalle's joyful *Sun God*, the first piece commissioned for the collection. This exuberant 14-foot-tall, brilliantly colored bird roosts with feet and wings outstretched on a 15-foot-high concrete arch. He is the logo for campus souvenirs, and is honored in the spring with a Sun God Festival. For graduation he dons cap and gown, and for the annual AIDS Day commemoration he wears a shroud. He was titled "Sony Walkbird" after students appended earphones.

The Stuart Collection was formed in 1982 when James DeSilva, an art patron who made his fortune in tuna fishing, initiated purchases through his Stuart Foundation. All the sculpture was commissioned for individual sites on campus. New works are regularly added.

Sculptors represented in the collection include Terry Allen, Michael Asher, Jackie Ferrara, Ian Hamilton Finlay, Richard Fleischner, Jenny Holzer, Robert Irwin, Elizabeth Murray, Bruce Nauman, Nam June Paik, Niki de Saint Phalle, Alexis Smith, and William Wegman.

A color brochure describes the collection. Short videos on the pieces are available at The Playback Center in the undergraduate library.

Guided group tours can be arranged.

How to Get There: The campus is off Interstate 5, between San Diego and Del Mar. Use La Jolla Village Exit to reach the campus. Metered parking is available.

University of California, San Diego
The Stuart Collection of Sculpture
9500 Gilman Drive
La Jolla, CA 92093
619-534-2117
Hours: On view at all times.

Colorado

Museum of Outdoor Arts

Englewood, Colorado

Set in a sprawling business complex in suburban Denver,
Greenwood Plaza's outdoor sculpture collection covers 400
acres, an area the size of America's largest sculpture park at
Storm King in New York state.

Unlike Storm King's rural setting, where sculpture adorns
rolling hillsides, works at Greenwood Plaza are placed around
office buildings and suburban plazas. But the site, with its clear
150-mile vista of the Rocky Mountains, is no less spectacular.
And here, unlike Storm King, the sculpture is fair game for chil-
dren, who are encouraged to take a hands-on approach.

The collection of mostly figurative works is displayed in
seven separate locations. Around The Triad, in the north section
of the complex, is the Lion's Den, where seven stone and bronze
reproductions of ancient Greek and Roman lions crouch, snarl,
and roar. These reproductions of lions found in Italy are nestled
in groves of trees.

At Harlequin Plaza, the museum headquarters, a black-
and-white diamond terrazzo floor is designed in the spirit of
Picasso. Cavorting energetically on the diamond-shaped pat-
terns are Harry Marinsky's elongated *Seven Harlequins*. A high
red wall running through the plaza converges at a purple wall.
Almost invisible between the walls is a narrow waterway.

Also at the plaza is Red Grooms' whimsical painted steel
caricature of the Brooklyn Bridge. It is a magnet for kids and has
twice been restored from the ravages of youngsters at play. Just

off the plaza, Henry Moore's *Large Spindle Piece,* a mammoth bronze organic form, presides over its own island.

Arnoldo Pomodoro's immense bronze disc, *Disco Emergente,* is a forceful presence at the Greenwood Athletic Club. With its exposed high-tech network of sprockets, barbs, and cubes, it looks as if it were shattered in a fall from outer space.

The museum opened in 1982, the fulfillment of developer John W. Madden, Jr.'s twelve-year dream. He envisioned a publicly accessible business park that blends art, architecture, and landscape design. Within the complex are office buildings, a hotel, athletic club, amphitheater, and shops, all surrounded by paths, gardens, and groves of trees. The sculpture collection prominently features Colorado artists.

MOA opened with nineteen art works from Madden's private collection. By the mid-1990s the collection had grown to

Harry Marinsky, one of *Seven Harlequins,* Museum of Outdoor Arts, Englewood, CO

fifty-five pieces. A new work is added every two years. The museum offers an extensive arts education program, as well as concerts in the 18,000-seat Fiddler's Green Amphitheatre, designed by landscape architect George Hargreaves.

Sculptors whose work is represented include Giovanni Antonazzi, Louise Atkinson, Carolyn Brasksma and Andrew Dufford, Michele Brower, Beniamino Bufano, George A. Carlson, Red Grooms, George Hargreaves, Erick C. Johnson, Larry Kirkland, Grace Knowlton, Jon Leitner, Dennis Leon, George W. Lundeen, Robert Mangold, Harry Marinsky, Ivan Mestrovic, Henry Moore, Arnoldo Pomodoro, George Rickey, Pietro Tacca, Lynn Tillery, and Madeline Wiener.

Admission is free; guided tours available for a fee. A map and description of the complex and the sculpture is available at the MOA office. Parking is available around each of the seven sculpture sites.

How to Get There: Englewood is south of Denver, near the University of Denver. To reach Greenwood Plaza take I-25 to Orchard Road. RTD public bus service is available along South Quebec Street, East Berry Avenue, and around Greenwood Plaza Boulevard.

Museum of Outdoor Arts
600 East Orchard Road
Englewood, CO 80111
Hours: Sculpture on view at all times. Museum: 8:30 A.M.-5:00 weekdays.

New Mexico

Albuquerque Museum of Art

Albuquerque, New Mexico

Albuquerque's 5-acre garden features works by local sculptors. Several of the pieces pay homage to the cultural and artistic traditions of New Mexico and the Southwest. Lincoln Fox's 12-foot-high bronze *Sheepherder* is a tribute to the essential role of sheep in the culture of pre-Anglo New Mexico. Sebastian's

painted steel *Varacion Nuevo Mexico* is a colorful artistic interpretation of Spanish and Pueblo history: three diagonal columns represent the missions and haciendas, while thirty disguised cubes reflect the Pueblo culture of the Rio Grande. Luis Jimenez, Jr.'s *Howl* refers to the artist's Mexican origins. According to art critic Terry Barrett, "He is howling for his people, for the Indians and the cowboys, for the coyotes, and for the vanishing west."

One of the most popular pieces is Jesus Bautista Moroles' *Floating Mesa,* a 22-foot-high work that incorporates New Mexico boulders with stainless steel. Moroles said the work attempts to balance "the mechanical man and the natural stone...to get them to work together."

The oldest piece in the collection is Oliver LaGrone's *Mercy,* which was originally produced in plaster under the Depression-era W.P.A. arts program in 1937. LaGrone lived in Albuquerque in his twenties and went on to become a professor of sociology, black studies, and art at the University of Pennsylvania. He returned to New Mexico in 1987 to restore the sculpture and have it cast in bronze. "My African ancestors invented the lost-wax method of casting, so whenever I work in bronze I am reminded that I am carrying on the work begun by my people," said LaGrone.

The two-story museum, completed in 1979, was designed by local architect Antoine Predock. It specializes in art of the Rio Grande region. The sculpture garden was established in 1991 with eighteen works. Pieces are regularly added to the collection.

Most of the sculpture is accessible at all times; some are behind gates in the enclosed museum courtyard and can be seen only when the museum is open. The grounds are landscaped with native flowers. Teakwood benches and large boulders provide seating. This is a popular spot for picnics and sunbathing. Summer jazz concerts are presented on the garden's outdoor stage on Saturday evenings. The garden leads to Albuquerque's famous Old Town historical district.

Sculptors whose work is represented include David Anderson, Richard Beckman, Larry Bell, John Connell, Paul

Cooper, Ron Cooper, Michael Davis, Linda Fleming, Lincoln Fox, Edward Haddaway, Una Hanbury, Bob Haozous, Jim Hill, Doug Hyde, Luis Jimenez, Jr., Joyce Kohl, Oliver LaGrone, Jesus Bautista Moroles, William Moyers, Michael Naranjo, Joe Orlando, Dan Ostermiller, Stephen Porter, Reynaldo Rivera, Sebastian, Patrick Simpson, Ed Vega, and Tom Waldron.

No admission fee. Docents lead sculpture tours three times a week, except in the summer.

How to Get There: The museum is at the northern edge of Old Town, between 19th Street and San Felipe, across the street from the Museum of Natural History.

Albuquerque Museum of Art
2000 Mountain Road NW
Albuquerque, NM 87104
505-243-7255
Hours: 9:00 A.M.-5:00 P.M., Tuesday through Sunday.

Shidoni Foundry, Galleries, and Sculpture Garden

Santa Fe, New Mexico

"Shidoni," the Navajo greeting of friendship, aptly characterizes the welcome visitors receive when they enter Shidoni's grounds, 5 miles north of Santa Fe. This active foundry and 8-acre sculpture garden, formerly an apple orchard, is among Santa Fe's most beloved attractions. Founded in 1971 by sculptor Tommy Hicks and his partner Gil Beach, Shidoni features works by Hicks and a host of nationally recognized sculptors. All the works are for sale.

The sculpture garden evolved from the foundry, where Hicks and Beach poured bronze molds for sculptors. When artists failed to pick up their works, the pieces were placed outdoors beside the foundry. Santa Fe art lovers began visiting the foundry to see the sculpture that was left behind. Shidoni's fame spread and the foundry evolved into a sculpture garden. Today, the garden displays as many as seventy-five large-scale metal sculptures, plus dozens of smaller pieces suitable for home gar-

dens. In keeping with Shidoni's origin as a foundry, all the sculpture is metal.

The emphasis is on the sculpture, not the landscaping, although the grounds are attractive and well maintained. The wide entrance lawn is filled with brightly colored, eye-catching sculpture that contrasts dramatically with the arid desert setting. Some pieces are placed in a densely wooded, hilly area beyond the foundry.

Most of the sculpture is abstract, and even the figurative pieces tend toward abstract forms. As befits a successful gallery in which pieces move in and out regularly, there is no obvious system for siting the works. The overall impression is a cheerful jumble. The sheer number and variety of sculptures mean there is something for every artistic taste, from powerful abstract forms to works of whimsy. A strong sense of creative energy is evident, although the quality of the works is uneven. Some are crude, while others are clearly the products of accomplished sculptors.

Artists represented include Jim Amaral, Mary Bates, Ali Baudoin, Bruce Beasley, Mary Bonkemeyer, Fred Borcherdt, Doris Cross, Ron Cross, Linda Dumont, Rico Eastman, Enrico Embroli, Bella Feldman, Lisa Gordon, Ed Haddaway, John Heric, Thomas G. Hicks, Richard Hunt, Robert Indermaur, Ron Jermyn, Bea Mandelman, Christiane T. Martens, Frank Morbillo, Willie Ray Parish, Michael Pavlovsky, Kevin Robb, Linda Tasch, Robert Tully, Hans Van de Bovenkamp, Bill Weaver, Edwin Wenger, Karon Winzenz, and Glenn Zweygardt.

Tours are given frequently. The sales staff is knowledgeable and willing to answer questions. Food is not available for purchase, but picnicking is permitted.

How to Get There: The garden is on Bishop's Lodge Road, 5 miles north of Santa Fe.

Shidoni Foundry, Galleries and Sculpture Garden
P.O. Box 250
Santa Fe, NM 87574
505-988-8001 or 800-333-0332
Hours: 9:00 A.M.–5:00 P.M., Monday through Saturday.

Washington

Western Washington University

Bellingham, Washington

Western Washington University, near the Canadian border, is everything one could hope for in a campus in the verdant Northwest. Rolling lawns are bordered by dense groves of trees, and sweeping terraces overlook the spectacular San Juan Islands. The many and varied large-scale sculptures are distinctive complements to both the classical buildings and the recent modern additions.

At the center of the campus is Richard Serra's 100-ton *Wright's Triangle*. This typical Serra piece, with massive, angled steel plates and triangular openings, sits smack in the middle of a busy campus pathway. While it is most definitely a barrier to smooth movement, the sculpture generates none of the hostile reaction that a similar Serra piece produced in New York City's Federal Plaza. Perhaps an appreciation for this work, and other pieces in the campus collection, is fostered by orientation tours for new students that are conducted each semester. Students are encouraged to walk inside the structure to experience the play of light and shadow. When first installed in 1980, it was the target of graffiti and plastered with posters. Vandalism was quickly brought under control with the enforcement of a law that permits the university to send vandalism cases to court.

Isamu Noguchi's *Skyviewing Sculpture* is the cornerstone of an expansive Italian-style central courtyard. This mammoth tilted steel cube with a wide circular cutout seems to rest precariously on three brick piers. When looking up through the circular opening it elicits the sensation of being lifted skyward. At night, artful interior lights give the piece a Darth Vader kind of presence.

Mark di Suvero's *For Handel* was one of the first big pieces to be acquired, and its dominating presence was initially widely criticized. Now the nearly 30-foot-tall bright red steel I-beam structure is among the most beloved. Originally a swing hung

Magdalena Abakanowicz, *Manus* (1994), Western Washington University, Bellingham, WA

from its rafters, but it was removed when a student broke his arm on it. The musical allusion is apt since *For Handel* literally springs from the music auditorium; supports for the sculpture are embedded in auditorium's roof.

A popular lookout spot is George Trakas' *Bay View Station,* a wood and steel pathway of irregularly shaped decks that offers an extraordinary vantage point for viewing the port and the stunning San Juans in the distance. Trakas' imagination for the sculpture was sparked by an old, narrow steel path that is still visible on the steep hillside just below the site.

Magdalena Abakanowicz's powerful *Manus* is a 15-foot-high bronze and beeswax tower that resembles a hollowed-out tree or a gnarled hand, depending on the direction of view. The piece seems hemmed in at its present site alongside the major entrance to the campus. Eventually, when plans for reconfiguring the roadway are implemented, the sculpture will show to better advantage on an open grassy field. Abakanowicz lives in Warsaw and is widely recognized for her espousal of individual freedom against any form of political tyranny. Many of her works reflect an intermediate state between human and organic shapes.

Western Washington's sculpture collection was initiated in 1957. The first piece, *Rain Forest,* a bronze fountain with a bark-like finish, was created by Northwest sculptor James Fitzgerald and was installed in 1960. The campus of nine thousand students is continually expanding, and with the expansion come new opportunities to add to the collection.

Sculptors whose works are on display include Magdalena Abakanowicz, Alice Aycock, Fred Bassetti, Richard Beyer, Anthony Caro, Mark di Suvero, James Fitzgerald, Lloyd Hamrol, Nancy Holt, Donald Judd, John Keppelman, Robert Maki, Michael McCafferty, Robert Morris, Isamu Noguchi, Beverly Pepper, Mia Westerlund Roosen, Richard Serra, Steve Tibbetts, George Trakas, and Norman Warsinske.

An audio tour of the collection is available from the Visitors' Information Center. The audio tour uses the artists' own words to describe the pieces. A map of the collection is also available at the Visitors' Center and at the Western Gallery.

No admission charge.

How to Get There: Bellingham is approximately 90 miles north of Seattle and 50 miles south of Vancouver, B.C. Take I-5 to Exit 252 (the McDonald Parkway) and follow signs to the campus.

Western Washington University
Outdoor Sculpture Collection
Bellingham, WA
360-650-3963
Hours: Sculpture is on view at all times. Western Gallery is open when classes are in session, 10:00 A.M.-4:00 P.M., weekdays; noon to 4:00 P.M. on Saturday.

Warren G. Magnuson Park

National Oceanographic and Atmospheric Administration (NOAA)

Seattle, Washington

Tucked into an out-of-the-way corner of Warren G. Magnuson Park, on the sparkling shores of Lake Washington, is a rustic shoreline sculpture trail, a little-known treasure even to Seattle residents who pride themselves on their knowledge of the city's artistic treasures.

Artfully situated to exclude from sight the prosaic modern glass NOAA regional headquarters is an unmarked sculpture path that begins a short distance from the parking lot at the park's swimming area. About a quarter of a mile along a wide dirt road edged with tall grasses and wildflowers, the first sculpture comes into view, a distinctive Siah Armajani bridge. The only trail marker is a diminutive knee-high map placed discreetly alongside the bridge.

Armajani's small reddish-bronze bridge, and its duplicate at the far end of the trail, act as bookends for the remarkable sculptures that were commissioned by NOAA for the site. The bridges could understandably be overlooked by a casual observer who would assume they were ordinary culverts. Close inspection yields much more. Inlaid in bronze on the edges of the bridges' supporting cylinders are quotations from Herman Melville's *Moby Dick,* a reference to NOAA's role in protecting the oceans.

Two other pieces also blend so successfully into the landscape that their significance as sculpture might be missed. George Trakas' *Berth Haven* is a glorious lookout point on Lake Washington. Designed to complement the natural setting, this elaborate V-shaped steel and wood dock propels visitors to the water. Scott Burton's *Viewpoint* is another naturalized shoreline setting. Burton, well known for his sculpture-as-furniture, created an aggregate stone terrace with a stainless steel grid and fashioned seating areas from granite boulders dredged from the lake.

Douglas Hollis' *Sound Garden* would never be mistaken as an utilitarian construction. A dozen tall skinny steel rods topped with rectangles resembling weather vanes dominate the landscape. Extending from these rods are vertical tubes that act as a pipe organ. Music is produced when wind on the weather vanes is forced through openings in the tubes. The differing lengths of tubing create variations in sound. Music from *Sound Garden* so impressed a Seattle rock group that it adopted the sculpture's name as its own.

Scott Burton, *Viewpoint*, Warren G. Magnuson Park, National Oceanographic and Atmospheric Administration, Seattle, WA

The sculpture trail was funded by the National Endowment for the Arts. The Seattle Arts Commission supervised the artistic selection process, which produced more than 250 proposals. The total cost of the project was $250,000.

Sculptors represented in this collection include Siah Armajani, Scott Burton, Douglas Hollis, Martin Purdy, and George Trakas.

The park has picnic tables and barbecue pits, a boat launch, and a wide swimming area with lifeguards. NOAA's cafeteria is open to the public on weekdays during lunchtime.

How to Get There: Follow Sand Point Way N.E. to signs for Warren Magnuson Park. Walk on a pathway along the lake shore from the public bathing area.

Warren G. Magnuson Park
National Oceanographic and Atmospheric Administration
Western Regional Center
7600 Sand Point Way N.E.
Seattle, WA 98115
Hours: Sculpture trail is open at all hours.

More Sculpture Attractions in the West and Southwest

Arizona

Sculptor **James Turrell** is fashioning the colossal Roden Crater in the interior of an extinct volcano on the edge of the Painted Desert, northeast of Flagstaff. It will be a major artistic and scientific contribution when it is finished at the end of the decade. Turrell purchased the cinder cone in 1977 and is filing down its rim to make it perfectly concave. The crater is being excavated to align its spaces with the sun and certain stars. Tunnels and rooms inside and alongside the cone will eventually allow visitors to explore the interconnections between light and space; as Turrell puts it, to see "how light inhabits space" and the "physical feeling and power that space can give." This complicated work-in-progress is expected to be open to the public around the year 2000.

Sculpture funded by Phoenix's aggressive Public Art program adorn many of the city's public works projects, including such unlikely sites as freeways and solid waste plants. On a mile-long stretch of Squaw Peak Parkway, **Mags Harries's** polychrome, vessel-shaped pieces called *The Pots* are perched atop the highway's sound barrier. When installed in 1992, these whimsical objects were the instant target of jokes about the infrastructure "going to pot." They are now cherished by local residents. The works can be seen along the parkway from I-10 on the south to Glendale Road on the north.

Further down the highway, at the Thomas Road Overpass, artist **Marilyn Zwack** created a sculptural form for massive freeway overpass supports. Six immense lizardlike forms reach up to support the triple-span overpass. These stylized biomorphic forms recall the centuries-old archeological remains of the ancient Hohukum civilization that flourished where highways now cross the landscape.

The **Tempe Arts Center,** just south of Phoenix and Scottsdale, is surely the only art association in the country that displays sculpture in abandoned swimming pools. The two Olympic-size pools, dating back to the mid-1920s, were part of a public swimming pool complex that fell into disuse in the 1980s when many residents built backyard pools. Contemporary, large-scale sculptures sit in the pools on beds of gravel. The works are on loan, and all are for sale. Typically, more than a dozen pieces are on display. No admission fee for the garden; admission charge for the museum, except on Sunday. Picnics are permitted in the park. The Center is in Tempe Beach Park, along the Salt River at the corner of Mill Avenue and First Street.

California

Southern California—Los Angeles Area

Watts Towers, in the Watts section of Los Angeles, is one of the country's most famous folk art sites and a major tourist attraction. The complex was created by **Simon Rodia,** who worked alone for thirty-three years, using only the tools of a tile-setter and a window-washer's belt and bucket. Rodia came to the

United States from Rome as a child and worked as a construction worker, logger, and miner before dedicating his life to the towers, in 1921. The seven towers, made with reinforced steel rods and wire mesh, are covered with cement into which Rodia embedded bottles, broken dishes, mirrors, and thousands of seashells. The tallest steeple soars 100 feet in the air. Also on the triangular lot are fountains, birdbaths, and a mosaic wall. "I had it in my mind to do something big, and I did," was Rodia's simple statement about his masterpiece. Abruptly and without explanation, Rodia deeded his property to a neighbor in 1954, in exchange for a bus ticket to Martinez, 500 miles away. He never looked back. In the late 1950s the towers began to deteriorate and Los Angeles threatened to demolish them as a safety precaution. The city relented after an engineering survey demonstrated their structural integrity and arts groups campaigned to preserve them. The property is now owned by the state and leased to the city. The drive to save the towers left Rodia unfazed: "If your mother dies and you have loved her very much, maybe you don't speak of her," was Rodia's assessment. He died in 1965. The towers are open daily from 10:00 A.M.-4:00 P.M. They are located on 107th Street in south central Los Angeles, not far from the International Airport.

Downtown Los Angeles is another exceptional sculpture adventure. More than sixty outdoor sculptures festoon the city's core. At Civic Center, sixteen sculptures are displayed, including Jacques Lipchitz's towering bronze *Peace on Earth* at the Music Center. Bunker Hill's commercial banking district is particularly rich in notable works: Alexander Calder's painted steel stabile *Four Arches* with its gracefully looped tentacles presides at the Security Pacific Plaza; Michael Heizer's stainless steel study of shapes, *North, East, South West,* and Frank Stella's *Long Beach* adorn the Wells Fargo Bank; and Nancy Graves' *Sequi* and Louise Nevelson's *Night Sail* are centerpieces at Crocker Center. At Little Tokyo's Japanese American Cultural & Community Center, Isamu Noguchi's serene 1-acre plaza features his rock sculpture *To The Issei,* which sits on an austere stepped platform. The area's north-south boundaries run between the Hollywood

and Santa Monica Freeways; its east-west boundaries are Alameda Street and the Harbor Freeway.

In Simi Valley, northwest of Los Angeles, is one of the few folk art environments created by a woman, **Tressa (Grandma) Prisbrey's** landmark *Bottle Village*. On a third of an acre, purchased with her husband in 1950, Prisbrey created a complex of fifteen buildings and sculptures made with bottles and concrete. Each has its own theme, such as *Pencil House, Little Chapel, School House, Doll House,* and *Shell House*. All have mosaic floors. Among the artifacts are mosaic walkways inlaid with ceramic tile, a fluorescent fountain. Prisbrey died in 1988. The installations, at 4595 Cochran Street, are being restored from damage in the earthquake and are open by appointment only. (For more information, call 805-583-1627.)

On the campus of Pierce College in the Woodland Hills section of the San Fernando Valley is *Old Trapper's Lodge,* the inspiration of **John Ehn**. For many years Ehn was a government trapper in Michigan. He moved to California in 1941 and built a motel he called Old Trapper's Lodge in honor of his former occupation. For fifteen years he created historical and fictional characters from folk song and stories, using strong wire covered with cement. His *Texas Bed Bug* incorporates a giant Mexican turtle shell. *Boot Hill Cemetery's* tombstones are inscribed with the fates of the deceased. After Ehn's death in 1981, the lodge was moved for preservation purposes to its current location, not far from its original site.

The **Skirball Museum** of Hebrew Union College will offer Angelenos another outdoor sculpture collection when its new building, designed by Moshe Safdie, opens in April 1996. The building is considered a piece of sculpture on its own. The architectural design integrates sculpture in the landscape, and on terraces and hillsides of the 13-acre site that sits in the shadows of the Santa Monica mountains in West Los Angeles. The museum features works by artists whose life or works relate to the Jewish experience. The museum is at the intersection of Sepulveda Boulevard and Mulholland Drive in West Los Angeles. (For more information, call 213-749-3424.)

Southern California—Long Beach/San Diego

The **Newport Harbor Art Museum** in Newport Beach displays ten outdoor sculptures, seven of which are set around the museum's cafe. The collection includes works by such well-known sculptors as Fletcher Benton, Jonathan Borofsky, and Clement Meadmore. The museum, a 15-minute drive from California Scenario in Costa Mesa, was founded in 1962 by a dozen local women to promote post-World War II California art. From the San Diego Freeway (I-405), take the Jamboree Exit and travel south for 5 miles; turn left at Santa Barbara Drive and left at San Clemente Drive. The address is 850 San Clemente Drive. (For more information, call 714-759-1122.)

Farther down the coast, in San Diego's bustling Balboa Park, is a small but impressive sculpture collection at the **San Diego Museum of Art's** Mary S. Marcy Court and Garden. Sculpture is mounted on concrete platforms amid swaths of grass and shrubs. Simple T-shaped benches provide comfortable rest spots. Slim, vertical slats of black iron fencing around the garden's perimeter offer a distinctive backdrop for the sculpture; the fencing is particularly effective as a counterpoint for Louise Nevelson's black rectangular construction, which features zig-zagging support columns, and for Joan Miro's amusing black amoebalike form. Alexander Calder's bright red bisecting steel circles are nestled next to a group of vivid green trees. The garden was established in 1968, although the collection dates back to the early 1950s. The largely contemporary collection frames the sculpture garden cafe.

In the rugged back country of northern San Diego County is **Sho-En Environmental Gardens,** a 50-acre sculpture center and tree nursery. This is a region where hiking boots and front-wheel drives are standard equipment, but the arduous trek is well worth the effort. Sho-En, the Japanese word for pine forest, displays more than a hundred contemporary sculptures in wood, stone, bronze, ceramics, copper, and marble. Smaller works include traditional granite Oriental lanterns, birdbaths, and Indian petroglyphs. All the pieces are for sale. Shaded benches on a floating pavilion offer a welcome respite from the heat and a vantage point from which to enjoy the sculpture and the won-

drous mountain setting. Sho-En's forest has thirty thousand Japanese black pine and a wide variety of bonsai, including magnolias, maples, and pomegranates, some of which bear fruits the size of peas. Sho-En is open for a month from mid-November to mid-December and for a month in the spring. The garden is in Ramona, an hour's drive east of San Diego. The address is 15090 Sho-En Lane. (For more information, call 619-789-7079.)

Southeast of San Diego is *Desert View Tower*, a memorial to the pioneers who trudged through the desert on their westward migration. Construction on the three-story circular tower with thick native stone walls was begun in the 1920s by **Bert Vaughn** and completed in the 1950s by **Dennis Newman.** Surrounding the tower are statues of real and mythical animals created by **M. T. Ratcliffe,** an engineer turned sculptor. This popular tourist attraction is in Jacumbo on Interstate 8, near the Mexican border, 40 miles west of El Centro.

Northern and Central California

In San Francisco, the **Esprit Sculpture Garden** was initiated in 1983 when San Francisco art dealer John Berggruen took over a long, square block at Esprit's corporate headquarters as a temporary site to exhibit several large pieces by the prolific Mark di Suvero. The garden mounts two shows annually, typically the works of one artist. Esprit exhibits both well-known and emerging artists in its well-tended 2-acre garden. Shows are up for three to six months; sometimes no sculpture is on display. Only blocks away, towering waterfront cranes offer another distinctive sculptural image. Esprit is located at 900 Minnesota Street, east of the Mission District, among warehouses at the base of Potrero Hill. To check if works are on display, call 415-648-9000 or 415-243-0940.

The Oakland Museum exhibits contemporary California sculpture at **City Center,** the world headquarters for the American President Companies, at 1111 Broadway. Surrounding the building are large-scale marble sculptures by Richard Deutsch. It is a 15-minute walk from the Oakland Museum.

The scenic pleasures of vineyards and sculpture combine in the Napa Valley at **Clos Pegase,** designed by architect Michael

Graves. The architect's design, which combines architectural elements from Greek, Roman, and Aztec temples, is set against a steep hillside. Owner Jan Schrem opened this "temple of wine" in 1986 and began exhibiting sculpture from his personal collection the following year. Set among the earth- and russet-colored postmodern winery buildings are two dozen works by internationally known sculptors, including Anthony Caro, Mark di Suvero, Jean Dubuffet, George Rickey, Richard Serra, and Elyn Zimmerman. The 450-acre winery is in Calistoga, north of St. Helena. From I-80 take the "Calistoga, 29 North" exit and turn right on Dunaweal Lane. Clos Pegase is at 1060 Dunaweal Lane. (For more information, call 707-942-4982.)

Another sculpture treasure in Napa Valley can be found at **Auberge du Soleil,** a French country inn and luxurious resort less than a 10-minute drive from St. Helena, in the heart of the wine country. The inn, located on a former 33-acre olive grove, has sweeping views of the valley. The inn recently created a 4-acre sculpture garden that features sixty works by local and nationally known artists. The works are displayed along a half-mile nature path through a sloping grove of trees. The extensive grounds are filled with flowers, rosemary, and lavender. Tours are conducted on the first and third Wednesday of each month. Most of the pieces are for sale. The inn is at 180 Rutherford Hill Road, Rutherford, California. (For more information, call 707-963-1211.)

Colorado

Among the earliest earthworks is **Herbert Bayer's** 1955 *Earth Mound,* a broad, grassy circular berm that encloses a broad conical depression of earth near the guest complex at the Aspen Institute for Humanistic Studies, in Aspen, Colorado. Bayer, like his contemporary fellow sculptor Isamu Noguchi, used Japanese garden design concepts. As an accompanying and contrasting work, Bayer created *Marble Garden,* a fountain, square pool, and geometric figures that emphasize the horizontal plane, as opposed to the vertical lines in the companion piece.

Artyard, a landscaped former parking lot, is the brainchild of Peggy Mangold, who created the space to display the large-scale kinetic works of her husband, internationally known sculptor Robert Mangold, and other western abstract sculptors. Eight exhibitions are mounted a year, each with as many as forty works on display. The gallery's informal space with concrete floors resembles a gallery in New York's SoHo or London. Artyard is about 1 mile southeast of the Civic Center and the Denver Art Museum, at the intersection of Louisiana and Pearl. (For more information, call 303-777-3219.)

Nevada

Michael Heizer, a pioneer in earthworks projects, came into prominence in the 1970s. His sculptural forms use and alter the natural landscape to fit the artist's grand vision. With bulldozers and dynamite, Heizer created *Double Negative* in 1970, a massive construction cut into the top of Mormon Mesa in the Nevada desert. The title suggests an absence or a removal. He displaced 240,000 tons of desert sandstone to create two 30-foot-wide, 50-foot-deep gashes that face and echo each other along a vast escarpment. The colossal incisions run for 1,500 feet. These seeming voids focus attention on the grandeur of this natural setting. The earthwork, 80 miles from Las Vegas, is now part of Los Angeles' Museum of Contemporary Art collection. Ask for directions at the Overton, Nevada, airport, which is about 5 miles from the sculpture installation.

Just outside Las Vegas, the community of **Green Valley** adorns its streets with distinctive sculptures by J. Seward Johnson, Jr. In an ever-changing display, a dozen pieces are on view. Works bear titles such as *Match Point* and *Par, What?*, testifying to the recreational focus of this suburban oasis. Everyone in town, from youngsters to seniors, draws pleasure from these sculptures represent. A sculpture guide is offered at the visitor's center. Green Valley is in Henderson, 20 miles southeast of Las Vegas, on U.S. 93. (For more information, call 702-458-8855.)

Chief Rolling Mountain Thunder (born Frank Van Zant in 1911) built his homage to the American Indian in Imlay, Nevada,

in the northwest part of the state. The chief had been a logger, miner, police officer, and minister and was a strong believer in self-reliance. From discarded tools, railroad ties, concrete, and rocks he constructed more than two hundred sculpture images of Indians. The many-chambered, airy monument, which resembles a giant Indian carrying basket, has an interior staircase made from bicycle wheels and handle bars. In 1983 vandals set fire to the monument, but much of it has been restored. Imlay is 30 miles southwest of Winnemuca. Open daily, 7:00 A.M.-5:00 P.M. The monument is on the south side of I-80, at Exit 14S. (For more information, call 902-538-7402.)

New Mexico

Visitors to New Mexico who seek a singular sculpture experience might consider a visit to **Walter De Maria**'s *Lightning Field*, a major earthwork in Quemado, in west-central New Mexico. Completed in 1977, this installation presents a spectacular lightning show that dramatizes man's insignificance in the face of nature's power. Steel poles are grouped to attract lightning. When lightning strikes the poles, silver streaks of light against the black sky create an astonishing sight. De Maria erected four hundred thin stainless steel poles in a rectangle that stretches for more than a kilometer in the vast New Mexico desert. The field is on a flat, semiarid site where lightning is a frequent occurrence. The installation, created as a celebration of lightning's "power and visual splendor," is maintained by the Dia Foundation, which provides overnight accommodations for up to six people per night. Of course, lightning is not guaranteed, but even without the nighttime drama, the site has distinct attractions; the seemingly endless lines of poles glimmer at dawn and dusk, and the scale of the desert and the mountain ranges offers a lesson in man's insignificance. The operating sensations here are space and solitude. Open from May 1 through October 31. For information, call the Dia Foundation in New York City at 212-431-9232, or contact the New Mexico office at Wind N.W., in Albuquerque, NM. (For more information, call 505-898-5602.)

Oregon

The agriculturally rich Willamette Valley, known for its expansive wheat fields and grapevines, is the setting for an exciting and varied collection of outdoor art, presented by the **Lawrence Gallery**. The gallery, about 25 miles southwest of Portland, boasts the largest volume of gallery sales in the Northwest. This 5-acre setting features lush perennial and Japanese-style gardens, a rose arbor, and secret courtyards with waterfalls that cascade from basins to pools. Birdbaths, fountains, and bells are all part of the ever-changing sculpture attractions. All the works are for sale. The gallery is on Route 18, just east of Sheridan. (For more information, call 503-843-3633.)

Rasmus Peterson's *Rock Garden*, in central Oregon, 160 miles southeast of Portland, is a complex of miniature buildings, lagoons, and bridges, all decorated with his collection of Oregon agates, obsidian, petrified wood, malachite, and jasper. An immigrant from Denmark, Peterson started his jeweled garden when he found the rocky Oregon soil inhospitable to farming. He died in 1952. The garden, at 7930 S.W. 77th Street, is open daily. It is off Old Redmond Highway, between Bend and Redmond. (For more information, call 503-382-5574.)

Utah

Robert Smithson's *Spiral Jetty*, completed in 1970, is one of the most widely documented earthworks, and it offers an adventurous outing for the really dedicated sculpture fan. In a desolate area of Great Salt Lake, filled with long-abandoned industrial debris, Smithson bulldozed black basalt, limestone rocks, and earth to form a giant spiral in Great Salt Lake. The spiral form is a reference to the molecular structure of salt crystals; a local legend speaks of an enormous whirlpool at the lake's center. A particular draw of the site is the water's soft pink cast caused by a micro-organism in the lake. The lake rose in 1972, covering the sculpture; whether the work can be seen depends on the level of the lake. It is usually exposed during the summer months. The site is 15 miles from the Golden Spike National Historic

site, where Park Service staff will point you in the right direction. Call the National Historic site at 801-471-2209 to learn if the sculpture is visible.

Nancy Holt's *Sun Tunnels* is another dramatic Utah earthwork adventure. In the desert near Lucin, Holt installed four 18-foot-long industrial concrete pipes in an X-shape, about 50 feet apart, in the vast, scrub-brush flatlands. Pipes are aligned with the summer and winter solstices; at sunrise and sunset the sun and moon can be seen through the aligned pairs of pipes. Holes in the upper surface of the pipes are shaped to form celestial constellations. When peeking out through the end of a tunnel, distance compresses, and the view is similar to a scenic vignette, a distinct contrast with the sweeping vista experienced when the viewer stands on the desert floor. Lucin is in northwest Utah, 10 miles from the Nevada border, due west of Great Salt Lake. The site can be reached on a 4-mile gravel road off Route 30, about 17 miles northeast of Montello, Nevada. From Lucin, drive south 2.5 miles and bear left. The sculpture will be visible on the right. After 2 miles, bear right and go one-half mile to the sculpture site.

Washington

With the possible exception of the nation's capital, Seattle is home to more outdoor art per acre, and certainly a greater variety, than any city in America. Seattle's Percent for Art program funds sculpture installations at fire stations, street corners, bus stops, electric substations, plazas, parks, and on its spectacular waterfront. Even cast-iron manhole covers receive artistic attention. Nearly two hundred outdoor works have been installed with support from the public art fund. A few of the outstanding attractions are briefly described here.

Seattle Center, the city's large cultural, scientific, and entertainment complex established on the 1962 World's Fair site, has more than two dozen outdoor sculptures. One of the most forceful is Alexander Liberman's 4-story steel *Olympic Iliad,* an installation of forty-one huge bright red cylinders that sit to one side of the Space Needle. A work that never fails to delight visitors is

Lauren Ewing's *The Endless Gate*, at the southeast entrance to the park. A lined-up series of brightly colored gateways, each with titles such as "The Gate," "Neither One," and "Nor the Other" are placed over the arches. Ronald Bladen's *Black Lightning*, a 60-foot-long representation of one of nature's most dramatic outbursts, is positioned at the Flag Plaza Pavilion, near the center of the complex. The point of the lightning bolt is directed to the northeast. Seattle Center can be reached by Monorail from Westlake Center in downtown Seattle.

Gas Works Park, at the north end of Lake Union just off Northlake Way, began as a gas production facility in 1906. Later transformed to an oil-fired plant, it closed in the 1950s when the city converted to natural gas. The land lay fallow until 1975 when, after a public debate over tearing it down, the city began to appreciate the uniqueness of the eccentric towers. They now serve as an anachronistic backdrop for a giant concrete, bronze, and ceramic *Sundial*, created by Charles Greening and Kim Lazare on a mound designed by landscape architect Richard Haag. The shadow of a visitor standing at the center of the oval dial will point to the correct time. The 28-foot-diameter sundial, embellished with zodiac signs and sea life shapes, has a bronze sun and moon at opposite ends.

In the realm of folk art is **Milton Walker's** *Rock Garden*, a series of towers, walls, miniature mountains, lakes, paths, fountains, and a patio—all built with semiprecious stones, rocks, crystals, geodes, and chunks of glass. A winding, rock-encrusted wall surrounds the fountain, which shoots jets of water into the air. Walker worked on his creation for more than twenty years, until he became ill in 1982. After his death in 1984, his wife continued the project. The garden, which is a popular spot for garden and rock clubs and school children, is open April to Labor Day, by appointment. The garden is at 5407 37th Avenue, S.W., Seattle. (For more information, call 206-935-3036.)

The Kirsten Gallery's Japanese Zen sculpture garden reflects the personal vision of artist **Richard C. Kirsten-Daiensai**, an American-born Zen priest. The garden is a blend of natural elements from the Northwest and religious and decorative objects from Japan. Graceful, broad gravel steps are rimmed in cedar.

Gentle sounds of rustling bamboo and tingling bells express a distinctly Eastern sensibility. A beatific, seated stone Buddha, with a painted gold face, is framed by a small grove of tall bamboo and bright flowers. Other sculptures from Japan include a three-hundred-year-old *jizo* or birdbath. Stone monoliths, flat rocks, river rocks, and moss-covered stones are sculptural elements throughout the garden. This is a community oasis for neighbors, who come to meditate, eat lunch, and help with maintenance chores. Admission is free. Near the University District, the gallery is at 5320 Roosevelt Way N.E., Seattle. From downtown Seattle on I-5 use Exit 169.

In the Seattle suburb of Kent, **Herbert Bayer** created *Mill Creek Canyon Earthworks* in 1982 as the focal point for a 100-acre park. His design includes giant circular grassy mounds and wide sloping berms that offer flood protection during the rainy season and an inviting public performance space. To minimize erosion, a stone-lined stream meanders through the installation. A long wooden pedestrian walkway supported by berms provides easy access to the performance area. Mill Creek Canyon Park is at Titus and Canyon Streets

Resources

City Guidebooks on Public Sculptures

Bach, Penny Balkin. *Public Art in Philadelphia*. Philadelphia: Temple University Press, 1992.

Gayle, Margot and Michele Cohen. *Guide to Manhattan's Outdoor Sculpture*. Englewood Cliffs, NJ: Prentice Hall, 1988.

Lincoln Arts Council. *Public Art: Lincoln, Nebraska*. Lincoln, NB: The Council, 1993.

Los Angeles, Community Redevelopment Agency. *Public Art in Downtown Los Angeles*. Los Angeles: The Agency, 1986.

Rupp, James M. *Art in Seattle's Public Places*. Seattle: University of Washington Press, 1992.

Seattle Arts Commission *A Field Guide to Seattle's Public Art*. Seattle: The Commission, 1991.

The Empire State Collection. *Art for the Public*. New York: Harry N. Abrams, 1987.

Resources on Outdoor Art

Beardsley, John. *A Landscape for Modern Sculpture: Storm King Art Center*. New York: Abbeville Press, 1985.

———. *Earthworks and Beyond*. New York: Abbeville Press, 1989.

Elsen, Albert E. *Origins of Modern Sculpture: Pioneers and Premises*. New York: George Braziller, 1974.

Francis, Mark and Randolph T. Hester, Jr., eds. *The Meaning of Gardens*. Cambridge: MIT Press, 1990.

Goldwater, Robert. *What is Modern Sculpture?*. New York: Museum of Modern Art, 1969.

Greenberg, Jan and Sandra Jordan. *The Sculptor's Eye: Looking at Contemporary American Art*. New York: Delacorte Press, 1993.

Harrison, Marina and Lucy D. Rosenfeld, *Artwalks in New York*, second edition. New York: Michael Kesend Publishing, Ltd., 1995.

———— *Art on Site*. New York: Michael Kesend Publishing, Ltd., 1994.

James, Philip, ed. *Henry Moore on Sculpture*. New York: Viking Press, 1971.

Kassler, Elizabeth B. *Modern Gardens and the Landscape*. New York: Museum of Modern Art, 1964.

Kazanjian, Dodie and Calvin Tomkins. *Alex: The Life of Alexander Liberman*. New York: Alfred A. Knopf, 1993.

Kelleher, Patrick J. *Living with Modern Sculpture: The John B. Putnam, Jr., Memorial Collection, Princeton University*. Princeton, NJ: The Art Museum, 1982.

Krauss, Rosalind E. *Passages in Modern Sculpture*. Cambridge, MA: MIT Press, 1981.

Laumeier Sculpture Park, Ten Sites: Works, Artists, Years. St. Louis: Laumeier Sculpture Park, 1992.

Laumeier Sculpture Park, First Decade 1976-1986. St. Louis: Laumeier Sculpture Park, 1986.

Lawrence, Sidney and George Foy. *Music in Stone: Great Sculpture Gardens of the World*. New York: Scala Books, 1984.

Levkoff, Mary L. *Rodin in His Time: The Cantor Gifts to the Los Angeles County Museum of Art*. Los Angeles: Los Angeles County Museum of Art, 1994.

Lippard, Lucy R. *Overlay: Contemporary Art and the Art of Prehistory*. New York: Pantheon, 1983.

Lucie-Smith, Edward. *Sculpture Since 1945*. New York: Universe Books, 1987.

McCue, George. *Sculpture City: St. Louis*. St. Louis: Laumeier Sculpture Park, 1988.

Mitchell, W. J. T., ed. *Art and the Public Sphere*. Chicago: University of Chicago Press, 1992.

Proske, Beatrice Gilman and Robin R. Salmon. *Brookgreen Gardens Sculpture*, Volumes I and II. Murrells Inlet, SC: Brookgreen Gardens, 1968 and 1993.

Raven, Arlene, ed. *Art in the Public Interest*. New York: Da Capo Press, 1989.

Richman, Michael. *Daniel Chester French: An American Sculptor*. Washington, D.C.: The Preservation Press, 1976.

Robbins, Daniel, ed. *200 Years of American Sculpture*. New York: Whitney Museum of Art, 1976.

Robinette, Margaret A. *Outdoor Sculpture: Object and Environment*. New York: Whitney Library of Design, 1976.

Sculpture Inside Outside, Catalogue. New York: Rizzoli, 1988.

Senie, Harriet F. *Contemporary Public Sculpture*. New York: Oxford University Press, 1992.

───── and Sally Webster, eds. *Critical Issues in Public Art*. New York: HarperCollins, 1992.

Stern, H. Peter and David Collens. *Sculpture at Storm King*. New York: Abbeville Press, 1980.

Stone, Lisa and Jim Zanzie. *Sacred Spaces and Other Places*. Chicago: The School of the Art Institute of Chicago Press, 1993.

Sonfist, Alan, ed. *Art in the Land*. New York: E. P. Dutton, 1983.

Thacker, Christopher. *The History of Gardens*. Los Angeles: University of California Press, 1979.

Tuchman, Phyllis. *George Segal*. New York: Abbeville Press, 1983.

Tucker, William. *The Language of Sculpture*. London: Thames and Hudson, 1974.

Wagenknecht-Harte, Kay. *Site + Sculpture*. New York: Van Nostrand Reinhold, 1989.

Wrede, Stuart and William Howard Adams, eds. *Denatured Visions: Landscape and Culture in the Twentieth Century*. New York: Museum of Modern Art, 1991.

Yard, Sally, ed. *Sitings*. La Jolla, CA: La Jolla Museum of Contemporary Art, 1986.

Photo Credits

The authors gratefully acknowledge the personnel at the sculpture parks and gardens for their assistance in assembling the photographs.

Introduction

p.3. Robert Indiana, detail of *Love* (1970), Indianapolis Museum of Art, IN

p.6. Louise Nevelson, *Atmosphere & Environment VI* (1967), Kykuit, The Rockefeller Estate, North Tarrytown, NY; photo Charles Uht

p.12. Siah Armajani, *Irene Hixon Whitney Bridge*, Walker Art Center, Minneapolis, MN; photo Max Protech Gallery, New York City, NY

Northeast Section

p.22. Forrest Myers, Untitled (1968), The Aldrich Museum of Contemporary Art, Ridgefield, CT

p.27. Jacques Lipchitz, *Mother and Child II* (1941-1945), The Baltimore Museum of Art, Baltimore, MD

p.31. Louise Nevelson, *Transparent Horizon* (1975), MIT List Visual Arts Center, Cambridge, MA

p.39. William King, *Unitas* (1991), Grounds For Sculpture, Hamilton, NJ; photo James Barton

p.43. David Smith, Untitled (1964), The Newark Museum, Newark, NJ; photo Stephen Germany

p.55. View of the Abby Aldrich Rockefeller Sculpture Garden, Museum of Modern Art, New York NY; photo Scott Frances

p.59. Overview of the Isamu Noguchi Garden Museum, Long Island City, NY; photo Shigeo Anzai

p.72. Shinkichi Tajiri, *Granny's Knot* (1968), Kykuit, The Rockefeller Estate, North Tarrytown, NY; photo Charles Uht

p.77. Lin Emery, *Tree* (1991), Hofstra Museum, Hempstead, NY; photo Hugh Rogers

p.80. Fernando Botero, *Man on Horseback* (1984), Nassau County Museum of Fine Art, Roslyn Harbor, NY, on extended loan from the Metropolitan Museum of Art, New York City

p.83. Isamu Noguchi, *Momo Taro* (1977), Storm King Art Center, Mountainville, NY; photo Jeff Goulding

p.87. View of Balinesian pavilions at the Hans Van de Bovenkamp Sculpture Garden, Tillson, NY

p.89. John Hock, *Mashomack Molasses* (1992), City of Poughkeepsie Sculpture Park, Poughkeepsie, NY

p.94. View of the Albright-Knox Art Gallery Sculpture Garden, Buffalo, NY; Runco Photo Studios

p.99. Gail Scott White, *Dora and Lucy Discuss Freud*, Stone Quarry Hill Art Park, Cazenovia, NY; photo Courtney Frisse

p.101. Winifred Lutz, *Stone Tower*, part of *A Reclamation Garden* (1994), Abington Art Center, Jenkintown, PA; photo David Gamber

p.104. Ephraim Peleg, *Three Rings* (1980), Lehigh University Art Galleries, Bethlehem, PA

p.108. Lynn Chadwick, *Seated Couple on a Bench*, (1984), Ursinus College, Collegeville, PA; photo Art Wilkinson

p.111. Auguste Rodin, *The Burghers of Calais*, (1886), Hirshhorn Museum and Sculpture Garden, Washington, D.C.

p.112. Henry Moore, *Three-Piece Reclining Figure No. 2*, The Kreeger Museum, Washington, D.C.

Midwest Section

p.131. Jean Ipousteguy, *Man Going through a Door* (1966), Northwestern University, Evanston, IL

p.137. Martha Enzmann, *Dancers*, Mitchell Museum, Mt. Vernon, IL; photo Daniel Overturf

p.140. Bruce Nauman, *Animal Pyramid* (1990), The Des Moines Art Center, Des Moines, IA; photo Jimm Kascoutas

p.145. Francisco Zuniga, *Three Women Walking*, (1981), Edwin A. Ulrich Museum of Art, Wichita State University, Wichita, KS

p.149. Jonathan Borofsky, *Man with Briefcase* (1987), General Mills, Inc., Minneapolis, MN

p.152. Claes Oldenburg and Coosje van Bruggen, *Spoonbridge and Cherry*, (1985-1988), Walker Art Center, Minneapolis, MN

p.157. Alexander Liberman, *The Way*, (1972-1980), Laumeier Sculpture Park, St. Louis, MO; photo Robert LaRouche

p.161. Claes Oldenburg and Coosje van Bruggen, *Shuttlecocks* (1995), Nelson-Atkins Museum of Art, Kansas City, MO

p.167. Aristide Maillol, *La Montagne* (1937), Columbus Museum of Art, Columbus, OH

Southern Section

p.193. Philip Nichols, *Receptor Series Number V*, Chattanooga State Technical Community College Sculpture Garden, Chattanooga, TN

p.196. Brian Rust, *Red Earth Aerial*, University of Tennessee, Knoxville, TN

p.199. Barbara Hepworth, *Sea Form (Atlantic)* (1964), Dallas Museum of Art, Dallas, TX

p.203. Alberto Giacometti, *Large Standing Woman I* (1960), The Museum of Fine Arts, Houston, TX

p.206. Donald Judd, The Chinati Foundation, Marfa, TX; photo Marianne Stockebrand

West and Southwest Section

p.220. Auguste Rodin, *The Gates of Hell*, The B. Gerald Cantor Rodin Sculpture Garden at the Stanford University Museum of Art, Stanford, CA; photo Stanford News Service

p.223. Bruce Beasley, *Tragamon* (1972), Oakland Musuem, Oakland, CA

p.227. Gerhard Marcks, *Maja* (1942), UCLA Franklin Murphy Sculpture Garden, Westwood, CA

p.231. Artist Unknown, *Shiva Dakshina Murti Seated*, 14th Century, Norton Simon Museum, Pasadena, CA

p.242. Harry Marinsky, one of *Seven Harlequins*, Museum of Outdoor Arts, Englewood, CO

p.248. Magdalena Abakanowicz, *Manus* (1994), Western Washington University, Bellingham, WA; photo Rod del Pozo

p.251. Scott Burton, *Viewpoint*, Warren G. Magnuson Park, National Oceanographic and Atmospheric Administration, Seattle, WA; photo Max Protech Gallery, New York City, NY

Cover Photo

Martha Enzmann, *Dancers*, Mitchell Museum, Cedarhurst Sculpture Park, Mt. Vernon, IL; photo Daniel Overturf

Index

Aalto, Alvar, 207
Abakanowicz, Magdalena, 41, 63, 82, 102, 153, 248, 249
Abdell, Douglas, 84, 146, 186
Abduljaami, John, 224
Abington Arts Center, 100-102
Ablah, George, 160
Acconci, Vito, 66, 120, 135, 158, 159
Adams, Robert, 75
Ahearn, John, 63, 66
Akagawa, Kinji, 154
Albany, NY, 91-93
Albers, Josef, 221
Albright-Knox Art Gallery, 93-95, 97
Albuquerque, NM, 243-245
Albuquerque Museum of Art 243-245
Aldrich, Larry, 21-23
Aldrich Museum of Contemporary Art, 21-23, 24
Alleghany Landing, 24
Allen, Matthias, 20
Allen, Terry 239, 240
Allentown, PA, 108, 123
Alliance, NE 174-175
Allom, Charles Carrick, 79
Althouse, Tom, 104
Amaral, Jim, 246
Amarillo, TX, 213
Ames, IA 142-143
Anderson, David, 224, 244
Anderson, Michael, 218
Anderson, Robert, 143
Annesley, David, 84
Anonymous Art Recovery Society, 67
Ant Farm, 213

Antonakos, Stephen, 116, 166, 167
Antonazzi, Giovanni, 243
Appalachian State University, Rosen Sculpture Garden, 189-190
Appel, Karl, 75
Archipenko, Alexander, 113, 169, 227
Armajani, Siah, 12, 51, 82-83, 84, 150, 151, 154, 188, 250, 252
Arman, 23, 113, 146
Armitage, Kenneth, 95, 130, 146
Arneson, Robert, 224
Arnoldi, Charles, 79
Aronson, Adam, 158
Arp, Jean, 75, 81, 113, 115, 126, 131-132, 225-226, 227
Artschwager, Richard, 150, 151,
Artyard, 259
Arvanetes, Andrew, 181
Asawa, Ruth, 224
Asher, Michael, 239, 240
Askman, Tom, 143
Aspen, CO 14
Aspet, 37-38
Atkinson, Louise, 243
Atlanta, GA, 211
Auberge du Soleil, 258
Ave Maria Grotto, 208
Averbach, Alan, 186
Aycock, Alice, 83, 84, 102, 159, 165, 229, 249
Ayres, Antoinette, 139
Azuma, Kengiro, 237, 238

Bacon, Henry, 35
Baizerman, Saul, 84, 113, 154, 165

Baker, George, 233
Baker, Hildegarde Krause Sculpture
 Garden, 122
Ball, Lillian, 45
Baltimore, MD, 25-28
Baltimore Museum of Art, Wurtzburger
 & Levi Sculpture Gardens, 5, 25-28
Baraclough, Dennis 97
Barankenya, 169
Barbera, Melinda, 224
Barks, Richard 78
Barnard, George Grey, 75
Barnes, Edward Larrabee, 154, 183, 198
Barnhill, James, 233
Barr, Alfred, Jr., 21, 47, 48, 56
Barrett, William (Bill), 20, 23, 218, 235
Barrett, Kevin, 20
Barrett, Terry, 244
Bart, Robert, 22, 23
Baskin, Leonard, 95, 113, 146, 188, 227
Bassett, John, 11
Bassetti, Fred, 249
Bates, Mary, 246
Battery Park City, 50-53
Baudoin, Ali, 246
Bayer, Herbert, 14, 258-259, 264
Bayfront Park, 208-209
Beach, Gil, 245
Beasley, Bruce, 221, 222, 223, 224,
 227, 233
Beasley, George, 181, 246
Beckelman, John, 143
Beck-Friedman, Tova, 41, 42, 45, 49
Beckman, Richard, 244
Beer Can House, 212
Beinecke Library Courtyard, 62, 116
Beljon, J.J., 237, 238
Bell, Larry, 207, 244
Bell, Roberly Ann, 97
Bellingham, WA, 4, 247-250
Bendel, Henri, 24
Ben-Haim Zigi, 20, 109
Bennett, Chris, 143
Ben-Shmuel, Daniel, 146
Benson, Elaine, Gallery, 120-121
Bentham, Douglas, 90
Benton, Fletcher, 224, 227, 233, 256
Berggruen, John, 257
Berkshires (MA), 7, 117-118
Berman, Muriel and Philip, 6, 103-104,
 107-108, 123

Berman, Muriel and Philip Sculpture
 Collection, 103-104
Berman Museum of Art, 107-109
Bermudez, Jose, 217, 218
Berry, Roger, 20
Bertoia, Harry, 48, 104, 147
Bertoldi, Allen, 79, 224
Besthoff, Sydney III, 188
Bethesda, MD, Business District, 116
Bethlehem, PA, 103-104
Beyer, Richard, 249
Beyer, Steve, 151
Bigger, Michael, 224
Bill, Max, 26, 75, 84, 95, 169
Bills, Tom, 20, 41, 44, 45, 66, 102
Birmingham, AL, 182-183, 208
Birmingham Museum of Art, 182-183
Biro, Ivan, 24
Bitter, Karl, 67, 75, 192
Bjorge, John, 97
Bladen, Ronald, 56, 93, 263
Blitt, Rita, 235
Bloc, Andre, 238
Block, Leigh, 6, 132
Block, Mary and Leigh, Gallery, 130-132
Bloom, Miriam, 20
Bloomfield Hills, MI, 146-148
Blum, Andrea, 151
Blunk, J.B., 224
Boccioni, Umberto, 188
Bolinsky, Joe, 97
Bolomey, Roger, 93, 224
Bonet, Jordi, 130
Bonkmeyer, Mary, 246
Bonsignor, John, 24
Booker, Chakais, 58, 59
Boone, NC, 189-190
Booth, George and Ellen, 147
Borcherdt, Fred, 246
Bordes, Juan, 20
Borglum, Gutzon, 24, 61, 67, 176-177,
 192
Borofsky, Jonathan, 149, 151, 185, 186,
 256
Bosworth, William Welles, 32, 73
Botero, Fernando, 79, 80, 144, 146,
 159, 182, 234, 235
Bottle Village, 255
Bottoni, David, 224
Bourdelle, Emile-Antoine, 26, 48, 56,
 113, 167, 204, 227, 229

Bourgeois, Louise, 204
Bowman, Ty, 234-235
Bradley Family Foundation Sculpture
 Park 4, 168-170
Bradley, Harry Lynde, 169
Brancusi, Constantin, 73, 75
Brasksma, Carolyn, 243
Brenman, Joe, 49
Briarcombe Sculpture Courtyard, 122
Bridgehampton, NY, 120-121
Bright, Barney, 169
Bright, David E., 226
Bromberg, Manuel, 84
Brookgreen Gardens, 4, 15, 84,
 190-192
Brookline Village, MA, 11
Brooklyn Museum, 67-68, 229
Brooklyn Museum, Frieda Schiff
 Warburg Sculpture Garden, 67-68
Brower, Michele, 243
Brown, Judith, 70
Brown, Thom, 84
Browne, Tom, 224
Bryant, William Cullen, 79
Bryce, Lloyd Stephens, 79
Brzezinski, Emile Benes, 41
Buchanan, James, 21
Buchen, Tony, 208
Buchman, James, 23, 75
Bufano, Beniamino, 221, 224, 243
Buffalo, NY, 93-95
Buffalo Rock Effigy Trumuli, 172
Bullock, Benbow, 20
Bunshaft, Gordon, 95, 112
Buonaccorsi, Jim, 196
Buri, Samuel, 169
Burkert, Robert, 169
Burlini, Joseph, 133
Burri, Alberto, 227
Burt, James, 20
Burton, Scott, 26, 31, 32, 48, 51, 56,
 129, 130, 150, 151, 154, 187, 188,
 199, 200, 212, 251, 252
Bush, Martin, H. 145-146
Butler, Reg, 48, 73, 75, 95, 113
Butler, Eugenia, 238
Butler, Robert, 7, 33-34
Butler Sculpture Park, 33-34
Butler, Susan, 33-34
Butterfield, Deborah, 154
Bynum, NC, 210

Cadillac Ranch, 213
Caesar, Doris, 146
Cafritz, Anthony, 88
Cairns, Christopher, 106
Calaboyias, Peter, 130
Calder, A. Sterling, 48, 123, 192
Calder, Alexander, 13, 19, 26, 30, 32,
 47, 48, 54, 56, 69, 70, 74, 75, 81, 83,
 84, 91, 93, 111, 112, 113, 123, 154,
 166, 184-185, 186, 202, 204, 221,
 227, 229, 236, 254, 256
California Scenario, 235-237, 256
California State University at Long
 Beach, 237-238
Callery, Mary, 75, 93
Calo, Aldo, 169
Cambridge, MA, 30-33
Camillos, Charlotte and Angelos, 19
Campbell, Kenneth, 84
Canal Center Plaza, 126
Cantor, B. Gerald Rodin Sculpture
 Garden, 218-221
Cantor, Iris and B. Gerald Roof Garden
 118
Capps, Kenneth 23, 84
Carhenge 174-175
Carlson, George A. 243
Caro, Anthony 41, 84, 88-90, 107, 113,
 122, 154, 159, 182, 184, 186, 204,
 225, 227, 229, 249, 258
Carter, Dolly Bright 226
Casanova, Aldo 227
Cascella, Ansera 95
Cassidy, Shaun 90
Castanis, Muriel 41
Castelli, Leo 136
Caswell, Dick 1-4
Cataract, WI 178
Cattlett, Elizabeth, 59
Cavalier Galleries, 115
Cave, Leonard, 20
Cazenovia, NY, 98-99
Cedarhurst Sculpture Park, 9, 136-139
Cemin, Saint Clair, 41, 78
Chadwick, Lynn, 75, 107, 108, 109,
 146, 167, 188, 227
Chamberlain, John, 135, 205, 207
Chaplain, Penny, 78
Chase Manhattan Sunken Garden, 62
Chase-Riboud, Barbara, 57, 59
Chateau-sur-Mer, 125

Chattanooga, TN, 192-195, 211
Chattanooga State Technical Community
 College Sculpture Garden, 192-195
Chaurika, Ephraim, 169
Cheekwood, 211-212
Cherne, Leo 227
Chesterwood Museum, 7, 34-36
Chicago, IL 6, 8, 13, 129-136, 171-172
Chief Rolling Mountain Thunder, 260
Chillida, Eduardo, 66
Chin, Mel, 183
Chinati Foundation, 205-207
Chinns, Peter, 75
Christo, 14
Cincinnati, OH, 175-176
Cincinnati Gateway, 175-176
Claremore, OK, 217
Clos Pegase, 258
Cocteau, Gesso, 233
Codman, Ogden, 79
Cohen, Nancy, 45
Collegeville, PA, 107-109
Collins, Jim, 194
Columbus, OH, 166-168, 176
Columbus Museum of Art, 166-168
Complex One, 14
Connell, John, 244
Connemara Conservancy, 197-198
Consagra, Pietro, 8, 24, 151, 204, 227
Cook, Robert, 133
Cooper, Alexander, 52
Cooper, Paul, 245
Cooper, Ron, 245
Coral Castle, 14, 209
Corbero, Xavier, 79
Cornell, Ralph D., 226
Cornish, NH 7, 36-38
Costa, Joan, 20
Costa Mesa, CA, 235-237
Couper, William, 221
Covarrubias, Miguel, 200
Cox, Kris, 20
Craddock, Robert, 58, 59
Cragg, Tony, 113, 154
Cranbrook Academy Art Museum, 146-148
Cravath, Ruth, 224
Crazy Horse Mountain Memorial, 177
Crolius, Clark, 97
Cronin, Robert, 20
Cross, Doris, 246
Crovello, William, 70

Crowder, Susan, 102
Cullen, Lillie and Hugh Roy, 204
Cullen Sculpture Garden, 202-204
Cullman, AL, 208
Cummings Art Building, 221
Cummings, Nathan, 130
Cunningham, Linda, 106

Daen, Lindsay, 169
Dallas, TX, 11, 197-202, 213-214
Dallas Art Museum, 198-200
Darrow, Edwin, 235
Davidson, Jo, 146, 192
Davidson, Robert, 70
Davis, James E., 48
Davis, Michael, 233, 238, 245
Davy, Woods, 238
De Cordova, Julian, 28
De Cordova Museum & Sculpture Park,
 28-30
De Creeft, Jose, 79, 146
De Guatemala, Joyce, 102, 104, 109
Dehner, Dorothy, 84
DeKooning, Willem, 113, 186
DeLue, Donald, 146
De Maria, Walter, 7, 260
Demetrios, Aristedes, 221
Demetrios, George, 192
Deming, David, 166, 167
Denver, CO, 241-243, 259
De Rivera, Jose Ruiz, 26
Derst, Leon, 123
De Saint Croix, Blane, 196
Desert View Tower, 257
DeSilva, James, 6, 240
Des Moines, IA, 139-142
Des Moines Art Center, 139-142
DeStaebler, Stephen, 143, 224, 233
Detroit, MI, 174
DeVries, Andrew, 117
Dia Foundation, 205, 260-261
Dickeyville Grotto, 177
Dietel, Fritz, 102
Dileo, Tony, 194
Dill, Guy, 233, 238
Dillon, Victoria, 41
Dinsmoor, Samuel Perry, 13, 173
Di Suvero, Mark, 6, 8, 26, 29, 32, 64-66,
 79, 83, 84, 134, 135, 154, 159, 164,
 165, 168, 169, 185, 186, 198-199, 200,
 202, 204, 224, 247-249, 258

Doner, Michele Oka, 41
Dorrien, Carlos, 29
Double Negative, 14, 259
Doyle, Tom, 19, 20, 41, 49, 66
Drake, James, 189, 208
Dreyfuss, Alice Ransom Memorial
 Garden, 42-44
Driscoll, Ellen, 41
Dubuffet, Jean, 70, 186, 238, 258
Duchamp, Marcel, 81
Duchamp-Villon, Raymond, 26, 75
Duckworth, Ruth, 130
Dufford, Andrew, 243
Dumont, Linda, 246
Dusenbery, Walter, 159
Dutchess County, NY, 123
Dyfverman, Johan, 130
Dykes, Dan, 233

Eakins, Thomas, 113
Earth Mound, 14, 258-259
Easley, William, 11
East Brunswick, NJ, 49-50
East Otto, NY, 96-97
East Stroudsburg State University, 108, 123
Eastman, Rico, 246
Eckstut, Stanton, 51, 52
Edge, Doug, 236
Edwards, Melvin, 40, 41, 102
Effigy Mounds National Monument, 173
Efrat, Benni, 75
Egbert, Elizabeth, 102
Ehn, John, 255
Elizabeth Street Sculpture Garden, 118-119
Ellis, Clay, 90
Eloul, Kosso, 84, 238
Elozua, Raymon, 186
Embroli, Enrico, 246
Emery, Lin, 19, 20, 76, 77, 78, 188
Emmerich, Andre, 136
Empire State Plaza Art Collection, 91-93
Englewood, CO, 241-243
Engman, Robert, 106
Enzmann,Martha, 137, 138
Epstein, Jacob, 27, 48, 113
Erdman, Richard, 68, 70
Ernst, Jimmy, 78
Ernst, Max, 70, 113
Esprit Sculpture Garden, 257
Etienne-Martin, Henri, 84
Etrog, Sorel, 75, 84, 130, 133, 169, 188, 227

Evans, Rudulf, 75
Evanston, IL, 130-132
Every, Tom, 178
Ewing, Lauren, 66, 263

Falkenstein, Claire, 224, 227, 236, 238
Fane, Lawrence, 20, 29
Farnham, Sally James, 192
Fasnacht, Heide, 41
Fay, Ming, 41
Federal Plaza (New York City), 10, 247
Feilacher, Johann, 20
Feldman, Bella, 246
Ferber, Herbert, 56, 75, 84, 93, 232
Ferguson, John, 104
Ferrara, Jackie, 150, 151, 153, 154,
 157-158, 159, 167, 239, 240
Ferrari, Virginio, 130, 132, 133
Finlay, Ian Hamilton, 159, 240
Finley, Karen, 23
Finster, Howard, 209
Fischer, R.M., 51
Fisher, Frederick, 238
Fishman, Richard, 29
Fite, Harvey, 121-122
Fitzgerald, James, 48, 249
500 Mile Sculpture Garden, 175
Flanagan, Barry, 27, 154, 185, 186
Fleischner, Richard, 14, 31, 32, 75, 125,
 140-141, 151, 159, 240
Fleming, Linda, 66, 245
Florida International University, 184-186
Flower Man's House, 212
Floyd, David, 49
Folk Art Society of America, 211
Fontana, Lucio, 75, 95, 113, 154, 204
Forakis, Peter, 24, 66
Fordham University, 53-54
Foster, John, 90
Fox, Lincoln, 243, 245
Foyil, OK, 211
Frank, Denise, 193
Fraser, James Earle, 192
Fredericks, Marshall, 147
Frega, Al 97, 196
French, Daniel Chester, 2, 7, 34-35, 67,
 129, 163-164, 165, 192
Frey, Viola, 224
Frick, Childs, 79
Friedberg, M. Paul, 51, 126
Friedberg, Richard, 84

Friedeberg, Pedro, 187, 188
Frink, Elizabeth, 113, 188
Fulbrecht, William, 49
Fuller, Mary, 233

Gabo, Naum, 48, 93
Gallagher, Dennis, 233
Galloway, Ed, 211
Garden of Eden, 14, 173
Gardiner, Be, 181, 194
Gargallo, Pablo, 27, 113
Garofalo, Mark, 90
Garysburg, NC, 210
Gas Works Park, 263
Gebhardt, Roland, 84
Gedney Farm, 117
Gehry, Frank, 154
General Mills Art Collection, 5, 6, 148-151
Gerard, Michel, 44, 45
Gerst, Leon, 97
Gettysburg Memorial, 124-125
Giacometti, Alberto, 70, 73, 75, 113,
 203, 204
Gianakos, Christos, 20
Gibbons, Arthur, 78
Gilhooley, David, 222, 224
Gill, Eric, 227
Ginnever, Charles,79, 84, 135, 154,
 159, 165, 169, 186, 188, 2 12
Giusti, Karen, 235
Glavin, Matt, 224
Glenn, Rob, 213
Godfrey, Dewitt, 204
Gold, Betty, 224
Goldberger, Paul, 154
Goldblatt, Aaron, 102
Goldsworthy, Andy, 159
Gonzales, Bennie, 217, 218
Goodacre, Glenna, 11
Goodwin, Jeralyn, 208
Gordon, Harry, 109
Gordon, Lisa, 246
Gottlieb, Adolph, 79
Gottlieb, Richard, 84, 104
Governors State University, Nathan
 Manilow Sculpture Park, 134-136
Gozu, Masao, 188
Graetz, Gideon, 70, 133
Grafly, Charles, 146
Graham, Dan, 159
Graham, Robert, 188, 204, 227

Grand Rapids, MI, 13
Grand Rapids Project, 14
Grausman, Philip, 41
Graves, Bradford, 45
Graves, Michael, 42, 258
Graves, Nancy, 41, 122, 159, 254, 258
Greco, Emilio, 84
Greenamyer, George, 29, 102, 143
Greening, Charles, 263
Green Valley, NM, 259
Greenwich, CT, 115
Greenwood Plaza, 241-243
Griffis, Larry, 96-97
Griffis, Larry, III 96-97
Griffis, Mark, 96-97
Griffis Sculpture Park, 96-97
Grooms, Red, 241, 243
Gross, Chaim, 53, 79, 146, 167
Grosvenor, Robert, 23, 84
Grounds for Sculpture, 38-41
Guimard, Hector, 56
Gumbiner, Abagail, 233
Gustin, Richard, 97
Guytin, Tyree, 174

Haag, Richard, 263
Haas, Richard, 143
Hadany, Israel, 106, 113
Haddaway, Edward, 245, 246
Hadjipateras, Mark, 20
Hadzi, Dimitri, 20, 32, 48, 93, 146, 221,
 227
Hajdu, Etienne, 75
Halahmy, Oded, 75
Hall Family Foundation, 160
Hall, Maria, 20
Hall, Michael David, 48, 147
Hamburger, Sydney, 49
Hamilton, Juan, 165
Hamilton, NJ, 38-41
Hamilton, OH, 176
Hamrol, Lloyd, 249
Hanbury, Una, 245
Haozous, Bob, 245
Hargreaves, George, 243
Haring, Keith, 138
Harper, Barri, 194
Harrell, Hugh, 48
Harries, Mags, 29, 253
Harris, Allen, 115
Harryn, Paul, 109

Hart Plaza, 174
Hartley, Jonathan Scott, 192
Hartman, Ben, 176
Hasinger, Karen, 238
Hatch, Vermont (Monty), 84
Hatcher, Brower, 154
Hatchett, Duane, 21, 23, 97, 169
Hawkins, Gilbert, 24, 84
Hebald, Milton, 88, 146
Heidelburg Project, 174
Held, Marion, 45
Heizer, Michael, 14, 27, 31, 32, 159, 164,
 165, 172, 185, 186, 224, 254, 259
Helliger, Bernhard, 169
Hempstead, NY, 76-78
Henrik, Richard, 78
Henry, John, 129, 130, 133, 135, 168,
 169, 186, 189, 194, 200
Henselmann, Albert E., 45
Hepworth, Barbara, 70, 84, 113, 131,
 132, 146, 167, 168-169, 182, 188,
 199, 200, 204, 226, 227, 230, 232
Hera, 159
Herberta, Victor, 212
Herd, Stan, 15
Heric, John, 246
Hertzberg, G.R., 24
Hicks, Sheila, 236
Hicks, Thomas, 245, 246
Hide, Peter, 90
Higashida, Zero, 19, 29
High Museum, 211
Highland Park, IL, 132-134
Highstein, Jene, 38, 66, 120, 130, 134-
 135, 151, 155, 159, 186
Hill, Elizabeth, 20
Hill, Jim, 245
Hill, Robin, 20
Hinsdale, MA, 118
Hirshhorn, Joseph H., 111-112
Hirshhorn Museum & Sculpture Garden,
 4, 26, 109-113, 126, 134, 187
Hobart, Garret, 45
Hock, John, 89, 90
Hoffman, Malvina, 192
Hoflehner, Rudolph, 48
Hofstra University, 76-78
Hofstra, William S., 76
Hokanson, Hans, 84
Hollis, Doug, 183, 251, 252
Holt, Nancy, 14, 249, 262

Holzer, Jenny, 153, 155, 186, 239, 240
Homestead, FL, 14, 209
Horwitt, Will, 75, 93
House, John, 151
Houston, TX, 8, 202-204, 212-213
Houston Museum of Fine Arts, Cullen
 Sculpture Garden, 8, 202-204
Hoving, Thomas, 48
Howard, Linda, 168, 169, 188
Howard, Robert, 224
Hrdlicka, Alfred, 84
Hund, Frederick, 49, 117-118
Hunnicutt, Barry, 218
Hunt, Bryan, 56, 165, 204, 238
Hunt, Richard, 59, 79, 84, 113, 129,
 130, 133, 135, 159, 227, 229, 246
Hunt, Richard Morris, 2, 35
Huntington, Anna Hyatt, 4, 15, 79,
 190-192
Huntington, Archer Milton, 190-191
Huntington, Chuck, 151
Huntington, Jim, 84, 165, 236
Huntington, WV, 214
Huntington Museum of Art, 214
Hyde, Doug, 245
Hyde Park, IL, 129-130

Imlay, NV, 260
Indermaur, Robert, 246
Indiana, Robert, 3, 144, 146, 172
Indianapolis, IN, 172
Indianapolis Museum of Art, 3, 172
Indick, Janet, 49
Iowa State University, Art on Campus
 Program, 142-143
Ipousteguy, Jean 75, 113, 131, 132, 188
Ireland, Charles W., 182-183
Ireland, Charles W., Sculpture Garden,
 182-183
Irwin, Robert, 120, 238, 240
Isherwood, Jon, 20, 90, 107, 109

Jackson, Joe, 97
Jacob, David, 78
Jacobson, David, 49
Jacquard, Jerald, 159
Jacumbo, CA, 257
Jaudon, Valerie, 182
Jenkintown, PA, 100-102
Jennings, John Douglas, 143
Jennings, Richard, 88

Jermyn, Ron, 246
Jiminez, Luis, 146, 244, 245
Johanson, Patricia, 84
Johnson Atelier, 41
Johnson, Bruce, 138-139
Johnson, Erick C., 243
Johnson, J. Seward, Jr., 7, 40, 41, 76, 78, 124, 259
Johnson, Philip, 56, 114
Johnstown, PA, 124
Jones, Clyde, 210
Joseph, Nathan Slate, 41
Joseph, Pam, 24
Judd, Donald, 93, 159, 186, 205-207, 229, 249
Judson, Sylvia Shaw, 133

Kadishman, Menashe, 84, 113, 188, 212
K & B Plaza 6, 187-188
Kaiser, Diane, 24
Kaneko, Jun, 159
Kansas City, MO 5, 160-163
Karp, Ivan, 67
Karpowitz, Terry, 135
Katonah Museum of Art, 121
Katzen, Lila, 24, 29, 53
Kawashima, Takeshi, 122
Kearney, John, 138, 144, 146
Kelleher, Patrick J., 48
Kelly, Ellsworth, 27, 93, 113, 153, 155, 169, 199, 200, 204, 229
Kendall, Donald, 69
Kendall, Donald, Sculpture Garden, 68-71
Kendrick, Mel, 151
Kennedy, John, 233
Keppelman, John, 249
Kessler, Lorraine, 88-91
Keswick, Sir William, 84
Ketchman, Niki, 20
Keystone, SD, 176
Kiley, Daniel Urban, 161, 222
King, Dave, 45
King, Katherine, 20
King, Phillip, 27
King, William, 39, 40, 41, 78, 122, 143, 144, 146, 159, 165, 167, 212
Kipp, Lyman, 45, 84, 93, 165, 169
Kirk, Jerome, 84
Kirkland, Larry, 243
Kirschenbaum, Bernard, 169
Kirsten Gallery, 263-264

Kirsten-Daiensai, Richard C., 263-264
Kleiman, Gary, 186
Klein, Ron, 102
Knapp, Pascal, 88
Knox, Seymour, 95
Knowlton, Grace, 24, 42, 66, 84, 243
Knoxville, TN, 195-197
Knuth, Mark, 143
Kodama, Masami, 53
Koenig, Fritz, 84
Kohl, Joyce, 245
Kohler Foundation, 170-171
Kohler, John Michael, Arts Center, 178
Kohlmeyer, Ida, 188
Kohn, Gabriel, 238
Kolbe, George, 75, 155, 229
Kondo, Israel, 169
Konzal, Joseph, 84
Kosta, Alex, 84
Kowal, Dennis, 29, 133
Kowalski, Dennis, 130
Kowalski, Piotr, 237, 238
Kouros Sculpture Center, 19-21
Kraft, Kenneth H., 133
Kraisler, David, 218
Kramer, Mary Ellen, 44
Kreeger, David Lloyd and Carmen, 114-115
Kreeger Museum, 114-115
Kripal, Nicholas, 102
Kruger, Anders, 207
Kurhajac, Joseph, 88
Kusama, Yayoi, 207
Kutztown University, 108, 123
Kykuit, The Rockefeller Estate, 5, 71-76

Labriola, Ann Lorraine, 97
Lachaise, Gaston, 4, 25, 27, 48, 54, 56, 73, 75, 94, 110, 113, 164, 165, 192, 225, 227
La Grasse, Deborah, 194
LaGrone, Oliver 244, 245
La Jolla, CA, 239-241
Lake Merritt Channel Park, 224
Land of Pasaquam, 209-210
Lapka, Evan and Milan, 98
La Quinta Sculpture Park, 234-235
Larson, Philip, 151, 155
Lash, Jon, 41
Lassaw, Abram, 78
Las Vegas, NV, 259

Laudenslager, Jeffrey, 233
Laumeier, Matilda and Henry, 158
Laumeier Sculpture Park, 5, 8, 9, 136, 155-159
Laurens, Henri, 27, 70, 113, 227, 232
Lavatelli, Carla, 221
La Verdiere, Bruno, 167
Lawless, Billie, 97
Lawrence Gallery, 261
Layland, Charles, 105, 106
Lazare, Kim, 263
Lee, Billy, 181
Leedskalnin, Edward, 14, 209
Lefevre, Minard, 119-120
Lehigh University, 103-104
Lehigh Valley Hospital Sculpture Garden, 123
Leicester, Andrew, 142-143, 175-176
Leitner, Jon, 243
Lekakis, MIchael, 20
Leon, Dennis, 224, 243
Letendre, Rita, 239
Levi, Ryda and Robert, H. 26
Levi Sculpture Garden, 25-28
Levine, Eric, 155
Levy, Stacy, 102
Lewis, Evan, 194
LeWitt, Sol, 23, 84, 155, 183, 186
Liberman, Alexander, 9, 29, 75, 84, 93, 138, 156, 157, 159, 168, 169, 184, 186, 229, 263
Lichtenstein, Roy, 78, 79
Lieberman, Claire, 20
Lightning Field, 9, 260-261
Lin, Maya, 10
Lincoln, MA, 28-30
Lincoln, NE, 163-166
Linn, Steve, 41
Lipchitz, Jacques, 27, 32, 46, 48, 54, 56, 70, 75, 113, 114, 115, 132, 155, 165, 182, 188, 201, 221, 226, 227, 232, 254
Lipsky, Dariusz, 98
Lipsky, Donald, 159
Lipton, Seymour, 70, 78, 93, 188, 214
List Visual Arts Center, 30-33
Lobe, Robert, 41
Loewenstein, Daniel, 102
Long Beach, CA, 237-238
Long Island University, Brooklyn, 119
Long Island University, C.W. Post

Campus, 120
Longman, Evelyn B., 75
Lopez-Chicheri, Enrique Saavedra, 98
Lorenz, Elaine, 41, 44, 45
Los Angeles, CA 5, 6, 14, 225-232, 237, 253-255
Los Angeles County Museum of Art, 6, 228-230, 259
Love, Arlene, 102
Love, Jim, 204
Lovet-Lorski, Boris, 146
Lucama, NC, 210
Lucas, KS 14, 173
Lucchesi, Bruno, 165
Luchsinger, Bill, 143
Lundeen, George W., 243
Lutz, Winifred 100, 101

Mack, Heinz, 169
Mack, Rodger, 98
Macklin, Ken, 90
MacMonnies, Frederick W., 192
Madden, John W. Jr., 242
Magnuson, Warren G., Park, 250-252
Mahler, Anna, 227
Maillol, Aristide, 56, 70, 73, 74, 75, 113, 146, 167, 200, 201, 204, 227, 232
Maki, Robert, 240
Mallary, Robert, 93
Manca, Albino, 192
Manchester, VT, 125
Mandelman, Bea, 246
Mangold, Peggy, 259
Mangold, Robert, 235, 243, 259
Manilow, Lewis, 6, 135
Manilow, Nathan, 135
Manilow, Nathan, Sculpture Park, 5, 134-136
Manship, Paul, 94, 110, 147, 192
Mantynen, Jussi, 147
Manzu, Giacomo, 27, 113, 155, 159, 167, 201
Marcheschi, Cork, 144-145, 146
Marcks, Gerhard, 27, 75, 113, 146, 167, 169, 227
Marcus, Stanley, 118
Marcy, Mary S., Court and Garden, 256
Marfa, TX, 205-207
Margulies, Martin, Z. 184
Marika, Denice, 11

Marini, Marino, 27, 70, 74, 75, 79, 155, 201, 204
Marinski, Harry, 241, 242, 243
Mark, Phyllis, 78
Marsh, Stanley, III 213
Martens, Christiane T,. 246
Martin, Eddie Owens, 209-210
Martinelli, Ezio, 88
Massachusetts Institute of Technology (MIT) List Visual Arts Center, 30-33
Mason, John, 224, 232
Mason, Raymond, 113
Mastroiani, Umberto, 75
Matisse, Henri, 29, 56, 110-111, 113, 202, 204, 227
Matisse, Paul, 29
McAndrew, John, 56
McCafferty, Michael, 249
McCollum, Allan, 188
McDiarmid, Duane, 196
McDonnell, Joseph, 20, 233
McGraw, DeLoss, 233
McGuire, Frank, 185, 186, 188
McKissack, Jeff, 212
Meadmore, Clement, 48, 75, 93, 136, 167, 169, 212, 256
Meadows, Algur H., 201
Meadows, Elizabeth, Sculpture Garden, 200-202
Mennin, Mark, 20
Mercer, Grey, 49
Mestrovic, Ivan, 243
Metropolitan Museum of Art, 118, 229
Metzler, Kurt Laurenz, 87
Metzler, Lawrence, 20
Miami, FL, 184-186, 208-209
Middlefield, MA, 117
Mies van der Rohe, Ludwig, 207
Miki, Tomio, 84
Milkovisch, John, 212
Milkowski, Antoni, 76, 78, 93, 169
Mill Creek Canyon Earthworks, 264
Miller, Elliot, 45, 49
Miller, Richard, 165
Miller, Ross, 29
Miller, Samuel C., 42
Miller, Valerie, 233
Milles, Carl, 145, 147, 159, 236
Millspaugh, Dan, 194
Milwaukee, WI, 4, 168-170
Minker, Sally, 44, 45

Minneapolis, MN, 5, 12, 13, 148-155
Minneapolis Sculpture Garden, 5, 151-155
Mirko, Balsadella, 75
Miro, Joan, 4, 26, 27, 70, 113, 126, 132, 144, 146, 160, 186, 221, 236, 256
Miss, Mary, 51, 135, 136, 141, 157-158, 159
Mitchell, John, 136
Mitchell Museum, Cedarhurst Sculpture Park, 9, 136-139
Mitchell, Tyrone, 59
Mittelstadt, Robert, 219
Mock, Richard, 66
Mooney, John David, 130
Moore, Harriet, 49
Moore, Henry, 25, 27, 31, 32, 46, 48, 56, 71, 73, 75, 76, 78, 84, 88-89, 109-110, 11, 113, 114, 115, 126, 129, 130, 132, 144, 146, 155, 166, 167, 169, 187, 188, 200, 201, 221, 226, 227, 229, 230-231, 232, 236, 242, 243
Moore, Henry, Sculpture Garden, 5, 160-163
Moore, Jesse, 102
Morbillo, Frank, 233, 246
Moroles, Jesus Bautista, 66, 188, 189, 212, 244, 245
Morris Arboretum, 105-107, 108
Morris, John T. and Lydia, 106
Morris, Robert, 14, 23, 159, 232, 249
Morristown, TN, 212
Morse, John, 66
Moses, Lemon, 169
Mt. Rushmore Memorial, 176-177
Mt. Vernon, IL, 9, 136-139
Mountainville, NY, 81-85
Moyers, William, 245
Muller, Robert, 227
Mullican, Matt, 200
Murphy, Franklin D., 226-227
Murphy, Franklin, Sculpture Garden, 225-228
Murray, Elizabeth, 240
Murray, Robert, 84, 159, 165, 166, 167, 169, 237-238
Murrells Inlet, SC, 190-192
Murrill, Gwynne, 233
Museum of Contemporary Art

Museum of Modern Art, Abby Aldrich
 Rockefeller Sculpture Garden, 4, 26,
 54-57, 110
Museum of Outdoor Arts, 241-243
Myers, Forrest, 21, 23, 41, 84, 93

Nadelman, Elie, 56, 75, 164, 165, 192
Nagare, Masayaki, 48, 75, 95, 169, 188
Nakian, Reuben, 20, 25, 79, 93, 95,
 113, 155, 165, 212, 227
Napa Valley, 258
Naranjo, Michae,l 245
Nash, David, 155, 157, 159
Nashville, TN, 211-212
Nassau County Museum of Fine Arts,
 78-81, 120
National Endowment for the Arts, 252
National Gallery of Art, 126
National Oceanic and Atmospheric
 Administration (NOAA), 250-252
Nauman, Bruce, 135, 136, 140, 141, 240
Negri, Mario, 41
Neizvestny, Ernst, 234, 235
Nelson-Atkins Museum of Art, Henry
 Moore Sculpture Garden, 5, 160-163
Neri, Manuel, 41
Nesjar, Carl, 48
Neubert, George, 164
Neuland, Dan, 97
Nevelson, Louise, 27, 30, 31, 32, 47, 48,
 71, 73, 75, 84, 93, 94, 95, 119, 146,
 159, 170, 186, 217, 218, 254, 256
Nevelson, Louise, Plaza, 119
Newark, NJ, 42-44
Newark Museum Sculpture Garden, 42-44
New Haven, CT, 116
Newman, Barnett, 79
Newman, Dennis, 257
Newman, John, 84, 151
New Marlborough, MA, 117
New Orleans, LA, 187-188
Newport, RI, 14, 125
Newport Harbor Art Museum, 256
New York City, 4, 5, 6, 10, 50-68, 92,
 118-121, 185, 191, 247
Neylor, John Geoffrey, 166-167
Nichols, Philip, 193, 194
Nichols, Walter, 147
Nierman, Leonardo, 53
Niizuma, Minoru, 20, 95
Nivola, Constantino, 78

Noguchi Garden Museum, 59, 60-62,
 63, 65
Noguchi, Isamu, 6, 27, 48, 60-62, 69,
 71, 75, 82, 83, 84, 93, 95, 115, 116,
 122, 126, 155, 169, 174, 185-186,
 187-188, 200-201, 202-204, 208-209,
 227, 235-236, 247, 249, 254
Noland, Kenneth, 31, 32
Nomura, Stephen, 233
Nonas, Richard, 45, 79, 147
North Carolina Museum of Art, 211
Northshore Sculpture Park, 171-172
North Tarrytown, NY, 5, 71-76
Northwestern University, Mary & Leigh
 Block Gallery, 130-132
Norton, Ann, 84
Novak, Gyora, 93

Oakland, CA, 222-225
Oakland City Center, 257
Oakland Museum, 222-225, 257
Oakland Sculpture Project, 224
Odza, Theodore, 84
Ogden, Ralph E., Foundation, 84
OK Corral, 212
Old Alexandria, VA, 126
Old Trapper's Lodge, 255
Oldenburg, Claes, 13, 54, 56, 69, 70, 71,
 84, 93, 112, 113, 151-152, 155, 161,
 162, 164-165, 198, 201, 206, 207
Olmsted, Frederick Law, 220
Oppenheim, Dennis, 122, 159
Opus, 40 121
Orange Show, 212-213
Orion, Ezra, 75
Orlando, Joe, 245
Ostermiller, Dan, 245
Ostrander, OH, 176
Ottawa, IL, 172
Otterness, Tom, 52
Outterbridge, John, 58, 59

Padovano, Anthony, 84
Page, Russell, 70, 166
Paik, Nam June, 84, 240
Paine, Robert Treat, 224
Palace of the Legion of Honor, 10
Paladino, Mimmo, 204
Pan, Marta, 168, 169
Paolozzi, Eduardo, 48, 75, 84
Paradise Garden, 209

Paris, Harold Perisco, 224
Paraschos, Manolis, 20
Parish, Willie Ray, 247
Parker, Barry, 20, 102
Pasadena, CA, 230-232
Pasadena City College, 6
Pasaquan, GA 209-210
Pascual, Manolo, 76, 67
Paterson, William, College Outdoor
 Sculpture Collection, 44-46
Pattison, Abbott, 133, 217, 218
Pavlovsky, Michael, 246
Payne, John, 136, 196
Peace Monument, 178
Peacock, Dennis, 194, 195
Peart, Jerry, 135, 136, 189
Pei, I.M. 31
Peleg, Ephraim, 103, 104
Pelli, Cesar, 51
Pels, Marsha, 19, 20
Pennville, GA, 209
Pepper, Beverly, 32, 40, 41, 66, 84, 93, 95,
 143, 156-157, 159, 169, 182, 200, 249
PepsiCo, Donald M. Kendall Sculpture
 Gardens, 5, 6, 68-71, 79
Perless, Robert, 22, 23, 25
Perlman, Joel, 42, 78, 84, 186
Perot, H. Ross, 10
Perry, Bea, 25
Perry, Charles O., 236
Perutz, Dolly, 78
Petersen, Chrstian, 142, 143
Peterson, Rasmus, Rock Garden, 261
Pevsner, Antoine, 48, 130
Pfann, Karl, 84
Philadelphia, PA, 13, 105-109, 123
Phillips, WI, 170-171
Phoenix, AZ, 217-218, 253
Picasso, Pablo, 4, 13, 30, 32, 48, 56, 74,
 75, 113
Pierce College, 255
Pigdom, 212
Pillhofer, Josef, 84
Pioneer Plaza, 11
Pittsburgh, PA, 124
Poirer, Anne and Patrick, 126
Polasek, Ablen, 130, 133
Pollack, Jackson, 82
Pomodoro, Arnoldo, 23, 48, 70, 71, 75,
 129, 130, 131, 132, 188, 221, 242, 243
Pomodoro, Gio, 75

Poncet, Antoine, 130, 132, 221
Popa, Mihai, 121
Porcaro, Don, 20
Porphyrios, Demetri, 52
Porter, Howard, 212
Porter, Stephen, 104, 245
Portland, OR, 261
Potsdam College, 122
Poughkeepsie, NY, 88-91, 122-123
Predoc, Antoine, 244, 245
Price, Art, 71
Price, Bret ,71
Price, Michael B., 106, 109
Priesner, Mike, 97
Princeton University, John Putnam, Jr.
 Memorial Collection, 4, 46-48
Prisbrey, Tressa ("Grandma"), 255
Promenade Classique, 126
P. S., 1, 63-64
Purchase, NY, 68-71
Purdy, Martin, 252
Puryear, Martin, 116, 136, 152-153, 155
Putnam, Lt. John, Jr., 46
Pyramid Hill Sculpture Park and
 Museum, 176

Quemada, NM, 260
Quietude, 49-50

Radoff, Sam, 133
Ramsaran, Helen, 57, 59
Rancho Mirage, CA, 232-234
Rand, Steven, 20, 218
Rank, Mary, 122
Ratcliffe, M.T., 257
Ravinia Festival, 132-134
Reder, Bernard, 75, 146
Reese, Jack, 196
Reginato, Peter, 25, 41, 84
Reinders, Jim, 174-175
Remington, Frederick, 192
Rennels, Frederic, 143
Ressler, Robert, 20, 29, 66
Revier, Allan, 118
Rich, Francis, 147
Richardson, Sam, 165
Richier, Germaine, 27, 113
Richmond, VA, 214
Rickey, George, 19, 20, 29, 46, 47, 48,
 68, 71, 75, 84, 93, 95, 105, 106, 115,
 126, 146, 159, 167, 169, 184, 186,
 188, 214, 224, 225, 227, 236, 243, 258

Ridgefield, CT, 19-23
Riek, John, 104
Riester, Dorothy and Robert ,98
River Gallery Sculpture Garden, 211
River Studio and Foundry, 117
Rivera, Diego, 94
Rivera, Reynaldo, 245
Robb, Kevin, 246
Robertson, Jacquelin Taylor, 161
Robus, Hugo, 146
Roccamonte, Giorgio Amelio, 227
Roche, Kevin, 222
Rockefeller, Abby Aldrich, 56
Rockefeller, Abby Aldrich Sculpture
 Garden, 54-57
Rockefeller Estate, 5, 71-76
Rockefeller Family, 6, 74
Rockefeller, Nelson, 73-74, 91, 92
Roden Crater, 252
Rodia, Simon, 14, 237, 253-254
Rodin, Auguste, 27, 48, 54, 69, 71, 109-
 110, 113, 146, 147, 182, 200-201, 204,
 218-221, 225, 227, 229, 230-231, 232
Rogers, Randolph, 192
Rogers, Will Memorial, 211
Rohm, Robert, 25
Rollins, Henry, 224
Roloff, John, 224
Romano, Sal, 49
Romeda, Bruno, 20
Rood, John, 169
Roosen, Mia Westerlund, 83, 84, 249
Rosati, James, 42, 75, 93, 126, 169
Rosen, Doris and Martin, 189
Rosen Sculpture Garden, 189-190
Rosenthal, Bernard (Tony), 48, 78, 93,
 147, 159, 165, 184, 185, 186, 227
Rosenwald, Lessing, 100
Roslyn Harbor, NY, 78-81
Roszak, Theodore, 146
Roth, Frederick George Richard, 75
Rothschild, Gail, 29
Rothschild, Peter, 154
Rothschild, Walter, 67
Rubin, Harris, 188
Ruckrien, Ulrich, 186
Rudolph, WI, 178
Russell, James T., 156
Rust, Brian, 196
Rutherford, William A., 84, 150-151
Rybicki, Edmund, 178

Saarinen, Eero, 13, 147, 222
Saarinen, Eliel, 146, 147
Safdie, Moshe, 255
Saganic, Livio, 20
Saint-Gaudens, Augustus, 2, 7, 35, 36-
 38, 129, 192
Saint-Gaudens, Louis, 192
Saint-Gaudens National Historic Site,
 36-38
Saint Louis, MO, 5, 8, 9, 13, 155-159
Saint Phalle, Niki de, 240
Salmones, Victor, 71
San Antonio, TX, 5
Sanderson, Raymond Phillips, 218
San Diego, CA, 239-241, 256
San Diego Art Museum of Art, 256
Sandle, Michael, 188
San Francisco, CA, 10, 257-258
Santa Fe, NM, 245-246
Santana, Ferdinand, 97
Saugerties, NY, 122
Savage, J. David, 48
Scanga, Italo, 186
Schade, Art, 20, 41
Schlar, Harold, 49
Schleeh, Hans, 84
Schmidt, James, 20
Schmidt, Julius, 48, 93, 143, 165
Schrem, Jan, 258
Schwartz, Buky, 104, 106, 129, 130
Schoonhoven, Terry, 238
Scott, Geraldine Knight, 222
Scott, John, 59
Scott, Joyce, 158, 159
Scottsdale Center for the Arts, 217-218
Scudder, Janet, 75
Sculpture Center's Motorgate, 119
Sealine, Eric, 143
Seattle, WA, 250-252, 262-264
Seattle Arts Commission, 252
Seattle Center, 262-263
Sebastian, 243, 245
Segal, George, 8, 42, 43, 47, 48, 69, 71,
 93, 155, 188, 221
Segerstrom, Henry T., 236
Seiler, Herbert, 103, 104, 109
Seley, Jason, 75, 93
Serra, Richard, 10, 79, 82, 84, 141, 151,
 153, 155, 159, 164, 165, 184, 186,
 200, 232, 247, 249, 258
Sewell, Lee, 103, 104

Shady, NY, 122
Shahn, Ben, Art Center, 45
Shanhouse, Bill, 78
Shapiro, Joel, 26, 27, 41, 56, 126, 136, 153, 204
Shaw, Ernest, 103, 104, 123, 169
Shay, Ed, 29
Shea, Judith, 38, 110, 113, 155, 156, 159, 164, 165
Sheffield, MA, 33-34
Sheldon, Mary Francis and Adams Bromley, 165
Sheldon Memorial Art Museum Sculpture Garden, 163-166
Shemi, Yehiel, 84
Sherbill, Rhoda, 78
Shelton, Peter, 55
Shidoni Foundry, 245-246
Sho-En Environmental Garden, 256-256
Shore, Richard, 23, 84
Shrady, Frederick, 53
Siegel, Julie, 97
Silberman, Bernadine, 49
Silver, Jonathan, 155
Silverman, Arthur, 188
Simon, Herbert, 103, 104
Simon, Norton, 6, 231
Simon, Norton, Sculpture Garden, 230-232
Simonds, Charles, 84
Simpson, Volles, 210, 245
Simun, Konstantin, 29
Sinaiko, Arlie, 169
Sisko, Paul, 104, 123
Skirball Museum, Hebrew Union College, 5, 255
Sklavos, Yerassimos 84
Skokie Northshore Sculpture Park, 171-172
Skolnik, Sara, 130
Slater, Gary, 218
Sloss Furnaces National Historic Landmark, 208
Smith, Alexis, 239, 240
Smith, David, 4, 43, 48, 56, 71, 75, 81-82, 84, 92, 93, 95, 112, 113, 165, 201, 204, 225, 227
Smith, Fred Concrete Sculpture Park, 170-171
Smith, Tony, 21, 23, 26, 27, 32, 43, 48, 56, 66, 71, 75, 93, 95, 113, 126, 153, 155, 165, 169, 186, 200

Smithson, Robert, 14, 261-262
Smyth, Ned, 51, 116, 124
Snelson, Kenneth, 48, 71, 75, 84, 95, 112, 113, 167, 186, 187, 188, 200, 221
Snug Harbor Cultural Center, 119-120
Snyder, Peter, 97
Socrates Sculpture Park, 45, 63, 64-66, 136
Soleri, Paolo, 115
Somaini, Francesca, 115
Sonfist, Alan, 41
South Coast Plaza, 235-237
Southern Methodist University, Elizabeth Meadows Sculpture Garden, 200-202
Southern Vermont Art Center, 125
Speed, Bonnie, 9, 137-138
Spiral Jetty, 14, 261-262
Springfield, OH, 176
Stackhouse, Robert, 159
Stahly, Francois, 92, 93, 221
Stamford, CT, 23-25, 115
Stamford Museum & Nature Center, 23-25
Stanford University, 8, 218-221, 228, 229
Stankiewicz, Richard, 43, 66, 84, 155, 159
Stein, Gila, 49
Steinberg, Bryan, 102
Steiner, Michael, 32, 84, 159
Stella, Frank, 204, 254
Stern, Jan, 84
Sternal, Tom, 104, 105, 106, 109, 123
Stevenson, Quentin J., 210
Stickley, Gustav, 207
Stockbridge, MA, 34-36
Stolz, David, 84
Stone, Edward Durrell, 69
Stone, Edward Durrell, Jr., 70
Stone Quarry Hill Art Park, 98-99
Stoney, John, 88
Storm King Art Center, 4, 79, 81-85, 87, 151, 156, 241
Story, William Wetmore, 221
Strautmanis, Edwin, 136
Streeter, Tal, 84
Strider, Marjorie, 43
Stritch, John, Sculpture Garden, 118
Strohbeen, Karen, 143
Stromeyer, David, 29
Strzelec, Patrick, 102
Stuart Collection, 5, 239-241
Stuart Foundation, 240
Studio Museum in Harlem, 57-60

Sugarman, George, 84, 91, 93, 105, 106, 124, 168, 169, 183
Sullivan, Louis, 67, 146, 165
Sultan, Donald, 165
Sun Tunnels, 14, 262
Surls, James, 97, 194, 200
Suttman, Paul, 113
Sveinson, Asmunder, 71
Swift, Jay, 20

Tacca, Pietro, 243
Taft, Lorado, 129-130
Tajiri, Shinkichi, 72, 73, 75
Takaezu, Toshiko, 41
Tallichet, Jude, 102
Tasch, Linda, 246
Tatro, Ron, 233
Taylor, Wendy, 75
Tefft, Elden, 227
Tempe Arts Center, 253
Thau, Sheila and Ed, 49
Thorn, Erwin, 84
Tibbetts, Steve, 249
Tillery, Lynn, 243
Tillson, NY, 85-88
Todd, Michael, 84, 165, 186, 224, 232, 233
Tognoni, George-Ann, 217, 218
Tomkins, Calvin, 60-61, 162
Tonetti, E.M.I., 75
Toole, Frank, 97
Totem Pole Park, 211
Townley, Hugh, 29
Trakas, George, 249, 251, 252
Tribe, Lee, 20, 84
Trova, Ernest, 84, 146, 158-159, 167
Tsutakawa, George, 227
Tucker, Richard, 79
Tucker, William, 56, 66, 73, 102, 113, 122, 159, 165, 186, 227
Tully, Robert, 246
Tumarkin, Igael, 104, 109
Turnbull, William, 227
Turner, Cleveland, 212
Turner, Richard, 238
Turrell, James, 252
Tuscaloosa, AL, 181-182

Ulrich, Edwin, Museum of Art Sculpture Garden, 144-146
Umeda, Kenji, 217, 218
Underhill, William, 169

Unger, Mary Ann, 102, 104, 108, 109
University of California at Los Angeles (UCLA) Franklin Murphy Sculpture Garden, 225-228
University of California at San Diego, Stuart Collection, 239-241
University of Chicago, 8, 129-130
University of Houston, 212
University of Nebraska, Sheldon Memorial Art Gallery Sculpture Garden, 163-166
University of Pennsylvania ,105-107, 123
University of Tennessee Sculpture Tour, 193, 195-197
University of Texas, San Antonio, 5
University Park, IL, 5, 134-136
Urban, James, 111
Ursinus College, Berman Museum of Art, 107-109

Vagis, Polygnatos, 56
Vail, Lorraine, 105, 106
Van Alstine, John, 113
Van Bruggen, Coosje, 13, 151-152, 155, 161, 162, 164-165, 206
Van de Bovenkamp, Hans, 7, 20, 49, 85-88, 246
Van de Bovenkamp, Hans, Sculpture Garden, 7, 85-88, 121, 122
Van Sant, Tom, 238
Van Sant, Frank, 260
Van Valkenburgh, Michael, 154
Vassar College Museum of Art, 122-123
Vaughan, Bert, 257
Vaux, Calvert, 220
Vega, Ed, 245
Viani, Alberto, 48
Vildziunas, Vladas, 227-228
Vinci, John, 131
Virginia Museum of Fine Art, 214
Virlane Foundation Collection, 187-188
Vlavianos, Nicolas, 19, 20
Von Rydingsvard, Ursula, 41, 82, 83, 84, 100-102, 122, 155, 159
Von Schleggel, David, 23, 84, 159
Von Tongeren, Herk, 41
Vostel, Wolf, 130
Voulkos, Peter, 93, 147, 222-224, 228, 229

Waddell, John, 133, 218
Wagner, Merrill, 45

Wagner, Father Philip J., 178
Walburg, Gerald, 84, 224
Waldron, Tom, 245
Walker Art Center, Minneapolis
 Sculpture Garden, 5, 12, 151-155
Walker, Milton Rock Garden, 263
Walker, Nellie Vern, 143
Walker, Thomas Barlow, 154
Wall, Brian, 165, 224
Walters State Community College
 Sculpture Tour, 212
Warburg, Felix, 67
Warburg, Frieda Schiff, 6, 67
Warburg, Frieda Schiff, Sculpture
 Garden, 67-68
Ward, John Quincy Adams, 192
Ward, Nari, 58, 59
Warhol, Andy, 26, 74
Warsinske, Norman, 249
Washington, D.C., 4, 109-115, 125-126
Water Mill, NY, 121
Watson, Colin Webster, 49
Watson, Willard, 213
Watts Towers, 14, 237, 253-254
Wave Hill, 120
Wayne, NJ, 44-46
Weaver, Bill, 246
Weber, Willy, 75
Webster, Meg, 157, 159
Wedig, Dale, 143
Wegman, William, 239, 249
Wegner, Paul and Matilda, 178
Weigel, Doug, 233
Weinberger, Steven, 97
Weinman, Adolph, 192
Weiss, Harvey, 20
Wenger, Edwin, 246
Wercollier, Lucien, 115
Werner, Zelda W., 133
Wernerus, Father Mathias, 177
Wesley, John, 207
Western Washington University, 4, 247-
 250
Westin Mission Hills Resort Hotel, 232-
 234
Westport, CT, 115
West Stockbridge, MA, 117
Wexler, Allan, 29
Whisler, Stephen, 20

White, Bruce, 20, 143
White, Gail Scott, 99
White House, 125
White, Robert, 78
White, Stanford, 2
Whitney, Gertrude Vanderbilt, 192
Whitney, Mac, 200
Wichita, KS, 144-146
Wichita State University, Edwin Ulrich
 Museum of Art, 144-146
Wiener, Madelyn, 243
Wight Art Gallery, 225, 226
Wilburton Inn, 125
Williams, Roger, 20
Williamsville Inn, 117
Wilmarth, Christopher, 48
Wilson, Roy, 102
Wines, James, 93
Winslow, Robert, 218
Winzenz, Karen, 246
Witkin, Isaac, 32, 84, 113, 124, 159, 169
Wolfe, James, 84, 124
Wolfe, James Sculpture Trail, 124
Wolff, Andrew, 102
Woodstock, NY, 122
Worthington, Mac, 176
Wotruba, Fritz, 27, 75, 84, 95, 113, 201
Wright, Dale, 217, 218
Wurtzberger, Alan and Janet, 26
Wurtzberger Sculpture Garden, 25-28
Wynne, David, 69, 71

Yale University, 62, 166
Yarborough, Dan, 136
Yosef, Sassom, 49

Zadkine, Ossip, 27, 188
Zajac, Jack, 221, 224, 228
Zang, Elena, 122
Ziegler, Laura, 167
Zimmerman, Elyn, 79, 116-117, 149-
 150, 151, 182-183, 258
Ziolowski, Korczak, 177
Zoettle, Joseph, 208
Zorach, William, 146, 165, 192, 228
Zuniga, Francisco, 113, 144, 145, 146, 228
Zwack, Marilyn, 253
Zweygardt, Glenn, 97, 103, 104, 108,
 109, 196, 246

5/16